Date: 6/12/23

PALM BEACH COUNTY
LIBRARY SYSTEM

3650 Summit Boulevard
West Palm Beach, FL 33406

NORMAN ROCKWELL'S MODELS

NORMAN ROCKWELL'S MODELS

IN AND OUT OF THE STUDIO

S. T. HAGGERTY

ROWMAN & LITTLEFIELD
Lanham • Boulder • New York • London

Published by Rowman & Littlefield
An imprint of The Rowman & Littlefield Publishing Group, Inc.
4501 Forbes Boulevard, Suite 200, Lanham, Maryland 20706
www.rowman.com

86-90 Paul Street, London EC2A 4NE

British Library Cataloguing in Publication Information Available

Library of Congress Cataloging-in-Publication Data

ISBN 978-1-5381-7035-9 (cloth)
ISBN 978-1-5381-7036-6 (electronic)

In memory of Charles Bentley Jr.,
who introduced me to the Rockwell models.
And to the people of Arlington,
Vermont, past and present.

Contents

Acknowledgments ix

Prelude xiii

Introduction 1

1 Search for a Marbles Shooter 5

2 One Tough Cookie 17

3 A Serendipitous Meeting 29

4 A Whole Family of Models 51

5 Son, Model, Author of Best Sellers 67

6 Talent Right Next Door 97

7 Like a Daughter 113

8 A Marine's Commander 137

9 An Extravaganza of Red 147

10 Auction at Sotheby's 155

11 A Sweet Bribe 169

12 Norman's Favorite Male Model 179

13 A Broken Heart 183

14 A Star in His Father's Paintings 199

15 The Vanishing Act 227

16 Saving *The Babysitter* 233

17 The Frantic Search for a Masterpiece 239

Reflections 257

Bios of the Models 261

Notes 267

Index 281

About the Author 297

Acknowledgments

First, I want to thank my daughter Christina, who provided excellent company and listened to parts of these stories; my stepson John O'Connor; and our cat Lucky, who often slept on my arm as I wrote.

Suandy Palencia for love and inspiration. You are the best!

Don Trachte Jr., organizer of Vermont Rockwell Reunions, suggested I write this book and got me off and running.

Rita Rosenkranz for representing me and for excellent editorial advice.

Charles Harmon, my editor at Rowman and Littlefield, for his professional diligence. Charles' assistants Erinn Slanina and Jaylene Perez and production editor Jessica Thwaite for being thorough and a pleasure to work with.

My parents, Richard and Virginia Haggerty, now deceased, inspired my writing and kindled a love of country living in me. They introduced us to our dear friends and Rockwell models Marie Briggs and Floyd Bentley. My brothers and sisters, Joe, John, Chris, Bill, Cecilia, and Dan. Together we hayed the fields and swam the Batten Kill in West Arlington under the red covered bridge, where we socialized with Rockwell models and their families. Also, my half-siblings Dick, Jamie, and Martha.

Jeff Edrich, a fine friend and freelance sound engineer who videotaped interviews, criticized my stories without patronizing, edited photos, and encouraged me from start to finish.

Jarvis and Nova Rockwell, who hosted me at their home many times. Jarvis and I have great times reminiscing about his father's models, many of whom were our mutual friends. Buddy Edgerton spent many afternoons with me, telling me of the years he lived next to Norman Rockwell and about our friends and neighbors who posed. Don Fisher, a Rockwell model, first told me the story of Marine Duane Parks and gave me anecdotes about our Arlington friends.

Margaret Rockwell at the Norman Rockwell Family Agency for pictures and paintings.

The Mahopac Writer's Group and our leader Vin Dacquino have been indispensable with comments and suggestions throughout. Bob Lee did much editing and formatting and helped me with computer issues. George Robinson cut chunks of non–priority material. Charles Milau, who has passed on, had an incredible listening ear and advice on making writing concise. Andy Campbell, thanks for the encouragement.

Beckie Herrick sharpened the book with line editing and helpful ideas.

Shirley Letiecq described her parents' friendship with Norman Rockwell and her mother's modeling experiences for *Freedom from Fear* and advised me on writing.

Walter Woodhouse encouraged me.

Gwen Tibbals and Oscar Rodriguez urged me to write the book. Steve Rayl, who has read my manuscripts since graduate school.

Good friends John and Debbie Thomes and Joan McCarthy energized me at Friday night dinners. Frank Zeller Jr. lightened my days with laughter.

Thomas Clemmons gave me good advice.

Maureen Haggerty encouraged me.

In memory of William Emerson Jr., my graduate school adviser at the University of South Carolina taught me how to write the nonfiction narrative. He also happened to be editor-in-chief of the *Saturday Evening Post* in Rockwell's day.

In memory of William Price Fox, writer-in-residence at the University of South Carolina, who taught me that a good book has many moods and that there ought to be humor. Bill was, at one time, a leading American short-story writer whose short stories were featured in the *Saturday Evening Post* during the Rockwell years.

The Reverend Mark D. Allen encourages us to push further, even if we must move out of our comfort zone.

Clint and Julia Dickens gave me an inspiring weekend in Norman Rockwell's former Vermont studio, which gave me deep insight.

And, of course, the Vermont Rockwell models who made the book possible.

Prelude

On December 4, 2013, Don Hubert Jr. sat among a crowd in the auditorium at Sotheby's auction house in New York City, waiting eagerly for the bidding to begin. Experts had predicted that a 1951 Thanksgiving painting created by Norman Rockwell in West Arlington, Vermont, would sell for about $20 million. At once after the auctioneer banged his gavel, bidders raised their numbered placards and shouted out bids. The auctioneer called out the amounts. Amped-up Sotheby's representatives sat at desks chattering into telephones. The numbers on an electronic scoreboard changed quickly, and after a couple of minutes, reflected that the bidding had rocketed to the expected $20 million. The bidding soared higher.

On his train ride to New York the day of the auction, Don had reflected on the day when he had been selected to model for the painting. He was only seven years old. He had been sitting at his school desk in the small country town of Arlington, Vermont. His teacher was standing in front of the chalkboard with a tall, skinny man holding a tobacco pipe. "This is Mr. Rockwell, and he is an artist. He does paintings for magazines. He is looking for a model for a new one he is working on."

Don recalled from more than sixty years earlier that the artist had a nice way about him. He smiled and said, "Children, please stand up. I'm going to look at each of you for a moment. I believe one of you will make a good model." Don and his classmates had been curious as to whom the artist would

choose. The artist's eyes moved around the room and lingered on certain children. A few days later, Don's mother told him, "An artist named Norman Rockwell visited your classroom. He called me and said he wants you to go model in his studio." Don's memory flashed back to his mother driving him to the west side of town and over the old covered bridge that spanned a river called the Batten Kill. He recalled dairy cows roaming the mountainside next to the studio.

It had been an interesting day, but he could not have known it would become one so significant in American history. Don remembered being greeted in the studio by Mr. Rockwell, who directed him to a makeshift stage. The artist seated him next to an elderly lady at a restaurant table in front of a huge window. He introduced her as May Walker and said that he and Mrs. Walker were to act as if they were praying over their supper. Don couldn't forget how his legs, dangling from a chair that kept his feet from touching the floor, wouldn't stay still. He'd had no reason to feel nervous. Mr. Rockwell had been friendly and respectful while moving him into position and instructing him to fold his hands like he did when he said his prayers. Don and his family had felt proud when the November 1951 issue of the *Saturday Evening Post*, a magazine everyone knew, featured him on its cover praying with Mrs. Walker in the busy train station restaurant. A bunch of scruffy onlookers were staring at them.

For nine minutes, an eternity for an auction, two telephone competitors in Sotheby's auditorium drove the price of *Saying Grace* beyond $40 million. A chorus of oohs and aahs rose from the crowd. The bidders continued battling. Could this painting actually break the record for the most valuable painting created by an American and sold at auction?

Introduction

The name Norman Rockwell hardly needs introduction. This beloved American illustrator has captured the hearts and minds of people across the globe through his paintings of mid-century small-town America. His scenes of a bygone era have survived the decades and transcend geographic location. Among his most popular works are *Shuffleton's Barbershop, Saying Grace, The Runaway, Girl at the Mirror,* and the *Four Freedoms* series. His total works number more than four thousand and have been reprinted billions of times, gracing the walls of homes, offices, and commercial and government spaces.

His original artwork commands millions of dollars. *Star Wars* producer George Lucas bought *Shuffleton's Barbershop* for a reported $30 million in 2018. He previously bought *Saying Grace* for a staggering amount. His collection of more than fifty drawings and Rockwell originals, valued at from $600 million to priceless, will be featured in his Lucas Museum of Narrative Art in Los Angeles on its opening. The Norman Rockwell Museum in Stockbridge, Massachusetts, offers the world's largest display of the artist's paintings. The National Museum of American Illustration in Newport, Rhode Island, features the second largest collection of Rockwell paintings.

Frequent references to Rockwell and his works continue to circulate on the internet. Such publications as the *New York Times*, the *New York Post*, the *Saturday Evening Post*, and *Reader's Digest* frequently publish articles relating Rockwell's work to current issues and events and their astonishing sale prices.

Although many articles and books have been written on Rockwell, they offer only snippets about the models, who were indispensable. *Norman Rockwell's Models: In and out of the Studio* is unique. It is the first book to reveal in detail the backstories of the friends and neighbors who posed for him in the quaint, rural village of West Arlington, Vermont. The models' personal stories offer profound insight into how Rockwell created his paintings as well as into the personality of the man himself. His models became his personal friends and loaned furniture, clothing, and animals to use as props. They referred him to other models. They critiqued his work, babysat his children, worked in his home, and delivered his paintings to publishers. Many are surprised to learn that Rockwell created his most famous paintings at his home studio in rural Vermont during the World War II and postwar era and that the characters portrayed were not professional models but the country people he associated with on a daily basis.

Rockwell had been a leading American illustrator living in the affluent city of New Rochelle, New York, for more than twenty years when he and his wife Mary bought a vacation home in the Green Mountains of Vermont. He felt his life and work had become stale. He also desired to escape the pretense he encountered in the city to live a simpler life. In 1940, the Rockwells made West Arlington their permanent home.

Three years later, the Rockwell family had become lonely and moved from their first home isolated in the woods to a white Colonial on the Village Green, the social center. The family became immersed in village life. The Rockwells participated in Grange meetings, church suppers, square dances, art fairs, and school events. One former model recalled, "He told all of us, young and old, 'Call Me Norman.'" The country folks revealed an authenticity of character and emotion. Many wore rough work clothing which revealed as much as their open faces. The artist reveled in the scenery around him and was inspired by the unspoiled richness and beauty of the Green Mountain countryside and the simplicity of life.

It could be said that Rockwell found his groove in West Arlington. This is where, from 1939 to 1953, the artist created his most iconic illustrations for the *Saturday Evening Post* and other magazines and books that are his most recognized works today. Is it any wonder that this passion for his rural home, community, and friends translated into the pages of the *Saturday Evening*

Post, the most popular publication of the time, and was embraced by a generation who fought for the sanctity of home and country?

The turmoil of World War II energized Rockwell to create his most popular works in Vermont, his son Thomas explained in a rare firsthand interview. Rockwell's *Four Freedoms* toured sixteen American cities in 1943, making him a major force in rallying the American people to back President Franklin Roosevelt, who had urged the country to join our European Allies during World War II. Large crowds gathered and bought $133 million in war bonds. Rockwell conceived every detail of every scene he painted, down to coaxing exact expressions from his carefully selected models. His vision and the arrangement of his subjects were part of his artistic genius as much as his painting skill. Gazing at these pictures, one is drawn in by the familiar settings and the demeanor of the models, and without a word, there is a visceral connection: sympathetic, heartwarming, and delightful.

Without these rural Americans—the dairy farmers, carpenters, country doctors, soldiers, mechanics, and spirited children—these beloved paintings could never have been created. Who were these models handpicked by the artist? What was their experience posing in his studio? These were the questions which inspired my research into a subject close to my heart. I have been part of the West Arlington community since I was three, when my parents purchased a farm so that their family of seven children could enjoy summers in the country. I have also lived or worked for significant periods of time in three of the other cities where Norman lived: New York City, where he spent his early childhood; Mamaroneck, New York, where he went to middle and high school; and New Rochelle, New York, where he lived for twenty years. During my youth, I joined Rockwell models and their family members in such activities as haying the meadows along the scenic Batten Kill River, attending dances, playing bingo on the Village Green, and swimming under the covered bridge on the Green, where Rockwell's former white colonial and red studio stood in the background in plain sight.

I came to know many of them well. In fact, two of the models closest to the Rockwells, Floyd Bentley and Marie Briggs, became my family's dearest friends. Floyd posed for *Breaking Home Ties*, a *Post* cover, and his cousin Marie for *We the Peoples*, which hangs at the United Nations building in New York. Marie, who had been the Rockwell's cook and housekeeper, prepared delicious dinners for my brothers and me after we worked in the hay fields.

One afternoon several years ago, I received a call from longtime Vermont friend Don Trachte, himself a Rockwell model. Don and his siblings had recently sold his original Rockwell painting *Breaking Home Ties* for $16 million and was inspired to organize the Vermont Rockwell Models Association. He wanted to document the models' stories and asked if I was interested in the project. I assured him I definitely was and began several years of extensive interviews with old friends and neighbors as well as Norman's sons Jarvis, Tom, and Peter. This was a labor of love!

Although the artist used models of a variety of ages throughout his career, which spanned from 1916 to 1974, most of the people I write about were children at the time they posed. They are the ones alive to tell their stories. I am happy to report that Norman maintained the highest standard of personal integrity in his studio, according to the twenty-five models I interviewed. People in these places have only positive things to say about him. In his book *My Adventures as an Illustrator*, Norman addressed the fact that, from the beginning of his career, he found it necessary for artists like himself to be accompanied by a chaperone, assistant, or parent in the studio so as to maintain his reputation.[1]

Norman Rockwell's Models: In and out of the Studio is the result of interviews with twenty-five models, which I was fortunate to obtain because of mutual friendships. I am honored to share these stories. As you read, I hope you are swept away to the "Rockwellian" land of enchantment, nestled in the Vermont Green Mountains, and that you enjoy reading these stories as much as I enjoyed collecting them.

1

Search for a Marbles Shooter

When Norman Rockwell left the New York City area and bought his house in rural West Arlington, Vermont, in 1940, he walked through a new portal. The artist was immediately enraptured with optimism at the marvelous faces he saw in cow barns, the dance pavilion, the swimming hole under the covered bridge, and clubs like Rotary. He observed that Vermonters, in contrast to city people, tended to be more open and revealed their true feelings on their faces. He found them relaxed, less self-conscious, and easy to move into modeling poses.[1] In fact, they were so effective that he abandoned the practice of using professionals. Soon, he found himself transitioning from creating paintings depicting historical figures to contemporary works. The fact that the country models were real people added an aura of authenticity and saved him considerable sums of money. During his two decades in New Rochelle, New York, he often used out-of-work actors, many for several days, which got expensive.

This new world of inspiration with its treasure trove of subjects could not have come at a better time for Rockwell. During the early 1930s, he had feared his folksy style might be passé. He considered abandoning the world of charming characters and traveled to Europe to try his brush at modern art.[2] Fortunately, the *Saturday Evening Post* continued to feed him assignments that demanded he remain true to his established style. In 1935, a project illustrating an edition of *Tom Sawyer* revitalized his brush.[3]

Many *Post* readers believed Norman was struggling creatively when they viewed his October 8, 1938, *Post* cover *Blank Canvas*.[4] In the painting, which he began in New Rochelle and finished in Vermont, he is scratching his head, and his collar is in disarray. His sketches lay in a mussy pile, brushes are stuck in paint, and his maulstick, used to steady himself while painting, lies under his chair. In reality, it was the distraction of his rambunctious young children that caused bewilderment; he was perplexed as to how to deal with them.

Nevertheless, in the spring of 1939, inspiration coursed through his veins after the *Post* signed off on his idea for an assignment for his premier painting in the newly renovated studio at his first home in West Arlington. It stood in a forest across a gravel road from the Rockwell home just footsteps from the Batten Kill and half a mile from their nearest neighbor. The lively, colorful, and contemporary illustration would be called *Marbles Champion*. The game was all the rage in school yards across America.

In April, the illustrator described to an acquaintance the type of spirited girl he needed to pose for *Marbles Champion*. Norman may have met the man at the Cambridge Grange or at an event in the Hall on the West Arlington Green. He envisioned a model with red hair because the dramatic color drew people's eyes into *Post* covers. The man told Norman he knew of a girl in Cambridge, New York, who fit the description but did not know her name.[5] The more he heard, the more the illustrator believed the redhead might indeed make a splendid model. Norman made the trip from West Arlington to Cambridge. Situated on the Vermont border, the village is an easy drive on quiet country roads. West Arlington people have always done business in Cambridge. The trip was no bother compared to others Norman made to scout models or to visit settings. To illustrate *Tired Salesgirl on Christmas Eve*, he traveled to Chicago to visit a department store.

Besides, Norman felt as if he had found heaven in the bucolic country. He had fulfilled the dream he had held in his heart since childhood. As he drove to Cambridge, smoke rose from pipes above the roofs of sugar shacks where locals were boiling sap into maple syrup. In the fields, men created furrows for planting corn in the moist earth as they walked behind huge draft horses pulling plows and guiding them with wooden handles. The moist, musty earth and warming air announced that lush green foliage would soon spread across the mountain valley behind red barns and corn silos where cows roamed the fields. It was all rich, organic, and true.

On this April day, the artist was absorbed in his mission to find the red-head for the entertaining cover painting. We can picture an enthused, tall, slender Norman with short curly brown hair, pipe clenched between his teeth, canvassing the little village of Cambridge like a detective. He walked past the late nineteenth-century brick and wood-framed commercial buildings, such as Murray's Blacksmith Shop, as well as the long, rectangular, many-columned Cambridge Hotel with its first- and second-story sitting porches. The Rice Seed Company, the largest of its kind in the world, stood in the background near the United Presbyterian Church with its steeple rising above the town. Norman felt he had a good chance of getting the name and address of the redhead's parents because people in the village tended to know each other. Most played a role in the dairy, seed, livestock, and farming equipment businesses. It was prior to superhighways, and the townspeople depended on one another for food, shelter, and clothing. The fact that this girl had bright red hair narrowed the search. The acquaintance had told him she was about ten years old. Anxious to find this important prospective model, he described her to clerks and passersby. "Do you know her?"

Norman had set the bar high. Even if he found her, she might not meet his requirements. From the description, her age did seem appropriate. But would this redhead have brown eyes, the second feature he required? The odds stood against it. Girls with red hair normally have hazel or green eyes. A face decorated with freckles would be nice but not necessary. He wanted her hair in pigtails, which most girls could manage. After locating her, he would have to sell her on the idea of modeling. It excited most people but not all. Even if she agreed, her parents might not consent. It wouldn't be the first time he would use his portfolio of *Post* covers to charm people.

Marbles Champion would provide Norman with an opportunity to showcase an illustration with a contemporary theme. The 1920s and 1930s had become the golden age for this school yard game. Factories in the United States manufactured billions of marbles during the twentieth century. Children sat poised to leap out from behind their desks when the lunch bell rang and hustle through the hall as fast as they could without being reprimanded. After drawing circles in the dirt, they opened their little pouches and shot marbles with a flick of their thumbs. They crammed in as many games as they could before the whistle told them to get back to their classrooms.

After inquiring of many, a man finally paused and told Norman, "I know the girl you're talking about. She's Franklin McLenithan's daughter. Ruthie is her name." The man explained that Franklin was an auctioneer who owned the Cambridge Valley Livestock Market.

The McLenithan business thrived to a point where Franklin found himself able to lend seed money to folks starting farms. Franklin and his borrowers sealed their deals with handshakes. He kept no written records. Franklin's voice alone was enough to draw people to his auctions. Some considered his rapid melodic chanting on the auction block a form of entertainment as fabulous as their favorite music. Standing at the podium, he'd chant, "Two hundred dollars now; will you give me two fifty? How about three?" When no more hands rose, he would pound the gavel and announce, "Sold to the man over here!"

Norman asked the stranger where he might find the McLenithan place. The man directed him back to local Route 313, the same road Norman had traveled in on. When he arrived at the farmhouse, Ruthie's Aunt Wilma greeted Norman. She told him he could find her niece at her grandmother's home in Shushan, New York, a rural town between Cambridge and West Arlington.

AT THE CLOTHESLINE

Young Ruthie McLenithan was busy pinning clothes on a line with her grandmother Susan Hedges when she saw a station wagon pulling into the driveway of their old farmhouse where generations of her family had lived. *What a rattletrap*, she thought. A tall, very skinny man with short brown hair strolled toward them. When his face came into focus, he appeared like the friendly sort.[6]

"I'm Norman Rockwell, and I'm an artist," he announced.

Ruthie noticed his eyes focus on her.

"You must be Ruthie." The artist offered a kindly smile.

"Yes I am."

Mr. Rockwell told them he illustrated covers for the *Saturday Evening Post*. Everyone knew the *Post*, whether they found it in their mailbox or on a newsstand or waiting-room table. Ruthie listened intently as Mr. Rockwell explained that she looked just like the model he had imagined for an illustration portraying a girl shooting marbles. Excitement welled up in her when the artist explained she would be beating two boys. Ruthie wanted to tell Mr.

Rockwell something he would find interesting, but she couldn't put together the words. She would tell him another time. Ruthie noticed the artist analyzing her from different angles. He explained to her grandmother that Ruthie's red hair and freckles would be perfect.

"You have the brown eyes I've been looking for," he exclaimed.

The artist turned to Susan. "Would your granddaughter like to pose for the *Post*?" Norman asked.

"It's all right with me," replied her grandmother.

Mr. Rockwell turned to Ruthie. "How do you feel about it?"

"I know nothing about being a model, but if you want me to, I'll do it."

Nothing in Mr. Rockwell's voice or mannerisms gave Ruthie or her grandmother reason to believe him to be anything but trustworthy. After discussing the details, the artist said, "I'll be back after lunch to pick you up. Do you happen to have a green and white dress you could wear?"

"A relative just made a dress for me, and it *is* green and white," Ruthie exclaimed. Something about the coincidence made the opportunity seem meant to be.

"Do you mind wearing it for me?" asked Norman.

"I'll wear it."

"I'll need you to put your hair in pigtails with ribbons."

Ruthie muttered reluctantly, "Okay . . . pigtails." She did not like wearing them but would for this opportunity.

"Can you wear brown shoes and green knee socks?"

"Okay. I have those."

"One more thing," Norman asked. "Another girl is going to take turns posing with you. Do you mind if she wears your dress?"

"That would be all right."

"Bring another set of clothes. I'll pick you up after lunch," Mr. Rockwell said.

Ruthie McLenithan felt enthused as she squeezed the ends of the wooden pins and fastened shirts and pants to the line. A drive to West Arlington would make a nice afternoon. *Everyone in town will see my picture on the cover of the* Saturday Evening Post! *Just wait until the artist sees what I can do with marbles! He would never suspect it in a million years.*[7]

The opportunity had come at the right time. Ruthie felt a sense of satisfaction performing the household chores for her loving family, but toiling for

them all could be tiresome and monotonous at times. Some days, she ironed thirty-five shirts and a pile of slacks. As the oldest daughter, Ruthie also babysat her brothers and sisters. They jumped out of bed constantly, and she had the responsibility to shoo them back. Her father often came home tired from auction events that ran into the evening. They did not have modern conveniences. Like many in town, they had an outhouse because they did not have indoor plumbing. They fetched their water in tall steel milk cans from another farm up the hill and pulled them back in a red wagon. They lit the house with kerosene lamps and candles. A woodstove cooked their food and kept them warm.

OFF TO THE STUDIO

Norman Rockwell returned in his "rattletrap" to pick up Ruthie after lunch. In those days, a grandmother would trust a girl to the care of a respected man. Outfitted in her pretty green dress, the girl felt special because the important artist had come all the way to her house to pick her up and take her to West Arlington. She didn't always like standing out because of her red hair and freckles but felt proud of them now. *What would modeling be like? I'll have a good story to tell everyone.* After the trip from her grandmother's home in Shushan over Route 313, they drove through the covered bridge past the Arlington Green and on to River Road. Several miles later on the gravel road just to the side of the Batten Kill, they arrived at the Rockwells' old white farmhouse next to an apple orchard.

After Norman ushered her into an old barn made into a studio, the spectacle of strange African swords, shields, and medieval costumes hanging on the balcony wall seemed to leap at her. *Oh my God*, she thought, *what would anyone do with all that?* Norman explained that he had gotten them during a trip to Africa.

Ruthie found a blond-haired boy a couple of years younger lingering in the studio. Taking the pipe from his mouth, Norman introduced his son Jarvis, who was on vacation with his brother Tommy, a lively boy with strawberry blond hair. They went to school in a city called New Rochelle next to New York City. Although they were newcomers to the country, they were friendly, and Ruthie took a liking to them just the same.

At the time, Jarvis and Tommy had been exploring the woods and searching for frogs and turtles by the river. They also rode their bikes up and down

the road. Winston Salter, the son of the man who owned the IGA grocery store in town, joined them. Through the artist's big studio window, Ruthie peered out at the Batten Kill, the same river she and her brothers and sisters swam at by their home. Norman also introduced the girl who would borrow her dress to take a turn at posing.

A LESSON IN POSING

Norman explained again to Ruthie how she would pose as a girl about to beat two boys at marbles. The children huddled around the artist, who took out the tobacco pipe he kept clenched between his teeth and spoke to them in a courteous but serious manner. Norman explained to Ruthie that she would be taking the final shot to win the game by knocking the last marble out of the circle. Norman set a bag bulging with marbles next to her. "Okay Ruthie, you have won all the marbles the boys had except one. Kneel down on one knee. We've got to position you like a real marbles champion. Put your knuckles to the ground with your thumb ready to shoot the last marble."

Ruthie finally found the words she'd been longing to speak, and they flew out of her mouth. "You don't have to explain to me how to pose. I really am a marbles shooter!"

"You are? Really? That is wonderful." Norman's lips curved into a smile.

"My brothers taught me how to play."

At that time, Ruthie was one of the few girls who actually owned a bag of marbles. She explained that she beat most of the boys who challenged her. During lunch recess, Ruthie hurried with the boys to the school yard, where serious players would set two pouches on the ground. The first held half a dozen of their favorite marbles designated as "shooters." They were bigger than "ante" marbles, which numbered something like one hundred. Ruthie would draw a circle in the dirt, perhaps three feet in diameter. She and her opponent placed an equal number of marbles in the center. When it came her turn to shoot, she closed her hand and put her knuckles to the ground. The phrase "knuckle down" became a popular American expression. She aimed at the marbles, flicked her thumb, and regularly knocked those of the boys out of the circle. She would reach down, pick them up, and put them in her pouch. The person who collected the most marbles won.

Her skill at marbles had given Ruthie something to make her feel better about herself. She had missed the entire first grade due to an itchy eczema

rash. In subsequent years, wrapping her hands during the winter made her comfortable enough to attend school. She struggled to write legibly but gradually improved thanks to the help of a kind teacher.

"All right," Norman said, "show us how you beat boys at marbles!" The artist liked to portray women and girls as inspired and capable.

Ruthie crouched on one knee and leaned toward the circle. She laid her knuckles flat on the ground and cocked her thumb to shoot the marble that would seal her victory against Jarvis and Winston. Norman instructed Jarvis to hang his empty pouch out of his back pocket to announce that he is losing badly. He arranged his son leaning close to Ruthie and told him to fix his eyes on her thumb.

"Jarvis, you can't believe that this girl is about to beat you at marbles! You've got to show it on your face." This was not difficult because Jarvis was surprised his father would paint a girl beating him. He didn't exactly like it either.

Norman guided Winston in a pose kneeling next to Jarvis. Norman told the boy to put a scowl on his face and to clutch his knees to show how tense he felt. The artist placed an empty bag next to him to announce that Ruthie has left him without a single marble.

"You are doomed, Winston."

Winston scowled.

Ruthie shot the marble off her thumb into the circle, and Norman exclaimed that they were doing a fine job.[8] All afternoon, Ruthie, Jarvis, and Winston had a grand time shooting marbles across the floor of Norman's studio while the artist sat at his easel sketching from different angles. Ruthie switched clothes to let the other girl model in her dress and wondered if Norman might put that girl on the *Post* cover instead of her. Ruthie found it fascinating to observe him glance back and forth from her and the boys to his sketch pad.

Red hair, brown eyes, and freckles had been all he asked for, but they had been only the beginning. One has to assume Norman found it to be a terrific bonus that Ruthie brought genuine skill to *Marbles Champion*. It gave the painting the authenticity he strived to create.

Toward the end of the afternoon, Ruthie noticed him beginning to paint *Marbles Champion* on a canvas set on his easel.

She walked over. "Can I watch you paint?"

Norman gave a warm smile. "You'll have to wait until it comes out in the *Post*."[9]

At the end of the session, Ruthie was elated when Norman handed her a $5 bill, which would buy a lot of little toys and candy at that time.

On their way home in the old, wood-paneled station wagon, Norman pulled into the Cambridge Valley Livestock Auction, her father's place. "Would you like to come in with me?" he asked. Most likely, Norman wanted to get a glimpse of the McLenithans' business operation to gain more perspective on Ruthie.

"No, I'll wait in the car," she replied. The eleven-year-old did not particularly care for her father's ways—getting people to spend money with his silver tongue.

NO COPY FOR RUTHIE?

Ruthie searched the magazine racks in stores during the days following, longing to see herself on the *Post*'s cover. Everyone would love it, and she'd be a popular girl. But she always walked away disappointed. Maybe Norman never finished the painting and forgot about her. But six months after the modeling session, an excited family friend informed her father that he had seen Ruthie on the *Post*'s cover. The girl was delighted when she learned that people all over town were impressed with Norman Rockwell's illustration of her as *Marbles Champion*! Her dad rushed to the drugstore to get the September 2, 1939, issue of the *Post*. Ruthie could not wait for him to come home. It seemed like forever when he finally pulled into the driveway. When he walked up to the porch, his hands hung empty at his side.

"Where's my copy of the *Post*?" Ruthie asked.

"I'm sorry. I didn't mean to, but I gave them all away."

"Oh no! You've got to be kidding. You didn't save one for me?"

Franklin McLenithan had bought every copy on the drugstore stand. After he realized that friends would adore the masterpiece of his daughter shooting marbles, pride filled him to the point that he took leave of his senses. He drove the countryside proudly handing out magazines.

Poor Ruthie could not express the depth of her disappointment. Not until several years later did she have the opportunity to view Norman's magnificent portrait of her beating the boys at marbles in her green dress (figure 1.1). Her Aunt Jane, a teacher in Schenectady, New York, had stowed away a copy and

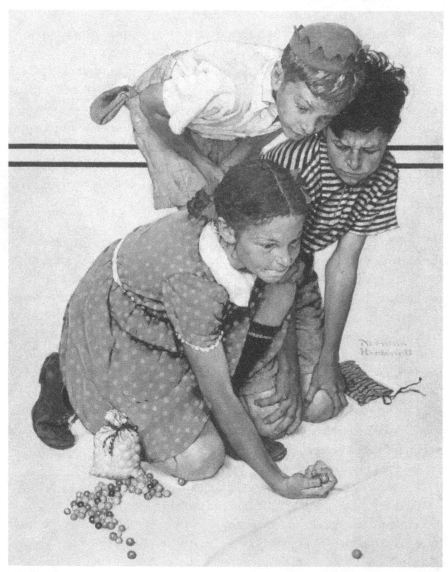

FIGURE 1.1
Marbles Champion: Ruthie McLenithan, unbeknownst to Norman, was a real-life marbles star. The artist's son Jarvis posed in the red whoopee cap. The local grocer's son Winston Salter posed as the second boy. *Source*: Courtesy of the Norman Rockwell Family Agency.

waited to give it to Ruthie when she was old enough to make sure no one in her big family could take it. *My hair in pigtails doesn't look so bad. The painting actually looks just like me* (figure 1.2). As she studied the cover, she saw that Norman had painted an almost exact likeness of her. He changed only the color of the bows around her pigtails, from brown to a brilliant red. She marveled at the way Norman had depicted her intense focus. Jarvis and Winston posed on the left side of her. The pitiful empty marbles bag sticking out of Jarvis's pocket made it clear that she had beaten them soundly, and she loved it!

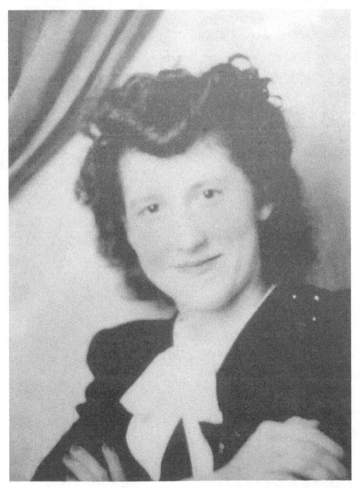

FIGURE 1.2
Ruth McLenithan Skellie. *Source*: Courtesy of Ruth McCuin.

Norman had illustrated Winston's marbles bag and shirt with matching black stripes and a look on his face revealing that he is deeply disturbed. He painted a red "whoopee" cap on Jarvis. Kids during that era made the popular caps by dying their father's fedoras red, cutting sawtooth patterns with scissors, and folding the fabric so the points formed a circle around the rim. A popular character named Jughead Jones wore one of them in the famous *Archies* comic strip. Ruthie noticed that on the *Post* cover her knuckles were poised to shoot. Norman left viewers imagining Ruthie hitting her target— Jarvis's last marble!

We have to assume Norman released a deep sigh of relief when his fans in America gave an enthusiastic round of applause for his first Vermont cover. He had plenty of reason to believe the move he made from the city to West Arlington would bring success. He couldn't have imagined the heights he would reach.

2

One Tough Cookie

It was late in September, and Norman Rockwell felt the breath of a dragon on his back as he searched for a model to pose for a *Saturday Evening Post* cover. It was to be titled *Tired Salesgirl on Christmas Eve*. He and the magazine planned to feature another strong, young female who would win the admiration of Americans. As with *Marbles Champion*, Norman had not been able to find the right model near his home and then got sidetracked. Ideally, he wanted a young woman who worked as a clerk in a department store, and there was no such store in Arlington. The artist needed to find a model, get her into his studio, take photographs, and sketch and paint the illustration well before the holiday.[1] His wife Mary or a willing neighbor would hand carry the painting by train to the publisher in Philadelphia in a crate. Sometimes, paintings were handed off to the art director just as the magazine was going to press.

Anxiety nagged Norman in these situations. He feared that he would not be able to maintain the quality that had made him the *Post*'s top-paid illustrator for three decades. The artist had a wife and three growing children to support, and funds were needed to pay the salary of Gene Pelham, his photographer/assistant. Not only would a problem with the *Post* hurt his financial status, but it would be a blow to his pride as well. Norman demanded no less than perfection; he would hunt doggedly for the young woman who would give his illustration an authentic aura.

Norman wanted the picture to tell a compassionate story about the fa-
tigue American workers endure, specifically in department stores during
the Christmas rush. In contrast to the widespread belief that the American
economy would slow after World War II, demand for consumer products
actually rose sharply. The automobile, housing, and airplane industries like-
wise experienced higher demand. With the emergence of the Cold War, the
military continued investing heavily in weapons systems. Due to the pressure,
workers in many industries suffered from fatigue. Perhaps a *Post* cover could
foster compassion for these American workers.

Norman described his frustration to Gene. In such predicaments, he found
his assistant indispensable. Gene, who lived about a mile from Norman, was
a devoted employee and friend. He could spot good prospective models and
had illustrated a couple of *Post* covers himself.

On that September afternoon in 1947, Gene drove south from upstate and
stopped for a late lunch in the scenic town of Springfield, Vermont, an hour
northeast of Arlington on the New Hampshire border. At that time, the scenic
town produced ten percent of the country's machine tools in brick factories
along the Black River. The town was so vital to the US military that two years
earlier, Adolf Hitler had placed it as number seven on the list of American
cities he intended to bomb.

At the Duck Inn, the manager seated Gene in a section covered by an
attractive eighteen-year-old blonde named Sophie Rachiski. Sophie had
taken the waitressing job to help her family make ends meet. Her father had
succumbed to a brain hemorrhage when she was seven. He was employed
shredding clothes in a shoddy mill that recycled material into yarn and fabric.
Fortunately, her mother, Ruzia "Rosa" Rachiski, had found employment as-
sisting the cook at the Hartness House, an upscale Vermont inn, and was able
to modestly support her family. The original house with prominent gables
was constructed for James Hartness, a former Vermont governor, and was
a busy landmark location. As her daughters were able, they also found jobs
waitressing at the nearby Duck Inn.

Sophie had recently parted ways with a convent where her mother, a
strict Russian immigrant, had placed her because it provided twenty-four-
hour supervision for girls. Rosa had refused to allow her daughter to remain
unsupervised at home. Eventually, the nuns realized Sophie didn't have the

requisite focus on religion. That summer, she met her future husband Turk, confirming the nuns had made a wise decision.

A crowd had packed the Duck Inn during lunch hour but was now thinning. Dishes clanked as busboys loaded trays at high-back booths. Servers hustled from the kitchen to serve their last lunch plates and grab tips. The cash register went "cha-ching, cha-ching, cha-ching!" Exhaustion weighed on Sophie, but a kindly middle-aged customer would be her last before she could go home and kick off her shoes. After setting a plate before the amiable-looking man, she plopped into a seat and slumped down in relief.

A POTENTIAL MODEL

After the man cleaned his plate, she handed him his check. "I need to ask you something," he said. He held her at the table with his gaze. "How would you like to pose for Norman Rockwell? I'm Gene Pelham, his photographer."[2] Although not a department store clerk, Sophie was a fatigued salesperson of sorts, and the clock was ticking.

"I don't know," Sophie muttered. *Yeah right. Another man trying to pick me up.* But curiosity got the best of her. "Who is this artist?" She had not heard of Rockwell.

Gene told her more about Norman and described the covers he painted for the *Post*. She was familiar with the magazine featuring the big illustrations on its cover. The man's sincere manner told her the offer just might be legitimate. Gene explained the role Norman would want her to play in *Tired Salesgirl on Christmas Eve*.

"I'll have to talk to my sisters," she told Gene. Luckily, they happened to be working in the diner that day also. As Sophie left Gene's table, she turned and faced him. "You want my other sister. She's prettier than I."

Gene reassured Sophie. "No. I'm quite sure Mr. Rockwell would want you." Norman's assistant knew the artist was not interested in using models based on glamour. Norman had learned that lesson earlier in his career when he used professional models. He also refrained from using heavy makeup to prettify young women and, frankly, often found the faces of perfect beauties lacking in character.

In the Duck Inn kitchen, Sophie described the unusual encounter to her sisters, and they discussed Gene's proposal. They agreed she could give Gene her family phone number. Several days later, she learned that her mother

Rosa had spoken to Norman Rockwell by phone. He requested Rosa's permission to pick her up and bring her to his West Arlington studio. Rosa had been noncommittal. A few days later, Sophie found Norman Rockwell and Gene Pelham standing at her dining room table. Her mother, sisters, and brothers stood around the two men. She gazed with awe at Mr. Rockwell's portfolio of illustrations and felt at ease in the presence of the friendly and professional artist. Norman explained to Rosa the difficulty he had in finding Sophie for *Tired Salesgirl on Christmas Eve* and his trepidation at not being able to find another like her and meet his deadline. He assured Rosa that she had not the slightest reason for concern.[3] Scores of people had modeled in his studio, and he maintained the highest level of integrity. Gene would also be present.

The pressure mounted. He must get Rosa's consent. But he had reason to be optimistic because of much recent success. In April of that year, the public loved *Country Doctor*, his painting of Arlington physician George Russell examining a sick child. Norman's comedic painting titled *Going and Coming* had appeared a month earlier. The illustration in two parts showed an excited family with their kids packed into the family car for a day at the lake and the return trip with fatigue showing on all faces. The government had featured his *Four Freedoms* on war bonds. He'd even been to the White House to paint President Roosevelt.

Surely, Rosa would say yes.

Excitement coursed through Sophie as she stood with her family and Norman, anticipating a great adventure, a trip to Arlington with this famous painter! She had visions of her friends and people all over town admiring her face on a *Post* cover. Sophie watched her mother peer at the portfolio with a stone face. She did not expect the woman who sent her to a convent at the age of twelve to be happy, but she held out hope for approval. She knew Rosa would never allow any of her daughters to visit unknown men alone under any circumstance, never mind modeling in a secluded studio in the Vermont woods.

All waited on pins to hear the verdict. Sophie prayed her mother would manage a nod of approval.

Norman couldn't bear the thought of scrambling to find another model.

Finally, Rosa's lips moved. "No, I'm sorry. I can't let my daughter model for you."

Norman's heart sank. He stressed that it would be impossible to find a model like Sophie in time to meet his deadline. His plea wore Rosa down to the point where she granted Norman and Gene the opportunity to present their case to Father Nolan, the family's priest.

SEEKING A PRIEST'S PERMISSION

Norman and Gene drove to St. Mary's Church down the road. After their meeting, Father Nolan called Rosa and voiced his opinion that Norman Rockwell and his photographer could be considered upstanding professionals. Norman and Gene drove back to the Rachiski home with confidence. Rosa rolled the idea around again but stated that she still didn't like it. She needed to consult a family friend named Mr. Ewing, the proprietor of Ewing Photography.

Sophie read the expression on Norman's face, which seemed to say, "Oh, for God's sake!"

"You can trust Norman, I assure you," Gene stated.

Rosa phoned Ewing and explained the situation. She then told Norman that Mr. Ewing knew of his work and that his opinion was that Sophie ought to model for the *Post*. But the old-fashioned woman surprised Norman when her face turned to stone again. "It still doesn't sound like a good idea to me," Rosa said.

Tired of the rigmarole, Norman blurted out, "You can check with the police department if you want."

"You can go there if you like," said Rosa. Norman drove to the Springfield, Vermont, Police Department in the village. After a discussion, one of the officers called Rosa to let her know they had no concerns about Mr. Rockwell.[4]

Surely after all this, Rosa would be agreeable.

Back in the house, Norman found Rosa wearing the same stern expression. She declared once and for all, "My daughter will not model under any circumstances!"

Sophie felt a wave of disappointment. Her mother had killed her dream of an exciting opportunity and adventure, a chance to model for an important national magazine. Her friends would not see her face on the cover of the *Post*. Nothing she could say would change her mother's mind.

Norman walked out of the living room shaking his head. As he and Gene headed to her front door, Sophie felt a glimmer of hope when she noticed

her older brother Stan, a Springfield High School football star the kids called "Rags," whispering in Mr. Rockwell's ear. Stan got the nickname because his father had been employed shredding rags at a local shoddy mill.

Out at the driveway, Stan explained that he and the others were considering overruling their mother. They recognized that the chance to model was a once-in-a-lifetime opportunity. Soon after returning to West Arlington, Norman received a phone call from Stan. He told the artist that if Mrs. Rockwell were to come pick up their sister, the brothers would allow her to make the trip to West Arlington.

One morning in early October 1947, Rosa left for work at the Hartness House. Within the hour, Mary Rockwell pulled into Sophie's driveway. The jubilant young woman jumped into the car, and the two headed toward West Arlington. Sophie carried the black dress Norman told Stan she should bring. *This is so wonderful. I can't believe this is happening to me!* She thought.

Mrs. Rockwell couldn't have been friendlier. They chatted on the entire ride to West Arlington. Mary wanted to know all about Sophie's life. The famous artist's wife actually paid attention as she told her story about leaving the convent, working at the diner, and Rosa's concerns. Mrs. Rockwell explained that her husband could be trusted implicitly. She talked about his *Post* covers and explained his philosophy of painting real people like Sophie rather than prettied-up models.

Their drive seemed to pass in a flash as they turned onto the graveled Route 313 in the quaint center of Arlington. In less than ten minutes, they drove through the covered bridge and past the Village Green. Sophie loved seeing the cows lazing in the fields at the farms on either side of the Rockwell home. Autumn had painted the mountain foliage behind Norman's red studio festive colors of gold, brown, and yellow. She found it all very scenic.

MEETING NORMAN AND GENE

Mary parked behind the Rockwells' large white Colonial home. Dressed in tan khakis and a light green plaid shirt, the tall, slender, famous artist greeted her. He took his tobacco pipe out of his mouth and put Sophie at ease immediately. "I'm so happy you're finally here!"[5] As they engaged in small talk, Gene Pelham appeared. "I have no idea why I went through Springfield, but I'm glad you're here too."

She noticed the studio was spotless and in order. Two easels stood out on the floor of the large room below the steep steps that led to a balcony.

Norman told her, "Sophie, you can go into the back room and change behind the curtain. Gene and I will be out here. Don't be nervous. You'll do fine." In the area where the artist stored the picture frames and shipping crates, Sophie pulled on her black dress.

Back near the easel in front of his fireplace, Norman exclaimed, "Your dress looks good! But your hair is wrong." Sophie's blond hair hung straight and long. "We have to do something about this," he explained. Norman reached for his pipe and held it in his teeth. Sophie wondered, *Why does he keep it in his mouth if he doesn't light it?*

Norman found his wife Mary in their home and asked her to take Sophie to a salon and have a beautician "put her hair up." He wanted it to look as if Sophie had done it herself.

Sophie was soon again in Mary's car, heading toward a beauty parlor in Arlington. She enjoyed the fuss the stylist made while winding her hair around curlers. Her family could not afford professional stylists. She marveled as she pictured her friends looking at her on the cover of the popular magazine outfitted in a black dress with her hair done up in fancy curls, but she couldn't block out an image of her mother scolding her.

Back at the studio, Norman took her by surprise. "Your hair looks good except it's too neat." He plucked out a couple of springy curls and let them droop. Norman sat on a stool and arranged Sophie standing sideways next to his eleven-foot-high wall of glass panes. A soft glow of light shined on her face, and she felt comfortable in Norman's presence. With his camera set on a tripod, Gene photographed her from a variety of angles, including close-ups of her face, arms, and legs. Norman told Sophie to take a lunch break while Gene developed the film and printed the pictures in the darkroom at the back of the studio.

Mary treated Sophie to lunch at the Green Mountain Diner in Arlington Village. She pointed out that the logo on the menu had been drawn by her husband. Mary chatted about life in Arlington, and Sophie further described her time at the nunnery and work at the Duck Inn as she enjoyed a hearty lunch of turkey, mashed potatoes, and gravy.[6]

Back at the studio, Norman explained that he had not finished setting up props, so Mary brought Sophie to their home, where the three Rockwell boys

invited her to join them in the living room. Sophie took a seat on the floor with Jarvis (age sixteen), Tommy (fourteen), and Peter (ten) by their Philco radio, housed in a fancy, glossy cabinet. She had never listened to a ball game on the air before because her family couldn't afford a radio. The artist's hospitable children made her feel as relaxed as in the company of relatives as they listened to a game played by the Boston Red Sox, a team that was popular in Arlington. The Sox had no chance of finishing better than third place in their division at the close of that season, but any game proved exciting when Boston's legendary Ted Williams came to the plate. A year earlier, he had won baseball's MVP. With a batting average of about .340, he had a shot that year at winning the batting title, but Harry Walker, who hit .363, eventually took that category. Walker was known as "Harry the Hat" because he adjusted his cap between pitches.

Norman later painted Ted Williams in his painting *The Rookie*. While others greet a newcomer, Williams stands at his locker wearing one of the typical grumpy expressions for which he was known. The slugger refused to come to the Stockbridge studio, forcing the artist to paint him from a photograph. Williams could be loud, irascible, and stubborn, but fortunately he projected the excesses of his anger into his bat. Williams fought in World War II and proved to be an excellent fighter pilot. After the ball game, the boys took Sophie on a hike up the mountain behind Norman's studio to enjoy the colorful autumn leaves for which Vermont is famous.

Finally, the props were ready, and Sophie listened as Norman took time to explain more about the story she would help him tell. "Being a salesperson is a hard job," Norman said. "You have to be pleasant all the time no matter how you feel." They would impress on the public how draining it is to be on one's feet all day. She appreciated that a famous man like Norman cared about working people like herself.

TIME TO POSE

Norman positioned Sophie leaning against a child-sized car of the type kids climb into and push along with their feet. For the backdrop, he and Gene had arranged some stuffed animals, skis, and a sled with a "for sale" sign as well as some dolls he had purchased for $48.

"Fifty-four years old and I'm collecting dolls," he chuckled. Norman stood against a wall and demonstrated with his own body how he wanted Sophie

to slump down as Gene had seen her at the Duck Inn. At his instruction, Sophie kicked off her shoes to make it appear as if she was relieved her shift had ended. She leaned against the front of the little car, but its front lurched upward. She and Norman burst into laughter. Norman realized the futility of such a pose, so he posed her in a slumped position on a wooden crate. Her legs shook as she tried to maintain balance, and a sales book she had placed on her lap kept sliding down. Norman affixed it with cellophane tape and told her to slouch once again. "I want you to have the same body position you had at the Duck Inn."

She allowed herself to slide into the slouch ever so slowly. This time she felt balanced, and her legs did not shake. Norman sketched rapidly with his charcoal pencil, and Sophie felt wonderful because she had pleased him. Next, they worked on the facial expression Gene had observed, but Norman did not want her to appear as if she were smiling in relief. She must show a fatigue on her face that spoke louder than any other emotion. "I want you to appear tired," he instructed. "Like this." Norman let his head fall sideways and made his eyes droop.

She had no trouble mimicking him and bringing an expression of fatigue to her face. But acting became more complex when Norman had Sophie hang her arms limp and set the bare toes of one foot on top of the other at the same time. *My mother would be furious if she saw me posing with mussed hair in an unattractive slumped position with casual bare feet,* Sophie thought. *If my mother or the nuns saw how the dress exposed my knees, oh boy! Sooner or later they will see a copy of the magazine.*

Gene snapped photos, and Norman sketched several charcoal drawings. Finally, he rose from his stool and announced, "Sophie, you did a good job. I'm very pleased." The session was over at about 5:30, and Norman explained that if he needed her again, Mary would drive back to Springfield to pick her up. Norman stuck the pipe back in his mouth, and Sophie realized the artist had never once struck a match to it. *I guess it's something he just likes to hold on to.*

Norman explained that Mrs. Rockwell was busy, and, coincidentally, he needed to speak at a Rotary Club in Rutland, Vermont. "I'll take you there and put you on a bus to Springfield if that's all right," he said. Norman drove Sophie alongside the Batten Kill on the narrow, graveled River Road toward the center of Arlington. Dusk fell on the chilly, dark October evening, but she kept warm in a coat Mary had loaned her.

At one point, Norman fishtailed on the gravel road, which was muddy from rain. After yanking the wheel to straighten the car, he blurted, "An accident. That's all we need. Newspapers will have a field day. The headline will read, 'Artist and Young Woman in Accident on Vermont Back Road.'" He chuckled as he often had in the studio. Sophie laughed too. The artist's sense of humor had made for a fun trip. As she climbed out of his car at the bus station, Norman said, "Remember, I may call you to come back if I need to."

For the illustration, Norman traveled eight hundred miles to Marshall Field, an upscale department store in Chicago, to sketch an area where a clerk like Sophie would have worked.

SOPHIE ON THE COVER

Soon after her modeling session, Sophie left her position at the Duck Inn and took one at nearby Kent's Drug Store. That December of 1947, she noticed one of her coworkers carrying an armful of *Saturday Evening Posts* to the magazine rack. As he loaded it, she walked over with nervous anticipation. From a distance, she thought she saw her springy blond curls on its cover. *Is that me?* she wondered. When she held a copy in her hands, she saw it was indeed her on the cover as *Tired Salesgirl on Christmas Eve* (figure 2.1)! Norman had painted her in the slumped position wearing her black dress just as she had posed, except she was leaning against the bright yellow toy car instead of the crate. Rag dolls lay on a shelf, appearing as if they had been picked up and put back haphazardly by customers; a purple stuffed animal looked curiously in her direction. Wrapping paper was strewn about the floor. She noticed that Norman painted a round timepiece on her blouse that read 5:05. A sign above her read, "Store closes at 5:00." Her mind was a world away from the drugstore as she marveled at the exact likeness Norman had painted. Her hair, face, and body appeared just as she had looked in the studio. It would take less than a second for family, friends, and neighbors to recognize her (figure 2.2).

Oh geeze, she thought. *My mother's really going to be upset when she sees this.*[7] She prepared herself for a stern lecture. At Kent's Drug that afternoon, Sophie basked in glory as she signed copies at the counter. The rack sold out quickly, but the manager immediately called his distributor for additional bundles.

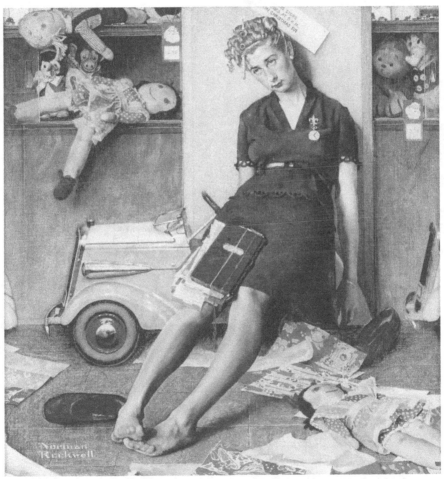

FIGURE 2.1
Tired Salesgirl on Christmas Eve: Sophie Rachiski Aumand modeled for this painting, which shows compassion for tired salesclerks. *Source*: Courtesy of Sophie Aumand.

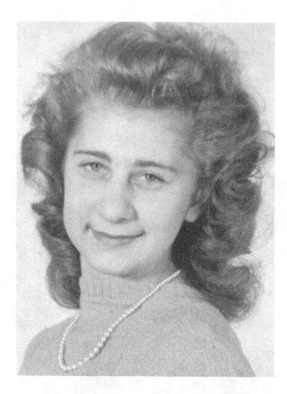

FIGURE 2.2
Sophie Rachiski, a waitress at the Duck Inn in Springfield, Vermont, at the time she modeled in Norman's studio. Gene Pelham discovered her while having lunch. *Source*: Courtesy of Sophie Rachiski Aumand.

On the same day, Rosa was at work in the Hartness House kitchen when a coworker stuck a copy of the *Post* in front of her face. "This looks like your daughter."

Rosa gaped at the magazine. "Oh," she grunted, and walked off.

As soon as she arrived home, Rosa greeted Sophie with her most severe expression and spoke through clenched teeth. "You disobeyed my orders. Why? You shouldn't have gone." Fortunately, her sisters came to her rescue. "We told her it was all right, Mom."

"How did you get there?"

"Mrs. Rockwell picked me up."

Her mother astonished her by cracking a smile. Then she felt Rosa's hard stare. "Don't you ever do something like that again without my permission. . . . And I don't like the way you were sitting—all slumped down like that."

"But I was a tired salesgirl, Mom."

Her mother eventually came around and admitted that Sophie had made her proud.

3

A Serendipitous Meeting

Gene Pelham was inspired to be an artist at age eight when a family friend and neighbor in New Rochelle, New York, named Norman Rockwell asked him to model for the Thanksgiving cover of a magazine. "I was round faced enough to qualify as an American boy well satiated with turkey and all the fixings," Gene later commented.[1] It was quite an honor because at age twenty-three, Rockwell had already achieved a status coveted by illustrators. He published his first *Saturday Evening Post* cover the year before. *Boy with a Baby Carriage* appeared May 20, 1916.

Born in 1909, Gene showed early promise when he sketched a portrait of New York Yankee baseball great Lou Gehrig, who lived across the street from him on Meadow Lane in New Rochelle. The Yankee slugger autographed it. Several years later, Gene won an art contest sponsored by the Boy Scouts of America. Norman Rockwell happened to be a judge.[2]

Life as a student was not easy for Gene. He struggled with dyslexia, now considered a disability. But rather than letting it be an obstacle, he used it to his advantage, setting his mind on a career in art.[3] He studied at the Grand Central School of Art and the National Academy of Design, both in Manhattan. Dyslexia typically makes reading, oral communication, and writing more difficult than for the average person. Dyslexics tend to have strong visual skills and vivid imaginations and think in pictures more than words.[4] They often excel as artists, innovators, and entrepreneurs. Today,

many famous and esteemed individuals have been identified with the condi-
tion, including George Patton, George Washington, John F. Kennedy, and
Stephen Spielberg.[5]

Gene enjoyed a privileged childhood in New Rochelle, a suburb of New
York City situated on the Long Island Sound. His father owned Pelham
Insurance Company in the city. The family enjoyed summers swimming at
the beach and sailing on their boat. Gene's grandparents resided on the posh
Riverside Drive in Manhattan. His extended family owned Pelham Operating
Company, which hoisted materials and equipment to the top of New York
City's tallest buildings. With hundreds of employees, it set up temporary el-
evators on the outside of skyscrapers. Pelham Operating assisted builders in
erecting many tall structures, including the Chrysler Building on 42nd Street
next to Grand Central Station.[6] It stood as the world's tallest building before
the Empire State Building was completed eleven months later.

Two tragedies struck Gene's family during the eleven-year-long Great De-
pression, which began in 1929. Pelham Operating was forced to shut down
after the stock market crash. Some members of the family, who had lived
among New York's elite for generations, lost their lofty positions in society.
Relatives had graduated from schools such as Yale and Princeton, but now,
many of them were broke.

Gene's second tragedy occurred when his father, only in his fifties, died
unexpectedly in 1938. His mother Vicky could not maintain the style of liv-
ing her husband had provided. Because Gene had worked for his father, he
lost his paycheck. They gave up luxuries such as their membership in the
exclusive Bonnie Briar Country Club in Larchmont, New York, where they
enjoyed friendships with elite businesspeople and artists like Norman Rock-
well. However, Vicky kept in touch with Norman and Mary through letters.

Despite the losses, Gene persevered. He landed some work designing and
painting murals for the New York World's Fair, which took place in New
York City in 1939. Gene worked on the murals of General Electric, Westing-
house, and the New York State Building. Bustling with designers and the lead-
ing artists of the day, the fair proved to be a lively place. Forty-four million
people eventually came to view its futuristic displays, such as custom kitchens
with exciting new inventions like dishwashers and refrigerators.

Doing artwork at the fair proved to be a productive time for Gene, but it
wasn't steady work. They eventually sold their family home, packed up what

possessions they could, and stayed temporarily with cousins in the rural village of East Arlington, Vermont. Gene could only wonder what fate had in store.

Soon after their arrival in Vermont, Vicky and Gene managed to purchase a 1790s farmhouse in West Arlington about a mile from the Village Green. Gene liked the cluster of simple working-class homes along the gravel road. Walt Smith's Cash Store stood about a half mile away. The country establishment sold everything from milk and eggs to shoes, pants, and fishing equipment in a clapboard building with charming worn plank floors. Gene set up his easel in fields and began painting weathered barns, old train depots, and lakes in meadows set before the majestic Green Mountains. He added impressionistic touches to make people feel nostalgia for the country.

Gene was more interested in enjoying health and pursuing the quality of life he tasted in Vermont rather than investing all his time in seeking the type of wealth and excitement he experienced in New Rochelle. He purchased a cow for fresh milk and made butter and yogurt. A man of many talents, he mixed the mortar and set the blocks to build his chimney and performed carpentry repairs on his home. He worked at the Benmont Paper Factory in nearby Bennington, Vermont, for a spell and sold some paintings to generate income, but he needed a full-time job.

A SERENDIPITOUS MEETING

One day in 1938, as he laid out the hammer, saw, and boards required for a home repair project, an old station wagon with a high, square cabin and wood-paneled doors pulled into his driveway. A man with a long, lean face rolled down his window. As Gene walked toward him, the face and the man's tight, curly brown hair looked familiar.

The man looked over at him with a quizzical expression. When Gene reached the car, the man asked, "Gene?"

Gene replied, "Norman?"

"What are you doing here?" Norman asked.[7]

"What are *you* doing here?" Gene replied.

"I have a house here."

"So do I!" Gene replied.

That year, the Rockwells had purchased their first house in West Arlington two miles from Gene's home and had enjoyed vacationing that summer. Both Norman and Gene were happy to have an old friend in town. When Norman

began creating paintings in his newly renovated Vermont studio in 1939, he found himself in need of a photographer. Norman had begun using black-and-white photographs as references since the late 1930s to compete with other illustrators. Most used photographs to create their works faster and with less expense. Cameras captured live models from a variety of viewpoints and cut down the amount of time needed to produce a painting. Cameras also froze movement, allowing the artist to depict people in motion realistically. An illustrator had to take photos in order to create the types of innovative illustrations the market demanded and to produce them quickly, "I had to adapt myself or drown," said Norman in his autobiography.[8] Norman used black-and-white photos exclusively. He also continued using live models in order to breathe their spirit into the illustrations and to add dimension and skin shade.

It just so happened that Gene had studied photography and owned the equipment to take pictures, develop negatives, and print them in a darkroom. He had a light meter and adjusted shutter speeds. Norman also needed a hand with other things, like studio maintenance, building sets, and picking up models. It was a match made in heaven. After about a year, Gene found himself working full-time as Norman Rockwell's assistant. He couldn't have guessed, even in his wildest dreams, that the leading illustrator for American magazines would show up in West Arlington, Vermont, and become his employer!

Gene, a nice-looking, stocky young man with black thinning hair, also proved to be an enthusiastic, versatile model. His expressive face gave him the ability to put on serious countenances or ham it up. Gene first modeled for Norman for the June 1941 feature in *American Magazine* called *Strictly a Sharpshooter*. Gene posed as one of the spectators sitting ringside at a boxing match, where a challenger is being brutally beaten by his opponent. Gazing at a sexy woman with a cigar hanging out of his mouth, Gene has the look of a mobster. Gene appears twice more in *Sharpshooter*, wearing a derby hat under the woman's chin and as the man tending to the boxer seated in a chair.

Also in 1941, he posed for Norman's first wartime painting, *Food Package from Home*. A soldier with the fictional name of Willie Gillis clutches a food package to his chest. Gene appears in a group of soldiers on the right side, marching in a brown uniform. They want Willie to share whatever goodies the package might contain. The group of soldiers, looking light-footed with a jovial attitude, resembles a Broadway dance routine.

Gene also proved to be quick with the camera when Norman needed photos of animals such as dogs and cats, whose expressions can disappear in a second. He worked well with children, who could be difficult at times. In *My Adventures as an illustrator*, Norman mentioned an instance when a shy boy would not open his eyes. After Norman left the room and came back, he found that Gene had persuaded the boy to model with them open.[9]

On November 15, 1941, Gene reached the status coveted by American illustrators; he too published a painting on the cover of the *Saturday Evening Post*. In *Sitting on the Wrong Side*, a disgruntled man wearing a black hat and black jacket sits alone at a football game among the other team's yellow pennants. A spectator sitting nearby taunts him with a salute, the wave of his hat. On April 25, 1942, the *Post* ran another Pelham cover called *New Chair*. A woman in a sharp blue dress suit stands in front of a deliveryman who lugs a lounge chair decorated with a complicated floral design. Holding *Home Planning Guide*, she contemplates where she would like to have it placed, while the delivery man clearly just wants to have it off his back. Both covers have deep, vivid, contrasting colors.

AN INDISPENSABLE ASSISTANT

The significance of Gene's work with Rockwell is no better illustrated than in the production of the *Four Freedoms* paintings. They were reprinted four million times as war bond posters during World War II and became among the most reproduced works of all times. Gene was beside Norman every step of the way during this ambitious project, taking photographs, offering his own professional advice, suggesting models, and supplying props.

The inspiration for the *Four Freedoms* set of paintings came to Norman in 1942 after he listened to President Franklin Roosevelt's rousing State of the Union Address. Roosevelt had spoken boldly in an effort to rally support for the country's involvement in World War II. Because the United States was isolationist at the time, Roosevelt had written a persuasive speech that stood on a strong platform. With intense emotion, he told politicians and citizens that countries in Europe were in danger of losing the four basic freedoms every person has the right to enjoy: freedom of speech, freedom of worship, freedom from want, and freedom from fear. He emphasized the importance of supplying weapons to the European allies. At home in Vermont, Norman

conceptualized bold illustrations to inspire everyday Americans to support Roosevelt's plan.

Like many people of that era, Norman felt a personal obligation, but part of his motivation stemmed from the fact that he had been discharged, albeit honorably, from the navy during World War I. At nearly six feet tall and 140 pounds, he proved that he would be physically incapable of enduring the rigors of combat. To ease the sting of rejection, he found humor in the military's paperwork regarding his status. When World War II came, he was determined to be of service to his country.

The concept for Norman's painting *Freedom of Speech* came to him at an Arlington town meeting. His friend, a dairy farmer named Jim Edgerton, stood and spoke out boldly against a motion to build a new Arlington school. (Jim had posed with Gene in Norman's *Food Package from Home*.) The Arlington school had burned down. As the lone opposing voice, Jim believed the town should bus the children to a bordering town. Norman thought it remarkable that in the United States, everyone has the right to voice their opinion at town meetings, whether popular or not, and that people respect the opinions of others, who should not be "shouted down."[10] How better could he illustrate *Freedom of Speech* than to depict a man standing and speaking at a grassroots town meeting (figure 3.1)?

Soon after, in the middle of the night, Norman rode his black, three-speed English racing bike up a challenging two-mile incline in the dark to present his idea to his friend, American book illustrator Mead Schaefer. He didn't telephone Mead because his was a party line with three other families, and he did not want to wake them. Mead and his wife had moved from New Rochelle to Vermont to be near the Rockwells. Mead was enthusiastic about the idea.

Norman drew sketches and drove to Washington, D.C., with Mead. They pitched the idea to the Army Ordnance Department, which didn't have the resources to support the project. On the way home, the two men stopped at the office of the *Saturday Evening Post* in Philadelphia. The editor, Ben Hibbs, told Norman to get started on his *Four Freedoms* paintings at once.

Norman struggled with concepts for the *Four Freedoms* due to the magnitude and scope of Roosevelt's speech. In fact, it was two and a half months before he began the project.[11] But then he dug in and spent most of the summer of 1942 recruiting and posing West Arlington models. Norman would work with more than forty models and use more than thirty in the finished

FIGURE 3.1
Freedom of Speech: Carl Hess, owner of the gas station where Norman filled up, posed in 1943 at the suggestion of Gene Pelham. *Source*: Courtesy of the Norman Rockwell Family Agency.

series. Gene proved to be indispensable in suggesting those who would make good models; he too had gotten to know people in the tiny village. Norman considered it terrific advice when Gene recommended Carl Hess for *Freedom of Speech*. Little did they know that they were creating a painting that would receive tremendous applause from people across the United States. Some consider it the best in American history.

Hess, who owned and operated the gas station and repair shop a mile from Norman's studio, stood tall and handsome with black hair. "He has a noble head," Gene told Norman, and would be able to pose with a commanding presence. Carl was a likable man too, known as someone who would "give you the shirt off his back." He did thoughtful things like patch kids' bicycle tires as well as the inner tubes they used to float down the Batten Kill. He had a gun shop in his garage and sold rifles and ammunition to hunters. Many needed venison to survive the winter.

Revved up with enthusiasm to create *Freedom of Speech*, Norman strolled into Carl's garage. The mechanic was working in his pit under a car. He did not have a hydraulic lift at that time. "Can you come up for a minute?" Norman called down. Carl climbed out and stood before Norman. The enthused artist began to speak but slipped and fell on a patch of grease. Back on his feet, he smiled at the mechanic. "Carl, you have a noble head."

"Yeah, but there ain't much brains in it."

Both of them chuckled over their Vermont-style self-deprecating humor.

THE RIGHT MAN

In the studio, Carl proved to be the right man for the job. Norman realized he needed an article of clothing, a shirt or a jacket, that would state clearly that the "noble head" was a regular workingman. "Hold on, Norman," Gene exclaimed. He fetched the beige leather jacket he wore while doing yard work. Well worn with ground-in dirt around its buttonholes, the jacket could explain better than words that the person in *Freedom of Speech* was indeed a workingman.

Norman struggled with *Freedom of Speech* and did not get it to his satisfaction until he created four different versions.[12] One is a long view that depicts Carl standing in the midst of an entire room of people who attend a town meeting. Norman eventually used the close-up perspective of a seated model, who looks up from his seat admiringly at Carl. With bright green

eyes, dramatic black hair, and a strong jawline, Carl is a man speaking boldly. His strong working hands grip the bench in front of him. The others seated around Carl have their eyes focused on him. Bob Benedict, whom Norman visited often at his hunting camp just up their graveled road, posed as the man smiling in admiration at Carl.

For the other *Freedoms* paintings, Norman and Gene brought model after model into the studio. Gene helped to get them situated and ready to pose. Norman was intense and singularly focused as he explained and demonstrated the physical pose and facial expression he required. Gene moved to his camera, which was mounted on a tripod, and photographed all day long to capture precious expressions the second they appeared. All the models were Arlington people. Jim Martin, a local carpenter, appeared in all four paintings. Walt Squiers, who renovated Norman's studio, posed for *Freedom of Worship* (bottom right), as did his wife Clarice (top right). Half of Walt's face also appears in *Freedom of Speech* at the back of the painting, next to the speaker's left shoulder. The Squiers's children posed lying in bed in *Freedom from Fear*. Mary Rockwell posed in the front left corner of *Freedom from Want* and Norman's mother Nancy, with white hair, across from her.

Gene captured the poses and expressions Norman needed on film, sometimes taking dozens of photos of the same person. Gene developed his negatives in a darkroom at the back of the studio. He pinned photos and parts of photos, such as hands and faces, to the studio wall. Norman worked himself to exhaustion, and Gene stayed alongside him all the way.

Creating the concept of *Freedom from Fear* and executing it on canvas came fairly easily. With his brushes, Norman depicted a woman tucking her children into bed with her husband standing behind her. The man, Jim Martin Sr., holds a copy of the local Vermont newspaper, the *Bennington Banner*. Its headline tells of the "Blitz," short for "Blitzkrieg," a battle which began on September 7, 1940. At 4:00 p.m. that day, more than three hundred Luftwaffe, or German bombers, surprised Britain with a heavy attack that lasted until 4:30 a.m. Germany persevered in pounding Britain from the sky for fifty-seven consecutive nights. Fire burned many parts of the city, and residents fled to underground shelters. Numerous casualties were sustained. Hitler had intended to render Britain helpless when Germany attacked the Soviet Union. However, the British Royal Air Force fought back valiantly, thwarting

the Luftwaffe's effort. In May 1941, Germany departed to invade the Soviet Union, but by that time, forty thousand British had been killed.

Freedom from Want portrays a Thanksgiving scene wherein the family's matriarch is setting a roasted turkey on a snow-white tablecloth surrounded by a family joyously anticipating the annual holiday feast. He created a couple of versions of *Freedom of Worship* and settled on one illustrating the faces and hands of a diverse group of people in prayer.

The paintings were completed six months after he began, and Norman was emotionally and physically exhausted from the arduous task.[13]

At the time, the *Post* boasted a circulation of three million subscribers, one of the largest of that era. It ran the *Four Freedoms* in consecutive issues beginning on February 20, 1943. The series became more of a success than Rockwell could have dreamed. More than twenty-five thousand *Post* readers promptly ordered sets of full-color reproductions, and the artist received sixty thousand letters.[14]

One such letter from President Roosevelt stated, "I think you have done a superb job in bringing home to the plain, everyday citizen the plain everyday truth behind the Four Freedoms."[15] Norman's son Jarvis accompanied him when he went to the White House to meet with the president.

West Arlington buzzed with excitement as copies of the *Four Freedoms* circulated around the country. Norman and Gene hung the originals in the Grange Hall on the Village Green in West Arlington to allow models and neighbors to view themselves on canvas. The paintings became a centerpiece of war bond advertising and played a huge role in motivating citizens to help finance the war. The US Office of War Information printed 2.5 million copies as posters to raise money for the war effort. They could be spotted hanging in homes, businesses, and workplaces. These Rockwell posters acted as a crucial rallying cry that convinced many Americans to go along with Roosevelt's plea to give aid to our European allies and eventually enter the war.

The US Treasury Department featured the *Four Freedoms* during the second American war bond drive. The first event took place at Hecht's department store in Washington. More than fifty thousand people attended, and more than $1 million in bonds were sold. As the honored guest, Norman sat at a table with long lines of people eager to get his signature on posters. So many people demanded his attention that he didn't have time to eat or drink. The level of excitement reached such heights that women in the crowd fainted

in Norman's presence.[16] By the end of the event, the exhausted artist gracefully returned home to peaceful Vermont instead of attending the following bond drives.

The US Treasury Department, at the request of its secretary and President Roosevelt, featured the *Four Freedoms* posters in a tour of fifteen more cities. At these events, thousands of volunteers organized rallies, parades, and celebrity appearances. *Four Freedoms* posters appeared everywhere, in train stations, schools, and churches across the country. In all, more than 1.2 million attended the tours, and $133 million ($2 billion today when adjusted for inflation) in war bonds were sold. At the Filenes event in Boston, Carl Hess and three models from *Freedom from Want* appeared: Shirley Hoisington (little girl); Bess Wheaton, the Rockwell's cook and housekeeper (delivering the turkey); and Charley Lindsey (balding man) (figure 3.2). Charley had come to Vermont on a train with a herd of sheep. Wild animals ate the sheep, and he became a carpenter.[17]

Although Norman had failed as an enlisted man during his youth, he, with Gene alongside him, proved to be a rallying force that influenced people to support the war effort. For his part, Gene eventually felt satisfied as one assisting in a mission critical to his country's victory in a most terrible war.

After the push to complete the *Four Freedoms*, Norman was physically and emotionally exhausted.[18] Fortunately, he and the *Post* had the sense to realize that he needed a lighthearted, less complex subject to allow his mind and body to rest. Gene stood ready to brainstorm ideas and help Norman relieve some of the pressure. The result was the playful painting *April Fools*, which the *Post* published directly after the *Four Freedoms*. One of Gene's much-welcomed contributions was his comedic nature, which lightened up the studio's atmosphere. He also suggested humorous elements that Norman incorporated into paintings.

A COLLABORATOR

Gene's daughter Melinda believes her father contributed so much creatively to paintings such as *April Fools* (figure 3.3) that Gene could be considered a collaborator for those works. In that painting, a gray-haired man (a German immigrant named Henry Hess) offers a warm smile to his wife during a game of checkers. Henry was the father of Carl Hess, the *Freedom of Speech* model. Melinda recognizes her father's "signature" on the following outrageous bits

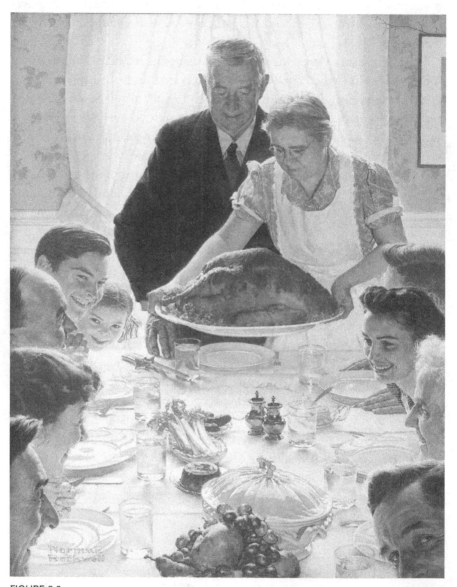

FIGURE 3.2

Freedom from Want: In Norman's iconic Thanksgiving painting, he found his models in the village: Charlie Lindsey (balding man); Mary Rockwell (next to balding man), Thaddeus and Bess Wheaton (standing at head of table), Nancy Rockwell (Norman's mother—with white hair), Billy and Shirley Hoisington (young man and girl). *Source*: Courtesy of the Norman Rockwell Family Agency.

of humor in the picture. He and Norman created a number of out-of-place items and invited viewers to find the "mistakes." Gene himself (figure 3.4) appears in a portrait above the fireplace with his hands folded outside the frame. A fish swims up the stairs. Henry grips a hoe instead of a cane. A deer lies at Henry's feet, and he has a bird in the pocket of his robe. Melinda pointed out that Gene hauled many of the props for *April Fools* from the Pelham's home, including the elegant chairs, the card table with gold patterns, and her grandmother's clock. These were family treasures that Vicky and Gene had brought from New Rochelle.

FIGURE 3.3
April Fools, 1943: Gene Pelham collaborated with Norman on this painting and provided the furniture. Norman had been exhausted after creating his *Four Freedoms*. Doing this whimsical painting with Gene helped him reenergize. Gene himself published two *Saturday Evening Post* covers. *Source*: Courtesy of the Norman Rockwell Family Agency.

FIGURE 3.4
Norman's assistant Gene Pel-
ham stands with the painting
he created of Norman. *Source*:
Courtesy of the Pelham Family.

"Norman and my father absolutely loved being humorous together,"
recalled Melinda, a model herself, who posed as the infant in the 1948 *Post*
cover, *The Babysitter*, where a befuddled babysitter tries to calm a bawling
baby. "They had a very good relationship. My father had a quirky sense of
humor. He could think up funny things. Dad liked his *April Fools* cover a lot,
probably because it was so much fun to do. I bet they killed themselves laugh-
ing when they put that together."[19]

Gene's paycheck from Norman meant that the Pelhams never went hun-
gry. Gene supplemented his income by selling his own paintings. "Dad sold
a lot of them. My guess is that he sold most of what he painted," said his son
Tom Pelham. At low points in the economy when art didn't sell well, Gene
took loans against the house. "He was a starving artist," explained Gene's
daughter Anne, "and that was not easy for the boy who grew up in a well-to-
do family in the affluent New York suburb of New Rochelle."

As time went on, the Pelhams grew fond of the Rockwells. Norman served as the best man at the wedding of Gene and his bride Katharine, known as "Kay." In the guest book for that event, Norman and his three boys each drew little pictures by their signatures.[20] Later, Norman included the couple in a comical painting called *Trimming the Tree*. Gene stands on the top step of a ladder while his wife has her feet on a lower rung. She holds him by his belt to keep him from falling forward onto the tree. After it was produced as a Hallmark Christmas card, it became a popular image reproduced on other Rockwell memorabilia, including T-shirts, coffee mugs, Christmas ornaments, and plates.

SPEAKING HIS MIND

At gatherings in West Arlington, Gene seemed to enjoy livening up the party with his off-the-cuff remarks. At times, his wife and children's faces reddened with embarrassment.[21] Gene's comments at a media event in New York City shed light on his personality. Norman and Gene once traveled to the CBS Studio in New York City at the invitation of *Arthur Godfrey's Talent Scouts*, the most popular TV show of the 1950s. Godfrey, who was affectionately known as "the old redhead," played the ukulele. Some of the most popular singers of the day were discovered on his show. He often promoted products such as powdered Lipton Soup. He'd mix a pack with hot water, take a sip, and proclaim to the studio audience, "This soup is so good!" Of course, the audience would erupt in applause. On the night that the two West Arlington artists made their appearance, Godfrey gave them each a cup of soup to sample. Norman proclaimed, "This is good soup." When it came Gene's turn, he blurted, "This is the worst soup I've ever tasted." Gene was not one to patronize. He was early into the "whole food" craze and went to great lengths to supply natural, healthy foods for his family. He raised cattle for beef, baked his own oatmeal bread, and made yogurt with milk from his cow. He prepared dishes with sea kelp and made delicious homemade soups.

During Godfrey's next show, as the guest again slurped soup, he exclaimed, "This soup is great, isn't it?" His guest agreed. Godfrey told him, "We had some nut on the program last time. He said he didn't like it! Can you imagine?"[22]

Norman appreciated the fact that the *Post* required him to vary his body of work from the serious to humorous. He liked discussing the balancing of light

and dark with fellow artist and model Mead Schaeffer. They understood that creating only dark-themed works made an artist's real-life outlook gloomy. "Norman was an outsider in a circle of artists who mostly did more serious paintings. I think Dad was a natural character for those fun settings," said Tom Pelham.

In 1947, Gene posed for *First Sign of Spring*. Although not a humorous painting, it exudes positive energy. Gene stands over the first crocus that has pierced the earth and points down at it. Anne Pelham said it is her favorite painting because it evokes happy memories. When snowdrops, delicate flowers of three white petals on a stem, would appear by the Pelhams' front steps in early spring each year, Gene would joyfully exclaim to his family, "The snowdrops are up!" *Signs* is another example of Norman's knack for finding a model with authentic feelings for the subject matter.

In a 1948 *Post* cover, Gene is clowning around once again as he grabs another man's hat in *Happy Skiers on a Train*. A bunch of people in a railcar are en route to a resort.

GENE IN MORE SERIOUS WORKS

Gene's first serious pose was for the 1941 feature in *American Magazine* called *Strictly a Sharpshooter*, where he sits ringside at a boxing match looking like a tough guy. In May 1947, Gene appeared in another, more serious painting, *Merry Go Round*, where he poses as an artist at work next to a circus ride. Gene also posed for *Saying Grace*, which in 2012 became the most valuable painting done by an American and sold at auction. The illustration shows a group of curious onlookers staring at a prim elderly woman and a boy praying in a busy restaurant. Gene sits at a table at the front. His cup of coffee is cold, his cigar crushed out on a plate. Only the front of his face and a hand are visible, but his role is integral to the mood of the picture.

THEY *ARE* WORTH SOMETHING

During his years in Arlington, Norman would give his paintings away or sell them for a nominal price. He told people his paintings were not worth much. It's true that, at that time, the sale of one of his originals wouldn't have brought the several thousand that the *Post* paid to publish them. Tom Pelham also thinks Norman couldn't be bothered with the sales aspect and that a hundred or perhaps a thousand dollars here and there was not worth the effort.

He did not want anything, even for a moment, to cause him to lose focus on the painting on his easel. However, it became obvious that Rockwell paintings were worth "something" during a sale at the library in Arlington. Tom Pelham recalled the story of how Norman sent his father with the original 1943 *April Fools* cover despite the fact that the artist cherished it. "Norman told my dad to put a price tag of $500 on it. 'I don't want to sell it, and nobody will pay that much for it.'" Gene didn't want the painting to be sold either because he had collaborated and modeled for it. He displayed it on the sidewalk in front of the historic Arlington Inn, known then as the Colonial Inn. During the sale, he noticed a glamorous lady meandering along the rows of paintings on display. Eventually, she appeared in front of him. Her face brightened as her eyes lingered on *April Fools.*

"It's one thousand dollars," Gene announced, believing the steep price would discourage her.

To his surprise, she exclaimed, "I'll take it." The lady promptly wrote out a check and carried *April Fools* away. Gene felt tense during his short drive back to the studio. As expected, Norman wanted to know why he wasn't carrying *April Fools.*

"Some lady bought it."

"I told you to price it at $500 so no one would buy it," Norman complained.

"I put $1,000 on it!" Gene replied.

"After that sale," Tom Pelham explained, "they started to realize there was a market for Norman's originals."[23]

As the years passed, Norman grew increasingly dependent on Gene. "My dad was ever-present in his studio," said Tom. Norman often beckoned his assistant at odd hours, and because the drive to his studio on the Green, where he moved in 1943, was only a mile, he had a hard time saying no. "My impression was that Norman was always under deadline," remarked Tom. He often fell behind schedule with book publishers and advertisers, not just with the *Post.*

Added to this pressure was Norman's insistence on perfection. "He had to get the nuances right. If he couldn't get them, he'd paint over parts or destroy them and start again," Tom explained. "He always knew what the next one would be. He'd tell my father, 'We're all set on this one. Go think about the next one.'"

My dad was totally dedicated," Tom said. "He was a strong supporter of what Norman was doing."

When Norman, Mary, and the kids spent periods of time away in California where she grew up, Norman would write, "Can you mail me this or that?" Gene would find letters in his mailbox from Mary. "Thank you very much. That's what we wanted."

Every so often, Norman would make a ridiculous request, such as one on a Christmas Day. Gene was enjoying family time when Norman phoned. "Gene, we need you at the studio. We really need you!"

"Norman, it's Christmas Day. I'm here with my family. I'm not coming down. Good-bye." He rarely spoke sharply to Norman, but this time he couldn't help himself.

The phone rang again. "Gene, I *really* need you."

"It's Christmas Day, Norman! It can wait. Good-bye." Gene slammed down the receiver. "What's wrong with him!?" he hollered angrily as Kay and the children looked on.

A few minutes later, the Pelhams heard a knock. When Gene opened the door, he stood face to face with Mary. "Gene, Norman *really* needs you!"

"This is nuts," Gene replied. "Tell Norman I'm not coming. Not on Christmas Day!"[24]

THE PELHAM CHILDREN AS MODELS

Tom Pelham himself appears in several Rockwell paintings. He, his sister Melinda, and their neighbor Mike Hess all modeled for paintings that Norman submitted for the front of Kellogg's Corn Flakes boxes. Kellogg's used only the one featuring Mike Hess because his hair was red and his face freckled. Melinda laughed, "I guess I wasn't redheaded and freckled enough."

In a Massachusetts Mutual Insurance Co. advertisement inside the *Post*, Tom sits on the shoulders of Norman's friend Don Trachte Sr. Tom's mother Kay appears as the wife. Trachte was an artist for *Henry*, the most syndicated comic strip of that era. Henry, a hearing-impaired boy, finds himself in all types of humorous situations. Tom still has the teddy bear that Norman gave him after the modeling session (figure 3.5).

Tom is another model who grew up enjoying the rural atmosphere and safety of the Arlington valley in the glory of its four distinct seasons. A favorite activity was floating down the Batten Kill in tire tubes. "I was an Arlington river rat," he said. Tom, like Tommy Rockwell, played basketball between hay mows on an old plank floor, worked in dairy barns, and drove tractors.

FIGURE 3.5
Gene Pelham's children, Melinda, Anne, and Tom, lived a life of farming, fishing, and hunting in the Batten Kill Valley with the Vermont models. They posed for Norman's Corn Flakes cereal box paintings and others. *Source*: Courtesy of Melinda Pelham.

However, by the time he came along, mechanical balers had replaced pitchforks in the hay fields. Tom hurled bales on wagons and stacked them for a stout farmer named Stubby Wilcox, who ran a farm across the street from the Wayside Country Store, previously known as Walt Smith's. Stubby was from an old Vermont family, some of whom modeled for Norman. Stubby would challenge the boys to see who could throw a bale the highest. Tom and other kids would struggle to land one atop a stack of three on the wagon. Stubby would show the boys who was boss. He'd grab the strings of a bale, swing it backward, and hurl it high enough to land on a stack piled seven high. "Growing up in Vermont, you became a jack of all trades—hunting, fishing, repairing machinery, farming, and dropping trees with chainsaws," he said. "You appreciated the science of it all. You learned about soil composition, cattle diseases, and how to butcher deer and squirrels."

By the time Tom graduated from high school in 1967, Arlington family farms were close to extinction. Profit margins had always been thin. But higher taxes, along with replacing steel milk cans with expensive bulk milk tanks and pouring concrete floors in milk houses, dealt the death blow to the small farmer.

Although the old-fashioned type who believed "kids should be seen and not heard," Gene taught Tom how to maintain the lawn and do household maintenance. "He wanted me to learn how to fend for myself."

THE BABYSITTER

Norman's most popular painting of Melinda Pelham appeared on the November 8, 1947, *Post* cover titled *The Babysitter*, where she appears as a distraught infant held by a frazzled teenage babysitter in a cluttered room. The sitter, a local teen named Lucille Holton, reads a babysitting instructional manual, hoping to learn how to calm the baby. Melinda cherishes a letter she received from Norman thanking her after she once posed for fifteen and a half hours for another painting in the 1950s. During breaks, Norman's wife would entertain her. "Mary would take me into the house. We picked flowers in her garden together. She was very lovely."

Norman also depicted Melinda in whimsical greeting cards. In a Hallmark card called *Caught Napping*, she and a boy have fallen asleep in an armchair. Santa Claus, modeled by Gene, hides at the side of the chair and peeks at her. On a cover of *Child Life* magazine with *Santa's Helpers*, Melinda and neighbor Don Trachte Jr., both about five years old, stand in front of Gene posing as Santa once again.

On his days off, Gene set up his easel in quiet fields. His works re-create the beauty of New England rivers, lakes, and mountains as well as quaint covered bridges, barns, and railroad stations. Of Vermont, Gene said, "It is still early America, and its variety never fails to evoke nostalgia from people throughout the country."[25]

In his painting *Spring Landscape of Equinox Pond, VT*, leaves rustle in the breeze on white birches set before a Green Mountain, evoking the feeling of summer days to come. "Dad was one of the better southern Vermont artists to capture the color, feel, and tone. He didn't wander far from what he saw. My dad's art reflects the Vermont reality I connected with," said Tom Pelham. Gene painted a portrait of Norman in 1950, which currently hangs at

the Stockbridge Museum. Norman appears remarkably relaxed as he sits on an antique wooden bench wearing a casual blue shirt with green work pants, brushes in hand. His face looks fuller, his eyes rested. "He was posing for Dad. I'm sure he *was* relaxed," said Tom. Melinda believes this portrait was the best her father created. "It shows his admiration for Norman. He put the time in it. He wanted the portrait to be his best."

Tom spent his entire childhood around Rockwell models such as Carl Hess, who patched his bicycle tires and the inner tubes he used to float down the Batten Kill. Tom also cherishes memories of Floyd Bentley, the melancholy farmer who sits on the bumper of a rusted truck at a train station in *Breaking Home Ties*, voted second favorite by *Post* readers. Tom is another who considers the painting an exact likeness of Floyd, whom Norman proclaimed one of his favorite models. Floyd's weather-worn face added character to the painting. He was the only man remaining in West Arlington during Tom's era who cut fields without a combustion engine. Tom would be lying in bed half asleep when he'd hear the snorting of horses and the clatter of the mechanical mowing machine, "ch-ch-ch." Periodically, a moment of silence would ensue, and Tom's ears would stand up as he pictured Floyd lifting the sickle bar to turn a corner. He could only relax when the rhythmic "ch-ch-ch" resumed.

At times, Norman would give Gene paintings on canvas that he hadn't finished. Gene would paint over Norman's work or use the blank side. "I tell people if you ever see a Gene Pelham, take a look at the back. If it has a piece of brown paper or a covering, slit it. If you see something there, buy the painting. It might be a Rockwell," Tom laughed. Gene stored them in his barn, thinking that one day, they just might be valuable. He couldn't have imagined just how valuable!

In 1953, after fourteen years in Vermont, Norman moved to Stockbridge, Massachusetts. He and Gene remained friends and saw each other from time to time. Gene stayed in West Arlington and eventually made his living from a publication he founded, which today is called the *Vermont News Guide*.

4

A Whole Family of Models

Norman and Mary Rockwell did not know a soul in town when they bought their home on the north end of River Road in Arlington in 1938. After seeing an advertisement in a New Rochelle publication listing Vermont homes for sale, they drove to the area and were immediately charmed by what they found. The brilliant fall foliage, the farmland, the quaint country town nestled in the Green Mountains, and the salt-of-the-earth people convinced them that this was the place to buy a vacation home. They purchased their house on their second day in Vermont, fulfilling Norman's lifelong dream of living in the midst of green meadows, flowing water, and grazing animals. The move also signified a fresh start for Norman professionally, and he looked forward to discovering what his new surroundings might inspire. Despite the beauty of their new home next to an apple orchard and sixty acres alongside the Batten Kill, the Rockwells would discover that living way out on the gravel road on the forested side of town could be lonely.

Fortunately, they became acquainted with Walt Squiers, whom they contracted to renovate their house on the day they purchased it. He lived a half mile down the graveled road, which made him their nearest neighbor. Perhaps Bert Immen, their real estate agent, referred Walt to Norman. Six-foot-two and broad shouldered, the easygoing Walt had kind blue eyes and short brown hair. His lean, wiry arms were well muscled, perfect for swinging a hammer and reaching up high and down low. He worked hard to please his

customers and carried the burden of hoping they would pay him. He felt the pressure of making sure his crew worked hard so that he could provide a good living for his family.

Around Arlington, people accepted Walt's quotes with a handshake. He soon set up a carpentry shop at the Rockwells' and began working on the house and creating a studio out of one of the two red barns across the road. A year earlier in 1937, electric poles had been erected in West Arlington and power lines strung. In December of that year, electricity lit up people's homes and energized tools.[1] This gave relief to the tired arms of carpenters. Hand-held circular saws, first marketed in the late 1920s, could now be plugged in and cut through wood effortlessly.

Norman desired to be connected to down-to-earth people like Walt after living so long in cities where he considered many to be pretentious. Born in Arlington in 1906, Walt finished his formal education after ninth grade, allowing himself an early start in his trade. He learned carpentry and drove the local roads estimating jobs and hiring subcontractors and employees. In the autumn, he hunted deer to put meat on the table. Neighbors like the Squierses were bound to find themselves in Rockwell paintings. Walt, the second person in Arlington to find himself on a *Post* cover, became Norman's symbol of physical and spiritual strength. He and members of his family eventually appeared in about as many as any other family during the artist's career. Some are among those *Post* readers cherished most.

MUSIC HATH CHARMS

Norman first brought Walt, then age thirty-three, to the studio to pose for the comedic November 4, 1939, *Post* cover *Music Hath Charms*, where he poses as a prisoner in a county jail. The sheriff sits weeping on a stool outside the cell with his dog dozing at his feet as Walt is absorbed playing a tune on his harmonica. Norman met the sheriff, Harvey McKee, early on in Vermont and enjoyed his warm presence and the tales he told about the brawls that sometimes broke out as he arrested unruly men. In the painting, Harvey holds a rifle in his lap. His swollen hand lets viewers know an altercation has taken place. Norman often went to great pains to find the right model, but in the case of *Music Hath Charms*, it was pure luck. Harvey's broken hand is authentic, sustained the night before when he rushed to the aid of a girl crying out

from an abandoned shack. A belligerent young man busted Harvey's hand as he struggled to make the arrest.

The sheriff has tears in his eyes, but one can't be certain why. Perhaps the music is soothing his pain. Maybe it's making it worse. The sheriff may be exasperated by the prisoner's seeming lack of concern for his condition since he is playing a happy-go-lucky tune. In real life, Harvey resided in a large comfortable farmhouse with a wide wraparound porch built for sitting chairs. His home stood less than a mile from Norman's studio on the West Arlington Green. Carl Hess, the featured modeled in *Freedom of Speech*, ran the gas station and gun shop across the street from Harvey.

Walt's daughter Marjorie Squiers Coulter tells the story of how her family's friendship with the Rockwells progressed and how she came to model. Marjorie was born in the early 1930s in a house her father built at the base of the Green Mountains a couple of miles from Arlington village where River Road hugs the Batten Kill. Back in the 1930s, Marjorie, a tall tomboy, spent hours in the wooded area exploring the thirty-foot-wide river, generally waist high with a rocky bottom. Brown trout would shoot like missiles from tree roots overhanging the water from the banks.

"The river was our entertainment," she said. Marjorie and her brothers would jump from the wood plank bridge on the gravel road into brisk water fed by mountain brooks. At that spot, the water came up to their chins. "You got used to the cold water when you stayed in for a while. You were refreshed when you pushed yourself up the bank," Marjorie recalled.

Marjorie would sit on a boulder in the center of the river with her fishing pole. Fly fishermen waded by in rubber pants, snapping their lines in what was known as one of the premier trout fishing rivers in the country. After they asked her if she caught anything, she'd lift up a fish on a stringer, which never failed to impress. After all, the Batten Kill's brown trout were some of the smartest fish anywhere and elusive. She and her brothers skipped rocks, grabbed frogs, and gazed up at hawks and vultures circling the sky.

A PORTRAIT OF RESILIENCE

As she sat on the bank or a rock in the river, Marjorie had plenty of time to think. She was accustomed to the slow-paced life and tranquil setting of her rural home, where folks were comfortable with uninterrupted thoughts meandering through their minds and feelings lingering in their hearts. No

electronic media existed at that time. People learned about current events from newspapers, although some had radios by this time. She might have been consumed ruminating about the fact that her mother Clarice was partially paralyzed on the right side of her body from a car accident. At an intersection in nearby Bennington, Clarice was riding with Walt when a car smashed into them.

In the hospital, the doctor gave Walt the grim news that his young wife "will never walk again."[2]

Walt was devastated. His happy dreams of a future with his lively young bride had been shattered in a moment. She would forever be in a wheelchair. Nonetheless, he made up his mind to remain with Clarice and help her in any way he could. For a time, he even carried Clarice from room to room. The accident did not stop Walt from building a new home for his family on River Road along the Batten Kill. Walt and Clarice found strength at St. James Episcopal Church at the center of Arlington, where they sometimes chatted with Mary Rockwell. "My parents were both spiritually strong," said Marjorie. Friends and family considered Clarice an excellent listener who was genuinely interested in their lives and feelings. If someone was in a difficult situation, she, of course, understood pain.

Clarice was not one to give up. She set her mind on living a full, active life despite the forecast of the medical profession. She eventually regained more strength than the doctor could have anticipated. She made herself get up and walk, though her right foot dragged. When she turned twenty-seven years old, her physician surprised her with a preposterous suggestion. "I think you ought to have children. It would be good for you." Before long, she gave birth to Marjorie, then David and Raymond. "The neighbors were amazed at how she managed to change diapers with one hand," Marjorie said. Clarice insisted it was prayer that allowed her to live a full life after the car accident. Her spiritual strength would later make her an ideal Rockwell model.

Marjorie didn't think of her mother as having a handicap because Clarice refused to let herself wallow in self-pity. She endured the pain with little complaint and did what she needed to do to adapt, such as learning to write and change diapers with her left hand. "Every cloud has a silver lining," Clarice liked to say. Prayer became her oxygen, which would later make her supremely qualified as the type of authentic model Norman needed for *Freedom of Worship*.

Workers at a sawmill next door to the Squiers's home were impressed when they observed Clarice walking to the plank bridge where her children swam. Clarice dragged her right foot on the gravel road and steadied herself with a cane. Three hours later, she would arrive at the swimming hole, just a quarter mile away.[3]

THE BOYS HAVE BIKES

One day in 1939, it was as if the Rockwell boys fell from the sky! Jarvis, the oldest, rode past Marjorie. He then stopped and jumped off his bike. "You can ride it if you want," the friendly boy offered. The Squiers lived comfortably enough but like most of their neighbors couldn't afford bicycles. She had never ridden one before and feared falling. Soon, she found herself at the Rockwell home learning to ride her bike in the studio of a famous artist!

The boys and Norman, a tall skinny man who kept a pipe in his mouth, steadied her on the bike. Marjorie gained the confidence to ride it without help and circled the studio so fast that she became nauseous and toppled to the floor. Norman and the boys drove her home. When the Rockwells went on vacation, the boys left their bikes for her and her brothers to ride. The Rockwell and Squiers children enjoyed other simple fun, such as taking turns hopping into Walt's concrete mixing machine. One would turn the crank to spin another kid around and around until they heard the scream, "Let me out!" Marjorie and her brothers also joined the Rockwells swimming in the river, and Mrs. Rockwell was happy to see the children having so much fun.

In the summer of 1940, about the time the Rockwells made the decision to move to West Arlington permanently, Norman called Walt over to the studio he had renovated to model for *River Pilot*. The illustration appeared inside the *Post* of September 21, 1940. The illustration depicts an intense moment during a steamboat race on the Connecticut River, where a captain grips the wheel and peers ahead. A river pilot scopes the water so as to advise the captain, and a railroad inspector slouches on a bench behind him. Norman used only Walt's body to make the inspector look imposing. His legs are stretched out to make them appear extraordinarily long. Atop Walt's neck, Norman painted the head of a man with a hawk nose wearing a Lincoln top hat.[4]

THE HORSESHOE FORGING CONTEST

During the Rockwells' first year in town, he invited Walt and Harvey to pose for an oversized painting called *The Horseshoe Forging Contest*. Norman used a blacksmith shop in Shaftsbury, Vermont. At the time, Robert Frost, the renowned American poet, was writing poetry in his home just up the road.

In the November 2, 1940, edition of the *Post*, one of Norman's most popular pieces appeared on a two-page spread. In this large painting, Walt is the tall blacksmith in a green plaid shirt with lean, defined muscles energetically pounding steel at his anvil in a highly charged contest against another blacksmith. Sitting among a boisterous crowd, the deputy who played the mustachioed sheriff in *Music Hath Charms* stares wildly back at the viewer. Norman placed Harvey again, without the mustache, as a spectator on the other side of the painting (figure 4.1).

Marjorie recalled that their families enjoyed good times together. Some Christmases, Walt drove Norman to hunt for a Christmas tree for their living room. Norman especially liked the Kelly Stand, a scenic gravel road that begins in East Arlington, snakes through a national forest, and extends to the Stratton Mountain ski resort. Cabins sit at the foot of cedar and pine groves anchored into cliffs. They overlook the Roaring Branch, a river tinted green from minerals that flows around boulders.

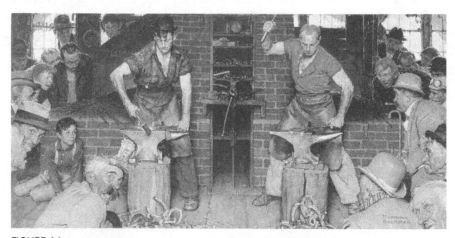

FIGURE 4.1
The Horseshoe Forging Contest. Walt Squiers, Norman's building contractor (blacksmith to left), and local sheriff Harvey McKee (grand moustache) bring the painting to life. *Source*: Courtesy of the Norman Rockwell Family Agency.

One year as they drove scoping the woods, neither Walt, Norman, nor little Marjorie could spot a tree to suit the artist. They finally stopped at a promising grove, and the two tall men and tall girl entered the forest and ran their eyes up and down twenty- to thirty-foot-tall fir trees.

"Which one do you like?" Walt asked.

Marjorie, shivering from the cold, watched Norman as he looked over the trees surrounding them. They were all too tall. Norman pointed to the top of one with branches that formed a full, balanced shape. "Be nice to have the top half," he said in his usual way with a chuckle.

"Looks good to me too," Walt replied.

"We oughta climb up and saw it off." Norman took his tobacco pipe from his mouth. The rugged builder walked to his truck and returned carrying his rifle and ammunition.

"What are you going to do with that?" Norman asked.

Walt loaded the rifle, peered through the scope, and pulled the trigger. "Boom!" The rifle jumped back, and the bullet tore a hole in the tree. "Boom. Boom." The top portion of the tree fell to the snowy ground.

"There's your tree, Norman."

Norman took his pipe out of his mouth and looked in awe. "That's one way of doing it! Mrs. Rockwell will like it."

After they secured the tree in the back of Walt's truck, Marjory complained that her feet were freezing cold. "Norman, would you rub Marjorie's feet?" Walt asked. Norman agreed and warmed them up, endearing her to the artist.

FREEDOM FROM FEAR

In 1942, when Marjorie had missed half of the school year due to kidney problems, she got the chance for which she had been waiting. Norman was in the process of creating the *Four Freedoms* series to be published in the *Saturday Evening Post*. Eight years old at the time, Marjorie and her brother David were the perfect ages for the wartime painting called *Freedom from Fear*. Clarice was delighted, and the day was special for Marjorie because she didn't have to go to school. Plus, the friendly Mary Rockwell would pick her up, and the two would chat along the way. "I was really happy," she said.

In the studio, Norman and his assistant Gene had made up a bed with sheets and pillows. He explained to Clarice that the painting would be set two years earlier, when the Germans bombed London and destroyed buildings

and killed people. In the United States, children were fortunate to go to bed not having to fear bombs.

Marjorie knew about the war. She had joined the children in picking the milkweed pods that manufacturers stuffed into army parachute jackets and life preservers to insulate. Those who collected them were paid $5 for a bag of pods. When the war effort needed help, Walt took a job in a defense plant in Schenectady, New York. Clarice would not be left out. She posted herself on a small tower atop a hill to scan the valley for enemy planes in the event the Nazis made it to Vermont.

With Clarice assisting him through the modeling session, Norman posed Marjorie and David to look as if they were asleep while their mother is gently adjusting the sheets. He instructed Marjorie to lie on the right side and face away from her brother David, who slept on the left. In his gentle but firm manner, Norman told them, "Close your eyes. Pretend you're asleep." Marjorie and her brother lay still, but she yearned to see Norman sketch and Gene Pelham take photographs, so she peeked.

Norman didn't miss a thing. "You have to look as if you are asleep. Keep your eyes closed."[5]

The girl could not resist peeking again. "You must look as if you are asleep." Norman was demanding, but he always kept cool. Her mother persuaded her by flicking an ear lightly with her index finger.

Norman brought a schoolteacher, a friend he knew from social gatherings named Dorothy Lawrence, to pose as the loving mother. According to Shirley Lawrence Letiecq, the daughter of Dorothy, her mother's brother Clyde Dunlop was the first to pose as the husband and father who stands to the side of the bed. Norman believed Dunlop's face appeared too young and summoned Jim Martin to the studio. Jim was the Arlington carpenter whose son Jimmy was Tommy Rockwell's best friend as well as the only person to appear in all *Four Freedoms*. The artist painted Jim Martin's head on Dunlop's body.[6]

In *Freedom from Fear*, the master took pains to present each model's emotions as they might have revealed themselves in real life. The tender faces of sleeping Marjorie and David represent their trust in their country and parents to keep them safe. The father can't quite hide his concern. A folded newspaper held at his side announces the horrible bombings that took place during the Blitz in 1940 and 1941. When the Nazis pounded Britain from the air, they reduced buildings to rubble, killing 40,000 people. The father keeps the shocking headline facing away from his family as if to shield them.

By the father's foot lies a doll Clarice made. She named it Delisha after a character in a children's book she had read to Marjorie. Norman wanted to convey that Marjorie felt secure enough that she didn't need to take her dolly to bed. He painted a framed picture of an angel above the children's heads.

After her session, Norman tucked a $5 bill in Marjorie's hand. The *Post* published *Freedom from Fear* on the cover of the March 13, 1943, issue. The government made posters with the caption "Buy War Bonds" and featured them on the tour of sixteen American cities to eventually raise $133 million for the war effort (figures 4.2 and 4.3).

FIGURE 4.2
Freedom from Fear. Norman's next-door neighbors, David and Marjorie Squiers, sleep peacefully at a time when the Nazis were bombing London. Schoolteacher Dorothy Lawrence, and carpenter Jim Martin posed as protective parents. *Source*: Courtesy of the Norman Rockwell Family Agency.

FIGURE 4.3
Marjorie and Raymond Squiers in front of the Batten Kill River down the road from the Rockwell's first Vermont home. They posed lying in bed for *Freedom from Fear*, though it was Marjorie and other brother David who appeared together in the final painting. *Source*: Courtesy of Marjorie Coulter.

THE MIRACLE

One day when the children were small, a miracle of sorts occurred. At the dining room table, one of the Squiers boys began choking. "Oh no!" Clarice hollered when she saw the panic on her little boy's face as he tried to cough up food stuck in his throat. She sprang into action and patted him on the back with her right hand until he dislodged the food and began crying. After she calmed down, Clarice thought, *This is amazing. I just used my right hand.* She lifted her arm and opened and closed the hand. *It's not paralyzed anymore!* From that day on, she had adequate use of it, and it proved invaluable in chores like canning the vegetables that helped the Squiers make it through the winter.

When Norman needed a woman to model for his final version of *Freedom of Worship*, he had to look no further than next door. None other than Clarice, with black hair and bold brown eyes, appeared top center with her hands pressed together in prayer. Norman couldn't help but use his friend and contractor Walt again, placing him in the lower right corner wearing the yarmulke that some Jewish people wear during prayer.

Freedom of Worship circulated around the United States in the *Post* on February 27, 1943.

Had the *Post* returned Norman's *Four Freedoms* originals to Vermont sooner than it did, the masterpieces would not have been available for the public to view today. On May 15, 1943, Walt was in bed just after 1:00 a.m. when he heard a banging and yelling at his door. "Walt! Walt!" He ran downstairs and opened the door, and standing with mussed hair in a nightshirt was Thaddeus Wheaton, Norman's handyman. "Norman Rockwell's studio is on fire. The phone line is out. Call the firemen!" Walt alerted the fire chief, jumped into his truck, and raced the half mile to Norman's.[7]

As cars, pickups, and fire trucks raced past their home, Marjorie told her mother, "We want to go over to the Rockwells. We want to see the fire! Oh please?"

"We can't go to the Rockwells. The boys have the measles." Clarice was firm.

The next day, Marjorie saw the charred remains of the studio where she had modeled for *Freedom from Fear*. She also noted that the bicycles had been saved!

Clarice's injuries sometimes caused discomfort and fatigue. Her friend Mary Rockwell would periodically stop by to give her a break by putting Marjorie and her brothers to bed. Everyone loved to hear Mary read. Just as she did for students at the schoolhouse, she treated the Squiers to her favorite children's book, *The Hobbit*, as well as *Dr. Doolittle*. Mary held Marjorie and her brothers' attention with her dramatic reading about Bilbo Baggins, a boy who is determined to get a share of treasure guarded by a menacing dragon. He grows wiser through his challenges. "She read with feeling and expression," Marjorie said.

WALT'S NEXT PROJECT FOR NORMAN

Periodically, Norman would take Walt and Clarice out to dinner at places that would not have normally been in their budget, such as the Mistral Restaurant, set on a picturesque location near the Bromley Mountain ski area in

Manchester, Vermont. In 1943, they had an important topic to discuss: the construction plans for Norman's new studio on the West Arlington Green. Once after Clarice had been feeling particularly worn and achy from her old injuries, Mary and her housekeeper cared for her at the Rockwell home for two weeks.

During the Saturday night square dances at the pavilion, Clarice found it interesting to watch Norman gazing around the floor. She could tell when he was sizing up a potential model. He would pull his pipe out of his mouth and lock his eyes on a person with an interesting face. He'd give him a good looking over from head to toe and from various angles.

"He's at it again," Clarice would tell Walt or a friend.

People would reply. "Ayyyy-up. Looks like he might have found himself a good model."

Norman called on Walt again when he wanted to build a retreat cabin less than a mile down River Road. At times, the artist felt overwhelmed by his friends and family or by gawkers trying to catch a glimpse of him. About a mile from the Green, next to the home of two models who appeared in *The Gossips*, Amelia Harrington and her husband Jesse, Walt excavated a small site. He built a cabin for Norman, leaving just a couple of feet between the house and the bank of River Road. Its roof was barely visible below the road, making it a well-camouflaged hideout.

WALT MODELS

"Walt, I need you for another painting," Norman told his builder in 1944.

Walt drove to the studio on the Green, which he and his men had recently completed, to model for the 1944 Independence Day issue of the *Post*. The war had taken its toll on America. For *Disabled Veteran*, Walt posed in an army helmet and uniform in various positions, such as lying on the ground sleeping and pretending to be dead. The most prominent back image is of Walt assuming the stance of an alert soldier patrolling the woods, ready in waiting should the enemy attack. In the foreground as the soldier on crutches, drops of blood-like tears trickle down his cheek as he remembers friends lost on the battlefield. So many across the United States and even in Arlington had been killed or injured during the past several years.

Later in 1944, Norman called Walt again to model for *The Long Shadow of Lincoln*, which would be published by the *Post* as an inside feature. Walt ap-

pears at the center of the painting. As in *Disabled Veteran* and *The Horseshoe Forging Contest*, Norman gave Walt an impressive stature. Walt posed as a disabled soldier gripping a crutch, as his left leg has been amputated. He also holds an open book on his knee, signifying the value of knowledge. Norman toyed in the studio with having Walt in a wheelchair with a blanket covering his leg but decided against it. Walt knew, of course, the feelings of disabled people and did not have trouble bringing the expression Norman needed to his face. "My father is portrayed about the way he looked in real life," Marjorie said.[8]

Norman also placed Clarice in a position where she would make an authentic model once again. Wearing a somber expression, she kneels at center right in a dark blouse. Her hands, which appear extraordinarily large, are folded in prayer. In front of Clarice, a dog tag hangs on a cross. Norman gave Clarice the sketch of *The Long Shadow of Lincoln* and signed it "To Clarice and Walt Squiers, Sincerely Norman Rockwell" (figures 4.4 and 4.5).

FIGURE 4.4
The Long Shadow of Lincoln: In this somber painting, Norman used neighborhood models: Ardis Edgerton Clark (girl kneeling), Walt Squiers (sitting on chair), Clarice Squiers (woman praying), Curnel Vaughn (looking to sky), Jim Edgerton (holding hand out), Jarvis and Tom Rockwell, Buddy Edgerton (front left), Alva Edgerton (old woman praying), Joy Edgerton (girl with braid). *Source*: Courtesy of the Norman Rockwell Family Agency.

FIGURE 4.5
Home photo of Clarice and Walt Squiers. Clarice modeled for *Freedom of Religion* and the *Long Shadow of Lincoln*. Walt posed in many, such as *Music Hath Charms, The Forging Contest*, and *Kansas City Spirit*. He too appeared in the *Long Shadow of Lincoln* at center, holding a crutch. *Source*: Courtesy of Ginny Coulter Colon.

In 1951, Norman needed to portray a hero capable of inspiring the people of Missouri to rebuild after a huge flood. The image of Walt Squiers once again floated into the artist's mind—the six-foot-two stature, wide shoulders, muscled forearms, and sharply chiseled, square jaw. The storm had damaged the warehouses of Hallmark Cards in Kansas City. The artist enjoyed a thriving partnership with company owner Joyce C. Hall during the 1940s and 1950s. Hall believed a Rockwell painting would inspire residents to rebuild.[9]

The devastating flood of July 13, 1951, "swept down the Kansas River valley . . . and became one of the costliest floods in Kansas history. From July 9–13, some areas in the Kansas River Basin received 18.5 inches of rain . . . 116 cities and towns were affected . . . 22,000 residences were flooded . . . 336 businesses destroyed . . . and 1 million acres flooded. Total losses in the region exceeded $725 million, quite a sum for 1951."[10]

Train cars were pushed on their sides, roads and bridges were destroyed, and power was knocked out. Twenty-eight people died.

Norman traveled to Kansas City to sketch and photograph neighborhoods for the painting that became known as *Kansas City Spirit*. In the final illustration, Walt stands tall as King Kong with his sleeves rolled up and holding a set of building plans. Walt dwarfs the building behind him. A plane flies next to his shoulder.

A COLLABORATION

Norman had never officially collaborated with another artist, nor did he aspire to do cityscapes. *Kansas City Spirit* became an exception when he partnered with illustrator John "Jack" Atherton, who had moved to West Arlington to be near his good friend.

Hallmark applauded their collaboration. "Atherton's cityscape appears as a monumental still life that includes iconic images of agriculture, trade, and transportation to convey the industriousness of the thriving metropolis."[11] J. C. Hall's thoughts on rebuilding were distributed with posters of *Kansas City Spirit* to inspire citizens during their long period of rebuilding. The painting toured the United States and now resides in Hallmark's headquarters in Kansas City.

5

Son, Model, Author of Best Sellers

In 1935, Thomas Rhodes Rockwell was a three-year-old playing with little toys when his father came to him and said, "I need you to help me."

"Why, Dad?"

"I need you to model for a painting." Norman was working on an illustration for the *Saturday Evening Post* that would be published the next year of a boy whose jolly grandfather invites him to search for a present in one of the deep pockets of his winter overcoat. At this point in time, the artist was accustomed to employing professional models, but Tommy fit this part, and using his own son would save money.

Tommy knew what modeling meant because he sometimes saw his father sitting at his easel in front of people moving into poses. The artist's studio stood next to their home on Lord Kitchener Road in New Rochelle, New York. When readers saw the illustration *Puppy in the Pocket* on the January 25, 1936, cover of the *Post*, they couldn't help but smile. Tommy's character has no idea that the gift he's searching for waits on the other side of the coat. Everyone but him sees the playful puppy in the second pocket. Viewers anticipate the moment when boy and puppy will meet. Norman used his Uncle Gil as the model, painting him from a childhood recollection. Although eccentric and disliked by his father, Norman loved his uncle, who always brought gifts and a spirit of fun on holidays.[1]

In a photograph taken around the time Thomas Rockwell was about twelve years old, he is seen standing in front of a row of six hunters next to a rustic hunting cabin in the Vermont woods with their hunting rifles pointing to the ground.[2] They all smile triumphantly because they have taken the black bear and several deer hanging behind them on a rod fastened to tree branches. The photo was taken about six years after Tommy, as his friends called him, moved from New Rochelle to Vermont. He offers a friendly smile matching those of the other hunters, which suggests how comfortable he felt with these native Vermont outdoorsmen, hunting, fishing, and camping. The town was small and tightly knit, and newcomers sometimes found it difficult to fit in, but Tommy connected because he had an abundance of energy and didn't give his neighbors a chance to put him off.

In the photo, Tommy wears a bright beige jacket, which stands out against the others' dark plaids. It too is symbolic. Tommy would not be afraid to shine in his studies and in extracurricular activities. The hunters are not just a haphazard group of people. They are ones who were significant in molding Tommy's character. Since West Arlington was a tiny village, the people, young and old, interacted throughout the week.

Jim Edgerton, the dairy farmer who lived next door to the Rockwells after they moved to the Village Green, stands closest to Tommy. Jim also stood by Tommy spiritually and acted as sort of a second father. Jim was a steady man whom Tommy came to lean on during times when he struggled personally. Tommy's favorite Vermont days were spent haying fields with Jim and his children. Clara, Jim's wife, is also among the group. She served as a second mother to Tommy, who enjoyed many meals at her table. Clara felt proud to model for Norman's *Happy Skiers on a Train*. Bob Benedict, who stands to the left of Tommy, posed around the time of this picture for *Freedom of Speech* as the gray-haired man looking up at the speaker with admiration (figure 5.1).

In his eighties, Thomas Rockwell reminisced about how his father got a kick out of his energy as a boy, even when it led him to mischief. Tommy often observed his father entertaining friends at cocktail parties with funny stories about the shenanigans of him and his older brother Jarvis. Norman would tell them at places like the Bonnie Briar Country Club in Larchmont, New York, where he was a founding member. One of Norman's favorites stories took place during a dinner party at the Rockwell home.

FIGURE 5.1
Tom Rockwell joined the native Vermonters in hunting, fishing and camping. In the beige jacket, he appears after a hunt. L to R, Robert Smith, Clara Edgerton, Edward Killington, Bob Benedict Sr., Jimmy Edgerton. *Source*: Courtesy of Buddy Edgerton.

Tommy enjoyed listening and observing his father tell the story. "Jarvis and Tommy were running around upstairs, and we thought nothing of it. Then, out of the front window we see something big fall to the ground. *What the heck is that?* we wondered. I look out the front door and see a chair lying on our front lawn."

Norman's friends would be listening with rapt attention.

"I run up the stairs yelling, 'Tommy! Jarvis! What is going on?' I find them sitting on the floor trembling like two scared mice. Of course I told them not to do that again."

The cocktail party guests would chuckle along with his father.

UPROOTED
Not long after *Puppy in the Pocket*, Tommy's father and mother announced something that would eventually change his life drastically and permanently.

"We bought a house in West Arlington, Vermont. It's out in the country next to a river where you can swim." During the summer of 1938 and 1939, the Rockwells spent considerable time in the Green Mountains. Tommy, around eight or nine years old at the time, lean and of average height with strawberry-blond hair, found the setting enchanting, from the wide, starry skies shining on mountains at night to days exploring the fields, Batten Kill, and brooks for snakes, crawfish, and frogs with his brothers Jarvis and Peter was great fun. Sometimes, Norman would join them.

As places go, New Rochelle was at the other end of the spectrum. It was a prosperous city where businesspeople, artists, and professional athletes dressed in fine suits and commuted to New York City. During Tommy's first years, some of the newest, most fancy art deco buildings in New York sprung up. Many of the buildings were two-, three-, and four-story brick structures attached in long rows. Some had tall peaks, even spires, while others had colored bricks, rounded corners, and tall marble columns. Their fronts featured large, arched-glass windows and decorations of ceramic faces, seashells, ribbons, and wings. The new Lowes Theatre seated 2,500 people in luxurious seats. Excited kids like Tommy watched new releases, such as *Snow White and the Seven Dwarfs*, *The Adventures of Tom Sawyer*, and *Pinocchio*. Dark-colored shiny cars with powerful engines, such as Cadillacs, Mercedes-Benzes, and Rolls-Royces, lined the streets along with common Chevys and Fords. The hoods of the luxury cars were long, their high cabs rounded.

When Tommy first saw the village of Arlington, a form of beauty altogether different struck his eyes. Lines of tall elm and maple trees shaded the wide, graveled Main Street, a brief commercial stretch of simple wood-framed buildings with tall mountains as a backdrop. A Greek Revival mansion converted to an inn with many columns along its porch stood at the intersection. Next to it, a marble walkway led to the Arlington Community House and Library, a historic brick house with wings on each side. Across the street stood St. James Episcopal Church, a stately stone structure rising to a lookout deck with pointed posts. Revolutionary War soldiers, including some of the Green Mountain Boys, are buried in the cemetery beside it behind a stone wall. Much activity centered around George Howard's country store. Two rectangular windows gave an old two-story house the look of a market. Tommy would shop there with his parents. The white-haired George, outfitted in a

suit and tie, would greet them and take orders. He would turn around, pull groceries stocked on shelves, and set them on the counter.

Tommy's new house was also a far cry from their home in New Rochelle, which was situated in a suburban neighborhood lined with cultivated trees and groomed lawns. Their Vermont farmhouse was set on rustic acreage next to an apple orchard at the base of a tall mountain. From his window, he had a view of green meadows, their two barns, and the Batten Kill River. Walt Squiers, the contractor and model who lived down the road, livened things up when he brought a couple of carpenters carrying saws, hammers, and nails to fix up and winterize their home and transform one of their barns into a studio for his father. The Squiers's children, Marjorie, Ray, and David, became friends with the Rockwell boys and joined them in swimming and splashing in the river and riding bicycles. Tommy's father liked the fact that he could work close to home. This allowed Tommy and his brother Jarvis to spend time in the studio while their father worked at his easel. During 1939, Norman brought Ruthie McLenithan, the lively, redheaded girl, to model with Jarvis for *Marbles Champion*. The boy named Winston Salter, whose family owned the IGA grocery story in town, also joined them in the studio.

It was during the next summer that Tommy's mother announced, "We're moving here for good."

This came as a surprise. "You mean we're not going to go back to New Rochelle?" Tommy had expected to attend first grade in the city.

"Your father wants to work here and paint people in Arlington. There are so many interesting ones."

Kids at the Arlington school wore flannel shirts and jeans, whereas in New Rochelle, they came to school in slacks and dress shirts. Many of the Vermonters were wiry, strong kids who worked on farms. They also sounded much different than his friends in New Rochelle, some of whom would say things like "We live in "Westchestah, New Yawk," and "Hey Tommy, can ya come ovah heah to play today? My mother will take us faw a swim at faw. My fatha will pick us up theah afta."

In Vermont, speaking in a country accent, the kids said things like "Ma and Pa moight be goin' to the dance tonoight. Last week my mother made me squeah dance with a girl. She was all roight."

During the early days, Tommy would feel secluded with just his family and Thaddeus and Bess Wheaton. Bess cooked and kept house, while Thaddeus

helped with maintenance chores. They were the elderly couple who modeled for his father's *Freedom from Want* as the husband and wife delivering a plump Thanksgiving turkey to the table.[3]

Quiet often, newcomers from the suburbs or cities found it difficult to feel at home in Arlington because its people were generally a tightly knit group. Many families had known each other since before the Revolutionary War of 1776 when they fought against the British as the Green Mountain Boys. Some were reticent and took time to warm up. Tommy's father didn't take this to be an insult. Instead, he appreciated that they wanted to know something about a person before they engaged in hearty handshakes and warm smiles. He had found too many people in the city to be "fast talkers." Norman was soon a face around town and became acquainted quickly because he attended many local events as a means to find models.

Before long, Tommy made friends himself. "For the most part, they were wonderful people," he said, reflecting while in his living room in Dutchess County, New York, almost eighty years later.[4]

AN OUTDOOR ADVENTURE

Vermonters did not have television then, so children spent a good deal of time outdoors. Nature became the Rockwell boys' chief entertainment, and Norman and Mary's second son found plenty to discover. During the warm months, the boys continued swimming in a deep spot across from their home in front of a tiny island. They spent days into evenings leaping into the brisk river, swimming, splashing, and shouting. Tommy ran through the meadows and hiked the mountains of thick brush and slender white birches, sugar maples, and gnarly locusts. Chipmunks scurried along old stone walls, woodchucks waddled back to their holes, and white-tailed deer loped into the shrub. They picked red raspberries, sweet and tart with a crunch of tiny seeds, from their prickly flowers. Like his father, Tommy enjoyed watching cows traipsing into barns, men and boys pitchforking hay on wagons, and teams of horses pulling mowing machines. When snow covered the ground, Tommy and his brothers trudged up the hill beside the house, strapped on skis, and took runs down.[5]

Tommy also joined men and women hunters at the Benedict family's cabin up the road. Bob Benedict Jr., the son of the man who owned the cabin, ran a car repair shop. He appeared in Norman's popular wartime painting *Home-*

coming Marine. Deer hunting in the autumn was the event of the year. Many Vermonters took time off from work and school, including Tommy. Norman would write notes to teachers notifying them that Tommy would be absent. In town at the Green Mountain Diner, at the covered bridge, and at Walt Smith's Cash Store, men and boys told stories after the first bullet flew, such as "Joe got a four-point buck down from Rockwell's property."

Tommy Rockwell had a front-row seat to observe the man who would become America's most beloved illustrator. A writer named Arthur Guptill once found Tommy at an easel in his living room. Norman sat in a lounge chair offering advice. Guptill perceived, "Tommy has taken an interest in drawing."[6]

Tommy would notice how his father analyzed people and developed relationships with them. He found many of them endearing. Tom explained, "My father would get the right person for the character he would paint. He'd been studying people since he was fifteen or so."

One of Norman's first friends in West Arlington was the warm, garrulous local deputy sheriff with a bushy moustache named Harvey McKee. Harvey, who operated a small farm by the covered bridge, entertained the Rockwells with heartwarming and amusing stories of small-town life. Norman met Harvey at the West Arlington Grange, which the artist joined. During a visit to the McKee home, Norman found its dining room table to be the perfect setting for *Freedom from Want*. The McKee's country dining room is featured in the Thanksgiving painting Americans know and love today.[7] Harvey's appearance was reminiscent of Norman's colorful and endearing New Rochelle model James K. Van Brunt. Both Harvey and James sported moustaches that Norman found magnificent.[8]

Tommy loved stories like those of Harvey, who told dramatic ones about wrastling drunks and other unrulies and dragging them to jail. They inspired Norman to pose the deputy as the guard sitting in front of the prison cell of a small jail in *Music Hath Charms*. Walt the builder modeled as an annoying prisoner playing a harmonica behind bars. When working on a painting, Norman would sometimes summon friends and neighbors like Harvey and Walt to join him in the studio. His father would say, "Take a look at my new painting. What do you think?" By that age, Tommy knew the routine. He would watch his father waiting to hear what they had to say as they studied a painting on his easel. His father hoped his choices of props, models,

expressions, and body positions were not too obvious or too difficult to grasp. Were eyes focused the way he intended? What did a model's hands tell them? Had he made some obvious mistake he hadn't noticed? Sometimes, the off-the-cuff remarks of these men with untrained eyes were valuable to Norman as indications of how paintings might be viewed by the general public. Norman would periodically make a change as a result of their comments. He'd also ask Tommy and other children for their reactions because they tended to tell him exactly what they were thinking.

Tommy took to sports in West Arlington and befriended Jimmy Martin, a tall, skinny kid with the same high energy and a good sense of humor as well as the tendency to blurt out wisecracks here and there. Jimmy's father, Jim Martin Sr., an Arlington carpenter, was the model who appeared in all of the *Four Freedoms* paintings. When Jimmy was about ten, Norman brought the brown-haired boy to pose in a red sweater for a 1943 Upjohn pharmaceutical ad in *Life* magazine titled *When Your Doctor Treats Your Child*.

In the illustration, a concerned mother, modeled by Norman's wife Mary, sits with three children gathered around her while the doctor takes notes about the sick child, Jimmy. David (Walt Squire's son) is Jimmy's brother. Phyllis Decker (Mason) posed as the little girl. David Squiers also posed for *Freedom from Fear* as the boy sleeping peacefully as his parents stand by his bed when the Nazis bombed London. Phyllis's father Clarence Sr. posed as the man being tattooed in *The Tattoo Artist*. Tommy and Jimmy eventually played basketball on the Arlington Memorial High School team.

Tommy and the other kids in town couldn't help absorbing some of the fear the adults felt as German planes dropped bombs on Europe. He also felt the enthusiasm people around town displayed for his father's patriotic work, especially when Norman displayed all of the *Four Freedoms* paintings, oversized at almost four feet wide by four feet high, in the church hall on the West Arlington Village Green. The many neighbors who posed were thrilled to view themselves in paintings of such national prominence.

Tommy would notice that his father, age forty-six when the Rockwells moved permanently to Vermont, greeted his models in a relaxed, friendly manner at the studio and displayed patience as they posed. With his pipe in his mouth, Norman would hold his sketches before the models' eyes and explain the stories he would tell in the given picture. Tommy would take in the scene as he arranged props and held gray or white screens behind models.

He began taking an interest in photography as Gene Pelham took pictures. While his father waited for a model to arrive, Tommy sometimes sat in so that Norman could begin getting a perspective. When a model gave Norman what he wanted, Tommy would hear his father call out, "Good! Good! We got it, Gene!"[9]

Tommy observed his father create what he believes to be the best work of his career during the Arlington years. During a chat in Tom's living room, he explained, "In New Rochelle he was reflecting the same values, but it was different in Arlington." The artist's endearing son went on to say, "He was living among those people. He was closer to those he was painting. He saw things differently, I'm sure. The war made a difference. He only did a little about the First World War. In his biography he said he took WWII more seriously."

A PREOCCUPIED DAD

Tommy would pop into the studio carrying a baseball glove, a basketball, or a critter from the woods. He enjoyed spending time with his father and adopted his manner of chuckling at life's absurdities. He found the atmosphere in the studio especially appealing when his mother read books aloud to his father as he sat at his easel painting. Photos of Norman and Mary reveal the love they felt for each other and their family. They both have big smiles as they sit on the bumper of their car at about the time of their marriage in 1930. In 1933, a family photo shows them smiling with pride as they hold their toddlers Jarvis and Tom in their arms. In another, Norman and Mary appear very much in love as they sit on the steps of his first Arlington studio. In one taken in the living room of their home on the Green, Mary sits on the arm of a lounge chair and leans back into Norman's arms.[10]

In baseball season, Norman tuned his radio to listen to the Boston Red Sox, the baseball team most popular among Arlingtonians. During Tommy's second year vacationing in Vermont, Ted Williams, known as baseball's "god," had one of the greatest rookie seasons ever when he hit .327 with thirty-one home runs. It was said of Williams that his eyesight was so good that he could see the stitches on the ball as he stood ready to swing.

Tommy enjoyed following the cantankerous player's career. During 1940, the year the Rockwells moved permanently to Vermont, Williams became enraged when a sportswriter criticized his bad start that season. He vowed that he would never tip his hat to the fans again after hitting a home run. He

also refused to sign autographs or do interviews. In 1941, when Tommy was eight years old, Williams, who came from poverty, posted the highest batting average in modern baseball history at .406. The next year, after the Japanese bombing of Pearl Harbor, the military drafted Williams, and he became an expert naval pilot in the US Marines.

Tommy would step over to the easel where his father leaned over his palette of colors and dabbed paint from the long-stemmed brushes he used. Under short, wavy brown hair, the artist's eyes would be riveted to a canvas.

"Dad, what's the score?" Tommy would ask.

His father would glance at him but return his eyes to his picture.

"I don't know," Norman would say, continuing to dab.

Tommy felt abandoned by the emotional distance his father kept. It was almost as if his father rose from his seat at his easel and stepped into the world of make-believe and was chatting with the characters he was painting.

"Any home runs?" Tommy would ask.

"Don't recall."

Norman's children remember him as a man who was kind to them. However, due to the exhaustion he experienced during the six months he spent on the *Four Freedoms*, Norman admitted that he was sometimes irritable with Tommy and his brothers.

Tommy and the family sometimes felt even more neglected when his father got up from the dinner table and went right back to his studio. Often, it seemed like he cared only about his illustrations. Ironically, Ted Williams's daughter Claudia also remarked, "My father was so focused on what he was doing, it was to the exclusion of everything else."[11] It wouldn't be until Tom helped his father write his autobiography that he would learn about the man's inner thoughts, childhood insecurities, and failure in the military, as well as about the loneliness he endured before he met his wife Mary.

Later in life, Tom realized that, although creating new masterpieces energized his father, other motives also drew him deep into his work. Norman needed to turn around a large number of high-quality paintings to meet the family's expenses. The artist did not turn down assignments even during busy times for fear a publication might not commission him again. In reality, Norman feared losing commissions for a variety of reasons. In his autobiography, the illustrator explained his fear that new *Post* illustrators would replace him and that he felt the urgency to prove himself throughout his career.[12] The art-

ist's granddaughter Abigail Rockwell believes "Pop" didn't turn down commissions because living in a shabby brownstone in a run-down part of New York City during his early childhood, haunted him throughout his life. He feared returning to poverty. Also, photographers in the 1940s were already nipping at illustrators' heels, and Norman knew at some point they would essentially replace them. Perhaps another reason he kept himself glued to his canvases was to avoid the late-night partying that played a role in breaking up his first marriage in New Rochelle.[13]

Norman once said, "I feel that I don't have anything else, that I must keep working or I'll go back to being pigeon-toed, narrow-shouldered—a lump. When I was younger, I used to work night and day, possessed by a sort of panic that I'd lose everything if I didn't drive myself . . . I can't stop working. That's the long and short of it."[14]

Tom enjoyed the occasional trips the boys took to New York City with their father for events like the circus. In Arlington, Norman led his children and other folks on an annual hike up a mountain to a place called Flag Rock. Norman also led classes for young people in sketching at the Arlington Community House. He would move a volunteer into a pose, and the other children would draw. Norman would offer comments and suggestions.

SOME DROVE NORMAN NUTS

When his colors seemed to create pictures by themselves, an aura of calm enveloped the artist. Other times, he'd announce, "Tommy, I need to be alone." In order to complete such elements as faces with subtle expressions Norman needed to focus like a farmer driving a bull into a barn. Some illustrations drove Norman nuts, Tom recalled. A look of disgust would appear on the artist's face as he crumpled a sketch and threw it into the wastebasket. He sometimes rubbed out paint and began anew or put a canvas in his closet, never to return to it. Sometimes, perfection required a number of attempts. Perhaps the storms stimulated the impetus to stop dillydallying and to "get it right."

After *Puppy in the Pocket*, Tommy's next opportunity to pose for a *Post* cover was at age nine when his father had him pose as the cute model in his 1942 painting *Boy Reading Sister's Diary*. Here he is seated on a stool at his "sister's" dressing table against a pink background, gleefully reading his sister's personal journal. As a reward for sitting still, Norman bought him a gift.

A DIFFERENT DREAM

At bedtime, Tommy looked forward to the ritual of story time when he would enter into the enchanting world of imagination. His mother read books like *The Hobbit* to him, almost as if she were making up the tales herself. The dream of becoming a children's author had stolen Mary Rockwell's heart during college, and the same was beginning to take hold of Tommy. Mary had studied at Stanford University with Edith Mirrieles, whom John Steinbeck considered his most enlightened teacher. Steinbeck penned the American classics *Of Mice and Men* and *The Grapes of Wrath*, the latter of which chronicles the 1930s Dust Bowl in Oklahoma. The same types of colorful characters who modeled for his father would one day move Tommy's pen.

In the summer of 1943, just after Norman had completed his hugely popular *April Fools* cover for the *Post*, a harrowing event provided an opportunity for Tommy to model again. The ten-year-old, sick with measles, awoke in the middle of the night to flashes of light jumping around his ceiling. He sprang from his bed and through his window saw flames licking his father's studio across the road. He dashed to his parents' bedroom and shouted. Soon, sirens blared, and volunteer firemen pulled up in front of his house, leaped from their cars, and pulled hoses from the truck. They managed to douse the blaze but not before it devoured most of the studio.

To his surprise, Tommy found a cartoon essay of the disaster drawn by his father in the *Saturday Evening Post*. Norman called it *My Studio Burns*. Tommy noticed himself in a cartoon bounding down the staircase three steps at a time in hysterics. With his hands thrown into the air, he screams "fire." Judging how he exaggerated Tommy's panic, Norman may have been poking fun at Tommy for making such a fuss over the whole thing. However, the fire destroyed many of the artist's paintings as well as other valuables, costumes, and memorabilia he had collected over his career, such as old guns, brushes, paints, easels, African swords, shields, and medieval outfits. Ironically, he also realized a freedom from the task of storing and maintaining dated possessions that distracted him from moving forward in his new work. Hand in hand with his beloved Vermont models, he would go on to create America's most beloved works of contemporary art but in a new location.

MOVING TO THE GREEN

The Rockwells had grown lonely living on the isolated site at the end of River Road in West Arlington. Rather than rebuild Norman's studio, they purchased a house on the Village Green in need of updating. One of two identical white Colonial homes at the foot of a mountain happened to be available. On the Green's spacious field stood a historic church with a community room, a one-room schoolhouse, and a dance pavilion. From their windows, the Rockwells enjoyed a view of the 1867 covered bridge. The second of the "Twin Houses" was occupied by Jim Edgerton and his family. Jim Edgerton was the dairy farmer and model who inspired Norman's *Freedom of Speech*.

The Rockwells were happy to have a big family living next door and took the Edgertons up on their offer to join them in their work and recreation. Tommy became a regular farmhand as they milked cows in their barn, hayed their hills and meadows, and hunted deer. It was important for them to take deer from the woods in order to have meat to eat during the cold Vermont winters. He helped them tap maple trees in spring and carry the buckets of sap into their sap house, an old gray building patched with random boards. The Edgertons were warmhearted people who also chuckled at life's everyday absurdities as Tommy and his father did.

At ten years old, Tommy immediately latched onto James "Buddy" Edgerton, Jim's son, who was three years older. Buddy became a friend and mentor; Tommy became the younger brother Buddy never had. The two hunted, camped, fished, and worked on the Edgertons' farm together. Tommy didn't like to sit around for long except to pore over his schoolbooks. Since he was an energetic, adventurous kid, Tommy could be counted on whenever Buddy needed help. One autumn day in 1945, Buddy made his way over the plank floor of the covered bridge and proceeded to climb the mountain across the street. He spotted a large buck with antlers. It lay in the grass behind one of three shacks where a man named Bill Sharkey lived. Bill posed as the rustic man pulling on his coat in a restaurant in Norman's most popular masterpiece, *Saying Grace*. The deer did not see Buddy as he backed out of the forest on tiptoes. "Mom," he hollered as he burst through the front door. "I need someone to chase a deer out of the woods. It's above the bridge."

"Go get Tommy!" Clara Edgerton cried out.[15]

It took Tommy but a second to bolt out of his front door to join Buddy's mother.

At the foot of the mountain, Buddy told them, "You scare it out. I'll wait on the other side."

Tommy and Clara hurried up the mountain and spooked the white-tailed deer, which loped toward Buddy. He peered through the scope of his rifle, fired—and to everyone's disappointment missed.

Buddy and Tommy would pitch their tent in a clearing on the mountain behind their homes. As they sat under wide, starry skies next to glowing fires, they could hear the Batten Kill whooshing though the valley below. They chatted about haying, hunting, fishing, girls, the Boston Red Sox, and the New York Yankees, but more about the Brooklyn Dodgers. Tommy dreamed of one day playing third base for that New York team. "We were great Dodgers fans. Jackie Robinson was our hero. He came in as the first black player," recalled Buddy Edgerton. He and Tommy traveled twice to Ebbets Field in Brooklyn to see the Dodgers play on their home field. Later, in 1947, when Tommy was fourteen years old, Jackie Robinson, the team's second baseman, would break the color barrier. He refused to allow hecklers to lure him into acting out. In 1950, Robinson scored ninety-nine runs and batted .328, the fifth best in the league. That same year, he played himself in the film *The Jackie Robinson Story*. These were great years for baseball.

As young teens during the last but brutal years of World War II, they couldn't help but feel anxiety for themselves, their loved ones, and their neighbors fighting in Europe and the Pacific. They heard adults discussing battles like the Japanese attack on Pearl Harbor; the Nazi bombings of Poland, London, and France; and the American invasion of Iwo Jima. Like Norman, who painted World War II soldiers, the boys read haunting stories on the war-worn faces of familiar young men home on furlough and in the *Bennington Banner* newspaper. Adults expressed their fear that they might someday encounter Nazis marching down Route 313. Some thought Hitler's troops might fight their way through Canada and march south to Vermont. Hitler had, in fact, created detailed plans on how to destroy the United States.

It almost seemed beyond the realm of possibility that such destruction and violence was happening in the world or that it could ever reach them as they quieted down for bed. Outside, only the gentle mooing of cows in the Edgertons' pasture, the nickering of horses in the stalls, and the murmur of the Batten Kill broke the silence of the peaceful village by the mountains.

THE WAR ENDS

In mid-July 1944, while milking cows and tidying the barn, a voice came on the little radio Jim Edgerton kept in his barn. Tommy, Buddy, and Jim set down milking machines, buckets, and pitchforks to hear a newscaster announce that the Allied invasion of the beach of Normandy had proved victorious. The 150,000 troops had dealt a devastating blow to Nazi Germany, which almost certainly meant its war machine would be destroyed. A year later on May 7, 1945, Tommy, Jarvis, Buddy, Mary, and Norman huddled in the Rockwells' living room to hear a radio newscaster declare, "The war in Europe is over. The Nazis have been defeated. Germany has surrendered."[16] Throughout Arlington, people hollered, banged pots and pans, and blew car horns. It turned out that World War II was the most devastating war in world history, so much so that "in the summer of 1945, General Dwight Eisenhower, who later became US president, flew from Berlin to Moscow. He could not see a single building standing."[17]

In 1946, during the jubilance that followed the war, Norman featured the two boys in a painting called *A Guiding Hand*. Buddy posed in a Boy Scout uniform, Tommy in a Cub Scout uniform. With his arm thrown across Tommy's shoulder, Buddy guides the rope in Tommy's hand through two loops of a complex knot. Because the two boys were real-life pals, Norman was able to capture the authenticity of feeling he always aspired to create. Although neither were members of the Boy Scouts of America (BSA), Buddy eventually became Norman's most-used model for Scout calendars. He stood tall and handsome with focused eyes and was easy to fetch from next door. *A Guiding Hand* became, perhaps, America's most beloved Boy Scouts painting. It says much about Norman's appreciation of Buddy as a friend to his son (figure 5.2).

In addition to school and other activities, Tommy mowed lawns to earn extra money. He also hayed the hills behind the Edgertons' dairy barn and meadows along the Batten Kill. During those years, Tommy and the Edgertons pitchforked loose piles onto wooden wagons. On hillsides, they weaved rows, wrapped ropes around them, and dragged the hay down to the barn with tractors or horses. Jim and Buddy mentored dozens of boys and girls over the years in their fields. Tommy recalled those days as the favorite of his childhood, especially when Jim Edgerton put him at the wheel of his "Doodlebug" tractor. Due to the war, pickup trucks were hard to come by, so Ford

FIGURE 5.2

A Guiding Hand: Norman created a genuine feeling by using his son Thomas Rockwell (left) and close friend Buddy Edgerton as models. *Source*: Courtesy of the Norman Rockwell Family Agency.

Motor Company created kits that enabled mechanics to attach truck beds with tractor tires behind Model A cars. When he first drove the Doodlebug, Tommy's legs barely reached the pedals, causing him to release the clutch abruptly and stall sometimes. Jim would shoot him a stern expression and holler, "What are you doing, Tommy?" The boy would get the jitters until Jim's mouth curved into a grin. "Jim pretended he was yelling at me, and that was fun because you knew he wasn't really mad. He liked to kid you a lot. He was very nice," Tom recalled. The farmer's kindness and practical wisdom became a major influence throughout Tommy's life.[18]

To cool off and wash hayseed from their hair, Buddy and Tommy often hustled down to the brisk swimming hole under the bridge and jumped in. Most kids would drip-dry and go home for supper. Not Tommy. "Let's play some ball!" he'd exclaim. Tommy just had to be doing something, and Buddy couldn't say "no." The boys would fit in a little baseball on the Green or basketball in the Edgertons' hay mow. As they dribbled on the plank floor between the two haylofts, hay dust rose into the air. Buddy, a center over six feet tall, became the greatest obstacle. The lanky boy had no trouble reaching above the others to block their shots and grab rebounds. Tommy liked to drive to the side of the barn and sink long jumpers. No one realized how much the shot he honed in the barn would mean to fans at Arlington Memorial High School.

Besides the baseball games, the boys enjoyed a couple of other outings to New York City during their teens. A gentleman farmer named Bob Smith once took him and Buddy to see the glamorous, leggy Rockettes at Radio City Music Hall. Buddy and Bob chuckled after their trip when Tommy exclaimed, "Those were some chicks!"

Buddy left for college at University of Vermont in 1947, and Tommy went to Oakwood Friends School in Poughkeepsie, New York, where he boarded for two years.

A CHRISTMAS CLASSIC

In 1948, Norman told Tommy, "I want you to pose for a Christmas painting I'm doing." Posing had become fairly routine for Tommy, whether he would be the final model in a painting or a stand-in. He went across his lawn and posed for *Christmas Homecoming*. It turned out that all the Rockwells posed for it, including Norman himself. Some of their family's dearest friends joined

them to model as a joyous group that has gathered to welcome a young man home from college. The mother, modeled by Mary Rockwell, wraps her son with a hug. Tommy's brother Jarvis posed as a boy who has returned home from school for the Christmas holiday. Fifteen years old at the time, Tom is dressed as a preppy kid in a brown flannel shirt and khaki pants. His animated smile informs us that he is overjoyed that his brother has come home. Although the painting is deeply meaningful to some of the other models, Tom does not particularly care for it. "If you notice my eyes, I'm looking the wrong way." But he cuts his father some slack: "There were a lot of things to get right."

Norman appears in the painting, holding a pipe to his mouth. Around that time, Jarvis and Tommy began goading him by calling him "Pop." The nickname stuck and eventually became an expression of endearment. Tom and his brothers only wished their father had verbally expressed the love for them his brush made evident in *Christmas Homecoming* (figure 5.3).

AN ARLINGTON STAR

Although Tommy liked Oakwood Friends School, he returned to Arlington for his junior year of high school in 1949, partly to be near his mother. Over the previous few years, she had begun to suffer from depression. It was now serious enough that she had begun drinking too much alcohol as a means of coping. She would often be very quiet, almost as if too worn and distracted to speak.

Much of the problem stemmed from his mother's fast pace of life. She supervised their cook and housekeeper, purchased props, and answered fan letters. For a time, she did his father's bookkeeping and paid the bills. During his younger years, she had driven Tom and his brothers to the Arlington school over rough dirt roads, even during the cold, snowy winter months. After his father finished a painting and put it into a crate, his mother was often the one who boarded a train and delivered it to the *Post* headquarters in Philadelphia. She also served for a time as a member of the Women's Guild at St. James Episcopal Church in Arlington. She had become more distressed after Tom and his brothers all went away to school, leaving her and Norman with an empty nest. In addition, Mary did a lot of reading and creative writing.

Back in Arlington, Tommy resumed helping Jim Edgerton on the farm. He sharpened his skills on the basketball court that lay in the barn between two haymows. During lunch breaks at school, friends would ask, "Where's Rock-

FIGURE 5.3

Christmas Homecoming: Norman included his entire family and dear friends. Front row: Sharon O'Neil, Grandma Moses, Tom Rockwell, Mary Rockwell, Jarvis Rockwell, Sharon O'Neil (twice). Back Row: Peter Rockwell, Mead Schaeffer, Elizabeth Schaeffer, Rena Crofut, Patty Schaeffer, Mary Atherton, Lee Schaeffer, Norman Rockwell, Ann Marsh, Donnie Marsh and Mary Immen. *Source*: Courtesy of the Norman Rockwell Family Agency.

well?" They'd find the five-foot-nine guard in the gym shooting jump shots, often from the corners of the court. The practice paid off; he became one of the stars of the Arlington basketball team.

"Basketball was the biggest thing in Arlington," said Don Fisher, a teammate and friend of Tommy's. "There was not that much to do around here."

There weren't many places to play ball either, so Norman blacktopped his tennis court and installed a hoop. Don remembered how they would be carrying the ball when they visited Norman in the studio and sometimes bounced it. The artist would be sitting at his easel but would turn toward the boys and

chat for a few moments. "Norman would ask us to look at his work and tell him what we thought. He asked *everyone*," said Don.

As a "thank-you" present after he painted an advertisement for Magnavox, the company gave Norman the first TV in town. Don and some others were anxious to watch. However, with only a portable antenna and mountains surrounding the house, reception was poor. "You could hardly make anything out," Don laughed.

The Arlington team got off to a terrific start in the 1950–1951 season by winning the first eighteen games. As center, Don Fisher pulled down rebounds, and Tommy averaged fifteen points per game. Tommy's mouth became an effective tactic. "He was a trash talker on the basketball court," Don's wife Doris remembered. At some point, Norman became friendly with Doris's grandfather, a plumber named Frank Secoy. "Norman knew everyone in town." The artist painted Frank in *Freedom of Worship* as the man at the center with a pointy noise. His tools became props for *The Plumbers*.

"Tommy was our number one trash talker," adds Don. "It got pretty personal. He knew how to get under someone's skin. He got in scuffles a few times. Everyone did."

Many an Arlington girl dreamed of being held in Tommy's arms. "He was a real nice guy, smart as a whip, and really good looking," remembered Don Fisher.

"Right, Doris?"

"Uh huh," she replied.

It didn't hurt that the girls saw Tommy driving around Arlington in his mother's new car. The families of most kids could afford only old, used ones.

Refining his skills in the barn paid off for Tommy. "Arlington teammates would drive to the hoop and throw it over to him at the wing. He had a great shot," recalled Buddy.

"Shoot, Tommy, shoot!" Arlington fans would holler. At clutch moments during important games, they'd stand and cheer when the ball swished through the net.

Norman attended many games and often sat next to Don's mother. "He never missed a game unless he had to," Don recalled. Norman would approach the center after closing buzzers and shake his hand. "You played a great game, Don."

That year, the Arlington Eagles made their way to the State Championship against Poultney. Unfortunately, the flu dragged most of the players

down, and they couldn't muster the stamina to win the deciding game. The Fishers recalled that Mary Rockwell, instead of attending Tommy's games, volunteered to drive the Arlington girls to field hockey and basketball games because they had no bus. She chatted with them going and coming. "She was a wonderful lady," Doris exclaimed.

In 1953, after the boys had graduated, Norman called Doris and told her he needed Don to come to the studio right away to model for *Breaking Home Ties*. Posing as the boy at the train leaving home for college, Don sat with the other model, the melancholy farmer Floyd Bentley, for six hours on a bench and recalled that the soft-spoken weathered farmer said no more than a few words.

DOWN-HOME FUN

For a few months during Tommy's high school days, the Rockwells lived in California, near where Mary had grown up. He briefly studied photography, his only foray into visual arts. On October 13, 1949, he got the chance to put his skills to good use in West Arlington when the proprietor of the country store staged a down-home marketing event. Tommy made sure to get himself to Walt Smith's Cash Store, a mile from his home, in advance. Walt had overstocked the place with an abundance of clothing that nearly burst the seams of the store. Norman had featured the store proprietor in his 1946 *Post* cover called *Framed*, wherein a portly museum worker carries an empty picture frame above his shoulders. It makes his face appear to be the center of a painting. The characters in other paintings on the walls gape at him suspiciously.

Passersby must have wondered what was going on when they saw three men and a boy standing on the porch roof of the store holding chickens. The birds belonged to Walt's son Ray, a friend of Tommy's brother Peter. A crowd packed the parking area beneath them. With his apron tied at the waist, the storekeeper appeared to be enjoying himself as he leaned against a post under the porch. Poised to capture the event on film, Tommy stood across the street. We can be sure that he found plenty of humor in the folksy event. At the climax, the men and boys tossed the birds high, and he snapped his shutter. As each chicken came close to the ground, a spectator caught it. Walt awarded the winners both the chickens and the dollar bill fastened to their legs. Tommy's newspaper photo shows a chicken flapping its wings in mid-flight and under it the credit reads, "Tommy Rockwell and Ray Smith."

Doris Fisher remembered Tommy expressing a desire to become his father's professional photographer. Don once found Tommy in his father's studio taking photographs with a camera set on a tripod. He said, "Gene Pelham is teaching me to take portraits." Tommy eventually moved on from that dream.

Tommy attended other down-home events. As was the custom then, locals gathered at hog-butchering time. Butchers were known as "Pig Stickers." During a session at a farm across from Walt's store, the butcher grabbed a hog and "stuck it." To everyone's horror, he missed his mark, and the mad hog tore off. People scattered, and the bleeding animal headed toward Tommy, who scurried to a wooden fence, leapt to the top rail, and sat. He sighed in relief once the hog charged by.[19]

A POETIC VALEDICTORIAN

During high school, Tommy grew more certain he would pursue a career as a poet and author. Perhaps Tommy followed the dream because it was one his mother had not realized. For Mary, writing had taken a backseat to raising children and assisting her husband in their art business. Tom Rockwell once said, "My father used to say, tongue-in-cheek, that he didn't want any of his children to become artists. He'd say he wanted us to go into business so that we could support him in his old age while he sat outside on the porch. . . . But the truth is that my father couldn't understand why anybody would want to be anything else but an artist."[20]

Tom first shared his talent in two poems that were published in the Arlington High School yearbook. In *I Shall Not Die*, he makes a statement that reveals deep thought for a high school student:

> I shall not die, for as I die so dies the world.
> Thus spake youth on the eve of war.
> For who has been young and can conceive
> Of a world where he will not be.
>
> So youth before the dreary, wasteful bareness of life
> Knows not, thinks not in bitter dark realities.

Despite spending time working on the Edgertons' farm and playing sports, Tommy found time to edit the school newspaper and yearbook and hit the

books hard enough to earn the title of valedictorian. Princeton University accepted him, and he departed for the New Jersey campus in 1951.

At Christmastime in 1951, Buddy Edgerton drove back home to West Arlington from the University of Vermont for the holiday. Now a slender six-foot-four, the college senior parked his 1932 Chevy in the driveway his family shared with the Rockwells. A blanket of snow draped the field of the Green as well as the bridge, the dance pavilion, and the old white church. It covered the surrounding mountains. The buildings appeared to huddle closer. Bare trees allowed a clear view of the river. Buddy strode across the yard of the family's white colonial to chat with his father in the barn. Everyone knew where to find farmers like Jim Edgerton 365 days a year at that hour in the afternoon. Crouched next to a cow, Jim was attaching a milk machine to the belt strapped to its back. Buddy felt uplifted as he stood near his father at Christmastime in the chilly barn, warmed only by body heat from the cows. The machine pulsed "ch-ch-ch." As Buddy and Jim caught up on news, a figure appeared in the dim light in front of the cow stanchions. Buddy focused. It was Tommy! What was going on? He should have been at Princeton. Tommy was dutifully carrying pails to the milk room and cleaning the barn with a shovel.

The face of Buddy's friend looked pained. Tommy pulled out a bottle of Maalox and took a swig of the formula that reduces stomach acid. He did it as if he wanted it to be seen.

Buddy spoke in a low voice to his father. "What's Tommy doing home?"

Jim explained that Tommy had quit Princeton, and he wanted to come home to comfort his mother. Mary's depression had deepened to the point where Norman had been driving her to Stockbridge, Massachusetts, to receive psychiatric treatment at the Riggs Center. Norman was also worn from all the driving and spending long hours in the studio. In an angry fit, Norman had even stormed out of his studio and chucked his 1951 painting *Saying Grace* into the snow. The artist had pushed himself to the brink with this ambitious painting. He had directed Gene Pelham to build a makeshift stage in the studio before the big window. Norman had used many models, including Jarvis, to pose in a variety of positions. He had traveled to Troy, New York, to sketch and photograph the background scene. Fortunately, the next morning, Norman came to his senses and retrieved *Saying Grace* from the snow. Perhaps the emotional storm stirred his passion and sparked the energy that made the painting his most beloved.

"Is Tommy okay?" Buddy asked.

"He has an ulcer," said Jim.[21]

Working on the farm with Jim revitalized Tommy. The two had grown close over the years as Tommy spent many of his boyhood days pitchforking hay, driving the Doodlebug, and playing basketball in the barn. When Buddy went off to college, Tommy hunted with Jim while Norman worked. He enjoyed sitting on fallen trees and stone walls in the woods with Jim, chatting in hushed voices as they waited for deer to walk by.

Visits with farmers like Jim would restore the souls of city people who vacationed in the valley. They would chat in cow barns, toss a few hay bales onto wagons in scenic meadows, and warm their hands on the sides of gentle cows. Jim was admired in the local community and was often consulted for practical advice on farming issues. Norman not only appreciated his comments on paintings but also respected his advice on family issues. Eventually, Jim became a Vermont state legislator.

The next year, Tommy would transfer to Bard College in Poughkeepsie.

MORE POSING

As his father began work on *Breaking Home Ties*, once named the second most favorite by *Post* readers, Tom found himself modeling once again. Norman had him pose seated on a bench next to Floyd Bentley, the horse trainer who would appear on the *Post* cover. Tom did not appear in the final painting, nor did he expect to. His father simply wanted him to sit in so he could get a general perspective.[22] Floyd's cousin Marie Briggs, who lived nearby, cooked and kept house for the Rockwells. It is likely she introduced Floyd to Norman. Tom has especially fond memories of this native Vermonter because her gentle, compassionate manner comforted his mother during periods of low moods during the early 1950s. Miss Briggs, as the Rockwell boys called her, posed for Norman's drawing called *We the Peoples*, which hangs in the United Nations headquarters in New York. Marie stands toward the right wearing a head scarf, as she did in real life. In the years after World War II, Floyd, a horse trainer who disdained combustion engines, sometimes drove her to the Rockwells by horse and buggy. That same year, Tom posed for a Boy Scout calendar painting called *On My Honor*. In a uniform, he stands before the organization's oath written on a wall.

Martin Oakland, a young boy in the neighborhood then, remembered how he wound up appearing in the same painting as Tommy.[23] He was playing baseball on the Village Green field one day when the artist appeared at the edge of the field and called out, "Boys, can you give me some help?" Norman's studio stood fifty yards behind his back.

The kids called back to the old guy wearing a smock stained with paint. "We're playing baseball."

"I really need some help," Norman hollered.

"After we finish the game!"

Eventually, Martin laid down his glove and helped Norman to move lights and hold screens behind models. Before long, he found himself posing as a kid in a blue Cub Scout uniform with a yellow neckerchief behind Peter Rockwell, who wears a green Boy Scout uniform. Tommy appears in a blue uniform with a necktie. The three pose as "All-American" boys standing straight and wearing expressions of reverence. The words behind them read, "On my honor, I will do my best to do my duty to God and my country." The creases in Peter's uniform remind us of the artist's disdain of perfect orderliness. Peter also modeled for *G.I. Homecoming* (1945), *Boy on a Diving Board* (1947), *Christmas Homecoming* (1948), *Boy on a Train Car* (1948), and *The Soda Jerk* (1953). Peter recalled how he had actually been frightened when his father made him crawl out over the yard to the end of a plank he had attached to his porch railing. This created the realistic fear on his face in *Diving Board*.

A PROFESSIONAL WRITER

Tom graduated in 1956 from Bard College with a degree in English. He took his first job as an editor in New York City with *Flower Grower* magazine, a publication that instructs its readers how to create elegant gardens. Two years later, a major break came when he heard his father's voice on the other end of the line. "Tom, can you help me write my autobiography? Norman had begun his book but had tired of recording his anecdotes on a Dictaphone.[24]

Numerous writers would have dropped everything to get to Stockbridge to interview Norman Rockwell, and Tom was no different. Tom was married to Gail Sudler and lived in Poughkeepsie. Both packed up and moved to Stockbridge, which enabled them to be near his mother and father as Mary continued to suffer with depression during the last two years of her life. Tom did not pester his father to provide painful personal anecdotes, such as

concerning his failed first marriage to Irene O'Connor. Norman and Irene had lived a life of wild cocktail partying in New Rochelle and New York City. The marriage lacked genuine love, and Irene ran off with another man. Two years later, she committed suicide. Norman also did not broach the subject of Tom's mother's mental illness. A somber expression comes over Tom's face as he said, "My father didn't want to talk about it." Perhaps one of the reasons the artist used Tom because it gave him more control over the content.

After Tom and his wife moved to Stockbridge, Gail became a model. She can be seen first in his August 27, 1960, *Post* cover *University Club* as a pert young woman standing on the sidewalk engaged in conversation with a young sailor, while gentlemen from inside the club peer curiously over their papers at them through the prestigious club's windows. Norman also used Gail as the model for his depictions of women in *Family Tree*, an October 1959 cover.

Norman regaled Tom with interesting stories of Rockwell family history and shared the major events of his life. Norman spoke of his parents and brother, ancestors, and childhood. He also recounted his quick climb to success as a young man and his adventures in Europe. Norman opened up about his fears as a young man, his periods of loneliness, and his struggles to find his identity as an artist. He also described the burst of inspiration that came over him after the move to West Arlington and gave Tom spirited anecdotes about the Vermont models. In a phonograph record that accompanied the book, Norman said the anecdote he finds most humorous concerns his discharge from the US Navy as a young man. He recalls how the navy gave him an "Inaptitude Discharge." The officer wrote, "Rockwell is an artist unaccustomed to hard manual labor. His patriotic attitude caused him to enlist, and he has no aptitude whatsoever. Moreover, he is unsuited to Navy routine in any kind of work." Norman chuckled as he explained to Tom that, under his signature, he wrote, "I concur absolutely with the above statement."

In 1960, Doubleday and Co. Inc. published the book *My Adventures as an Illustrator* and paid Norman an advance of $50,000, the equivalent of close to half a million dollars today. Tom's name appears on the cover as the co-author. The book quickly became a big seller. It includes fascinating stories of Norman's life beginning as a frail child in a worn brownstone in New York City and progresses through his fifty-year career as an illustrator. Tom penned the stories of his father's early success as an illustrator, which include

anecdotes about the characters and animals that modeled in his New Rochelle studio. The book includes serious and revealing anecdotes about his associations with other artists, ad executives, and the *Post*'s longtime editor Horace Lorimer. He discusses his philosophy of not mixing business and pleasure and includes intriguing anecdotes. His wife Mary died shortly after the book was published.

At age twenty-six, during the period he worked on *My Adventures*, Tom modeled for Norman's *Post* cover called *The Graduate* as a young man in a cap and gown holding his diploma. His facial expression suggests that he is overwhelmed. As the model, Tom appears to be thinking, "Good God, what kind of world am I entering?"

By using a young man of that generation to model, Norman once again managed to make the painting authentic. Bold headlines in the background of the painting tell of a troubled world. During one of the most frightening years of the Cold War between Russia and the United States, one reads, "Khrushchev Warns West of War Dangers." In recent years, the Soviets had tested their first atomic bomb, and the two countries had seemed close to nuclear war. Although the Soviets announced a unilateral halt to nuclear weapons testing in March 1958, Nikita Khrushchev resumed the practice six months later after the United States and the United Kingdom refused to ban them.[25] Another headline behind the graduate reads, "State Officials to Seek U.S. Help for Job Woes." During the first half of 1959, the country had made progress in recovering from the recession of 1957–1958. However, during the second half, it suffered a halt in economic growth.[26] A third headline, "Senate Passes Draft Extension," caused anxiety for many 1959 graduates. The US government maintained the military's right to enlist men ages eighteen to twenty-six.

A SOMETIMES TORTUROUS PROFESSION

Father and son had plenty of material to make a fascinating autobiography. However, conjuring up a marketable book of fiction became an ordeal for Tom. He endured years of writing that did not result in a published book. He set his mind to writing children's books after he began reading to his son Barnaby. *Rackety Bang and Other Verses* became his first published book. His wife Gail drew the illustrations.

Tom once explained his reason for writing for kids. "I suppose one of the reasons I write books for children is because I feel I can be more outrageous than if I were writing for adults."[27]

Sitting on the couch in his home in New York's Hudson Valley region, the author said he agreed with writers who say writing books can be torturous at times. "Yes. Yes. Yes. You know what it's like!" He bursts out laughing. "Sometimes writing was difficult. Sometimes it wasn't. I liked writing and wanted to be successful, so I worked hard."[28]

Sitting in his living room in his late eighties, Tom was friendly, down-to-earth, and slender and fit and moved fluidly around his home. A striking difference between father and son becomes clear. Norman could not stand any extraneous materials in his studio. Tom has many books; a shelf of them even runs over the door of his living room. He and Jarvis once ran a successful used bookstore in Stockbridge. After closing it, he kept many of the unsold books.

"I still have a shed full of books too. It's ridiculous. I feel guilty because I haven't read them all. I bought some only to sell, so I have that excuse," he laughed.

After years of work on middle-grade novels, a New York literary agent finally invited Tom to discuss his book but splashed his hopes with cold water. She spent much of the time pointing out things he needed to change in *Squawwwk*, one he had written. After the distressing meeting, a voice in his head said, "Trying to write books is like eating worms." Then, out of nowhere, a magical idea floated into his mind. "Why not write a book about a boy who eats worms."[29]

He began by telling the story of a bully who bets another kid named Alan $50 that he can't eat a fried worm for each of fifteen days. The bully and another antagonizer cook up schemes to keep the boy from winning the bet.

Despite extraordinary creative ability, Tom explained he found it agonizing at times to produce an exciting event for each chapter. "It got a little hard to think up ways to keep it interesting," he explained. "You'd just have to sit there and come up with them, sometimes reject them. You just keep trying."

For example, he dreamed up a chapter where the bully, also named Tom, plans an action-packed day for Alan in the hopes he'll fall asleep before eating his daily worm.

In another clever chapter, Alan, the boy who eats the worm, comes home to find a note written by a doctor. The MD tells his parents that worms can

make a person quite ill. The reader, with growing concern for Alan, is held on the hook until the boy's father comes home and tells his worried son the letter obviously has been forged.

At one point, Tom feared his book might be doomed. "I thought a worm might poison a child." Despite fearing his physician might kill the dream, he sought his advice. The doctor laughed as he explained that eating worms won't harm humans. "In fact, there's a lot of protein in them," he said. Tom erupted in laughter.

How to Eat Fried Worms took nine months to complete.[30] Many publishers rejected the work of genius. They believed teachers would find the fare unappetizing and librarians would be disgusted. One wise executive at Random House conceded their point but published it because he sensed kids would love it. Although unusual, the story teaches kids a way to stand up to bullies and even befriend them. It was as if at forty years old, Tom had rung the weighted bell with a sledgehammer at a county fair. Published in 1973, *Fried Worms* sold more than three million copies. Even today, it still sells enough copies that a person could buy an average car every two or three years from the royalties.

A grand smile formed on the author's face, and he chuckled. "It was nice. Yes. Very nice," he said in a grateful manner.

As a children's writer, Tom possesses an extraordinary ability to portray kids as they act in real life, much as his father did in his paintings. "I wasn't aware of studying kids," he said. "Sometimes it was very difficult."

Tom believes his father's diligence in studying his subjects, both young and old, rubbed off on him. He finds validity in the theory that his word depictions of spirited youth are of the same type as in his father's paintings. Norman used them in illustrations such as *Going and Coming* and *No Swimming* and in illustrations for the book *Tom Sawyer*.

"I suppose I picked up something from my father. He studied kids since he was fifteen. He understood people. That's what his career was based on. It's the family business."

It makes complete sense that fourth through sixth graders throughout Missouri voted *Fried Worms* their favorite book two years after its publication. What is the name of the prize they gave him? The Mark Twain Award, of course. In 2006, *Fried Worms* was adapted as a major motion picture that appeared in theaters across the country.

Tom eventually wrote titles such as *How to Be A Millionaire*, *How to Get Fabulously Rich*, and *Emily Stew*. With all the discussion about fried worms, who could resist asking, "Have you ever eaten a fried worm?" He burst into laughter. "No. I felt bad about it, though. I meant to, but never got around to it." Another laugh. "I should."

"Would you like to ease your guilty conscience and eat a fried worm for this story?"

"No. No. Ha ha ha!"

FIFTEEN MORE

After his father died in 1978, Tom continued writing, and published fifteen more books. Some of his later books didn't sell well. "That was difficult." After *Fried Worms*, he authored another book with clever, humorous stories and poems for children called *Portmanteau*. "It was successful, but not like *Fried Worms*." He tried his hand at self-publishing when he wrote a commentary on Shakespeare's plays. "I sold one copy. I didn't know how to promote it." He laughed.

6

Talent Right Next Door

The residents of the rural village of West Arlington, Vermont, could never have imagined that the nation's most celebrated illustrator would one day take up residence on the Village Green and feature their faces on the cover of a weekly magazine viewed by 5 million people. Twelve-year-old James A. "Buddy" Edgerton, who became the Rockwells' nearest neighbor, was as surprised and excited as anyone. The Edgertons and Rockwells lived in identical adjacent dwellings known as the "Twin Houses." Buddy's ancestor had built the Rockwell home in 1792, shortly after Ethan Allen, the brawling but brilliant leader, drilled the Green Mountain Boys on the field out front and became a significant force in defeating the Redcoats during the American Revolution. That ancestor later built Buddy's house from the same set of plans in 1812. The majestic Red Mountain rises on the left in the distance, and Big Spruce stands just behind the Twin Houses. The scene looked about the same in 1930 when Buddy was born to Jim and Clara Edgerton.

Vermont boys like Buddy couldn't grow up soon enough to suit their fathers. When Buddy was four years old, Jim stood on the straw-covered floor of his barn under rough-hewn log beams and positioned his son beside his herd's most gentle cow. Buddy squeezed milk from her into a pail. He soon began cleaning the barn with a shovel and went up into the hayloft to pitchfork loose hay down through a trapdoor into the milking parlor. He climbed the mountain behind the barn on rainy days and drove down reluctant cows

that huddled under trees. It wasn't long before the child pitchforked hay onto wagons in the meadows along the Batten Kill.[1]

Buddy was destined to be an outdoorsman. At age six, he caught his first fish, a nineteen-inch rainbow trout, from the Batten Kill. At age nine, he carried a shotgun into the woods to hunt small game, such as squirrels and partridge. Raccoons were a bother to the farmers and needed to be removed from cornfields. "They would raise a lot of hell knocking over stalks. Our coon dogs would chase 'em up a tree at night. You'd shine a spotlight on 'em and shoot." His grandfather taught him to catch muskrats along the river by placing half an apple on a trap. "I used to catch a few every year. You'd skin 'em, put 'em on a rack, and let 'em dry. There was always somebody in town brokering furs." That same year, in 1939, he felt like a man when he and his father took opposite handles on a crosscut saw and cut timber into logs for firewood.

Buddy, his parents, and his three sisters all participated in maple sugaring beginning in late February. They tapped trees; poured sap into a container on a sled pulled by their 1,500-pound, narrow-backed draft horses Prince and Dick; and boiled it in an evaporator in the old gray-board sugar house. They reduced their yield to as many as four hundred gallons of maple syrup per year. "If we hadn't had a good sugaring operation, we wouldn't have made it. It was a cash crop, and you made enough money to buy your seed and get started planting the corn and vegetable garden. Sugaring was our salvation."

Because labor was scarce during World War II, the school periodically gave kids like Buddy days off to help their fathers. As far as other help, Buddy never knew what type of characters might appear in spring after a long, snowy winter. A tall, bearded fellow, known in the valley as Herbie, often showed up just as the warm sun was melting the last snow. Herbie would come wearing the same clothes he wore all winter long. "He reeked when he came to the sugar house. But he was a nice guy. You had to like him," Buddy recalled. Herbie had slept in a coal bin, in crawl spaces, and in sheds during the winter months. The fellow arrived bursting with excitement after his winter isolation and chattering so fast you could barely get the gist of what he said. His bones now warmed, he raved about the weather and the beauty of the land. Many in the valley had a soft place in their heart for the poor, so they'd provide work for such folks.

Buddy studied his hardworking but loving father Jim as he hitched up Prince and Dick. Men and women of the community respected Jim for his in-

tegrity and practical wisdom in farming and raising children. At age thirteen, with Jim standing by, Buddy slid the bits into the big horses' mouths, placed harness collars around their necks, and wrapped straps around their sides ever so carefully so as not to spook them. One could get stepped on or kicked or, worse, killed. The workhorses pulled hay wagons, plows, and mowing machines. Buddy learned to click to make the huge, gentle animals move as they furrowed the earth. He would command them in a firm but gentle voice, uttering, "Get up . . . easy . . . whoahoa." Buddy's confidence grew as he became adept at the chores that allowed his family to make a living from the earth.

AN ARTIST APPEARS

At age thirteen in 1943, Buddy was absorbed by this simple but satisfying existence and little knew the changes that would take place when a moving truck appeared next door at the other Twin House. Buddy recognized the new owner who painted *Saturday Evening Post* covers. Buddy had seen Norman Rockwell during previous summers at square dances, where the artist wore a sport jacket and a bow tie. "He looked kind of dapper," Buddy recalled.

Buddy's father Jim had posed for the *Post* cover *Food Package from Home* and inspired Norman to create *Freedom of Speech* after standing and speaking out with passion for his cause at a meeting in the Arlington Town Hall.

As the men unloaded the moving truck, Buddy grew excited when he spotted the workers taking out bicycles, a luxury most families in the neighborhood couldn't afford. The artist told all the Edgertons, "Call me Norman." His energetic ten-year-old son Tommy would ultimately join Buddy in barn chores, haying, hunting, fishing, camping, and swimming. To his great excitement, the strawberry-blond Tommy invited Buddy to ride his bike!

Buddy began spending time at the Rockwells from the start. "Their doors were always open to us. Our doors were always open to them," he said. He had begun listening to World War II broadcasts after President Roosevelt announced that the Japanese had attacked Pearl Harbor in Hawaii on December 7, 1941. He especially liked listening to the Rockwells' fancy radio, housed in a large wooden console. "The radio came in pretty good at the Rockwells, though sometimes it faded in and out. I'd lie on the floor of their living room and listen." The war brought the community together. Buddy and other children participated in scrap metal drives and picked and bagged milkweed

pods from the fields. The military used the pods as a filling for life preservers because of their buoyancy.[2]

Except for times when he needed privacy, Norman allowed Buddy, Tommy, and Jarvis to visit in his studio while he worked. Buddy's collie Shep liked to lie outside on the steps. "When there was a thunderstorm, he would scratch on the door and Norman would let him in," Buddy explained. After having dinner at the Rockwells', Buddy couldn't understand why Norman remained so thin. He observed that the artist had a good appetite and ate regular portions of poultry, beef, potatoes, and gravy. "He had good cooks," Buddy noted.

THE SCOUT WHO WAS NEVER A SCOUT

On a summer day in 1943, several months after the *Post* published the *Four Freedoms*, Buddy was working in the cow barn when Norman summoned him to model. The artist showed him a sketch of a Boy Scout in uniform standing before the organization's pledge. Norman explained that he intended to call the painting *On My Honor*. The artist had enjoyed a long history with the BSA, beginning in his New Rochelle days when he served as art director of *Boy's Life*, its official publication. In all but two years since 1923, the organization had featured a Rockwell painting on its annual calendar. Buddy was mature for his age and exhibited leadership qualities. He had already been supervising his sisters and local children in farming chores and was well on his way to his eventual height of six-foot-two. He was handsome with focused eyes. "I had the kind of profile Norman wanted for *On My Honor*," said Buddy.

As a rule, the artist did not favor impeccably dressed and groomed models. He preferred children to be natural and working people with character in their wrinkled faces and hands and who dressed as they were. To give the Scout painting a touch of authenticity, the artist instructed Buddy to wear the uniform outside long enough to get it wrinkled and dirty. In *On My Honor*, Norman painted Buddy as the Scout saluting in front of the words "On my honor, I will do my best for God and my country" with creases and dirt visible on his uniform. The painting appeared in a 1944 calendar that was pinned to kitchen walls across the United States near the close of World War II. "I became the Boy Scout who was never a Scout," quipped Buddy, who would appear in more of Norman's BSA calendars than any other model.

Buddy enjoyed his time with Norman. "Norman was a very, very busy man, but he took time to make you feel good. That's the best way I could put it," said Buddy. The artist also took time out of his busy schedule to give presentations about his work to small gatherings like Rotary Clubs, church meetings, and the Southern Vermont Arts Center. "In Arlington he didn't turn down requests." However, Norman did not like speaking to large crowds.

Buddy instructed Rockwell's middle son Tommy and many other boys and girls in the valley how to load hay wagons and drive tractors. "I was his chief counselor," Buddy said. Norman and Mary felt fortunate the two boys had become fast friends. "Both he and Mary trusted me to mentor their boys." In their backyards and surrounding mountains, Buddy led Tommy on hunting and camping outings. "We made our own Boy Scouts." Norman would write notes accompanied by small pictures to the school, and the principal would dismiss Tommy to go hunting. When Buddy shot his first deer at age fourteen, Tommy and Jarvis helped him drag it home. They also fished for trout in the Batten Kill.

Norman paid Buddy $5 per modeling session and gave him chores to earn money, which was nice for a boy who did not receive an allowance. He even paid Buddy to help Walt Squiers build his studio.[3] In retrospect, Buddy believes that the artist's motivation came more out of generosity than out of the need of a laborer. Once the studio was completed, Buddy would find Norman painting at his easel in the large open area or spreading out photographs on the floor to study the faces, arms, and legs of his models, along with possible backgrounds. When he needed a break, he would stretch out on his couch in front of the fireplace. The stuffed head of a deer taken by Buddy's mother Clara hung over the mantel. In cold weather, he would enjoy snoozing in front of a crackling fire.

COW FLOP?

Norman would sometimes stroll over to the Edgertons' barn to chat with Jim and Buddy as they milked, forked hay, and scooped grain from sacks. The artist did not help with the chores, but he was not standing idly by. Norman was always observant and waiting for something that might inspire or trigger an idea. Perhaps a new model would visit Jim and Buddy. Once during a visit to the Edgertons' horse barn, inspiration did strike as he realized it was the perfect setting for *Mrs. O'Leary's Cow*, a painting commissioned by Brown and Bigelow for a 1946 fire insurance company calendar. During that era, Brown

and Bigelow produced millions of calendars for all sorts of organizations. Norman Rockwell created the company's first illustration, which was published in a BSA calendar. The 1946 painting was based on the Chicago fire of October 10, 1871. The damage was devastating. More than three square miles of buildings and shacks and $200 million in property were burned. Three hundred people were killed, and one hundred thousand were left homeless.[4] The next day, the *Chicago Evening Journal* reported that a cow named Daisy owned by Catherine O'Leary caused the blaze by kicking over a kerosene lantern. Chicago residents immediately heaped blame on Catherine, but the woman insisted Daisy was innocent. "I never milk my cows at night," she explained.

Buddy led his cow Bessie to the horse barn to pose standing over a bed of straw under the log beams. In order to observe the cow's leg as it would appear kicking a lantern, Norman instructed Buddy to lift Bessie's leg with its hoof facing back at him. A startled expression came over the cow's eyes when he pushed her head to face Norman. Sitting on a stool next to Bessie was Mrs. O'Leary, modeled by Norman's housekeeper Mrs. Labombard, wearing a bright red scarf and a velvety teal blouse. Although the illustration depicts the cow staring backward at the lantern, both its hind legs are firmly planted on the floor.[5] Why didn't Norman exploit the opportunity to create an action scene where the ornery cow's hoof is smashing the lantern? It would have made the picture more dramatic and exciting, but Norman took great pains to be historically accurate. He would carefully research events like the Chicago fire, which he mentions in his autobiography, though the account does not include any discussion of the cause of the fire.[6]

Buddy recalled that Norman would travel far and wide to get the truth of what he needed for his paintings. He traveled from Vermont to a Chicago department store to study the setting for *Tired Salesgirl on Christmas Eve*. While illustrating *Tom Sawyer*, he traveled to Hannibal, Missouri, to sit in the same cave Twain used as a setting. While working on *First Sign of Spring*, Norman drove half an hour each way to buy a crocus from a florist.

Buddy said Norman never mentioned the reason he didn't portray the cow's hoof kicking the lantern. He likely researched the event and decided it was inconclusive whether Mrs. O'Leary's cow had caused the catastrophe, and therefore she hadn't deserved the scorn and animosity that destroyed her life. Not until 1997 did the Chicago Committee on Police and Fire declare her innocent.[7] No one ever produced a shred of evidence that she caused the fire.

Buddy said Norman called *Mrs. O'Leary's Cow* his biggest flop because the calendar sold poorly. He chuckled. "No one wants to look at the rear end of a cow for six months." Despite its failure, *Mrs. O'Leary's Cow* has some fine qualities. The soft light of the lantern illuminates the warm brown colors of the cow and the barn's interior. The brilliant red scarf and teal blouse worn by Mrs. Labombard draws the eyes to the familiar rural scene. Her contented expression indicates that she is present in the moment to the task at hand, oblivious to the fact that the cow has turned her head and is curiously eyeing the lantern set just in front of her left hind leg!

Buddy was fascinated by how fast Norman's fingers moved when he gripped a charcoal pencil. "He could sketch a group of people sitting at a table in five to ten minutes." However, Norman wasn't satisfied with much of his work. Sometimes late in the afternoon, Buddy would notice smoke rising and smoldering pieces of paper sailing through the air from his backyard. He'd walk in the direction of the Rockwells' lawn behind the studio and spot the artist standing before a flaming incinerator which he had created by rearranging stones in the stone wall. Holding a trash basket in one arm, Norman dropped sketches into the fire. Almost as if it were a cleansing ritual, Norman seemed mesmerized by watching papers curl, ignite, and burn. The incinerator devoured sketches that would be worth large sums of money today. Buddy explained, "Anything he did is valuable now."

For the life of him, Buddy never understood how Norman "gave away paintings like they were candy" once the *Post* shipped them back from Curtis Publishing in Philadelphia. "He didn't realize they had value. Maybe he didn't care." Apparently, Norman had no time for what was finished and in the past, and his chief desire was to get rid of anything that distracted him from maintaining a strong focus on current and future work. His son Tom explained that when people asked him which of his paintings he liked best, his father sometimes quoted Pablo Picasso, saying, "The next one."[8]

When people asked for a painting, he'd say, "Go to Frankie's Diner and tell him I said you can take one off the wall." Frankie Hall, a former Vaudeville comedian, modeled for *The Gossips*, painted in 1948. In that painting, the comical man is portrayed laughing with his mouth stretched open as wide as is humanly possible. Norman and Frankie *did* enjoy great laughs. Buddy and his friends would often observe the two men chatting and enjoying light-hearted humor at the back of the diner.

A COMPULSIVE PERFECTIONIST

As a teenager, Buddy observed a perfectionist in action when he visited the studio. Norman labored hard during those years and often agonized over his projects. He was driven to conceive an idea that would result in an illustration that reached out and grabbed readers. He drove the point home in *Rockwell on Rockwell*. "Sudden inspiration has never been the source of a single idea." I have to "beat my brains out for each one. . . . Genius is the ability to take great pains," he wrote. He noted that when a great idea comes to an artist, "bells ring and lights flash. . . . You'll want to get busy and paint it and nothing else." Once an idea caught on, Norman launched into it painstakingly, creating layouts of his models' positions, props, and backdrops just as he wanted them in the final painting. He did not want to modify them while brushing paint at his easel.

"Believe me, I know better than anyone else that none of my pictures are even near-masterpieces, and I know some of them distinctly smell!" he wrote in *Rockwell on Rockwell*.[9]

"He could have done twice as much if he didn't go back and do some of them three or four times." Whenever he was stumped, Norman sought opinions. Buddy recalled an afternoon his father found the artist before his easel with a face twisted in frustration. He was glaring at the painting in progress for a December 15, 1945, *Post* cover, *Back to Civvies*, depicting a World War II soldier who returned to civilian life. He had settled on a tall fifteen-year-old as the model. As hard as Norman tried, he could not make the kid appear convincingly like a pilot.

Norman explained his dilemma, and an image of a model that would work for *Back to Civvies* came to Jim. The parents of a young soldier in the community had recently endured a harrowing ordeal. In 1943 while flying his B-17 bomber over Hamburg, Germany, Gene Pelham's next-door neighbor Art Becktoft Jr. had been shot down. Art had worked with Buddy in the Edgertons' hay fields the previous summer and had become like a big brother. The *Bennington Banner* ran the headline "Local Pilot Missing in Action." They feared the worst, but Art's parents and the community heaved a collective sigh of relief when they learned he was alive in a prisoner-of-war camp. Buddy's sister Ardis became Art's pen pal during his imprisonment; the Red Cross delivered the letters.[10]

"Hey, Norman," Jim exclaimed. "I know the perfect model! Art Becktoft." Norman got Art to the studio right away. His "luck" in finding the model who

would make his picture believable once again proved to be extraordinary. In *Back to Civvies*, the former prisoner of war smiles at himself in his bedroom mirror. The pants he wore before serving are now almost falling off him and so short that they rise several inches above his ankles.

When he painted model Mary Whalen in *The Shiner*, Norman realized he could not create a black eye from his imagination. He went to the extent of advertising in the newspaper and drove a father and his son with two fresh black eyes to the studio from Massachusetts. "Norman said a black eye isn't just black," explained Buddy with a chuckle. Black eyes also have blue and red highlights. "Why was he so fussy? He was his worst critic, actually. He was great because of his talent and attention to detail. If he didn't get it just perfect, it would wear on him. . . . It probably was a good thing." But Buddy noted that Norman could have produced many more pictures if he took his business a little less seriously.

PUBLIC CRITICISM

Norman sometimes experienced anxiety about using family, friends, and neighbors in his work, particularly after creating *The Gossips*, where he pokes fun at those with loose tongues. At that time, his wife Mary was suffering from depression, and real-life gossipers had annoyed him. As he often did, he projected his feelings onto his canvas. To avoid suspicion, the artist included himself and Mary in the picture. Norman considered including Buddy's mother Clara Edgerton, but she was Mary's close friend, and he didn't want to risk alienating her. "My mother later expressed that she would have loved to have been included," Buddy said. After *The Gossips* appeared on a *Post* cover, he phoned Rena Crofut, who lived a mile or so down the graveled River Road, and explained his feelings. In *The Gossips*, Norman had painted her wearing glasses and her daughter Doris in curlers. Rena laughed and reassured Norman the neighbors did not find the painting offensive. However, one angry woman whom some considered to be worthy of her portrait gave Norman an earful. She resented being portrayed as the gossip she was.

Norman was gratified when his mission of creating paintings that inspired his country was successful, according to his son Tom, who stressed that his father worked awfully hard to this end. Norman made it a point to start each studio session by greeting his models as if they were distinguished guests and treating them with respect so that they felt relaxed and uninhibited. In his book *Rockwell on Rockwell*, Norman explained that he would shout to make

models loosen up and put a look of distress on his face to make them appear sad.[11] He was not above such antics as taking off his shirt to reveal his skinny body if it would make a person laugh.

MODELING FOR ROCKWELL PAINTINGS

Buddy remembered seeing Norman in deep contemplation before sketching *The Long Shadow of Lincoln*, a February 1945 pictorial commentary on the tragedy left in the wake of World War II. During the time he worked on the painting, Norman asked Jim and Clara for comments a number of times, for it was a complicated task that required many models. *The Long Shadow of Lincoln* appeared as a feature inside the *Post* on February 10, 1945, shortly before the end of the war. It begs citizens for compassion for all affected, especially wounded soldiers, their wives and families, and others in their communities. From 1939 to 1945, the United States lost 405,000 soldiers. Across the world, about 55 million civilians and 20 million military personnel died, and another 25 million were wounded. A quarter of the people in the Soviet Union died or were wounded. All over Europe, Japan, Germany, and the Soviet Union, cities were destroyed. Stone and concrete rubble covered streets. Although Norman felt it his patriotic duty to allow the US government to reproduce paintings such as the *Four Freedoms* on war bonds, he made clear his feeling that the decision to engage in warfare should be taken extremely seriously.

The artist summoned a number of his Arlington neighbors to model for the somber collage and instructed some of the adults and children to kneel on his studio floor in prayer positions. In the painting, a distressed girl holds her face in her hands, and a mother, father, and child huddle together. Buddy, with his sister Joy (with a braid), sits in a group of children at the front left, listening intently as a woman enlightens them. Both Jarvis, with blond hair, and Tommy Rockwell, with red, appear in the group.

Three generations of the Edgerton family posed. Jim holds out his hand to ask the world for help. His sister Ardis kneels at the middle right of the painting in front of a cemetery cross next to a woman with black hair, modeled by Walt Squiers's wife Clarice. She is the woman who prayed fervently each day after being partially paralyzed in a car accident and also modeled for *Freedom of Worship*. Clarice attended St. James Episcopal Church in Arlington. Norman had been raised in the same denomination and attended church at St. James periodically. Buddy's grandmother Elva kneels behind the artist. A

soldier's helmet and his dog tags hang on a graveyard cross. Curnel Vaugh, owner of the farm that stood next to the dance pavilion, holds a carpenter's square, which signifies the will to rebuild. Walt Squiers, Norman's real-life builder, holds a crutch and architectural plans. Looking closely, one sees that Norman painted Walt with his left leg amputated. During the war, about 671,000 American soldiers suffered wounds; many were left handicapped and in need of lifelong care.

In May 1945, Arlington High School principal John Moore sat in the Edgertons' living room and announced that he had come to advise Buddy to register for college preparatory courses. Buddy had always assumed he'd take over the farm but was intrigued when the principal explained he would probably get a scholarship due to his good grades and athletic accomplishments. The moment turned bittersweet because Jim did not like the idea.[12] Who could blame a weary farmer who left school after the sixth grade for wanting his son to stay home and help him on the farm?

A Stanford University graduate who taught school before her marriage and a firm believer in higher education, Mary set out with Norman to convince Jim and Clara to encourage their son to go to college. Clara began considering the idea. Mary convinced Buddy he would succeed and advised him throughout the application process. Buddy eventually enrolled at the University of Vermont. Ironically, a catastrophic storm in 1950 tore down nearly half of the trees in the Edgerton's woodlot. Buddy and his father cut them into logs and sold them to pay for his final year of college.[13]

In 1946, Norman fetched Buddy from next door and showed him a sketch of two boys for the BSA calendar, *A Guiding Hand*, the painting for which Tommy Rockwell also posed. The artist always seemed to be under the gun. Buddy, age sixteen and dressed in a Boy Scout uniform, would help Tommy, age thirteen, tie a complex knot in a rope. Using close friends as models would lend authenticity once again. Norman had them pose sitting on wooden boxes and set a scouting manual by their feet. He explained that older Scouts should teach Cub Scouts, handed them a complex knot in a rope, and instructed them to focus sharply on it. Three years had passed since *On My Honor*, and Buddy's rounded cheeks had given way to sharply chiseled lines. Tommy's strawberry-red hair was neatly combed under his Cub Scout hat. With its warm brown background, the painting speaks volumes about Norman's approval of the friendship between the boys.

Norman instructed Buddy to put his arm behind Tommy's neck and to guide the younger boy's hand in moving the end of the rope through two loops. A close look at their feet reveals creases in their shoes, once again Norman's method of adding a rustic element. The calendar appeared and was pinned to walls in homes and offices across the country. Some years later, Buddy traveled to the BSA headquarters to view its collection of Rockwell illustrations. *A Guiding Hand* hung in the chief's office (see figure 5.2).

MEN OF TOMORROW

In 1948, Norman brought Buddy to the studio dressed in a Scout uniform to model for a painting called *Men of Tomorrow*. That day, Norman had been especially anxious to get down to business, and the session proved to be Buddy's most demanding.[14] Norman moved quickly around the studio calling out directions and acting out the expressions Buddy must show on his face. Now a young man, Buddy modeled separately for each of seven Scouts who are on a camping trip and carrying their canoes across dry land. Peter, Norman's son, joined the painting as a Cub Scout who is dreaming of going on the camping trip.

In his book *The Unknown Rockwell*, Buddy explained the process Norman used to get the desired poses. "To get the perfect angle of my legs and body coming downhill, Norman set up wood planks in the studio and tilted them at various degrees during the modeling session. He wanted to catch the muscles in my legs at a time where I was actually coming downhill. I had to hold a full-sized canoe over my head, balancing it, just as in the illustration."[15] In the oil painting, the seven teenage boys carry canoes, poles, and paddles through a dark section of woods as if on a mission. Their bright red scarves stand out against brown uniforms.

BUDDY'S "EAGLE" PROJECT

By age eighteen, Buddy had served as president of Arlington High's Student Council and the Arlington Athletic Association. He played center on his basketball team and pitched on the baseball team. He served as captain of both. Shortly before graduation, Buddy found himself in the center of a tumultuous community debate, and it seemed to him that this might be a greater challenge than he had heretofore experienced.[16] He would need to draw on the leadership qualities he developed during his childhood. Norman pushed him

to be brave and "to do the right thing" when Buddy squared off with a man some considered a tyrant.

The story begins when the Arlington basketball team set out on a forty-minute trip to Wilmington High School by bus on a winter afternoon. The team had reached the Vermont State Finals during Buddy's junior year. By the time they reached Vermont Route 9, ice had slickened the unusually steep and winding road. Going around a curve, the bus lost its brakes, but fortunately the teens were traveling uphill and plowed into a snow drift that held them fast. The players exited carefully and packed into the spectators' bus, but those brakes failed too. As they drove back to Arlington, one of the kids held the gear shift the entire time to keep it in first gear.

As president of the Arlington Athletic Association, the responsibility of resolving the situation sat on Buddy's shoulders. Along with two other Rockwell models—Freeman Grout, vice president, and Donald Crofut, secretary-treasurer of the Student Council—Buddy wrote a petition. Freeman also played basketball on the Arlington team and had appeared as the older boy in Rockwell's 1949 Scout illustration *Friend in Need*. He also posed for *Our Heritage* as a boy admiring a portrait of George Washington kneeling in prayer.

The shaken teenagers marched into a school board meeting and requested permission to use the town's third bus, which was in good condition. To their surprise, the school board accused them of acting out of turn. Board president Harlan Miller let it be known that he didn't even believe in high school sports. The boys were shocked. Buddy likens Miller's influence in Arlington to that of a nineteenth-century mill town owner. He and his wife resided in a mansion on an estate with two tenant houses and kept a herd of Jersey cattle.[17]

"A lot of people depended on him for their livelihood," said Buddy. Freeman Grout mowed the lawn.

Buddy knew he was not dealing with a lightweight. A Harvard-graduate lawyer, Miller was a big fish in a small pond. He had served as a diplomat for the United States in Paris and Rome. He was well connected enough that Charles and Ann Morrow Lindbergh stayed with him in Paris the night after the first nonstop Atlantic flight in 1927. Buddy presented his case at a second school board meeting. Miller accused Buddy of neglecting his schoolwork for sports. "Otherwise you would understand civic regulations." Miller told the boys the board would not allow them to use the newer bus and that the district would not be able to purchase another due to a shortage caused by

World War II. "But tell you what, son," said the former diplomat. "If you can find a bus, I'll buy it." Miller made eye contact with the other board members and chuckled.

Miller and one other voted down the petition, two to one, which fired Buddy's passion all the more. The eighteen-year-old contacted a dealer near Albany, New York, and a bus was delivered to the town offices two days later. Miller threw a fit and sent it back. Buddy called another meeting of the Athletic Association to explain that civics required a petition signed by five percent of the town's registered voters to call a special town meeting. On one of the most icy-cold days that winter, Buddy wrote the petition. Next door, Mary and Norman signed on the first two lines. Once they learned the story of the bus losing its brakes on treacherous Route 9, the townspeople rallied behind the boys. Miller lined up supporters too. "They either agreed with him or didn't want to get on his bad side," said Buddy.[18] The US diplomat turned school board president was none too happy to see Buddy lay the petitions on his desk. Buddy stepped back after Miller's expression intensified. It curved into a peculiar smile. He told Buddy that the boys did not have the power to "direct" the town in any matter. He barked, "Get out!"

"Perhaps if he took the time to listen to us, he would have understood," said Don Crofut.[19]

In the Rockwells' living room, Norman's blood boiled. "Don't you dare back down now, Buddy!" he shouted. The artist paced the floor as he insisted Buddy write a new petition with more accurate language. "I'll be the first one to sign it—even before Mary!" Norman strutted around. "This isn't right! This isn't right!" he repeated. "Circulate another petition! Don't you dare let them push you around. You, Buddy, are a leader. You can do this. As a matter of fact, not only can you—you must!" Norman pounded his fist on the mantel.[20]

Joining Norman in their living room, Mary also insisted Buddy not back down. Buddy would have probably tossed in the towel had it not been for Mary. Buddy, Freeman, and Don rewrote the petition. They gathered even more signatures. Buddy felt pumped up as they marched back to Miller's office. They were surprised when Miller granted a special town meeting.

THE SHOWDOWN

Buddy arrived early for the meeting at the high school with his parents, Norman, Mary, and Tommy. Nearly half the town's 1,500 residents packed the bleachers. The moderator banged the gavel. Heated voices spewed opinions. Some labeled the three teenagers as rebellious youths. After two hours of heated debate interrupted by long stretches of commentary by Miller, the town moderator banged his gavel. The time had arrived to take a vote. The tyrant glared at Buddy. "I vote 'nay' against the petition."

The moderator called for a show of hands. "All in favor raise your hands."

Norman Rockwell led the charge by thrusting his fist into the air. Mary and Buddy's parents followed. To his delight, Buddy watched hands rise all over the gym, and eventually, most all were in the air. As if the Arlington kids had scored to win a championship game, the crowd cheered and stomped the bleachers! But the bull wasn't in the barn yet.

The moderator counted the number of hands voting "yea."

"All opposed?" he shouted.

Buddy's heart leapt. Only a small number of hands appeared in the air.

The moderator slammed his gavel. "The yeas have it!"

The crowd jumped to their feet as if one of the Arlington boys had swished a jump shot to win a game at the closing buzzer. Buddy, Don Crofut, and Freeman Grout had beaten the Harvard lawyer/US diplomat! Buddy's mother threw a hug on him.[21]

Harlan Miller slammed the gavel to regain control. "You ungrateful fools!" he shouted. The crowd erupted again. They jumped up and down as if they had won that state championship.

Mary leaned over and whispered, "See, Buddy. It was the right thing to do."

With a huge smile, Norman gave Buddy a vigorous handshake.

Arlington's sports teams now drove a safe bus on the steep road to Wilmington High School. Soon, Buddy received a letter of congratulations from John Fisher, the Vermont school superintendent, expressing that he was proud that Arlington could not be bought by anyone.

"Harlan Miller resigned his position and kind of rode off into the sunset," Buddy reminisced. Buddy eventually graduated from the University of Vermont and retired as a professor of agriculture from the same school. He has remained lifelong friends with Norman's sons Tom and Jarvis.

In 1951, one of Norman's students, Don Spaulding, who became a noted artist of the American West, used Buddy as a model sixteen times on the cover of the Dell comic book series *The Lone Ranger*. Buddy wore the comic's signature cowboy hat and black mask around his eyes and held a pistol in each hand (figure 6.1).

With much help from Buddy as a model, Norman received numerous awards for his paintings from the BSA during his lifetime.[22]

FIGURE 6.1
Norman's favorite Boy Scout model Buddy Edgerton also posed for Norman's student Don Spaulding for *Lone Ranger* comic books. *Source*: Courtesy of Buddy Edgerton.

7

Like a Daughter

Like her brother Buddy, Ardis Edgerton grew up with their parents Jim and Clara and sisters Edith and Joy. She felt well loved. She also worked on the farm feeding and taking care of the family's chickens, pigs, horses, and cows. Sometimes, her clothes were worn and dirty, but she was comfortable with that and being considered a tomboy. Ardis also helped her mother in the house, preparing and canning vegetables from the garden to stock up for the winter. Since they raised animals for meat, the Edgertons were nearly self-sufficient. In the spring, Ardis helped with sugaring. She did not like the fact that she got stuck with the worst job—scrubbing sticky sap from empty metal buckets.[1]

Ardis felt closest to her father as they worked side by side haying or tending to the animals. He was tied to his work most of the time. Following in the footsteps of his ancestors, Jim rose seven mornings a week at 3:30 a.m. to milk his herd of about thirty cows. Depending on the time of year, afternoons were spent spreading manure; cutting, loading, and stowing hay in the barn; planting and harvesting corn; and repairing equipment. He would return to the barn for evening milking at 4:00 p.m.

Ardis was an athletic girl whose legs and back had been made strong from her farm tasks. She also found time to deliver newspapers. When she delivered them on her bicycle, her hair puffed into a red mop. On summer afternoons, she played softball on the long field. She attended suppers and

Grange activities in the hall of the little white church and swam in the Batten Kill under the covered bridge. In 1943, ten-year-old Ardis learned that Norman Rockwell and his family would be moving into the identical house next door. *Will they be fun?* she wondered. Their son Tommy was in her class at school. Norman had let it be known around town that Ardis's father Jim had been the inspiration for his war bond masterpiece *Freedom of Speech.* Jim had also appeared on the cover of the *Post* in *Food Package from Home.* Neighbors said of the farmer, "If a stranger walked into the room, he left a friend of Jim's."

THE ROCKWELLS ARRIVE

The Rockwells were under close surveillance by the children next door as the movers unloaded the family's possessions. Buddy was excited by their shiny bicycles. Ardis, who could be impulsive at times, left Buddy standing by the window and was soon knocking on their new neighbors' door. Mrs. Rockwell invited them in and led them to the parlor. She introduced her sons Jarvis (age ten), Tom (eight), and Peter (four). Ardis exclaimed excitedly, "We're glad you moved in because now we'll have kids next door to play with." Buddy and Tommy immediately headed toward the river with fishing gear. Ardis and Mary, who stood five-foot-six and wore her wavy brown hair pulled back, discovered that they both loved to chat.[2] Ardis believes Norman's most realistic portrayal of Mary appears in the *Post* cover *Christmas Homecoming*, where she modeled as a mother hugging her son, who has returned home for winter vacation. Mary's son Jarvis posed as the young man. Mary had made her first appearance in the 1930 *Post* cover *Breakfast*, four months after she and Norman wed. Mary posed as a dejected woman sitting across from her husband, whose face is buried in a newspaper. She also appeared in others, such as the iconic *Freedom from Want*, where a husband and wife deliver a Thanksgiving turkey to a table of smiling family and friends. Mary is on the left, the second person from the end. In *We the Peoples*, the charcoal drawing that hangs in the United Nations building in New York, Mary stands behind Buddy Edgerton, who wears an army helmet.

Soon after moving in, Mary hired Ardis to clean house, help in the kitchen, and babysit for her son Peter.[3] She welcomed the work because spending money was hard to come by for a humble farmer's daughter. Mary paid her twenty-five cents per hour to start but soon increased it to fifty cents. That

was far better than the three cents per newspaper she earned delivering by bike in all sorts of weather. It was a newspaper called *Grit*, which included coverage of local events.

Ardis also posed for Norman a number of times, and he paid her $5 for each session. She believed that, some of the time, he simply wanted an excuse to give her more spending money. Other times, he needed a person to pose so he could get perspective before a designated model arrived. Norman also called on her and members of her family to view his work and make comments. As he would with others, he led them to his easel and asked for their thoughts. Occasionally, their feedback would result in a change, but usually, they'd see that his work remained the same.

A MODELING OPPORTUNITY

Little more than a year after the Rockwells moved next door, Norman invited Ardis to his studio. She couldn't have been happier when she learned that he planned to have her model for an illustration that would appear in the *Post* once World War II ended. However, she knew that often, more than one model posed for a role, and no one knew who would ultimately be featured until the magazine was pulled from the mailbox. Now age twelve, she wore her Sunday dress and shoes and walked across her lawn to Norman's studio.

The ever-present Gene Pelham was ready with his equipment to help set up the session and take photos. As usual, Norman greeted her warmly. However, on analyzing her outfit, he sent her home. "Put on an old dress you usually wear outside. I want you to look like you've been playing." She returned in a worn flowered dress that pleased him. Norman instructed Ardis to stand and grip a picture frame as if it were a railing on a front porch. The sun projected a stream of light through the studio's front window. Norman was in his usual relaxed working mode. He explained the story he intended to tell and showed her his layout sketch. "World War II is over. Your mother has announced that your brother has just appeared on your back lawn. He's come home from the war. Everyone has hurried out to the porch. Your mother has thrown her arms open. Your little brother is so happy he's leapt down the porch steps." Norman continued, "You see your big brother standing in the yard in his army uniform. You feared he might never come back from Europe, but now the war is over. He's safe, and you are thrilled!"[4]

Standing at the makeshift railing, Ardis had no trouble bringing herself to the right frame of mind. For about the past five years—since she was six—she had overheard adults talking of fighting and bombings in faraway places. Ardis and her classmates at the one-room schoolhouse on the Green had picked purple lilac blossoms in spring and arranged the fragrant flowers in mayonnaise jars. In solemn ceremonies, they marched single file down Route 313. At the cemetery where both her family and the Rockwells owned plots, she felt sorrow as they laid flowers on the graves of deceased neighbors and a couple of local boys who had been killed in the war. She had volunteered to be the pen pal of Art Becktoft, the tall, lanky fighter pilot who helped the Edgertons load hay in their fields during the summer. He had been captured and put in a prisoner-of-war camp in Germany. She sent letters via the Red Cross.

People around town were predicting the unimaginable war *was* indeed almost over, and Ardis *was* overjoyed. She *did* feel strong emotions as she and her neighbors awaited the return of their young men.

"Your brother is home!" Norman exclaimed. "You're standing at your porch railing looking out at him. I want you to look like you have been taken by surprise. You are overjoyed, Ardis."

She felt her face curve into a smile. Gene snapped photos, but Norman was not satisfied. Norman grew intense, strutted back and forth, and called out in a loud voice, "You are completely surprised and really, really happy! You can hardly believe it."

After more attempts, Ardis was finally able to show a huge smile on her face. "That's great!" Norman exclaimed.

After Gene developed the photographs, he presented Ardis with one. It looked like a professional shot of a movie star! Her eyes were dramatic.[5] She sure hoped she would find herself on the cover of the *Post*. *He better put me on it this time! He said I did a great job.*

SHE *HAD* TO WATCH

One day after her modeling session, Ardis made her way across the lawn behind their home to his red studio at the foot of the mountain. She knew she should restrain herself, but her legs kept moving. As she strode, she glimpsed her family's cows roaming the mountain and the workhorses Prince and Dick ripping grass and chewing. Pigs rolled on their backs in dirt as they awaited their slop, and hens pecked the earth for insects and worms. The rooster

strutted across his territory in front of his hens and flapped his wings, "Er-er-errrr!" Ardis stopped next to the two slabs of rock that formed the steps below the door at the side of Norman's studio. She peeked through the screen. Standing at his easel, with his fireplace in the background, Norman leaned in toward his canvas and dabbed paint with a long-stemmed brush. His short brown hair was grayed at the temples above his wiry frame and long legs. His pipe lay on a table next to him in the usual manner. She wondered why he kept it close by. He rarely lit it. Ardis came to think of it as a sort of "security blanket."

Ardis felt invisible because she stood still and took shallow breaths as she watched him paint the orange bricks of a dilapidated building on his canvas. The girl almost jumped out of her skin when Norman called out, "You can come in, Ardis, if you sit and be quiet." *He must have known I was there all the time*, she thought. Ardis felt special as she sat with Norman, whose old pants and shirt were dabbed with paint. He explained that he had traveled to Troy, New York, to find a tenement house he could portray as the home of the soldier. "Do you like it so far?" he asked.

"Yes," she replied, but was more concerned with the thought that he might not include her in the final version, the *Post* cover. *Gosh, I hope I'm in it.*

On May 26, 1945, a couple of weeks after the Nazis surrendered in Europe, the *Post* arrived in the Edgertons' mailbox. *G.I. Homecoming* appeared on the cover. Ardis saw that the scene was bursting with excitement. At the center, the Edgertons' neighbor Jenny McKee had modeled as a mother who has thrown her arms open as wide as arms can open to welcome her son. He has just arrived in the yard. Jenny's real-life husband, the mustachioed West Arlington deputy Harvey McKee, had modeled for *Music Hath Charms*. Then Ardis spotted herself standing on the porch at a railing next to Jenny, looking like a movie star just as in the photograph! She felt even more special when she noticed that Norman had included himself as a wide-eyed man standing in the doorway behind her. He had colored the hair of almost every person red, whether or not it was their natural color. Norman had made her neighbors look like real actors even though none had ever stepped on a stage (figure 7.1).

A West Arlington handyman named John Cross Jr. posed as the homecoming soldier. Ardis's friend Billy Brown, who pitchforked hay with her in Jim's fields, modeled as a boy leaping down the porch stairs on his way to

FIGURE 7.1

G.I. Homecoming: West Arlington people posed for this painting, which celebrates the end of WWII in 1945. Ardis Edgerton Clark (gripping the post), Yvonne Cross Dorr (small girl), Billy Brown (leaping down steps), Norman Rockwell, John Cross Jr. (the soldier), Irene Hoyt (side of house). *Source*: Courtesy of the Norman Rockwell Family Agency.

greet his brother. John Cross Jr.'s real-life sister Yvonne, who played softball with Ardis, modeled as the cute girl peering behind Ardis. John Sr., a logger, modeled as the father kneeling on the porch roof with a hammer. All the Crosses, who were natural blonds, also appear in the car headed for a day at the lake in Norman's popular *Going and Coming*.

Longtime *Post* editor Ben Hibbs gave *G.I. Homecoming* his highest praise ever. "I have always felt it was the greatest magazine cover ever published."[6] Norman gave him the painting, and Hibbs hung it above the desk in his study. During the Society of Illustrators exhibition of 1946, the organization voted it their favorite of all on display, and it became the official poster for the US government's eighth war bond drive. The caption read, "Hasten the home-coming, buy victory bonds."

MARY'S HATS

As Ardis continued her work at the Rockwells, she noticed that Norman's wife was an extremely busy woman. Not only was she dedicated to helping him with his illustration business, she also supervised a cook and household, drove her children to and fro, picked up models, located props, and per-formed other tasks.[7] She would hurry from one to another. "Mary was all for Norman. Mary made Norman who he became. She was going every minute," said Ardis. She would even stand by Norman's easel, give him opinions on his work, and read to him. She made sure visitors did not go to her husband's stu-dio when a painting demanded his full concentration. "Norman was friendly with everyone, but sometimes he needed to be alone in the studio. He was well-protected with Mary."

As time passed, Ardis noticed that fatigue and sadness were gradually tak-ing over Mary's face. She became depressed and drank too much. It was hard for Ardis to watch her suffer because she was so kind.

For a time, the Rockwells were the only ones in the village to have a tele-vision and the first in town to have modern electrical appliances. One day, Ardis was sizing up a strange new machine in the Rockwells' kitchen. Mary appeared. "What is this?" Ardis asked.

"A dishwasher," Mary replied. She lifted the lid. "You load the dishes in it, and it washes them by itself."

"What do you mean? The only dishwasher around here is me!" Ardis laughed.

Ardis assisted Mary at dinner parties the Rockwells gave for other Arlington artists. She prepared food, polished silverware, and set the table. Mary would serve fresh meat and vegetables delivered to her home. Mary treated Ardis to fresh grapes and other fruits of a quality few in town could afford.

Mead Schaeffer, Norman's friend from his New Rochelle days, attended the parties and joined discussions about art. Schaeffer eventually illustrated forty-six covers for the *Post*. Like Norman, he too depicted members of the armed services during the war. He also illustrated nineteen classic books, including all the novels of Herman Melville, such as *Moby Dick*.[8] As a Rockwell model, Schaeffer appeared as the tattooist in *The Tattoo Artist*. His elegant daughters Patty and Elizabeth stood out among the regular people in West Arlington. Norman took advantage, featuring them in *Fixing a Flat* as two sophisticated girls in white dresses who are in the process of removing a flat tire from their car in front of a country shack, its lazy occupant gazing on from a porch chair. Another frequent guest, Jack Atherton, created a number of still-life *Post* covers, such as *Fall Bounty* (1933), *Allied Flags* (1943), and *Fishing Still Life* (1944). His magazine illustrations are bold and colorful. Atherton appeared in Norman's 1945 *Post* cover *April Fools* as a goofy fisherman trying to hook a fish in a plum can.

CLOTHES FOR ARDIS

After Ardis's teenage growth spurt, Mary would often pull a blouse or a dress from her closet. "Why don't you take this? I can't wear it. It looks like it will fit you." The clothing was more stylish than anything Ardis had ever worn. Funny thing was, some of the clothes appeared to be brand new. Ardis suspected that Mary had bought them for her and removed the tags so that she wouldn't feel embarrassed about taking charity. Ardis felt proud walking the halls of Arlington High School in the clothing Mary gave her.

One afternoon while Ardis was working downstairs in the Rockwell home, Mary called, "Come up to my bedroom." When Ardis entered, she noticed a pile of Norman's dress shirts lying on the bed. "Maybe you'd like these," Mary said. She explained that Norman had worn them with cuff links and suit jackets at cocktail parties during their New Rochelle days. Now he always wore plaid shirts with blue jeans or khakis.

"Are you sure?" Ardis asked. She rubbed the fine material and pictured herself proudly wearing Norman Rockwell's shirts around town. "Thanks,

Mary!" Throughout high school, she wore them knotted at the waist above blue jeans until they became threadbare.

Ardis's mother Clara also helped the Rockwells with certain tasks, such as carrying paintings to Philadelphia. Norman would pack them in crates he built in the back room of his studio. Clara felt honored, and the task put money into her pocket. At the time, she had no idea that the cargo she delivered would one day be worth millions of dollars. Clara modeled for the January 14, 1948, *Post* cover *Happy Skiers on a Train* with the playful Gene Pelham. A worried man outfitted in formal attire heading to a resort has found himself surrounded by a rambunctious group. Joining in the revelry, Clara sits at the back wearing a gray cap.

Ardis observed that Norman was not an eccentric, brooding artist who waited for bursts of inspiration as she imagined artists to be, but rather one who maintained a schedule. He was driven by the need to meet the strict deadlines of magazine and book publishers. He routinely sat for breakfast each morning and walked across the lawn to his studio at 8:00. After lunch, he napped and resumed working until dinner. He often continued into the evening, especially if a painting was causing him trouble. Although the artist attended social functions, he did not linger long after a main event.

Despite his ambitious nature, Ardis found Norman easygoing and fun to be around. "He always had a good chuckle."

NORMAN'S RECREATION

The country air refreshed Norman and gave him a break from tasks such as creating layout sketches, which he found most difficult of all. He hiked the mountain behind his house where the Edgertons' cows grazed. Ardis often noticed him walking his English springer spaniel named Butch or riding his bike along the graveled River Road next to the Batten Kill. In the spring and summer, he enjoyed the sweet fragrance of grass in green meadows, wildflowers, and mint. Fisherman would be casting their flies into one of the country's premier trout fishing rivers. He would pass the homes of many people he used as models. Norman enjoyed watching farmers and their helpers cut and rake hay and pitchfork it onto old wooden wagons. In autumn, he took in the breathtaking view of the orange, crimson, and gold foliage decorating the mountains and smelled the pungent odor of chopped corn being harvested and loaded into silos and wisps of wood smoke. In winter, blankets of snow

covered the Green, making the Batten Kill more dominant in the landscape. A skin of ice would form along the river's edges, but water flowed too fast to allow thick ice. April melted the last of the snow, and springs tumbling down mountains swelled the river, creating a rush of white water that sometimes overflowed its banks.

West Arlingtonians remember Norman as a man who enjoyed recreation that required little gear, such as tennis. He had been an avid player at the exclusive Bonnie Briar Country Club in New Rochelle. In West Arlington, he hired a contractor to build a clay court next to his studio and hired a pro named Beacom Rich to give him private lessons. As the two whacked the ball over the net one day, Norman began to feel guilty because his working-class neighbors could not afford the luxury. He soon treated Ardis, her family, and other neighbors to lessons.

Although he did not carry a rifle or a fishing pole, he tagged along with deer hunters and fishermen to observe them in their sport and enjoy their company. Perhaps he thought that maintaining guns and fishing equipment boxes would take his focus off painting. During the winter, he appeared at the frozen pond behind the Edgertons' home and joined folks in skating. He would often tumble to the ice. Ardis would be the one to help him get back on his feet.

Ardis and her family joined the Rockwells and other neighbors at the Saturday night square dances on the Green. They merely walked about seventy-five yards to the pavilion, which in summer stood in front of a field of corn.

In her early teens, Ardis would join the children dancing on the lawn in front of the pavilion. Her father had to have his feet on the floor at 3:30 a.m. to get dressed for morning milking and would bring Ardis home before the dance ended. However, she could not fall asleep until the band played its final tune. The music of a popular British tune would rise from the pavilion and float through her bedroom window:

> Goodnight sweetheart, 'til we meet again tomorrow.
> Goodnight sweetheart, sleep will banish sorrow.
> Tears and parting will make us forlorn
> But with the dawn, a new day is born . . .
> Goodnight sweetheart

After those final lyrics were sung, car engines roared to life. As headlights moved across her bedroom wall, her friend Norman would be on the dance floor pushing his broom to sweep the cornmeal that had been scattered for traction.

GIRLS' SOFTBALL

In addition to farm chores, helping Mrs. Rockwell, and doing schoolwork, Ardis cleaned five houses to save money for college. She used her right hand to work and saved the left for pitching. Ardis won many games and even threw a couple of no-hitters for the Batten Kill Dodgers. A lefty, Norman's apprentice Don Winslow coached her. Yvonne Cross, the little girl who stands on the porch with Ardis in *G.I. Homecoming*, also played for the Dodgers. She also posed as a cute girl blowing a bubble with chewing gum in *Going and Coming*. She can also be found in *The Voyeur* in a red hat, staring at a boy and his girlfriend who are nestled in a seat on a train.

On summer afternoons, Ardis would see her father and Norman rooting for her as she pitched. They would sit in a grass-covered triangle formed by a fork in River Road. Jim and Norman found plenty to discuss despite the fact that one came from New York City and the other was a native of rural Vermont. Although Norman passed on doing farm chores, Ardis would find him standing in the barn while her father milked. He and her father took an interest in each other's children and worked together on some community activities.

Ardis's grandmother Elva, a fixture on the Edgertons' porch, watched the games from her rocking chair, knitting all the while. Elva was a woman so thrifty that she used the strings that tied animal feed bags closed for her projects. Although Ardis remembered her as a reasonable woman, Elva had a stern expression etched on her face. Norman's son Jarvis once remarked, "She looked like she was weaned on a sour pickle." Norman considered Elva a terrific model for *Going and Coming* and painted her with that same look on her face both leaving in the car in the morning and coming back in the afternoon. Everyone else appears fatigued in the second frame.

Ardis and her family enjoyed other special times with the Rockwells. Her favorite was her family's annual watermelon picnic in their meadow by the Batten Kill. Their workhorses Prince and Dick would pull the hay wagon filled with both families toward the river. "It was the only time we had wa-

termelon. I remember that the most," Ardis recalled. Ardis also enjoyed an annual lobster bake put on by Bob Benedict, owner of the auto repair shop in Arlington where Norman staged *Homecoming Marine*. "A lot of the neighborhood, including the Rockwells, would go to Bob's hunting cabin. It was a lot of fun for us."

THE LONG SHADOW OF LINCOLN: AN EDGERTON AFFAIR

In addition to *Homecoming G.I.*, Ardis modeled with her grandmother Elva, her father Jim, and brother Buddy in the wartime painting *The Long Shadow of Lincoln*. She posed kneeling in front of a graveside cross with her hands folded in prayer. "It's a collage that teaches the horrible effects of war," Ardis explained. She recalled how the $5 that Norman paid Elva for posing paid for a good amount of knitting supplies. "My grandmother was pretty proud of those paintings," said Ardis, referring to this appearance and in *Going and Coming*.

During summer days of the early 1940s, Jim and the young people would harness Prince or Dick to pull wooden wagons along rows of raked hay while a crew of young people pitchforked loose bunches onto wagons with the hot sun on their backs. Ardis's beagle Spotty, white with black spots, would run alongside the wagon. Art Becktoft, the fighter pilot turned German prisoner of war who posed for *Back to Civvies*, would join them.

Ardis recalled the jitters she felt the first time she took the wheel of her father's Doodlebug tractor during World War II. She feared she might jerk the tractor and throw the workers off the wagon if she let the clutch out abruptly. To her relief, Tommy Rockwell climbed in. "Let me show you how to drive it," he said gently. He guided Ardis as she moved the shifter into gear and instructed her to let the clutch out gradually. She felt herself rise to a new level of confidence as she drove her father's Doodlebug across the meadow. Back at the barn, the Edgertons, Tommy Rockwell, Billy Brown, Art Becktoft, and other helpers loaded hay by lowering a grappling hook on a cable. It would grab a bunch of hay on the wagon in its jaws. Someone would coax Prince or Dick—or move the Doodlebug forward—until the cable lifted the load to the barn's second-floor window. The upstairs helpers would pull the load inside, where others would pitchfork the hay into the mows. Most often, Ardis found herself as one of the stompers, leaping up and down on the hay to pack it. After haying, Ardis would sometimes play basketball with Tommy on the full

court between the mows. She believed these activities distracted Tommy from worrying about his mother, who suffered from depression through the 1940s and early 1950s. Ardis's mother Clara gave him support as a "second mom" just as Mary was a "second mom" to Ardis (figure 7.2).[9]

Norman had to look no further than Jim Edgerton's barn next door to discover Billy Brown, who was as spirited as one of literature's most celebrated boys, Tom Sawyer. The artist had actually illustrated Twain's classic in the mid-1930s. The process of bringing the colorful characters to life had brought him out of a long slump, and Billy was one of the Arlingtonians who helped him remain inspired. Billy, a hardworking kid who worked in the Edgertons' hay fields, not only modeled as the boy leaping off the steps in *G.I. Homecoming* next to Ardis but also appeared as a rowdy boy sticking his body out of the car in *Going and Coming*. Billy came from an old West Arlington family of rugged working folks.

FIGURE 7.2
Norman's next-door neighbors, the Edgertons, and farmhands. Front, Billy Brown. L to R, Ardis Edgerton, Al Cleary, Clara Edgerton, Art Becktoft Jr., Marilyn Johnson, Joy Edgerton. Atop the hay is Jimmy Edgerton. *Source*: Courtesy of Ardis and Buddy Edgerton.

"Billy could handle any situation Norman gave him." Ardis remembered him, two years younger than herself, as "a cute little guy" with a mischievous side. Norman got good use of Billy, who also appears with his elderly neighbor Charlie Crofut in *Old Man and Boy Skating*, a painting published in a *Four Seasons Calendar*. Norman gave it the distinction of appearing on the cover of his popular textbook *Rockwell on Rockwell*. Norman liked best to paint old men and boys like Charlie and Billy, the former because their faces told the stories of their lives and the latter because they caused people to remember their childhoods.

Ardis graduated from the schoolhouse and attended Arlington Memorial High School. Tommy started as a guard on the team, while Ardis played on the girls' team. Tommy was editor of the yearbook; Ardis was the business manager. Already an aspiring writer, Tommy published his poetry in the school yearbook and joined the Allied Youth Club, a group of peers who encouraged one another to abstain from alcohol. Ardis acted in the school's senior mystery play called *Sally from Cherry Valley*, a beauty parlor murder mystery.

A MODEL'S DISAPPOINTMENTS

Ardis eventually felt disappointed because during his Arlington days, Norman included her in only two paintings: *The Long Shadow of Lincoln* and *G.I. Homecoming*. He never depicted her as the dominant model in a painting. For example, he had her sit for the popular *Post* cover *The Babysitter*. When it appeared in 1947, she saw that a neighbor named Lucille Towne Holton won the part. Later, when she reflected on the situation, she realized that Norman had never attempted to evoke a facial expression. Ardis was a good sport and said in jest, "Lucille did it much better than I could have. I was too good looking for the part." Ardis also posed for *Girl at the Mirror*, but neither she nor Sharon O'Neil, daughter of Arlington physician Jim, "made the cut." Mary Whalen is the girl featured.

Ardis also recalled a time in 1948 when she posed for a painting called *The Dugout*. Norman promised she would appear on the cover of the *Post*. He explained the story. "It's the end of the season, and the Chicago Cubs have had a miserable year. Their fans are disappointed, and the players feel awful. You're sitting behind the dugout. You're disgusted with the team." Norman

demonstrated by sticking out his tongue. Ardis mimicked him to his satisfaction. She felt sure he was going to include her because she found herself in the color study. However, when the *Post* cover appeared, she learned that a man in the Cubs' organization had persuaded Norman to replace her with the wife of one of the team's executives. "That's okay," said Ardis with a smile. "I got my $5 modeling fee."

FIGURE 7.3
Norman Rockwell's wife Mary at about the time of their wedding in 1930.
Source: Courtesy of Jarvis Rockwell.

FIGURE 7.4
Norman and Mary as newly-weds with their dog Raleigh in New Rochelle, New York, circa 1930. *Source*: Courtesy of Jarvis Rockwell.

FIGURE 7.5
Norman and Raleigh in New Rochelle. Source: Courtesy of Jarvis Rockwell.

FIGURE 7.6
The Rockwell family's first home and Norman's studio in a renovated barn in West Arlington, Vermont. *Source*: Courtesy of Jarvis Rockwell.

FIGURE 7.7
Tom and Jarvis (with their father seated in river) enjoyed swimming in the brisk Batten Kill River in West Arlington. *Source*: Courtesy of Jarvis Rockwell.

FIGURE 7.8
The Rockwell's 1792 white Colonial on the West Arlington, Vermont, Village Green. *Source*: Photo by S. T. Haggerty.

FIGURE 7.9
Norman's West Arlington studio and the family's Springer Spaniel Butch, who posed in such paintings as *Going and Coming*, in which a family leaves for a day at the lake enthusiastic but comes back exhausted. *Source*: Courtesy of Jarvis Rockwell.

FIGURE 7.10
L to R, Norman's son Peter, Jarvis's friend from Korea, Mary, and Norman in front of their West Arlington home on the Village Green with their dog Butch. *Source*: Courtesy of Jarvis Rockwell.

FIGURE 7.11
Norman at his easel in West Arlington. *Source*: Courtesy of Jarvis
Rockwell.

She eventually came to feel that the good times she enjoyed with the Rockwells more than compensated for her lack of starring roles. "I would have liked to be in every one I modeled for, but I enjoy seeing neighbors in them too." She mentions many photographs and props Norman had given her. After Norman finished *Tired Salesgirl at Christmas* in 1947, she happened to be in his studio. "Ardis, would you like these?" he asked, pointing to the $48 worth of dolls he had arranged behind the exhausted clerk. She loved the gift and eventually gave them to her children to play with.

The years passed, and when it came time for Ardis's senior trip to Washington, D.C., in 1951, Mary Rockwell presented her a brown wool suit and a blouse with a streak of lavender that complemented it nicely. "Would you like some other things to go with the suit?" Mary asked. "That would be nice," Ardis replied, excited. Mary drove her to Troy, New York, for a shopping adventure. On the trip, Mary told Ardis how happy she was that Ardis had done so well in high school and encouraged her to attend Castleton Teachers College. She bought Ardis brown suede shoes and gloves. That week, Norman drove to Bennington, where he bought a special watch, had her name engraved, and presented it to her. "I thought that was pretty nice," Ardis said.

One day during high school, Norman appeared at the Edgerton home with famous movie actress Linda Darnell.[10] She had come to see Norman to discuss publicity but also sat at an easel and tried her hand with a brush for several days. Norman had met her when she modeled for his painting *Murder Mystery*. Darnell, known as "the girl with the perfect face," starred in major films alongside Kirk Douglas and Henry Fonda, two popular leading men. She had a lead role in the classic *Star Dust* in 1940 at age sixteen. "We normally didn't meet movie stars in West Arlington. Norman knew we would get a kick out of it. Imagine a farm girl like me shaking hands with someone like Linda Darnell. She had these long fingernails with red polish. Her hand felt just like velvet." Perhaps Norman wanted Darnell to meet the down-to-earth people who had helped to stabilize his family.

Although she was only in her late twenties, Darnell's career was declining. She had experienced tragic romances and drank enough to spend time in rehab. "Norman had a lot of empathy for people," Ardis said. Tragically, Darnell died in 1965 at the age of forty-one the day after a house fire caused severe burns on her face and body. When the blaze ignited, she was watching herself in *Star Dust*.

As for the painting called *Murder Mystery*, *Post* staffers could not figure out whodunit by the clues Norman offered. It was never published. Norman attributed this to using actors. Years before, he had given up the practice of using professional models because they would appear stiff.[11] One of the actresses, the great Ethel Barrymore, flattered Norman when she told him that she remembered him from his teenage years when they had sketched together on Saturdays in Mamaroneck, New York.

Ardis earned the distinction of salutatorian when she graduated from Arlington Memorial High School in 1951. Tommy Rockwell was the valedictorian. He titled his speech "Getting the Beans Baked Right." For her part, Ardis researched and spoke about the evolution of the Arlington school system and the schoolhouses that flowed into the high school. Mary wrote a recommendation to the Elks Club, and Ardis received a modest albeit appreciated college scholarship award. Ardis attended Castleton State College. Norman noticed a drawing she had done on poster board. He built a black wooden carrying case. "He wanted me to have something professional looking."

MARY WEARS DOWN

Ardis continued helping in the Rockwell household as her college schedule permitted. She began noticing that Mary appeared even more strained and melancholy and continued to drink too much. Soon, Mary began spending more time at the Riggs Center. In addition to not resting enough between all the tasks she performed for Norman and the kids, the loneliness of empty-nest syndrome had worsened. Peter had remained in boarding school, Jarvis was in the air force, and after graduation, Tommy went away to college. Most of the Edgerton children had also left by that time. Mary also sometimes felt overwhelmed by the spotlight shining on her husband. She struggled in her efforts to achieve success as a writer and longed to spend more time with intellectuals like she had known at Stanford University. "Depression wasn't something people talked about in those days. No one considered it a disease," explained Ardis. "She just handled things the best she could. She was a wonderful, wonderful friend to me. She helped mold me into the adult I became."

To pay the substantial bills incurred at the Riggs Center, Norman logged even more hours at the easel, and he too wore down emotionally. Ironically, during that painful period, he created three of his all-time best: *Saying Grace*, *Breaking Home Ties*, and *Girl at the Mirror*. In *Breaking Home Ties*, he

projected his own lament at becoming an empty nester in the weatherworn farmer's face.

WEDDING GIFTS

In 1951, Ardis became engaged to Ray Clark, whom she met at the Arlington Federated Church youth group on the east side of town. May Walker, the elderly woman who modeled for *Saying Grace*, the most popular painting Norman created during his career, attended the same church. Ray's parents owned Clark's IGA supermarket in Arlington, which had provided the setting for *Shuffleton's Barbershop* and was the place Norman and the boys had their hair cut. The proprietor, Rob Shuffleton, along with a few other men are depicted as musicians making music in the back room in a glow of warm amber light.

Ardis and Ray decided to marry before he reported for duty during the Korean War, which had started a year earlier when North Korea invaded South Korea. The navy's most important task at that time was to aid the United Nations in preventing a catastrophe in Asia. President Truman warned the Communist Chinese leaders that the United States would not tolerate an attempt to escalate the war. Ray would be joining the navy crew aboard the aircraft carrier USS *Midway*.

As her wedding day approached, Mary drove Ardis to a Manchester, Vermont, hardware store, where she purchased a set of Spode China as a gift. It was the same English brand she had washed in the Rockwell household. On the morning of Ardis's wedding, Norman and Mary appeared in the Edgertons' home, vacuumed the downstairs, and placed silver candleholders on the fireplace mantel. They also paid for the wedding flower bouquets and hired the photographer. Standing prominently on the Green that evening, the two elegant white Colonial Twin Houses were so fabulously illuminated that a traveler knocked on the Edgertons' door and inquired about room rates. He believed it to be a grand hotel.

8

A Marine's Commander

The only time the people of West Arlington sat in traffic jams on rural Route 313 was on Saturday nights as the starting time of a square dance approached. Held in an open-sided pavilion, these dances were marvelous affairs. During that era, a charismatic caller named Ed Durlacher ignited a craze across the United States. As many as ten thousand people swarmed to a single event in New York's Central Park for country dancing.[1] He taught them to swing their partners in dances such as "Honolulu Baby." To join in the Arlington hoedowns, people came from many parts of southern Vermont and nearby New York State. Because Vermonters didn't have televisions yet, they had to leave home to find entertainment, such as street fairs, church suppers, and community dances.

After sitting in the long line of cars, a US marine named Duane Parks finally reached the plank-floor, wooden covered bridge. The old structure rumbled under his tires as he crossed over the Batten Kill to the Green. Riding with the twenty-year-old from Dorset, Vermont, were three of his seventeen brothers and sisters from their blended family. Twenty miles to the north, Dorset residents made their livings much like the people of West Arlington, working on dairy farms and in small furniture factories, country stores, shops, and restaurants. Dorset boasts of having opened the first marble quarry in the United States.

As Duane strolled past the little white church over the field to the pavilion, the young man hoped the fiddlers, country singers, and callers he loved would take him away from the fear of being shot at and having to shoot down Japanese fighter planes. Duane was home on leave after completing boot camp at the US Marine facility in Parris Island, South Carolina. His brother Ray had provoked him into the military by saying, "Duane, you're not tough enough to join the Marines."[2]

Duane's nerves were wound tight as a fiddle string that evening.[3] He couldn't shake the thought that the Marines would soon ship him to the hilly, muggy tropical island of Guam in the South Pacific to take a combat role. The Japanese had taken over the Pacific island and had forced the residents into hard labor building airstrips and underground tunnels and even executed some. The United States had been strategizing how the Marines and other branches could invade and seize Guam to build a military base. Concurrently, the Allied forces, led by the United States, England, and Russia, were bombing the Nazis in Hamburg, Germany.

It had been a letdown, to put it mildly, when Duane had returned to Vermont from boot camp. The camaraderie of other marines on Parris Island had been electrifying. They loved their country and faced a common enemy. He had become pals with men in the mess hall, during physical training, and in their barracks. Weapons instructors had trained him to fire an antiaircraft gun. He felt pride swell in him as his platoon sung the Marines' rousing song: "From the halls of Montezuma to the shores of Tripoli, we will fight our country's battles on land as on the sea. . . . The United States Marines." When he returned to the quiet woods of Vermont, fear seeped back inside.[4]

Prior to facing war, life had not proved easy for Duane. He often felt obligated to sign his paycheck over to his mother so she could pay the bills. Much of his spare time was spent laboring for free at his sister's farm.

Perhaps he'd find a lover that night. During a break, they might take a walk on the gravel road in blue moonlight and sit on the bank of the Batten Kill. They could gaze at a sky crammed with stars above the surrounding mountains, which cast deep shadows in the background. People who didn't mind the brisk temperature of the river, fed by mountain brooks, could take a swim.

THE TICKET TAKER AND SCOUT

At the same hour, Norman Rockwell eagerly awaited the opportunity to get out on the floor and dance and, as always, check out the scene for models. He dressed in a flannel shirt and blue jeans and clipped on a bow tie. Mary was getting herself and their three kids ready. After his studio three miles up on River Road burned down, he had moved to his white Colonial on the Green, one hundred yards from the dance floor.

These dances were also the highlight of the Rockwells' social calendar and a far cry from Norman's former social life in the affluent New York area. He had partied in the F. Scott Fitzgerald literary circles and was honored at the most prestigious art events. He now cherished dancing around the pavilion with country music with this down-to-earth crowd. He genuinely enjoyed these events and would break out in laughter if he missed a step or a turn.

On that summer evening, he stepped off his porch, crossed the gravel road, and walked over the field to the pavilion. He had volunteered as a "ticket taker" during the regular meeting of the local Grange, the agricultural organization that hosted the dances. His position at the rustic pipe-railing ramp at the side of a concrete ramp doubled as a lookout spot. He found many a model at dances, such as Bob Buck, who modeled as a soldier for eleven paintings in the Willie Gillis series. Perhaps he could find one to pose for a new World War II painting he had in mind.

At that time, Norman could hear the thunder of war in Europe and the Pacific echoing through the Green Mountain Valley. During the first couple of years, many residents of southern Vermont doubted the war was even taking place because they didn't have access to television news, and few owned radios. But by this time, they could not deny the reality of the attacks of Nazi Germany and Imperial Japan on the Western world. The military had plucked young men from southern Vermont and, after brief periods of training, shipped them overseas to fight. The fatigue, bewilderment, and fear on their faces spoke loudly to Norman, who would see them around town, at the Green Mountain Diner, or at the square dances.

When Duane Parks reached the pavilion with his red hair tucked neatly under his cap, a ticket taker with short curly hair stood at the pipe-railing ramp. He wore a bow tie and clenched a pipe between his teeth. The man looked Duane over from different angles like a cop. *Why is this man looking at me this way? This is weird.* The marine made his way onto the floor.[5]

The crowd often overflowed the pavilion, which was set in front of a corn-field that would be harvested in the fall by the Vaughn family, Norman's next-door neighbors. The patriarch, the short, slender, but rugged farmer named Curnel Vaughn, would soon appear in *The Long Shadow of Lincoln*, holding a set of building plans and a framing square. It would be a collage telling about the horrible suffering that war causes.

Since the floor was crowded, some adult sets were forced to dance on the lawn with the children, who were honing their skills. Smaller children and babies slept in cars; most everyone knew each other and kept an eye on them. Vendors sold sandwiches, hot dogs, and drinks. The smell of popcorn wafted through the air. A man named Hershey Pease, a familiar face in town, vended snacks from an elegant custom wagon.[6] It was painted in bright colors with pinstripes and could also be seen at baseball games, lawn parties, and band concerts. Periodically during the summer, a rowdy bunch that had drunk too much might pick a fight but nothing that would turn into an all-out brawl.

After giving his ticket to the man with the pipe, Duane stepped onto the floor. As he danced, his shoes ground the cornmeal that coated the floor with a waxy substance. Before the evening began and during intermission, Norman's friend down the road, Sidney Crofut, a farmer and Grange officer, would sprinkle the gritty material on the floor to aid traction. Five in his fam-ily appeared in Rockwell paintings, including his wife Rena, wearing glasses in *The Gossips*, and his granddaughter Doris, in curlers.

During a break from do-si-dos, promenades, and sashays, Duane chatted with a group sitting on a low wall to the side. He smiled easily and joked as he looked for his next partner. A man or woman could ask anyone to dance, whether single, married, or in a relationship. Duane noticed the tall, skinny ticket taker with the bow tie and tobacco pipe looking him over again. *Who the heck is this guy? I'm in no mood for this.* Feeling tense about his deploy-ment made him more irritated than he normally would have been.

Soon, the man stood before Duane and took his tobacco pipe out of his mouth. "I'm an artist," he declared. "How would you like to model for a painting I'm going to do?"

"Hell no!" Duane barked. "I ain't posing for no darned artist!"[7]

"But I have the picture all sketched out. I know how I'm going to portray you." As with Ruthie McLenithan, Norman appreciated the vibrant red of Duane's hair; it would draw the attention of readers.

"I said 'Hell no,'" Duane snapped. Duane fancied himself a rugged out-doorsman who liked to hunt deer and fish. He could be gruff and stubborn at times. He wasn't the type to associate with artists! The marine located his sister Lorraine and related what the artist had said. Twin sisters Jean and Jane listened in.[8] He scanned the floor until he could point out the so-called artist. "That's him," Duane said, pointing out the tall, slender stranger.

Duane watched his sister's expression turn from curious to stern. Lorraine projected a sharp look at him. "Do you know who that man is?"

"No, and I don't care. I ain't posing for no old coot."

"I hope you weren't rude. He's Norman Rockwell."

She pointed up to Norman's white Colonial house standing in plain view across the field. "He lives there."

"Who the heck is Norman Rockwell?"

He's the famous *Saturday Evening Post* artist." Lorraine refreshed Duane's memory regarding *Post* covers.

"Who cares?"

Duane danced the night away. The caller instructed four couples in "sets" to walk around their partners in do-si-dos and march their partners around in promenades. Fiddle, banjo, and guitar music echoed through the valley. The excitement displaced Duane's fearful visions of fighting in some mysterious land.

At the hour Duane was driving back to Dorset, Norman was engaged in his ritual of sweeping up the cornmeal. Norman loved to clean. His studio was immaculate. We can assume the artist was disappointed at the marine's rejection, but the gears of his tenacious mind were churning, contemplating where he might search next. Perhaps he was flipping through the Rolodex he kept in his head.

ANGRY TROOPS

The next morning, Duane awakened to his mother and sisters hovering menacingly over his bed. It took the groggy marine a moment until he realized that his insult of the artist had caused the assault by these angry troops.[9]

"Duane, you better go to Mr. Rockwell and apologize," spat his mother Blanche. Mrs. Parks had become easygoing, having raised eighteen children, but now she was tough as a drill sergeant.

The marine pulled his covers up over his head. "Get out of here, everyone," he shouted.

His sister Lorraine and the others joined their mother and fired away. "You're an idiot, Duane. It was rude the way you talked to Mr. Rockwell. He's a real famous artist. Everyone knows him. . . . This is a once-in-a-lifetime chance! You better model for that painting."

Duane clasped his sheets and blankets as the girls tried to rip them away.

"Get up! Get up! You're going to call Mr. Rockwell."

Duane finally flung his covers. "Okay. Okay. I'll do it. Just get out of here. Leave me alone!"

Duane refused to call Mr. Rockwell, so Mrs. Parks did and apologized for her son's behavior. "Duane will be there when you need him."

MODELING IN BENEDICT'S GARAGE

Meanwhile, Norman arranged to have the modeling session at the repair shop of his mechanic Bob Benedict across from the Arlington Inn on Route 7. Bob was also the man who hosted Norman, Mary, and their son Tommy for picnics at his hunting cabin. Norman usually asked models to pose in his studio where props, equipment, and his easel were an arm's length away. However, the rustic setting of Benedict's garage would be key in making the painting of a group of friends huddling around a marine telling war stories feel genuine. He loved the car parts and mechanics' tools strewn about. Gaskets, rubber belts, and spools of wire hung on the walls. A heaping pile of tools and an oil can sat next to a vise on a cluttered old workbench. Norman also arranged the session at the garage because, though a friendly man, Benedict also gave the appearance of a tough guy at times (at least rambunctious Arlington kids thought so). When they were acting up on the school bus he drove, one intense glare from Bob's eyes straightened them up.

The day Norman returned to the garage to confirm a date, the state of the garage distressed him. The Benedicts had cleaned the garage thoroughly and put all car parts and tools in order! They had no idea that Norman had his heart set on depicting the garage in its natural state. Norman explained to Bob that he considered the clutter a vital part of his painting and asked if they could please restore it. When Norman went back, the place was marvelously disorganized once again.

Chuck Marsh, who lived nearby and modeled for a number of paintings, such as *Day in the Life of a Boy* and *Christmas Homecoming*, heard a slightly different story.[10] He claims that after Norman found the garage organized, he told Benedict he would no longer stage the painting there. He waited and let time do its job.

"The garage found its way back to its normal cluttered self," Chuck laughed.

Once it did, Norman begged the Benedicts, "Please! Leave everything the way it is. Don't touch a thing."

Norman called Blanche and made an appointment for Duane. He explained that he wanted her son to model in the uniform he wore at the dance and that he would be posing as if telling war stories to a huddle of friends even though Duane had not experienced combat. After his mother hung up with Norman, Duane protested. "I don't want to go down there. I don't want to do it."

"Would you quit your bellyaching," Blanche said. Blanche commandeered her son into the car and drove him to the center of town across from the Arlington Inn. She forced him to march into Bob Benedict's garage.

For his modeling session, Norman explained that he wanted Duane to pretend that he was describing situations soldiers might experience and to maintain a serious expression. He positioned his young son Peter seated next to Duane. Wearing his uniform, Duane held a Japanese flag painted on a grease rag by Gene Pelham.[11] Norman went to great lengths to create body language, such as facial expression, posture, hands, and hair, that would be specific to the painting. The creases on the marine's forehead tell the story of fatigue. Norman had him hold the flag loosely as if he is humble in victory.

The *Post* published *Homecoming Marine* as its cover about two years after Duane posed. Norman described it as a marine telling stories of Iwo Jima rather than Guam, where Duane was headed. Viewers sense camaraderie between the folks huddled. In real life, they did indeed share a common enemy. Norman had all the models lean in toward one another and focus on Duane to make it evident his stories have captivated them. Two of the models, Peter and Jarvis, were Norman's sons, and all are Arlington neighbors, which helped to create the aura of authenticity for which Norman strived. Viewers sense the closeness between the folks in the huddle. Peter Rockwell, whose hands are clasped, and Duane sit with their legs touching as if family or close friends. Norman's son Jarvis, the boy with the "R" on his sweater, appears to

be fidgeting, and his shoulders brush the man next to him, the garage owner's brother. The letter "R" stands for Camp Ropeoa, a New Hampshire camp he and Peter had attended the previous summer. Norman and Mary thought it best to send their children away for the summer of 1943 while Walt Squiers constructed Norman's new studio on the Green. Norman rounded up two others from town as well—Herb Squiers and Nip Noyes. Herb sits with his back to the viewer, completing the circle of listeners. Sometimes, depicting someone from behind could be as telling as a frontal view. Noyes, who modeled as a policeman, worked as a night watchman and in-house newspaper editor for Mack Molding Inc. The Arlington company makes plastic parts for various industries (figures 8.1 and 8.2).

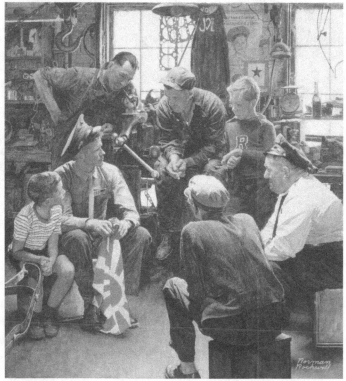

FIGURE 8.1
Homecoming Marine: L to R, Peter Rockwell, Marine Duane Parks, Bob Benedict Jr., John Benedict, Jarvis Rockwell, Nip Noyes, Herb Squires. *Source*: Courtesy of the Norman Rockwell Family Agency.

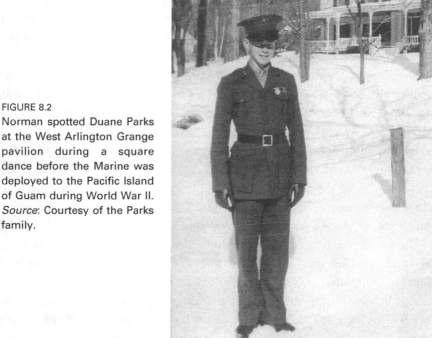

FIGURE 8.2
Norman spotted Duane Parks at the West Arlington Grange pavilion during a square dance before the Marine was deployed to the Pacific Island of Guam during World War II. *Source*: Courtesy of the Parks family.

THE SETTING OF IWO JIMA

The US military landed on the Japanese island of Iwo Jima, the subject of the *Post* cover, 750 miles off the coast of Japan, on February 19, 1945, and fought a ferocious five-week battle. The United States believed the island could make a strategic location for an airstrip should it become necessary to attack mainland Japan.[12] After bombing Iwo, the United States believed it had eliminated many Japanese troops. However, the air raids failed because the enemy had hidden in mountainous areas, and the Japanese made a surprise attack after seventy thousand marines landed. The marines found it difficult to establish footing in the soft volcanic ash on the beaches, so a five-week battle ensued.[13] Eventually, the United States suffered more than twenty-five thousand casualties, including nearly seven hundred deaths. Approximately twenty thousand of twenty-one thousand Japanese were killed because they refused to surrender and fought until the bitter end.

To force Imperial Japan to surrender once and for all, the United States dropped its atomic bombs. The president did so with great reluctance, but the military calculated that the bomb saved more than a million lives on both sides because it made it unnecessary for the United States to fight on the Japanese mainland.

Soon after the summer of 1943 West Arlington dance, Duane *did* find himself in a position that would give him war stories to tell like soldiers told about Iwo Jima.[14] The Marines shipped him to the Pacific, put a machine gun in his hand, and he fought on the ground in the Second Battle of Guam.

Beginning on July 21, 1944, the Marines, the US Army, and the US Air Force fought to end the occupation of that South Pacific island. By October 10, they defeated the Japanese, nearly wiping them out. Again, despite how badly they were being beaten, the Japanese would not quit. Almost two thousand Americans died; six thousand were injured.

Duane returned to Dorset when his enlistment ended. On publication, *Homecoming Marine* became an icon for World War II military service, and Norman considered it one of his favorites. In the Society of Illustrators 1946 exhibit, it was voted the number one painting. Reprints of *Homecoming Marine* remain popular today. In *Rockwell on Rockwell*, Norman referred to the marine as "Duane Peters," a fictitious surname because the marine had not been decorated with the Silver Star and Purple Heart medals he painted on his uniform.[15]

An Extravaganza of Red

Each year, Norman created illustrations for the BSA to be featured in an annual calendar published by Brown and Bigelow. These were the country's most popular calendars. In 1949, Norman decided to feature Cub Scouts. He phoned a Scoutmaster in Bennington, Vermont, named Duncan Campbell and explained that he planned to use a Cub Scout in his next Brown and Bigelow calendar. Campbell operated a business called Bennington Display, which produced products like merchandise racks for grocery stores. He asked the Scoutmaster if he would recommend some boys who would make good models.

Norman explained, "I'll need them to come to West Arlington."

"I'll bring my whole den to your studio," Campbell replied. "You can choose them."[1] Campbell worried a parent might feel hurt and blame him if Norman did not select his child. After all, people considered an opportunity to model for Rockwell quite special.

A few days later, Campbell rounded up the boys and drove them to West Arlington, a half-hour trip. Bennington is one of Vermont's largest towns but maintains a rural character.

Campbell led the boys through Norman's studio in single file. Norman looked them over from various angles. The artist was pleased when he spotted another person with hair of the glorious color red. The boy's name was Tommy Paquin. In his first Vermont painting in 1939, the redheaded girl in *Marbles Champion* made a winning illustration. For *Homecoming Marine*

in 1945, his redheaded model Duane Parks had been a hit. During the same year, he went so far as to create a whole family of redheaded characters in *G.I. Homecoming*. In real life, some were natural; others were not.

Norman decided he would have Tommy Paquin model with the "Scout who was never a Scout," Buddy Edgerton. Tommy's parents were impressed at the thought of their son becoming a Rockwell model. When the calendar appeared, the painting featured Tommy sitting next to a tree with another boy. They are dreaming of being Boys Scouts while admiring Buddy warming himself by a campfire. When Tommy found the artist putting a $10 bill in his hand at the close of the session, modeling suddenly became a marvelous opportunity. He could put some money in his bank account, even after buying a pile of candy and a toy or two. He returned to Norman's studio for a second session, and Norman laid another whopping $10 bill in his hand.

"Would you be willing to come back again?" Norman asked.

"Sure," Tommy replied. "*I'll model any time!*"

TRUMPET PRACTICE

Before long, Mrs. Paquin heard Norman Rockwell's voice on the phone again. "Could you bring your son back to my studio?" the artist asked. Norman had an idea for a new illustration that would pay tribute to the country's most famous artist of that era, Grandma Moses. He would include a work by Moses in the background; a redheaded boy would be essential.[2]

She assured him her son would be happy to model again.

"Don't have Tommy get all dressed up. Bring him in the same clothes he usually plays in outside. I want him to look natural."

The boy looked up into his mother's face as she explained, "Norman Rockwell wants you to come to his studio to model for another painting. Something about a boy playing a trumpet."

Tommy thought, *I don't want to go back. It was hard work to move into all the poses Norman wanted. But maybe he'll pay me $10 again. That's a lot of money.* Only if he went back to West Arlington would he find out. Tommy dressed in his play clothes— dungarees, shoes with creases and scuffed soles, and socks with bands of yellow, red, and green. His face curved into a smile when Norman turned to Tommy's mother. "The clothes are perfect."

Holding what looked to be a trumpet, the artist bent down to make eye contact with Tommy. He explained the story he would tell with his brush. "Imagine you are playing in your backyard. You're having a lot of fun. Then your mother calls you to come inside to practice your trumpet. You are angry. You throw yourself into the chair. . . . That's not hard to do, is it?"

It won't be hard it all. "No," Tommy replied, cracking a smile. He wouldn't have any trouble acting out that scene.

"Let's get to work," Norman said. They stepped over to a large, comfortable lounge chair. To the side of them, the steep steps climbed to a balcony and behind them was a fireplace. The chair was embroidered with bright pictures of white houses with red roofs and shutters and black cows with chickens silhouetted on a white background. Norman explained that the mother of Louis Bellemare, who owned a furniture store in Bennington, had copied a Grandma Moses painting on the slipcover. "Grandma Moses is a friend of mine," Norman said. Tommy knew the Bellemares and had heard of the lively old-lady artist.

In fact, everyone seemed to know the story of Grandma Moses, who had started her art career in her elderly years. She was even more famous than Norman. People saw the plainspoken, spunky old lady with white hair and round wire-rimmed glasses on covers of newspapers like the *Bennington Banner* and the *New York Times* and magazines like *Time*. About ninety years old at the time and still going strong with her brush, she lived a short distance from West Arlington in Eagle Bridge, New York, another small village. Some in town knew her personally and told stories about her. She inspired people across the country and in Europe to believe it was never too late to start a new career. Just a few years before, President Harry Truman had personally given her the Outstanding Achievement Award.

From the brilliant embroidery and one of the rings around the socks to the carrot color of Tommy's hair, Norman would showcase the color in dramatic shades that would leap off the page to draw viewers' eyes. The boy threw himself into the chair with the loud red cover. Norman handed him the small brass instrument that appeared to be a trumpet and explained that it was actually a cornet, which he had borrowed from his son, also named "Tommy."

Norman lifted the cornet and pretended to blow into the mouthpiece. "I want you to take a deep breath and blow hard." Norman puffed his cheeks and blew into it. "Like this."

Tommy took the instrument and ballooned his cheeks large and round.

"Now I want you to do it again and show that you're angry. Remember, your mother just called you inside. You were having fun outside."

Norman became demanding. "I want you to sit up straight and blow hard as you can."

Tommy complied, but it annoyed him that he had to make himself look angry, sit up straight, and blow on the cornet all at the same time. However, he couldn't argue because Norman was paying him. Norman's assistant Gene began snapping photographs. At times, the artist stopped and took some time to sketch on a pad.

"Now lean forward and blow hard . . . slouch down. . . . You're angry you have to practice."

I am getting angry, Tommy thought.[3]

Norman held the pipe between his teeth most of the time, taking it out to give commands. "Let's move the chair now. I want the light from the window to shine on you. . . . Now lean against the side of the chair. You're angry. You feel wild."

Tommy moved to that position. *I'm sick of being ordered around.*

"Good. Good. Throw your leg over the side and blow into the cornet. . . . Blow hard. . . . Puff your cheeks."

Tommy threw his leg over the armrest, blew hard, and puffed his cheeks.

Gene snapped photos.

"Did you get it, Gene?"

"Got it, Norman."

"Good work, Tommy! We're all done for today."

I'm so glad it's over. Will Norman really give me another $10? As he prepared to leave, the artist did hand him another $10 bill. *I hope he calls me again!*

CELEBRATING RED

Since *Trumpet Practice* would celebrate red in many hues, Norman would have to match each one perfectly, a painstaking task. The work was particularly daunting because he was replicating the art of the great Grandma Moses, and he felt an obligation to paint it skillfully. Perhaps he incorporated Mrs. Bellemare's slipcover because it would give him a profound feeling for Grandma Moses's style. To feature it inside his own painting would impress

Post readers. We have to remember that during the 1940s, Grandma Moses was the more celebrated of the two artists!

Soon the Paquins heard from Norman again. "Can you bring Tommy back in the same clothes?" When his mother told him, he didn't waste a second. "Sure, Mom, I'll model again." From Bennington to West Arlington and through the covered bridge, he and his mother drove once again. Although the money was good, Tommy dreaded the thought of the tedious work. But the outlook improved immediately on arrival when Norman asked, "How would you like some comic books to read?" Norman explained that little modeling was required for this session; his purpose was to perfect the various reds. *This is great!* Tommy thought. As he sat again on the big comfortable chair with Mrs. Bellemare's slipcover, Norman handed him a pile of comics belonging to his sons. Tommy buried his face in them. At the time, his favorites were *Superman*, *Spiderman*, and *Plasticman*, a superhero with extraordinary stretching capability.

Norman explained later in his book *Rockwell on Rockwell* his method of creating genuine values of red for *Trumpet Practice*. "I established the flesh tones and the color of his hair first, then related the other colors to this fixed and dominant note."[4]

Tommy modeled three more times for *Trumpet Practice*, a total of five, which is an extraordinary amount for one Rockwell painting. The sessions ran anywhere from forty-five minutes to three hours. Norman actually paid him to sit in the easy chair and read comics almost the entire time! By the time he departed from the last session for *Trumpet Practice*, Tommy had accumulated seven whopping $10 bills! He not only bought more candy but also downhill skis. He hiked up hills in his neighborhood and rode them down, and eventually the skis took him to a slope near his home called Prospect Mountain, where a rope tow and T-bars brought him to the top instead of his legs.

ON THE NEWSSTAND

After a friend in town alerted the Paquins he had spotted Tommy on the cover of the *Post*, they hustled to their North Bennington newsstand and purchased every copy. When he held the November 18, 1950, cover before his eyes, the boy found himself just as he had posed in his play clothes in the bright red chair. He sat sideways like a rowdy boy with one leg thrown over

the armrest. Norman had painted him blowing into the cornet with fully bal-
looned cheeks. Tommy noticed that Norman added a cute dog sticking his
head out from under the chair, peering up at him. The animal's face shows
that he is disturbed by the rowdy trumpet playing (figure 9.1). *Everyone in
town will see me on the cover of the* Post!

FIGURE 9.1
Trumpet Practice: Tom Paquin. Norman picked out Tom from a den of Cub Scout boys
from Bennington, Vermont. The boy's red hair was perfect for the painting. *Source*:
Courtesy of the Norman Rockwell Family Agency.

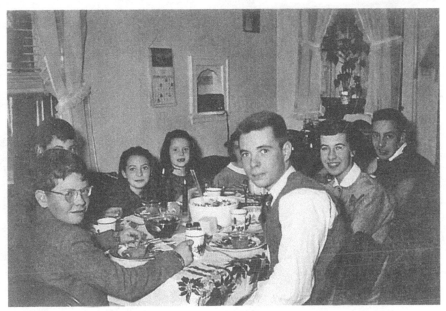

FIGURE 9.2
Tom Paquin (front left corner) with his family at dinner about the time he posed for *Trumpet Practice*. *Source:* Courtesy of Tom Paquin.

A year later, Tommy's parents handed him a large, curious envelope delivered by the postman. After tearing it open, he found a certificate signed by the country's favorite comedienne, Lucille Ball. Wow! She had appointed him a lifetime member of the Redheads of America Club![5] Tommy was a big fan of *I Love Lucy*. In the program, the zany actress got herself into all sorts of humorous mischief that annoyed her husband and friends and created big laughs. Another look at the certificate revealed that Arthur Godfrey, the famous TV banjo player and red-haired comedian, signed it too! He noticed a second piece of paper in the envelope. Things got better still! Lucy wrote him a personal note telling him she loved the Rockwell portrait! A letter from Lucy was even more exciting than $10 bills or everyone seeing your picture on the cover of the *Post*.

10

Auction at Sotheby's

When the *New York Times* announced in a feature article that Sotheby's auction house in Manhattan had scheduled the sale of *Saying Grace*, Don Hubert Jr. immediately noted the date: December 4, 2013. After all, he had an intimate connection to this most beloved of Rockwell illustrations only one other living person could boast. In 1951, Don modeled as the small boy praying with his "grandmother" before their meal in a busy train station restaurant. Jarvis Rockwell, Norman's son, modeled as the role of an indifferent onlooker.

The auction might be the only opportunity Don would ever have to view the original oil painting. Like Halley's Comet, some paintings like *Saying Grace* flash on a gallery wall only once in decades. Investors tend to hide them for safekeeping. He anticipated the pleasure he would have recounting the story of his experience with buyers and auction attendees.

He well remembered the day the tall, thin artist with a pipe between his teeth appeared in his classroom in Arlington, Vermont, and selected him from among his fellow students to model for an advertisement called *His First Day of School* and then the 1951 *Saturday Evening Post* Thanksgiving cover.

Don itched to learn how high the bidding would go for *Saying Grace*.[1] Many art experts believed that the final bid would break all records for Rockwell paintings. Rockwell's *Breaking Home Ties*, the poignant scene of the melancholy weathered farmer seeing his son off to college, had sold for $15.4 million

in 2008. Millions of *Post* readers at the time voted *Saying Grace* the cover that touched them most deeply. President Ronald Reagan called it his favorite.

Ironically, the pious *Saying Grace* became the focus of more greed and controversy than any other of Norman's paintings. In 1951, the publisher paid Norman $3,500 for the right to put it on the *Post*'s cover. The contract stipulated that the *Post* would return the original to West Arlington in the customary fashion. The artist would also retain print licensing rights. However, Norman told *Post* art director Ken Stuart to keep the original. He considered it a nice gesture to the man who wrote his check.

When he left the *Post*, Stuart hung the masterpiece in his home. On his death in 1987, Ken Stuart Jr. took possession. Curtis Publishing, owner of the *Post*, later sued the Stuart heirs, claiming it had been given to their father when he served in the capacity of their employee. "You might have it, but we own it," the publisher claimed. Ken Stuart Jr. won the suit; the judge ruled that the *Post* had waited too long to file. However, the fight for the painting continued when Ken Jr.'s brothers William and Jonathan claimed that he had forced Ken Sr. to sign the papers that give him possession when their father was dying. After a drawn-out legal battle, Ken Jr. and the brothers settled out of court.[2]

On the mild winter morning of December 4, 2013, Don dressed in a light jacket and boarded a Metro North train near his home in Bronxville, New York. As the train rolled down the tracks, memories of his childhood in rural Vermont rose. *It seems like I posed for Norman in a different life*, he thought, as elegant structures interspersed with blocks of dilapidated brick apartment buildings in the Bronx passed by his window. He remembered most clearly that modeling had been an adventure, but it hadn't been easy as a seven-year-old.[3] The chair he sat in was high, and his legs dangled. It was hard to keep them still. He had to sit quietly with an old lady. This too was difficult for an energetic boy.

Don strolled through Grand Central Station and onto the subway uptown, all the while wondering how much *Saying Grace* would bring. He walked up to the street level and entered the midtown Manhattan swarm. At Sotheby's, he made his way to the room where *Saying Grace* hung. Lit by warm lighting, the masterpiece, four feet wide and three feet high, was larger than he expected. His memory took him back to 1951 when he sat with May Walker.

As spectators lingered before the painting, he couldn't resist telling them that he was the boy with his head bowed in prayer. "That's me," he said.

"How did he happen to choose you?" someone asked.

"I modeled in Rockwell's studio in West Arlington, Vermont." Norman painted him from a rear view because that view accentuated his small, tender head with its tightly clipped hair and floppy ears.

The same feeling that brings special meaning to that period in his life came over him. He explained that one day out of the blue, Norman appeared in the classroom and selected him. Don smiled as he told how one summer day after Norman's appearance, Gene Pelham drove him to the studio on the historic Village Green by an old covered bridge surrounded by cows grazing on a mountainside. He modeled first for an advertisement, *His First Day of School*, and the artist later asked him to pose for *Saying Grace*. The folks at Sotheby's soaked it up. Don explained that though Norman had remained remarkably composed, he had been demanding. Don indicated with his hands the way Norman guided him here and there to position him. Standing in Sotheby's in bustling New York City, it seemed as if the painting was done in a different life. Beyond his story, there was something he could not explain: how had it come to be that he had become linked with those other four people—Jarvis, May Walker, Gene Pelham, and Norman Rockwell—to create a work of art of such importance in American history and of such an astonishing value?

"Turn around so I can get a picture of your ears," someone said. They took pictures of the back of the head Norman painted sixty-two years earlier.

Don took a seat in the Sotheby's auditorium among the chattering crowd of several hundred people. Unbeknownst to him, the Stuart brothers, current owners of the painting, were nestled in a private box. After the auctioneer banged his gavel, bidders raised their placards and called out numbers.[4] Representatives answered phones at desks off to the side, and the amounts of bids appeared on a scoreboard. In the first few minutes, bids rose sharply. The auctioneer announced, "Five million dollars . . . $10 million . . . $15 million." The bids rocketed to $20 million, where experts had thought *Saying Grace* might exhaust its fuel. After still, quiet moments in the auditorium, the bidders reactivated the frenzy, and the auctioneer declared, "We've got $21 million."

How high would they go?

IT ALL BEGAN IN A VERMONT CLASSROOM

People tell Don he is lucky to have found his way into *Saying Grace*. It had been an otherwise ordinary day in 1950 at the Arlington school when the seven-year-old Don looked up from his wooden desk as a tall, really skinny man with curly brown hair stood next to their teacher. "This is Mr. Norman Rockwell," he explained. "He is an artist. He paints covers for the *Saturday Evening Post*. He has come to see if one of you might make a good model. I want all of you to stand up and walk around the room."[5]

You might say Norman had the keys to the town. School officials, business owners, and leaders of community events all welcomed him. Don watched as the stranger moved his eyes over the group, holding them on a particular child.

A few days later his father Don Hubert Sr., a teacher at the same Arlington school, received a call from Norman. Don Sr., who stood tall and had a shock of black hair, enjoyed chatting with Norman at the school. Tommy Rockwell also attended it. Perhaps Norman had heard one of the presentations Don Sr. gave around town at places like the Rotary Club, where Norman was a member. Don listened curiously as his father explained that the artist wanted him to come to his studio. He didn't know exactly what "modeling" meant.

Norman held America's fighting men in high regard, especially Don Sr., who fought in the bloodiest World War II confrontation, the Battle of the Bulge. During his fourteen years in Arlington, one-third of Norman's paintings involved soldiers. Six years earlier in 1945, he had painted *Homecoming Marine* and *G.I. Homecoming*. The Battle of the Bulge began in the winter of 1944–1945, when the Allied forces had begun their invasion. The Germans became desperate and staged their last attack, or Blitzkrieg, on the Western Front in Europe. The Nazis hoped to split the American and British armies in France so as to block the port of Antwerp in Belgium and take control of the region. The battle took place in the Ardennes, an extensive forest with rough terrain that extends into Antwerp, Luxembourg, Germany, and France. It was the largest battle ever fought by the United States, consisting of more than six hundred thousand American troops and fifty-five thousand British versus five hundred thousand Germans. A barrage of planes dropped bombs and destroyed one another in the sky. Soldiers pounded the other side with artillery. As the Germans pushed deeper into the Ardennes, the Allies formed

a large bulge of soldiers and eventually neutralized the German counterof-
fensive under the brilliant leadership of General George S. Patton.[6] Many of
the American troops were young and inexperienced, and the country suffered
more than one hundred thousand casualties.

Norman and Don Sr. shared another connection. Both had strong ties to
Westchester County, New York, and moved to Vermont to enjoy rural living.
The Huberts had resided in Yonkers, which was next to where Norman had
lived in New Rochelle. They moved to Vermont in 1948 when Don Jr. was
five years old. Norman's paternal grandmother was descended from a man
named Robert Parkhill Getty. A downtown section of Yonkers, Getty Square,
bears his name.[7]

Don Sr. had decided the peaceful Vermont setting would help his trauma
to heal. He taught four subjects: industrial arts, music, driver's education,
and math. A musician, Don Sr. skillfully taught in the "Music Box," an old
schoolhouse the town moved and attached to the main school building. Don
Jr. recalled how his father suffered through math because he had not been
trained to teach the subject. Not an uncommon method in those days, the
elder Hubert allowed top students to assist.

HIS FIRST DAY OF SCHOOL

On the phone, Norman explained to Don Sr. that the Massachusetts Mutual
Life Insurance Company had commissioned him to create a series of seventy-
nine advertisements revolving around the theme of the American family.

At the time, Norman charged his advertising clients twice as much for ads
than for magazine paintings.[8]

Norman explained that Don Jr. would model for an oil painting in which
a mother and father would be grooming their son before sending him off
for his first day of kindergarten. Norman had already attempted the paint-
ing using other models and was dissatisfied with the results. For three and a
half days, he labored on what he called "a false start" because it resulted in a
sketch "which seemed too solemn." Norman requested that little Don wear
a dress suit; luckily, Mrs. Hubert had just the one. She had recently outfitted
her six-year-old during a trip to Montreal in a suit that brought back fond
memories of her school days in that city. Then, little boys wore gray flannel
shorts and dress jackets. When the salesman had asked for the name of her

son, she replied, "Donald Hubert." He repeated it in French, "Do-nald Hu-bear!" She loved that.[9]

As was often the case, Norman had a short deadline and felt pressure to get the painting to Mass Mutual for review.[10]

The opportunity sounded adventurous to a boy who lived a simple life attending the small school, playing in his backyard, and splashing in the brisk, shallow Batten Kill. On a summer day in 1950, Don's parents drove him from the east side of town on the graveled Route 313 and over the covered bridge to the Green.

After the studio's screen door closed behind Don, Norman exclaimed, "I love the suit!"[11] He found the short pants delightfully unique, and Don's slightly worn dress shoes would lend the right touch of realism. "But we're going to have to do something about your hair." It was sticking up in different directions. It could have suited one of Norman's more casual paintings but not this one. Don must look sharp for the advertisement. Norman rubbed a greasy gel in his hair, perhaps Brylcreem, the era's most popular. Don felt grown up with his hair slicked back. Norman explained that his "mother" would be fixing his clothing and that his "father" would be kneeling to adjust his tie. Don needed to look both a little excited and a bit nervous; his mother and father would feel the same.

"Okay, Mr. Rockwell," Don had said.

As usual, the artist told Don, "Call me Norman." He needed the boy to feel a casual connection with him and comfortable enough to reveal his genuine feelings. Norman wanted to make Don as "cute and lovable as possible for *His First Day of School*."[12] He guided the boy into a variety of poses and facial expressions: looking straight ahead with a neutral expression, smiling at the thought of his new adventure, and standing still as his "mother" adjusted his collar. It turned out to be harder than Don expected. He was a fidgety kid. Norman worked with him until he looked "still, obedient, and slightly mused." In the finished work, Norman "emphasized Don's boyish characteristics"—the long, thin face and floppy ears as well as "skinny neck, cute nose, plastered down hair."[13]

Norman ditched the first version because the man posing as the father appeared to be an "over-sweet, kneeling saint."[14] For the second, he would select a new "mother" and "father." After reviewing his mental catalog, he brought in one of the first he met in Arlington, the wife of Norman's real estate broker,

Dot Immen. Her daughter Mary later appeared in the 1948 painting *Christmas Homecoming* with the Rockwell family as a pretty blond teenager. In the final version, Dot wears a formal red dress as she stands behind Don adjusting the collar and holding a hairbrush in the other hand. Dot wore a "sweet, sympathetic" expression on her face.

Norman once again summoned Jim Martin, the father of Tommy's friend Jimmy. Jim had the distinction of being the only model to appear in each of the *Four Freedoms*. Posing in a long raincoat in *First Day*, he kneels in front of Don and is seen adjusting the boy's necktie. Norman wanted to evoke the "feeling of the responsibility of a father."[15] Norman also said, "I decided to concentrate on human relationships . . . the mother is sweet and ever loving."[16] After he posed, Norman handed Don a $5 bill, which made the task worthwhile.

His First Day of School appeared as an advertisement inside the September 23, 1950, *Post*. The viewer knows at first glance that the moment is bittersweet. The rich brown background, reminiscent of a Rembrandt, gradually turns to a lighter hue of warm brown. A glow of light illuminates the family. Had it not been an advertisement, the painting's realistic sentiment might just qualify it as fine art.

MODELING FOR *SAYING GRACE*

One day in the following year of 1951, Mrs. Hubert picked up the phone to hear Norman's voice again. "Would you send Don over in that suit with the short pants and old shoes?" He needed her son to model for a painting commissioned by the *Post* for its Thanksgiving cover. Now seven and a half years old and in second grade, Don told his mother he wouldn't mind going to the studio again when the image of another $5 bill lingered in his mind.

The idea for *Saying Grace* had come to Norman in 1950 in the form of a letter he found in his pile of fan mail. Only four times in forty-three years had he used a reader's suggestion. The *Post* typically provided ideas that would illustrate upcoming stories, and Norman created layout ideas. This time, however, a Pennsylvania woman had stirred his creativity. Norman found her recollection of a Mennonite family praying over their meal in an Automat Restaurant to be compelling. He sketched the group of people she described and added travelers who were observing them curiously. He decided that using an Automat Restaurant as the setting would make the painting distinct

and contemporary. The chain was founded in 1920 in Philadelphia and found its way to New York City. Customers dropped coins into slots, opened little glass doors, and took plates of food kitchen staff placed inside.[17]

Norman proposed the idea as the 1951 Thanksgiving cover, and the *Post* gave him the nod. His timing proved perfect. Attendance at religious services at mid-century was high. The same Americans who wept in churches and synagogues for fallen soldiers prayed with all their might that Hitler would not bomb their towns or march down Main Street and were grateful God had saved them from living hell. Americans now enjoyed unprecedented prosperity as factories churned out products. However, a new war in Korea had commenced and had the potential to become World War III.

As he began selecting models, the dragon's breath on Norman's back felt as fiery as it got. He had not only a deadline but a steep pile of bills as well. In addition to the usual household expenses, his son Peter was attending a private school, and Tom was away at college. His wife Mary was spending periods of time in an expensive psychiatric hospital in Stockbridge. Jarvis, however, was generating his own paycheck, having joined the US Air Force. The military stationed him in an office working with support staff for pilots fighting in the Korean War. North Korea had instigated the conflict in June 1950 when its government invaded South Korea with a large army. By July, the United States had joined the South in fighting in what American and UN diplomats considered a war against communism.

Perhaps Norman felt an incentive to pull out all stops in creating *Saying Grace*. He always aspired to create extraordinary art, not just illustration, but bills forced him to crank out paintings. Perhaps now, at age fifty-six, he believed that if he didn't create the ultimate masterpiece, he might never do it. The pressure appears to have built the head of steam that drives great artists to excel. He tried a number of different people as the model who would pose at the table praying, including Ardis Edgerton's uncle Orin Wilcox, who had modeled as *The Flirt*.[18] He would ultimately try seven models of different ages dressed uniquely, many props of varying colors, and a detailed background.

After the *Post*'s approval, Norman hired a mover to bring an Automat table to West Arlington along with one of the chain's distinctive glass condiment holders. Gene built a makeshift stage, essentially a platform sitting on wooden boxes.[19] The stage elevated the tabletop to the height where Norman could view the models at eye level. To capture a scene visible through the

restaurant window, the artist and Gene traveled to the Albany, New York, train station to observe and photograph. He originally intended to feature the heads of passersby. However, he decided on locomotives puffing exhaust because it would make it clear that the grandmother and boy were traveling.

THE MODELING EXPERIENCE

Don remembered Gene from *First Day* when Norman's assistant picked him up at his home. After he rode through the covered bridge and over Norman's driveway between the two large white colonials, Don felt anxious. The tension eased when the friendly artist smiled at Don's outfit, the dress jacket, and the distinctive short pants. The slender artist with the pipe in his mouth also liked Don's hair, which had been shaved to above his ears but left longer on the top of his head. After the Rockwells' friendly black and white springer spaniel Butch begged to be petted, Don felt more at ease.

Norman introduced Mrs. Walker, an elderly woman who sat on the platform at a table. As usual, the artist had taken pains to cast a woman who would look like the archetypal grandmother. That would make the painting "real." A professional model could not have fostered this authentic sort of feeling. May was no stranger to prayer, as she was a member of the East Arlington Federated Church. Norman probably spotted her and her husband Ralph at a church supper or a town meeting. Ralph, a short man who also smoked a pipe, maintained the boiler at the Hale Co., a busy Arlington furniture factory. Freeman Grout, who appeared in two of Norman's Boy Scout paintings, including *Helping Hand*, lived next door to the Walkers. Norman once cast Freeman as a Boy Scout helping May cross the street but never completed the picture. Freeman remembered May as the lady she appears to be, a humble woman who spent her spare time gardening and canning vegetables from her garden. As a boy, Freeman often found May visiting with his mother in their kitchen.

Once they were sitting at the Automat table on the makeshift stage floor, Norman explained to Don and May that he wanted them to act as if they were praying over their food. Don couldn't help but peer through Norman's large window at the Rockwells' home as well as the dairy farm across the road. Don felt tiny in the gigantic Automat chair.

Usually, Norman had models pose individually, but in this case, he wanted to establish a closeness between "grandmother" and "grandson." He tried

them in various positions at the table but thought it worked best to have them sit at adjacent seats. Don modeled in the studio several times with May, and Gene captured him from front, side, and back. At one point, Norman stepped up on the stage and sat at the table to demonstrate the pose he wanted May to assume. He leaned forward and bowed his head over a food tray with dishes on the table. He clasped his hands in prayer. He demonstrated for Don how he needed to lean his head forward and tilt it slightly to the right. Don began to feel overwhelmed—so many instructions and expectations. He grew fidgety and could not keep his nervous legs still because they did not reach the floor, where he could have steadied them. Don wanted to run out. Norman tried gently to persuade Don to hold his legs still, but Don could not do it. Norman had learned a number of techniques to persuade kids to cooperate throughout his professional career, which began in New Rochelle around 1917. He had promised them ice cream or soda or a coin each time they obeyed an instruction, but these techniques would not help in this particular case. Finally, Gene came to the rescue. He hustled to his darkroom at the far end of the studio and returned with a roll of cellophane packing tape.[20] He knelt by Don and taped his ankles together. To his relief, Don managed to hold his bound legs still.

May bowed her head over the table and clasped her hands as if praying deeply. Don tilted his head and put his hands together. Gene's flash lit up the stage and bounced around the room. After a few more shots, Don went home happy with compliments from Norman and another $5 in his pocket! Wow!

THE DEBUT

Five days before Norman shipped *Saying Grace* off to the Curtis Publishing Co. in Philadelphia, he brought May to his studio. The old gentlewoman sat before the masterpiece and basked in its grace. She died before it appeared on the cover of the November 24, 1951, *Post*.

The power of the painting stems from Norman's juxtaposition of a vulnerable elderly lady and a young grandson with a group of young men onlookers and armored steam locomotives chugging in the distance outside the window. It reveals the artist's knowledge that the weak in body are often those strong in prayer. Perhaps May Walker knew her death was imminent, which brought fervor and truth to the scene.

Don was excited to see the illustration on the *Post* cover. He didn't know what position Norman had placed him. In the picture, he noticed that Nor-

man had painted him sitting on the edge of his chair. Both he and May were praying with their heads bowed above their food trays. While May's face is visible, Norman painted Don from behind, which further emphasized the boy's vulnerability. Norman added a coat lying on the seat of the chair behind Don and painted the cushions, a flower pinned to May's hat, and the catsup on the table a dramatic red (figures 10.1 and 10.2).

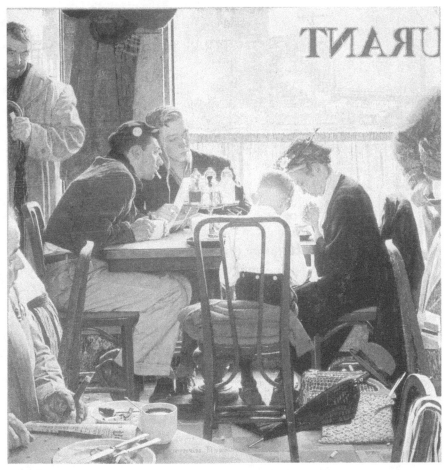

FIGURE 10.1

Saying Grace: Norman Rockwell's 1951 Thanksgiving picture featured Jarvis Rockwell (blond), Don Hubert Jr. (little boy), Gene Pelham (front left with cigar), Bill Sharkey (standing with coat), and May Walker (woman praying). *Source*: Courtesy of the Norman Rockwell Family Agency.

FIGURE 10.2
Norman loved Don Hubert Jr.'s floppy ears. *Source*: Courtesy of Don Hubert Jr.

Because Don and May and the four other models lived in Arlington, *Saying Grace* became the talk of the town. In *Saying Grace*, Norman's student Don Winslow, whom Jarvis had brought home when he attended the Art Students' League in New York, stares at May and Don, with a cigarette hanging from his mouth.[21] At the time, Winslow was staying at the one-room schoolhouse on the Green and assisting Norman as an apprentice. He published two *Post* covers himself that tell stories in a style similar to Norman. The girls on a softball team that played its games on the Green roped Winslow into coaching them, and he proved especially effective working with pitchers like Ardis Edgerton.

At the left of *Saying Grace*, Norman included the front of Gene Pelham's face. Sitting alone at a table, Norman's assistant, wearing a blank expression, observes the two. The cup of coffee before him is cold, but he holds a burning cigar. In real life, Gene did enjoy puffing on cigars.

Appearing as a weary traveler, Norman's neighbor Bill Sharkey stands behind the Automat table holding his umbrella. Bill lived in one of three shacks located a long baseball throw from Norman's home, just beyond the covered bridge. Bill did not have indoor plumbing, and he collected water for drink-

ing and cooking from a brook that tumbled down the mountain next to his home. A man who vacationed in a house about a mile down the road from Norman's gave Bill a job feeding his fighting gamecocks.[22] Norman would see Bill walking past his house on his way to work. Bill rocked away afternoons and evenings in a chair set on his porch.

Norman once offered his thoughts about *Saying Grace*. "In 1951, I painted a picture of an old woman and young boy in a shabby railroad station. People around them are staring. Some are puzzled. Some remember their own lost childhood. But all are respectful." He acknowledged that in reality, some people might have been rude or angry, some indifferent. "But I didn't see it that way. I made people respectful."[23] Shortly after *Saying Grace* appeared in the *Post*, enthusiasts bought hundreds of thousands of prints. Millions more prints have been produced since.

Saying Grace delivers more power than his 1943 painting *Freedom of Worship*. Norman also inspired readers in a similar fashion with his 1962 painting *The Golden Rule*, where he painted the words "Do unto others as you would have them do unto you."

As Don watched over the proceedings at the auction house, the bids shot over $30 million. For nine minutes, two telephone competitors drove the price up millions more, as Don could see on Sotheby's electronic board. The screen announced the bids in foreign currencies: European euro, Japanese yen, Swiss francs, and Chinese yuan. Between bids, spectators endured long quiet periods pregnant with a sense of anticipation. Don was astonished as he watched the numbers rise. A chorus of oohs and aahs rose from the crowd as the bids exceeded $40 million. The aggressive bidders drove up the price to $42 million and finally to $46 million eighty-five thousand dollars. Then a hush fell over the entire crowd as people sat quiet and still, waiting for the gavel to fall.[24]

The auctioneer finally declared, "Sold for $46 million eighty-five thousand dollars." The bidding had taken ten minutes, considered an eternity for an auction.

A NEW RECORD

Television and radio stations across the country announced that Norman Rockwell's *Saying Grace* had set a record for the sale of a single American painting by an auction.[25] Although considered the underdog, it soundly defeated

Edward Hopper's *East Wind over Weehawken*, which sold at Christy's auction house that week for $40.5 million. Considering all the paintings done by American artists over the last several hundred years and sold at auction, Don Hubert Jr. found himself at the center of the universe. "It is an honor to be included in such a reverent, popular painting," said Don. "It's hard to believe."

At his home, Jarvis, who appeared as the blond young man appearing indifferent, said he feels his father was at his absolute best when he produced *Saying Grace*.[26] "It's sentimental and real. It's serious." When reminded of the record-breaking price it sold for at Sotheby's, he exclaimed, "Forty-six million!" and let out a full belly laugh. "You could feed Greece for a year on that." How would his father react? "He'd sort of like it but be a little embarrassed."

Tom Rockwell, who ghostwrote *My Adventures as an Illustrator*, said, "My father would have been absolutely flabbergasted and a little embarrassed. Before he died, he bought one of his own back for $750."[27]

For a couple of years, the purchaser of *Saying Grace* remained anonymous. Don and many others believed one of four people might have purchased the painting: filmmaker George Lucas, who is reputed to own as many as fifty Rockwells; Stephen Spielberg, film director and trustee of the Norman Rockwell Museum; former presidential candidate Ross Perot, who bought *Rosie the Riveter* in a private sale; and Alice Walton of Walmart, who owns a number of Rockwells. George Lucas finally broke the silence in August 2016 when he revealed that he was the one who anted up the $46 million.[28] Lucas plans to display *Saying Grace* at the Lucas Museum of Narrative Art, which is scheduled to open in 2023.[29]

11

A Sweet Bribe

Martha Adams, a woman from Cambridge, New York, picked up the phone one day in 1952 to find the caller identifying himself as an artist named Norman Rockwell. Cambridge is fifteen country miles south of West Arlington, and many Vermonters would travel there to buy farming and gardening supplies and to attend livestock auctions. "Grandma Moses told me about your family," he explained. "I have an idea for a painting. I wonder if you and your children would pose for me."[1]

Norman Rockwell had asked Grandma, the most beloved artist in the United States at the time, if she knew a black family that might be willing to pose for him. He wanted to recognize and uplift the black race and included them wherever he could. During his years in Arlington, Norman and Grandma, who lived within half an hour of each other in the village of Eagle Bridge, New York, had established a friendship. In 1948, he included her in *Christmas Homecoming*, the only painting where his entire family appears. Norman hosted a birthday for the elderly artist in a restaurant in 1948 with a fifty-five-pound cake. It's important to remember that Anna Robertson Moses, or "Grandma," was even more popular than Norman then. Americans considered her "the grandmother of our country." President Harry Truman brought her to Washington when she was about ninety years old to present her with the Women's National Press Club Award in 1949.[2] When she turned one hundred on September 7, 1960, New York Governor Nelson Rockefeller

proclaimed it Grandma Moses Day. *Time*, a magazine everyone in America knew, published her picture on the cover in celebration.

Martha Adams and her five musically talented children, Virgil, Paul, Pauline, Carl, and Mary Beth, were friends of Grandma Moses. Martha enjoyed discussing art with Grandma from time to time. Martha's father, a Susquehanna Native American, and his wife Belle Diggriss would stop to visit with the artist along the sides of graveled roads in Eagle Bridge during horse-and-buggy days. Grandma invited the Adams children to sing gospel songs in her living room. Neighbors came to their home for little concerts; the children also sang in churches and for elderly shut-ins. The only cab driver in town, a short, pudgy, and kindly man folks called Shaky Bill Butler, drove them around town in his classy 1951 Plymouth. Martha would always ask Bill what he had for lunch, and his reply was always the same. "Baked bean sandwich and a glass of iced tea."

The first time seven-year-old Paul Adams visited Grandma, the slender spry woman with gray hair and round spectacles fetched two pets. They looked like a cross between a squirrel and a rabbit and hopped around the room. "What are they?" Paul asked.

"Chinchillas," she explained. "Go ahead, pick one up." He had a blast chasing the frisky animals around the living room, and when he caught one, he stroked its bushy fur, which felt soft as velvet. Relaxed and energized, Paul and his brother and sisters formed a line at the front of the room and sang inspirational songs. Grandma clapped with enthusiasm; they felt special.

THE LIVELIEST NINETY-YEAR-OLD EVER

Grandma began painting seriously at age seventy-five, creating lively country scenes from her memory, which went far as back as the mid-nineteenth century. Although a child at that time, she could remember a dark cloud hanging over the country when people wore black clothing the week after President Lincoln was assassinated. She painted country people and farm animals in a childlike, primitive style. Everyone is active. They carry maple syrup and load logs, oxen pull carts, and kids sled down hills and skate on frozen ponds surrounded by cows, horses, and dogs. She depicted farmhouses and white churches with high steeples.

Strong in her religious faith, she exhibited more energy than the public had ever seen in a woman her age. One of her contributions was making it plain

that older people could start new careers. She inspired the producers of the popular television comedy *The Beverly Hillbillies* to create one of the most unique characters in television history, Daisy Mae Moses. The other characters called the zany, plainspoken woman with boundless energy "Granny."[3]

Paul's mother was a big fan of Mr. Rockwell. *But how will I get the children to his studio? I don't drive, and I can't pay Bill for the day. Their father isn't going to sacrifice a day's pay to drive them.*[4]

"Don't worry, I'll pay the driver," Norman replied.

Martha told Paul, age seven at the time, about the conversation. He, his brother Carl, and his sisters Pauline and Mary Beth anticipated an interesting adventure. On the other hand, they felt a little nervous. What exactly did "posing" mean? Paul wore his church clothes—best slacks and white shirt. Pauline also dressed in her Sunday best. She was pleased to be out of school.

"You better all be on your best behavior," their mother warned them sternly.

On a winter day in 1952, Paul and his family piled into Shaky Bill's cab. At the end of their half-hour trip, they drove over a covered bridge, which rumbled as they crossed to the Village Green. Bill pulled up in front of two large identical white houses. He pointed to the one on the right. "That's where Mr. Rockwell lives." A blanket of snow covered the field, homes, and neighboring cow barns. Paul and his brother and sisters made their way across the yard to the bright red studio. The boy halted when he spotted large bottles of Coca-Cola pushed into a mound of snow. Paul wished he could have one like that. A tall, slender man with short, curly brown hair opened the door. Light bounding off the snow streamed in through a huge window.

"I want you and the children to call me Norman," he said with a smile. He bent down to their height to meet their eyes. They connected with the artist. Norman explained that he would include them in a mural among a group of people from all over the world at a meeting of the United Nations.

The Korean War had been raging for two years, and Norman wanted to depict the UN Security Council in a manner that would give Americans hope. He would honor a Russian diplomat who posed for him with a warm smile and planned to include sixty-five civilians of a variety of nationalities standing behind them. He would present it to the international organization as a gift.

Korea had been part of Imperial Japan prior to 1945, but following World War II, the United States and the Soviets split up the country. American diplomats took it on themselves to create the North and the South. In April 1950,

after North Korea attacked the South, the United States came to its aid as the head of a UN force comprised of more than a dozen countries. At first, the goal was to force the Communists out of South Korea, but it turned into an effort to also entirely liberate the North. Fearing that a third world war might break out between the United States and Russia and China, President Harry Truman began peace talks in 1951, but it was not until 1953 that both sides signed an armistice. About 5 million people died in the war, more than half Korean civilians (about 10 percent of their population). Almost forty thousand Americans died, and twice that many were wounded.[5]

Norman explained to Martha and the children that he wanted them to put sad looks on their faces. He arranged them in a line in front of his fireplace. Paul felt fidgety, and his brother Carl could not help being a bit of a "hot dog." Mary Beth, age three, walked off into a corner, stared at them, and sucked her thumb. Paul's mother led her back. Paul expected Norman to become annoyed. But the artist remained relaxed and even smiled. "If you stand perfectly still while I do this sketch, I'll give you a great big bottle of Coca-Cola."

So that's why the bottles were in the snow, Paul told himself. He *would* behave.

As he sketched, their mother kept them lined up and looking ahead toward Norman. A deer head with antlers mounted on Norman's wall next to his fireplace enchanted Pauline. But the atmosphere turned spooky when a man stepped before a camera and pulled a black hood over his head as if he were an executioner. The artist stepped aside, and without warning, a loud "pop" startled Paul and his siblings.[6] A burst of light bounced off the walls. Paul's sisters turned away and clutched their faces. Norman explained that his photographer Gene had taken a photo and needed to wear a black hood to focus the camera. Next, Norman had Paul take off his shirt to resemble an African native living in a sub-Saharan climate. With an image of Coca-Cola bottles dancing in his head, Paul forced himself to stand still as a statue. He could almost feel the sweet, carbonated soda burning the back of his throat. Pauline also thought of the Coca-Colas. Her mother couldn't afford soft drinks; they usually had Kool-Aid powder mixed with sugar and water. Norman's easy manner relaxed her. In new social situations, she normally hid behind her mother or a chair.

With Paul, Pauline, and their siblings standing around Martha, Norman explained, "I want you to look like poor, sad children." He gave Paul a ceramic flowerpot and told him to hold it high, then in front of his chest. *Why is he making me do this?* Because the Africans whom Norman envisioned didn't

normally wear fancy dresses or slacks, Pauline posed in her slip, her brothers bare chested. Norman directed them looking up, then down, straight ahead, left, and then right. Norman moved along, and the camera flash went "pop" and "pop." Soon, Gene disappeared. Norman chatted with their mother as the kids frolicked. Gene returned from his darkroom at the back of his studio with a wet photograph. With wonderment, Paul stared at the big, fancy picture of himself standing in the line. Carl, Pauline, and even their three-year-old sister Mary Beth looked sad, as if they were longing for help, just as Norman had wanted. Norman gave them the photo.

On their way to the door, Norman stuck a whopping $5 bill into Paul's hand. The artist also gave him one of the charcoal drawings he had sketched. "You did well. You can take a bottle of Coke from the snowbank." The artist smiled at him, making him feel proud for standing still. The boy hustled over to the snowbank. Just as he plucked a bottle of Coca-Cola, his mother's voice froze him. "That's not yours!"

"Norman told us we could have one."

Martha Adams barked, "Put it back. We don't take other people's property."

I guess my mother didn't hear him. "But Norman said we could each have one."

"Put it back."

He wanted to say, "You're kidding me," but he didn't dare cross his mother. Reluctantly, he pushed the bottle back into the snow. Bill Butler, who had been sitting in his idling Plymouth taxicab the entire time, kept glancing as if he were anxious to head home. "Let's go," his mother said sternly. Paul climbed in. Pauline also felt disappointed. Paul felt helpless as they drove past the little white church with a snow-covered roof, through the covered bridge, and back onto Route 313. In Cambridge, Martha Adams bought them ice cream at their grocery store, which partially made up for denying them the sodas. That made it a pretty good day after all.

On another day, Norman and Gene picked up Pauline to model for a *Look* magazine painting. It illustrates an article called "How Goes the War on Poverty?" She appeared in that painting in *Look* in July of 1965.

WHERE'S THE COVER WITH US?
Every week, the Adamses checked the *Saturday Evening Post* but never found themselves on the cover. *When will we see ourselves?* Weeks turned into

months.[7] Paul and Pauline's parents split in 1954 when he was nine. Their family received welfare, but after two weeks, Martha Adams refused the government's charity. Neighbors gave them food, such as chicken and duck eggs, and provided other basics. The Adamses raised chickens. On Sundays, Paul and his brother would lop the birds' heads off and scald them in pots to loosen the feathers. They plucked by hand. A retirement home gladly served them for Sunday dinners.

As graduation approached in 1964, Paul learned that Norman had not forgotten them. His brother Virgil, who was studying for his doctorate in Holland, wrote that he had spotted Paul and Pauline on a *Post* cover. Martha hurried to town and paid the fifteen cents for the *Post*. Paul found himself holding a golden bowl at the center of two dozen people: Americans, Africans, and Chinese. Norman had transformed the flowerpot and adorned him with a necklace and earrings. The painting seemed to be asking the American people to "fill the empty bowl."

It struck Paul that Norman had painted his skin a darker shade of black, and his face appeared longer and narrower. *It has to be me, right? I posed without my shirt and holding that bowl.* Although Pauline appeared with her hands folded in prayer, her skin was also darker. She stood at the front left corner. A somber expression appeared on her face as if asking the world for compassion. Paul recognized the Bible verse written across the bottom: "Do unto others as you would have them do unto you."

The Adamses felt disappointed when they did not find Carl and Mary Beth. Norman had also excluded the UN Security Council members. Paul learned later that Norman had scrapped his original idea. When his photographer took pictures of the diplomats, Norman got a smile from the Russian diplomat, Andrei Vishinsky.[8] The others wore blank expressions, and it would not be possible to put smiles on them with a paintbrush. Norman finished the sketch, but as time passed, the thought of painting so many faces became overwhelming. He created *Golden Rule* instead, using twenty of the models. Not long after it appeared in the *Post*, the Adamses found a framed canvas print of *Golden Rule* sent by Norman in their mailbox. *So it must be us*, Paul and Pauline thought.

Almost five decades later in 2018, a Rockwell Museum employee in Stockbridge set two archival photographs in front of Pauline, making it obvious that Norman had replaced her and Paul's faces with those of two having the

darker skin of black Africans.[9] In addition to being black, the Adamses also have Native American blood.

Although disappointed, the Adamses are honored that they do appear in *We the Peoples*, the 1953 mural drawing that now hangs at the UN building in New York City (figure 11.1). At the back right, their mother Martha also appears behind Marie Briggs, the Rockwells' Arlington housekeeper and cook. Marie wears the scarf that covered her hair in real life. Pauline and Paul appear as they modeled in 1952. She stands among the diverse group of various nationalities at the far-right corner with her hands folded in prayer. Paul is featured in the center, holding the flowerpot Norman transformed into a bowl. They join Arlington Scout model Buddy Edgerton, who wears an army helmet, and Mary Whalen, *Girl at the Mirror*, who stands behind Paul praying (figures 11.2 and 11.3).

AN INVITATION TO THE UNITED NATIONS
Pauline received a handwritten letter from the Rockwell Museum requesting her presence as Norman's representative at the United Nations in Manhattan for the unveiling of *We the Peoples*. Here, Norman did include the row of the UN Security Council in front of the diverse group of sixty-five civilians. Their expressions ask for a helping hand from those more fortunate. "It's a very serious work. No one is smiling," said Pauline. *We the Peoples* required major

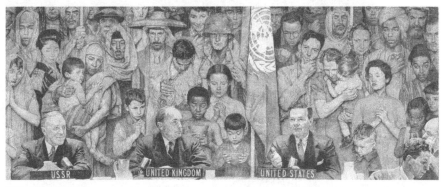

FIGURE 11.1
We the Peoples: Locals modeled for this drawing, which hangs in the U.N. Headquarters. Paul Adams (holding bowl), Marie Briggs (scarf on head), Pauline Adams Grimes (right front: black girl praying), Buddy Edgerton (wearing helmet), Mary Whalen (girl praying behind boy with bowl). *Source*: Courtesy of the Norman Rockwell Family Agency.

FIGURE 11.3
Marie Briggs was the housekeeper and cook for the Rockwells. She also prepared dinner of farm-raised meats and vegetables for the author when he worked on the dairy farm of Charles Bentley Jr., cousin to Floyd Bentley, model in *Breaking Home Ties*. *Source*: Courtesy of Charles Bentley Jr.

restoration because it had deteriorated in storage, where it had been kept for many years. A curator removed rubber cement from the back and cut it into three pieces before gingerly soaking it in a solution that preserved Norman's original charcoal. "They saved part of American history. My history as well," Pauline notes.

At the September 2015 exhibition, UN Deputy Secretary Jian Eliasson, protected by heavy security, greeted Pauline. He visited with her and her husband Peter in his office on a top floor of the UN tower. A guide led them on a tour that included the Security Council Chamber. "I was honored and am so thankful to the Museum." On September 25, Pope Francis praised the original *Golden Rule* painting during a photography session with UN Secretary-General Ban Ki-moon at the UN headquarters. Three days later, President Barack Obama and First Lady Michelle made a special trip to view *We the Peoples*.

Norman's Favorite Male Model

Chuck Marsh modeled for Norman the first time as a baby in diapers in 1943 for an Upjohn Pharmaceutical advertisement. Norman painted his parents Lee and Ann standing proudly over their baby, who is being weighed on a scale. Chuck laughed, "The ad tells you something like, 'If you feed your baby Upjohn vitamins, your baby will be big and fat like this one.'"

Norman had met Lee and Ann early on in Vermont at the Arlington Lion's Club. Ann had been the favorite teacher of his son Jarvis and was especially supportive as Norman's son made the difficult transition from city to rural life.

When Norman needed a model to pose for a Massachusetts Mutual advertisement slated to appear in *Dartmouth Alumni Magazine*, he selected Chuck, now age ten. Norman found Chuck to be a spirited child but one who was also well composed, took directions well, and could be directed to reveal all sorts of expressions. In the drawing, his father Lee Marsh, seated in a lounge chair with stylish glasses and a tobacco pipe in his mouth, studies his son's report card. Chuck peers over his shoulder. The caption reads, "Another Dartmouth Man On the Way." The Marshes considered it an honor for Chuck to pose for the prestigious magazine ad. Maybe one day, the small-town, studious country boy *would* apply to an Ivy League school. It wouldn't hurt to include a Rockwell painting of yourself in Dartmouth's magazine with your application.

In 1946, Norman had Chuck, his brother, and Ann pose for a painting called *Country Doctor*, one of the most ambitious and detailed paintings of his

career. It also included the town's beloved doctor, George Russell, who was an especially caring man. After the sessions, Norman called them back because he had modified his concept. Unfortunately, Chuck had gone to summer camp on Lake Champlain, and Norman couldn't wait. When Ann opened the April 14, 1947, issue of the *Post*, her heart dropped in disappointment. Norman had portrayed another family.

Perhaps Norman wanted to make it up to the Marshes because in 1948, Norman gave Chuck, his brother Donnie, and Ann the honor of posing with himself, his entire family, and dear friends for *Christmas Homecoming* (see figure 5.3). Chuck modeled as the little boy standing at the front of the picture with his back facing the viewer. Impeccably dressed in a brown suit with short pants, he appears like a young gentleman. Chuckie, as he was called, holds Jarvis's hat humbly behind himself. Behind Norman to the right, Ann holds her baby Donnie, who wears a pink sweater.

At some point in the late 1940s, Norman promised Ann one of his paintings, and when she reminded him, the artist told her that a number of them hung on the wall of the Green Mountain Diner in Arlington village. "Go down and tell Frankie Hall that Norman promised you one of his paintings. Tell him I said you can take whichever one you want off the wall in the banquet room." Frankie Hall, a former vaudeville actor, owned the diner. He appeared in *The Gossips* wearing a gray derby hat with a black stripe. Ann drove to Frankie's place and lifted *Christmas Homecoming* from its picture hook in the banquet room and took it home. It would become a popular painting.

Norman also used Chuck in two 1952 *Post* covers. Once they began working on *Day in the Life of a Boy*, Norman held his sketch before the eyes of the two children. "He asked Chuck and Linda Tuttle, the co-model, "What do you think the story is here?"[1] In his baritone voice, colored with a New York City accent, he led them in a brief discussion until they understood the theme. "He'd tell you what emotion he needed. . . . In the painting, I'm reading a comic book at breakfast." Norman would be direct with Chuck until he understood. "You have to look really interested, Chuck." When he wanted Chuck to appear goofy while swinging a baseball bat, Norman told Chuck to stretch his lips and stick them out. In a scene where Chuck struggles to understand a concept in a book, the artist directed him to grab his hair and look annoyed. Chuck also posed with Mary Whalen in *Day in the Life of a Girl*, the *Post* cover of August 30, 1952, that features Mary in such poses as

waking up, swimming, and riding on the back of a bike with Chuck. At one point, Norman told Chuck to kiss Mary on the forehead. "I was reluctant to do that. He had us pose separately and had me kiss a face on a marble bust."[2]

Chuck liked best the times Norman used him for Brown and Bigelow's Four Seasons calendars. Norman painted these in that same spirit of Dickens's *Oliver Twist* and Twain's *Tom Sawyer*. Norman had first created this type of painting in his iconic 1921 *Post* illustration *No Swimming*. Three boys are dashing past a "no swimming" sign as if being chased. Chuck actually engaged in some of this Dickensian mischief in real life when it got dull. The Mack Molding plant, where the manufacturer made plastic parts, stood just down the road from the Marshes. One Halloween night, Chuck and a couple of friends snuck into the back door and hung a weighted hook on the whistle that was blown to mark the end of shifts. The whistle blared and did not stop. The giggling boys heard the guard barreling from another part of the plant into the shipping department. They burst through the front door and broke into laughter as they dashed down the road. They glanced backward to catch a glimpse of the night watchmen hollering, "Stay out of here, you idiots, or I'll tell your parents."[3]

CHRISTMAS HOMECOMING

As they grew older, Ann and Lee enjoyed traveling. They would store *Christmas Homecoming* in the vault at Factory Point Bank in Manchester about fifteen minutes away. The founder of the Stockbridge museum eventually contacted the Marshes, and after a good deal of persuasion, the Marshes sold it to him for "a nominal fee." They forfeited any chance of reaping the impressive profit it brought in the future.

Each year during the Christmas season, the Rockwell Museum brings out the Marshes' former prized possession. *Christmas Homecoming* is now worth millions of dollars. Chuck laughed. "I wouldn't mind having it now and selling it. On the other hand, it's nice that so many people have a chance to view it."

Norman left Arlington in 1953, the year after he painted *Day in the Life of a Boy*. About seven years later, as Chuck completed his application to Dartmouth, Ann dug up Norman's Massachusetts Mutual ad. The high school senior included it with his application and wrote that his hope of attending Dartmouth had begun when he posed for the ad. The college accepted him, and he believes the ad helped, but he also was a National Merit Scholar.

13

A Broken Heart

Mary Whalen lived in a roomy white house at the center of Arlington. Front windows topped with stained glass added a touch of elegance. Her family's home stood among a cluster of others huddled around the library, post office, and shops. Mary could step across the street to Cullinan's, a country store and butcher shop owned by her cousins; pass a small brick factory; and climb a hill to the train station.

Although she could have occupied herself in her spacious playroom, the tomboy found the outdoors more exciting. She would join her brother's friends in basketball. With anyone willing, she played toss and catch by the henhouse in her backyard. At the diamond nearby, she hoped the boys playing baseball would ask her to pick up a glove and come on the field. She skied at Bromley Mountain in nearby Manchester, hoping to become a great downhill athlete. She eventually played basketball, field hockey, and softball at Arlington High. Despite the activity, days could become routine in a town where a kid saw the same people every day.

THEIR FIRST MEETING

Mary Whalen first met Norman Rockwell when she was nine at an Arlington High basketball game. The school stood a mile from her home on the same ridge as the train station. On Tuesday and Friday nights, the whole town came out to watch. Mary would sit with her parents John and Margaret in

the bleachers. When the concession stand opened at halftime one evening, it seemed like everyone brought something back to their seats except her. After the game resumed, Mary told her father, "I'd like a soda."[1]

"If you told me at halftime, I would have bought you one," her father replied.

Suddenly, an arm appeared in front of her.

A voice said, "You can have mine."

Mary took the soda.

Her father turned around. "Thank you, Norman," he said to a tall, slender gentleman who smiled warmly. She did not know the man or the woman with him, who appeared to be his wife.

She no longer felt left out; the bubbly soda tasted good, and she felt happy to have a treat from the concession stand like everyone else.

After the final buzzer, parents of the players stepped out on the court and mingled with the boys. The nice man who gave her the soda appeared.

"I'm an artist. I'd like to paint your picture. How would you like to model?"

"Sure," she replied. She had never posed for anyone and didn't really know what it meant, but why not?

She learned that his name was Norman Rockwell. He painted pictures for the cover of the *Saturday Evening Post*. Mr. Rockwell had come to watch his son Tommy, a star player. Girls were crazy about the boy with strawberry-red hair. He created excitement with his energy as he ran up and down the court. These games inspired Mary to play basketball.

The incident escaped her mind until the next summer. On July 16, 1951, the same day her grandmother died, the doorbell rang. Mr. Rockwell appeared in her foyer. Tall, slender, and with short curly hair, he offered her a charming smile and struck up a conversation with her dad.

Shortly, he said, "May I speak with Margaret?"

"She's taking a nap, Norman. We just buried her mother today."

Mary's mom and the rest of her family had returned from the funeral earlier that afternoon.

"I'm sorry to hear it. I'll come back another day," Norman stated.

"It's okay," her father said. "Let's go out back and visit. You come too, Mary."

Mary took a seat with her father and Mr. Rockwell on their back porch.

They chatted. She learned that Mr. Rockwell was a client of her father, who was a lawyer for many people in town. Norman said, "I'd like to ask your wife, your son Peter, and Mary to pose for me."

"I want to do it!" Mary exclaimed. Excitement shined through the heaviness everyone felt over her grandmother's funeral.

MODELING OPPORTUNITIES FOR MARY

Soon after the meeting with Norman, Mary, her mother, and brother Peter modeled in his studio for a 1950 Plymouth automobile ad. After Norman had finished his sketch of Mary, Gene was removing his photography equipment from the studio. The artist turned to her mother. "I think I'd like to use Mary for another painting I have in mind about a girl's life. I'll get back to you."

Mary was thrilled when the car ad appeared in a magazine. The caption read, "It's Pop with a New Plymouth." Norman painted them with angelic faces peering out a window under a festive green wreath with a red ribbon. Chickadees are perched on snow-covered tree branches near a feeder outside a window. Mary poses to the left of her mother, whose smile is bright. Peter's eyes are wide with excitement. Her mother's arms are wrapped around both of them. Mary's cousin, little Cheryl Cullinan, whose family owned the country store across the street, looks cute as can be, sticking her finger into her mouth. Norman added a perky little beagle to the group.

Two weeks later, the phone in the Whalen household rang. "I want to do a painting like *Day in the Life of a Boy*," Norman told Mary's mother Margaret. Their neighbor Chuckie Marsh had posed for a lively *Post* cover of that name as a boy engaged in his daily activities, such as studying and playing baseball.

"Okay, Norman," Margaret had said. "I'll bring her over."

"Let's get to work," Norman declared when Mary and Margaret arrived. Norman was glad to have Margaret assisting him along with Gene Pelham throughout the modeling sessions.

"And Mary, I want you to call me Norman." She always referred to a man as "Mr.," but she said, "Okay, Norman." It created a strong connection. Norman was going to treat her like a real person, not as a child who didn't understand things.

With her mother Margaret physically moving Mary into the various poses at Norman's direction, Mary modeled separately for each of the more than twenty frames that would appear on the *Post* cover, and she loved every

minute. Norman painted her yawning on her bed in pink pajamas, being dunked in the water, and going to buy tickets for a movie with Chuckie Marsh. Another scene shows her sitting at a birthday party where Chuckie's younger brother Donnie tears into a cake. Mary, who babysat for the rambunctious kid in real life, is wearing an ugly polka-dot dress provided by the artist for the occasion. They had great fun. Donnie lunged to grab a hunk of the cake. Norman jumped and grabbed him before he could ruin it. Norman and everyone else laughed. He said it would make the picture even better. Norman let Mary keep the polka-dot dress. It was nice to have but too garish to wear.

Some days after she thought she had completed her sessions for *Day in the Life of a Girl*, her mother heard from Norman again. "I need you and Mary to come back for one more picture," he told Margaret. He had completed the layout of all the frames but felt obligated to replace one. When they arrived in the West Arlington studio, Norman told Mary and her mother that he had received letters critical of *Day in the Life of a Boy*. He had not included a frame of Chuckie saying his prayers before bed. The criticism bothered Norman, and, besides, he liked the idea of Mary praying before bed. "Mary, you kneel down and say your prayers," Norman told her. "You know how to say them, don't you?" He continued, "I don't know how to pray."

He knows how to say his prayers, she thought. *He just wants to see me do it*.[2]

Mary knelt on her knees.

"Put your hands together."

She searched his eyes and waited. He usually instructed her on exactly what to do with her hands; however, this time he did not.

"Put them the way you do when you say your prayers every night."

Mary quickly pressed one hand against the other. Gene Pelham snapped a photo.

She felt like a star in town again on August 30, 1952, when *Day in the Life of a Girl* appeared as a *Post* cover. In the painting, Norman included the frame of her kneeling beside the bed with her hands folded. She later noticed in the photographs Gene had taken that she had posed her hands casually with spaces in between her fingers. Norman painted them tight to one another as children in her church were taught to do in formal prayer. The painting had been a bigger production than usual, which was fantastic because she'd been able to spend something like three or four days with Norman (figures 13.1 and 13.2).

FIGURE 13.1

Day in the Life of a Girl: Chuck Marsh and Mary Whalen Leonard appeared in this painting. Mary Whalen Leonard also posed for *Girl at the Mirror*. *Source*: Courtesy of the Norman Rockwell Family Agency.

FIGURE 13.2
Norman painted Chuck Marsh as a boy in an advertisement for Dartmouth College, calling his character a potential future student at the college. Chuck eventually graduated from Dartmouth. *Source*: Courtesy of Chuck Marsh.

What would have been an ordinary day in sixth grade began in a frightening way, and Mary had no idea what was going on. Mary and her classmates walked down the hill from their school to the Martha Canfield Library, a brick building between the Colonial Inn and post office. It was named after the mother of Dorothy Canfield Fisher, a friend of her family who was a well-known American author and who had written a play called *Understood Betsy*. Martha Canfield, a philanthropist, had made donations that helped develop the town's educational system. The librarian gave the students a tour and instructed them on the Dewey Decimal System of organizing books. When Mary and the others arrived back at school, their teacher picked up a note someone had put on her desk. Mary noticed the teacher gazing at her.

"Mary," she announced, "the principal would like to see you in his office."

A bolt of fear struck Mary. Mr. Burnett kept his hair clipped short and never wore anything but a dark suit and tie. She would see him standing in the hall with a stern expression and his arms folded at his chest. All the kids feared being sent to his office for a scolding. She began crying. She didn't even

know what she had done wrong. Her twin brother Peter noticed how upset she looked and led her by the hand. She cried as they made their way down the hall and through the gym.

At the office, Mr. Burnett surprised her when his mouth curved into the only smile she had ever seen on his face. He handed her a bag. "Your mother brought this clothing. You are to go to Mr. Rockwell's studio. Mrs. Rockwell will pick you up after school."

Why does Norman always let me know at the last moment?

Happiness erased her fear. In Arlington, you didn't often meet a woman who studied writing at Stanford University in California and liked to chat about many things. Mary could talk about anything with her, and Mrs. Rockwell would show interest in her life and encourage her.

RIDING WITH MRS. ROCKWELL

After Mary hopped into the car, they descended the ridge where the school stood and continued past the Whalens' home. Her hair in pigtails, she wore a corduroy skirt her mother had made for her along with one of her comfortable white blouses. They began their usual heart-to-heart chat as Mrs. Rockwell drove past St. James Church and the Arlington Inn. Mary cherished the privilege of leaving school early, being picked up in the Rockwells' shiny car, and having the artist's wife all to herself. They even had the same first name. The scenery changed into cornfields, cows, and barns when they entered West Arlington. Mrs. Rockwell listened with genuine interest as Mary talked about school, sports, and friends. The sophisticated woman had moved to Vermont all the way from California. Dorothy Canfield Fisher was helping her write a book.

Mary's chat with Mrs. Rockwell ended far too quickly when they drove through the covered bridge on the Green to the Rockwell's big white house and made their way to the studio. The sight of the high mountain ranges off to the side and the spacious meadow contributed to a beautiful setting.

Mary once again felt special when Norman greeted her warmly in the studio. By this time, she felt at home and took a seat in the lounge chair by the fireplace. The brown wash on the paneling gave a casual, comfortable feeling. Steep stairs led to the loft where he kept costumes. Mary liked to peer out Norman's big studio window at the little white church, the dance pavilion,

and the bridge. Gene Pelham came out of the back room where he developed pictures and greeted her. "Hello, Mary."

Norman began the fun when he held up his sketch. A schoolgirl sat on a bench outside the principal's office with a black eye. He described the scene she was to enact. "Mary, you were in a fight, and you're happy about it."

"What do you mean, Mr. Rockwell?" she asked.

"You stood up for a conviction. You didn't back down," he said.

Norman had Mary sit on a wooden chair. He told her to smile because she needed to appear proud. Mary could normally not smile at will, and imagining sitting outside of Mr. Burnett's office doing so only made matters worse. She panicked, pushing a smile even further out of reach. Norman made weird faces to evoke laughter, but even that did not help. She became even more desperate to please him. Finally, Norman dropped to his knees, pounded on the floor, and burst into laughter. Norman would do *anything* to get the expression he wanted. Mary felt a glorious smile on her face. *We did it again! What a relief.*[3]

"I knew we could do it," Norman exclaimed.

Mary laughed. The whole situation was hilarious!

A short time after that session, Norman called her parents again. Mary's mother painstakingly braided her hair. Mary arrived at the studio in a plaid dress as he had requested. Norman told Mary that he did not like the shoes she had worn, so her brother John, who had come along, gave her his. Norman had her muss up her hair and rubbed charcoal above her eyes to make them look as if she had been punched. This was the only time Norman used makeup to enhance her face. He grew frustrated because he could not create an authentic black eye using charcoal, but he could not think of a solution. Norman positioned his neighbor and fellow artist Don Trachte Sr. as the principal at a desk behind her, peering into the hallway where Mary sat on the bench. Trachte drew cartoons for *Henry*, the most syndicated American comic strip of that era. It appeared in newspapers around the world. At that time, Trachte's work was published under the name of Carl Anderson, who originated the comic.

Mary even got to see Norman paint. As he sat at the easel working on *The Shiner*, he told her, "Mary, come over and look. I'm doing a picture of you right now."

Although it was wonderful to see herself in color on a large canvas, the meaning of this illustration was a mystery to her. The whole thing seemed fuzzy.

"So, what do you think? Do you like it?" Norman asked. He searched her face.

"Yeah." Mary's mind went blank. She couldn't think of anything else to say. She wished she had said something meaningful. She just did not understand what the whole thing meant. Whatever it had been, it was more fun than she'd ever had.[4]

Mary thought Norman was crazy when she learned he had advertised for a black eye in the *Bennington Banner*. A wire service sent the ad around the country, and many newspapers published it. People from as far south as Georgia had called Norman. People in prison even offered him the opportunity to paint their wounds. Norman accepted the offer of a man from Springfield, Massachusetts. When he and his son walked into the studio, Norman loved the boy's two fresh shiners and immediately set out to paint them. Since they were real, they had all the genuine shades of black, red, and blue.[5]

WORKING FOR AN EXPRESSION

Next, Mary posed for a painting called *Girl at the Mirror*. The *Post* was a general interest magazine that offered illustrations and stories for the whole family and often featured children. One of the other two Arlington girls who sat for the painting, Sharon O'Neil, drove to the studio with Mary and her mother. She was the daughter of Dr. James O'Neil, one of Arlington's two physicians. Although Mary hadn't known, Norman's next-door neighbor Ardis Edgerton had already posed. No one, not even Norman, knew at that time who would actually appear on the *Post* cover. Mary hoped to be the one! In the studio, Norman had led her and Sharon to a short stool in front of a large mirror leaning on a chair. He explained the story he would tell in *Girl at the Mirror*. A girl wearing a white slip would sit on the stool in her bedroom and peer into a mirror she has leaned up against a chair. Her expression would reveal that she is wondering if she is becoming a beautiful young woman or not.

Norman explained to the girls that he needed them to show expressions of concern. Sharon posed first. She was taller and had a larger frame. When Mary's turn came, Norman told her to change in the room at the back of the studio and return wearing her slip. Mary tensed as she realized she'd have to

reveal something she would have never told anyone. She blurted, "I'm not wearing one." If her mother knew, she'd be horrified.[6]

"Could you put on Sharon's slip?"

Mary changed in the back room and returned to the mirror. Far too large, the slip hung uncomfortably from her shoulders. The two girls adjusted it with safety pins. Mary took her place on the stool. Norman coached her to arrange her body so she would be seen in the mirror from the top of her head to her toes. Light streaming from Norman's big window shone on her. Gene Pelham stood before his tripod in front of her, ready to snap the camera's shutter at the second she gave the perfect exact expression. Norman demonstrated how he wanted her to press the fingernails of each hand against a cheek. He told her to think about what she saw in her future. He allowed her to contemplate. Genuine thoughts about her life rose from her heart.

"You have reached the age where you don't want your doll anymore. You have thrown it to the side of the mirror. You know what that's like. Right, Mary?"

Mary could feel Norman standing behind her. "No. I don't. I've never played with dolls." Mary was proud of her athletic abilities.

"Haven't you played with makeup?"

"No."

After a pause, Norman confided, "When I was your age, I used to stand in front of the mirror and comb my hair different ways. I wanted to see if I was handsome or not."

Mary had to admit she did not think of Norman as handsome. She just thought he was wonderful. She was drawn into his personality, his work. She felt comfortable because she trusted him. He was full of life, kind, and gentle. He created masterpieces everyone loved. She felt special that he shared his feelings with her. But Mary grew anxious because she could not connect with the emotions that would bring the expression of concern to her face, and she wanted to please him.

Norman tried again. "Dream about the beautiful woman you are going to become."[7]

She grew uncomfortable. It was not that she sat in front of a mirror in her slip. Norman and Gene were trusted friends. She simply could not relate to a girl hung up on physical beauty. *Will I be a great skier one day?* she wondered.

Finally, Mary panicked. She was never going to be able to give Norman the look he needed. She became so fearful that she pressed her fingers against her face for real.

Gene Pelham snapped pictures.

Ironically, Norman announced, "Good. Good. We got it, Gene!"[8]

Got what? Mary wondered.

Mary's mother brought her to the studio for another session. Norman felt he must sketch her in her own slip to make the painting more real. Gene Pelham stood with them and took photographs. Norman delighted her by mailing her a copy of her posing in the mirror.[9]

He also called Mary before *Girl at the Mirror* appeared in print. "I hope you like it," the artist said. He paid Mary $5 for each session; she bought a blue Columbia bicycle with her earnings.[10]

Mary also appears with family members in the charcoal drawing Norman created for the UN sketch. With hands folded in prayer, Mary stands at the center in front of Norman's next-door neighbor Buddy Edgerton, who wears an army helmet.

Mary was inspired when Norman explained that he planned to audition for a role in a local play called *Understood Betsy* by Dorothy Canfield Fisher and suggested she try out too. Eleanor Roosevelt included Mrs. Fisher as one of the ten most important American women. It was a story about a nine-year-old orphan who moves from the city to a Vermont farm. Norman had been in a local theater production once before, and everyone had gotten a kick out of it. In *Tourist Accommodated*, he had dressed as a Native American with a feather sticking out from behind his head. He had done nothing more than stand on the stage with his arms crossed. Mary had felt great, imagining the town applauding her for a terrific performance in *Understood Betsy*.

SOME BAD NEWS

One autumn day after school in 1953, the wiry twelve-year-old Mary tossed a baseball back and forth with one of her brother's friends in her family's backyard. Crimson, yellow, and brown leaves lay scattered on the ground. Nationally and around Arlington, it was a happy time because the Korean War had ended earlier that summer and American soldiers returned home. Kids were excited over the release of the movie *Peter Pan*. She looked up when her mother called to her from the back porch. "Maaaaa-ry, come inside."

The energetic tomboy didn't want to quit playing. She reluctantly strode from the yard up the steps. When she arrived in the living room, she noticed a glum expression on her mother's face. Although her father John was normally a warm, quiet man with a quick wit, his expression matched her mother's. Mary searched their faces. Something was definitely wrong. They began by saying they had some bad news to tell her about Norman Rockwell. Her father explained they didn't want her to learn the news from someone else. He warned her she must not tell even one soul. Concern immediately came over Mary. When Norman Rockwell called and her parents took her to his bright red studio surrounded by dairy farms on the west side of town, life became wonderfully animated. During the previous three years, she had grown very fond of the artist, and her modeling sessions were cherished moments of her life.

"Mary," her mother Margaret said. "We're the only ones who know, except possibly the Edgertons." The Edgertons lived in the identical white house next to the Rockwells.

The secret would shoot through town like an electrical current if she mentioned it to even one person.

Why don't they just tell me and get it over with?

Her father had taught her the importance of keeping secrets. He ran his law practice from their home and made Mary promise to never speak to anyone about clients she saw coming and going. Norman Rockwell was one of them. Actually, most everyone used John Whalen. He was the only person in town who practiced law.

Time seemed to stop as she looked up at her parents. How bad could the news possibly be? Her mother finally dropped the bombshell. "Norman is moving to Stockbridge, Massachusetts. He needs to be with his wife. Mary is ill and has been in a hospital there." The words crushed her. Mary felt a wave of shock.[11]

Mary ran upstairs to her room, threw herself on her bed, and sobbed. She lay there in the still of the Arlington evening. As the dark of night crept in, the thought that she might never model for Norman again weighed heavily. She tried to hold out hope that, somehow, her parents had gotten something wrong. *Maybe Norman isn't moving away.* But their dreary faces left little room for doubt.

As she cried into her comforter, Mary made a vow. She would never—and she meant *never*—tell anybody about the fun she and her mother had with

Norman Rockwell, not even her closest friends. She had a friendship with a wonderful man who understood her and made her feel alive and special like no one else ever had. A man famous across the country actually cared about her. They worked together as partners. He would give her the story he intended to tell with his paintings and asked if she understood. He thought enough of her to ask her opinion. Norman had told people that she and President Eisenhower, who modeled for him at the White House the year before, were two of his favorite models. Over a few minutes' time, he could get each of them to show a variety of expressions on their faces simply by giving them situations to think about. Norman had come right out and said, "Mary Whalen is my favorite girl model." He had made it clear just how special he considered her, and she decided to lock her memories deep in her heart and protect them forever. She never wanted to forget him.

A reticent girl, Mary often felt uptight in social settings. But when she posed in front of his giant window, Norman brought her out of herself like a director would an actor. A genie from a bottle could grant no greater wish. She couldn't quite grasp the fact that people all over town and across the country saw her on the cover of the most popular magazine of the era. She didn't try to figure it all out. However, Mary was aware that people in town considered her some sort of star, and that felt really good.

She reminisced about all the good times. She had found Norman kind, understanding, and super interesting the first time she walked into his studio. She immediately felt she could trust him. He always respected her in every way. It was like playing like kids in his studio when she modeled. Mary even got to watch Norman sketch and paint her.[12]

Their friendship deepened when he shared thoughts from his own childhood. When she modeled, parts of her personality came alive in a way she had never experienced. She felt feelings of fear, happiness, and sadness. He served cake and soda to her and her mother. They had great laughs. He made her feel eager to work. The most special man in town gave her his undivided attention.

And now it was over. Pictures of their time in his studio ran through her mind like a movie. She wondered if Norman would choose her for *Girl at the Mirror*, their last picture together. It was still not complete, and nobody knew for sure if they would be in a painting until it was published. *But I don't care anymore.*

Why is Mary Rockwell in the hospital? she wondered. *Maybe she's going to die.* Anxiety weighed heavily on Mary's heart. A couple years earlier, Mrs. Rockwell had begun disappearing from town for a couple of months at a time. She'd heard her parents express concern, but she didn't understand why. *Mary is such a nice woman. I hope she's going to be okay. Don't let her die.*

Without Norman, she didn't even want to audition for *Understood Betsy*. That was another dream ruined.

NORMAN IS GONE

The day after Mary's parents gave her the bad news, Norman did move from Arlington to Stockbridge for good. To her relief, she learned that Mary Rockwell was not going to die. Norman's wife couldn't stop herself from feeling depressed and needed to be in a hospital where people could help her get better. The news did flash around town as fast as an electrical current when people learned that Norman and his family were gone.

As for Mary, she knew something had ended in her life. "I couldn't quite put it together that I was never going to pose again. Reality was too big," she explained.

On Norman's last day in Arlington, Margaret Whalen said something Mary would never forget. "Well, Norman left today, Mary. I don't think the people in this town knew who we had among us."[13]

GIRL AT THE MIRROR APPEARS

One day in 1954, the year after Norman left, Mary noticed a copy of the 1954 *Saturday Evening Post*, with *Girl at the Mirror* on the cover on her family's living room table. She forced herself to pick it up and peek. Seeing herself made her drop the magazine on the floor and run out of the room. Now a teenager, she didn't like pictures of herself, and the cover brought back the memory of Norman's departure. When she was in her twenties, she finally saw the original in the Bennington Museum during an exhibit. "It was just too much. I was overwhelmed. I went outside and cried," she recalled (figures 13.3 and 13.4).[14]

Once she felt comfortable enough to study her image on the *Post*'s cover, Mary found it interesting that Norman had chosen to depict the expression of concern she revealed in the mirror. She found another element interesting. Norman had put a magazine on her lap open to a page showing the gorgeous

movie star Jane Russell. She learned later that Norman had two other girls pose for the painting in his new studio in Stockbridge, which made the fact he had chosen her all the more special. She added this to her vault of precious memories of times spent with her friend Norman.

FIGURE 13.3

Girl at the Mirror: Norman brought feelings out of model Mary Whalen she never knew she had. *Source:* Courtesy of the Norman Rockwell Family Agency.

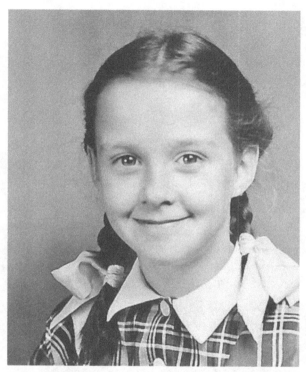

FIGURE 13.4
Mary Whalen Leonard is the daughter of John Whalen,
who was Norman's attorney in West Arlington, Vermont.
Norman said Mary was his favorite girl model because
he could get a range of wonderful expressions from her
in the studio. *Source*: Courtesy of Mary Whalen Leonard.

14

A Star in His Father's Paintings

In *Saying Grace*, one of the characters at the restaurant table staring at the little boy and grandmother praying looks more lost than interested (see figure 10.1). The mind of the young man with the blond hair appears to be far away. His complexion is pale, his expression sad. Just who is this young man Norman selected for what many consider the finest of his career, and why does he appear to be withdrawn? The young man is Norman's son Jarvis, who was at home on leave from the US Air Force the day he posed in 1951. Always seeking faces that would make his paintings feel authentic, we can be sure Norman used his son for a model as the forlorn onlooker because he fit the part.

Over the years, Jarvis has been open about his relationship with his father and readily admits that he indeed was emotionally distant during that period of his life. It is a long story as to how his expression in *Saying Grace* came to be and a longer one as to how he found himself and worked through his struggles. Along the way, he appeared in some of the finest Rockwell paintings.

Jarvis Waring Rockwell was born in 1931 from a family line with old American blood. His ancestor Stephen Hopkins was a passenger on the *Mayflower*, which arrived in Plymouth, Massachusetts, in 1620. Hopkins was his tenth great grandfather.[1] Jarvis's family had resided in the New York City area since the first part of the 1800s. His parents gave him the same name as his grandfather, who died less than one month after Jarvis's birth.

His mother Mary grew up in Alhambra, California; graduated from Stanford University; and taught school briefly before marrying Norman and moving to New Rochelle. Jarvis, known as Jerry during his childhood, lived his first years in a nicely landscaped, middle-class section of that city, which was the pride of one of the country's most wealthy counties. His father had already enjoyed a decade as one of the nation's leading illustrators. His studio stood next to their two-story home. Those rooftops can be seen in *Outward Bound*, the beloved painting of an old man and grandson peering out at a ship riding the sea.

"They would say, 'We're twenty minutes from Broadway,'" Jarvis quipped as he reflected on his childhood. On weekday mornings, dark-suited men—celebrities, artists, and business types—boarded the train to Grand Central. A throng of people walked streets lined with shops, delicatessens, and restaurants. Children frolicked in the sand and splashed in the ocean at Long Island Sound beaches. Brief train rides delivered them to New York subways that carried them along to museums and sporting events. The Rockwells kept a membership at the prestigious Bonnie Briar Country Club, where Norman was a founding member and played tennis.

About the time of Jarvis's birth, however, his father began suffering through a professional identity crisis. During Jarvis's first year, the family took a boat to Europe, where Norman hoped a change of people and scenery would revitalize his art.[2] He tried his hand at modern art but abandoned the genre quickly to return to his natural style. By 1935, good fortune found Norman when Heritage Press commissioned him to illustrate Mark Twain's *Tom Sawyer*. The spirited characters flipped on his creative switch, and Norman regained his grip and joie de vivre.[3]

IT SEEMS LIKE A LIFETIME AGO

Jarvis's New Rochelle years seem of another lifetime. He has few memories but does recall meeting some of his father's models. He once crawled into a doghouse and sat with the girl who lived next door named Mary Jane Butler. She modeled for his father's Niblets corn advertisement, *Who's Having More Fun?* Genteel Mary Jane picks at an ear of corn as a boy next to her is hunched over his plate chomping from one end of the cob to the other.

Twelve years before *Saying Grace*, Jarvis posed for *Marbles Champion* (see figure 1.1).

In the spring of 1939, he was on summer vacation, enjoying his new adventures in Vermont's Green Mountains. That autumn, Norman had canvased the streets of nearby Cambridge, New York, set on finding a model with red hair, brown eyes, and freckles to join Jarvis and another boy for *Marbles Champion*. Jarvis found himself modeling with eleven-year-old Ruthie McLenithan in his father's studio. In the painting, Jarvis has a strong presence as a befuddled boy being beaten by a girl. At that time, few girls even played the game. Steven Spielberg, director of classic films such as *Jaws* and *E.T. The Extra-Terrestrial*, would later call *Marbles Champion* a terrific example of cinematography.

During those summer days, he and his brothers Tommy and Peter immediately took to swimming in the brisk Batten Kill. Their father joined them occasionally and would sit down in the brisk water where it was shallow. While in his studio, he could keep an eye on them from the studio window. They ate apples from a crabapple tree in front of their house that had been grafted with a tastier variety.[4] They circled the barn next to their father's studio on bikes. In the summertime, the boys rode up and down the remote gravel road. When snow came, Jarvis and his brother Tommy made runs down the hill to the side of their house with skis strapped to leather boots. Eventually, they shared the bikes with the neighbors living half a mile down the road, Walt Squiers's children Marjorie and David, who were thrilled because, like most locals, they didn't have the luxury of bikes. Jarvis, sensitive and introspective even as a boy, generally spent his days closer to home, while his outgoing brother Tommy ventured out to join the locals in deer hunting, farming, hiking, and camping (figure 14.1).

Sitting on the flagstone patio outside his home in the Berkshires with his wife Nova, an artist and teacher, Jarvis marveled at a print of *Marbles Champion*. "That's really something," he said. He paused for a moment while his mind took him back eighty years to when his father painted the red whoopee cap with a sawtoothed pattern on his head. He became quiet and sentimental as he mused about the day he posed next to Ruthie. "I always liked the voice my father spoke in when he was directing models." Jarvis's voice has the same rich baritone quality.

"It's sort of like 'Women's Lib.' Look at the face!" Jarvis points to Winston Salter, the model standing on the other side of Ruthie, who has given the boys a beating at marbles. "He's really disturbed." Norman sketched feverishly

FIGURE 14.1
Jarvis Rockwell stands on the bank of the brisk Batten Kill River after a swim, circa 1939, the year he posed for *Marbles Champion*. *Source*: Courtesy of Jarvis Rockwell.

throughout the session, inspired by his new situation in Vermont. Jarvis enjoyed modeling for that first illustration his father began in Vermont. "That's what you did if you were my father's son, and you liked it. . . . I like the painting because it has me in it!" He smiled.

Despite playing important roles in *Marbles Champion*, *Homecoming Marine*, and *Saying Grace*, Jarvis said, "I never felt like a Rockwell model. I was

too distant or something like that. I was too real." Jarvis's criticism of himself is contrary to Norman's strategy of using models that showed genuine feelings. We have to believe that as an artist, Norman considered that the anxiety Jarvis reveals with discontentment—fidgeting fingers and mussed hair and a look of being lost in the three paintings—to be critical elements. "I never thought of that," Jarvis said.[5] *Homecoming Marine* (see figure 8.1) is another considered one of Norman's best. Prints are often found hanging on walls of the offices of military leaders across the country. Visitors to the Society of Illustrators exhibition of 1946 voted it their favorite.[6]

In *Homecoming Marine*, Jarvis stands in the right corner of the Benedicts' automotive garage in a circle of men huddled around the marine telling war stories, wearing the red sweatshirt bearing the letter "R" for Camp Ropeoa. It was when his parents sent him and his brother away while Walt Squiers constructed Norman's new studio. Jarvis knew Benedict's garage in Arlington village because it repaired his car. He remembered the establishment fondly and took pleasure in the scene. "I was fascinated by all the mechanics' tools hanging on the wall at the rear."

The next year, 1940, Jarvis unexpectedly found himself permanently transplanted to Vermont. Their pre–Revolutionary War home stood at the foot of Red Mountain, and the nearest neighbors lived half a mile up the road. The stimulation of the New York City area came to a dead stop in the still, quiet forest. Norman was reinvigorated by the change and teemed with excitement as he developed friendships with the rural Vermonters, exciting potential models. Jarvis, on the other hand, began feeling more and more like an alien as the weeks passed. He spent many of those days secluded with his parents and brothers, along with the old-time Vermont couple, Thaddeus and Bessie Wheaton, who lived in an apartment in their home.[7] The Wheatons became famous faces when in 1943 they appeared in *Freedom from Want*, also known as the "Thanksgiving Painting" (see figure 3.2). Bessie, the Rockwells' real-life cook, stands before the dining room table, poised to set a plump Thanksgiving turkey before a joyful family gathered around the table. Thaddeus stands beside her. Thaddeus had been a sergeant in the military's Motor Transport Corps, which supervised all US military vehicles.[8] "He was a real nice guy, but he couldn't do much," Jarvis recalled. Exposure to nerve gas during World War I had compromised his health.

As a supporter of the military who served a stint in the US Navy during World War I, we can imagine Norman and Thaddeus having conversations about World War II battles as the artist conceived the *Four Freedoms*.

CULTURE SHOCK

On his arrival at the Arlington school for his first time, Jarvis found himself among a handful of humble third graders speaking with Vermont accents. The children were reserved, quite the opposite of those he was accustomed to in New Rochelle. One walked in bare feet because the family could not afford shoes. Jarvis felt anxious. "It was very real, so quiet and still. I was face to face with the other children," Jarvis said. He had to escape; he turned around and walked the dirt road home. "We were living in an isolated spot in the woods. We weren't introduced to the school or any of the children beforehand." Jarvis longed to return to the camaraderie he felt with his friends in bustling New Rochelle.

Roaming the Green Mountain Valley and splashing in the Batten Kill with his brothers was the saving grace. "I loved the river. It was beautiful having flowing water as part of your intimate landscape." He also enjoyed the pastoral scenery of cows grazing in mountain pastures. Eventually, Jarvis went back and attended the Arlington school. His mother, accustomed to mild California weather, drove the boys over the dirt roads, even in heavy snow. He found his first teacher to be stern, but the second, Ann Marsh, encouraged him. The mother of Chuck Marsh, she posed for *Christmas Homecoming* with the group of dear Rockwell family friends. Jarvis modeled as the student (see figure 5.3). Holding her baby, Ann looks ahead at Jarvis. He also became more comfortable after striking up a friendship with a local boy named Jimmy Hoyt, who lived directly across from him on the other side of the river. "I badly needed a friend," Jarvis said. Jimmy's mother Rose, a favorite of Norman's, appears at the front of *Freedom of Worship* with a braid running over her head and in *Freedom of Speech*.

Jarvis remembers fondly the classic books his mother read to them as children, including *Dr. Doolittle*, *Swallows and Amazons*, and *The Hobbit*. Having been a teacher, his mother read with feeling in her voice, which engaged them. "That was wonderful. We have a whole library of her children's books." Mary wrote stories of her own in a study at the back of their home. It was when Jarvis was ten years old that he remembers drawing his first real picture,

a boat under a bridge. His inspiration came from drawings his mother showed him in a book about an apprentice learning to make furniture.[9] During his school years, his classmates noticed he would often be sketching on a pad, especially during study halls.

In addition to his love of drawing, Jarvis was a keen observer of human nature like his father. Life's events often struck him as comical, as they did Norman, and he laughed liberally as he recounted them. One day at about ten years old, not long after he had moved from New Rochelle, he heard a vehicle stop between the house and studio. Looking through a window, the city boy spotted a pickup in front of his house with a black bear sitting up against the back window of the cab. He feared the animal might jump off and attack. "Dad," Jarvis hollered in a panic. "Someone is outside with a bear! Come here and look."

"What?" Norman hollered.

"There's a bear outside. Hurry up!"

His father dropped what he was doing, hustled to open their front door, and peered outside. Jarvis felt safer standing behind his father.

Walking up to the house, the hunter called out, "Norman, we got you the bear."

Norman strolled out to the truck and gave the beast a good looking over. "That you have. Never thought you'd actually show up with one," Norman said with a chuckle. Jarvis relaxed once he realized the bear was dead. He marveled over the size of the animal, its jet-black fur, and its long nose.

"He had heard Rockwell wanted a bear and went out and shot one," Jarvis explained in his baritone voice and belly laughed.

Other memories amuse Jarvis. The owner of a field next to the Rockwells hoped to generate some cash by selling property to Norman. After Norman turned him down, the man sought revenge by nailing up a fence enclosure and stocking it with pigs. The stunt backfired because the unpleasant odor dissipated before reaching the Rockwell home, and the grunting hogs didn't annoy them. The man merely created more work for himself transporting and lugging slop and grain. "That's a real Vermont-style story," Jarvis said with a smile.

Quite by accident and like his brother Tommy, Jarvis posed for the comical drawing featured inside the *Post* in 1943 called *My Studio Burns*. On May 15 of that year, Norman depicted Tommy bolting down their staircase and

hollering that their father's studio is on fire. "Someone driving along Rt. 313 saw the fire and alerted everyone to it," Jarvis recalled.[10] Norman's hired man Thaddeus leapt from his bed, ran to the car in his nightshirt, and raced the half mile to the home of Walt Squiers.[11] The Rockwells' phone wires had already been destroyed. In the sequence of pictures, Jarvis stands on the back of a chair draped in a blanket and peers helplessly through a window. Fire has reduced the studio to a charred skeleton. Jarvis recalled watching firemen carry out bicycles and other possessions as flames spread and heard the ammunition of his father's .22 shotgun exploding. Norman lost original paintings, his gun collection, traditional costumes, and most everything relating to art he had collected since he began his art career. Norman admitted he probably started the fire by dropping ashes from his pipe onto his window seat cushion as he turned off the light above it.[12]

Strangely, the drawing showed that he felt more excitement over the event than distress. "A way to take care of it is to use it," Jarvis quipped. Later, the reality sunk into Norman that he had lost some cherished sentimental items.

THE MOVE TO THE GREEN

The fire, coupled with the fact that they had grown lonely living so remotely, prompted the Rockwells to buy the 1792 white Colonial three miles down the road on the Village Green. Jarvis and his family members became close friends of dairy farmers Jim and Clara Edgerton and their three children. Images of impressive people come to mind when he recalled Buddy Edgerton, his father's Scout model. "Buddy was like the Greek god Hermes. He was friendly, honest, and upright. A really nice guy." Jarvis especially appreciates the help and support Buddy's sister Ardis gave the family when she worked in their home. "Ardis was like a daughter to my mother."

In 1945, Jarvis appeared again along with the many West Arlington models in the deeply moving *The Long Shadow of Lincoln* as the blond boy in the front left corner listening intently to a woman with a book and a braid wrapped around her head teaching a gathering of children about the consequences of war (see figure 4.4).

Jarvis found his father to be more relaxed and spirited once they settled in on the Green. He revealed his playful side at times. "He was one of us children in a way. I don't mean he acted like a kid, but he was childlike. That goes with art." Jarvis recalled that sometimes around the house, Norman the

baritone would belt out a vaudeville song, such as "My Gal's a Corker, a Real New Yorker":

> My gal's a corker, she's a New Yorker
> I buy her everything to keep her in style
> She's got a pair of legs, just like two whiskey kegs
> Hey boys, that's where my money goes-oes-oes
>
> She's got a pair of eyes, just like two custard pies
> And when she looks at me, I sure get a thrill
> She's got a pair of lips, just like potato chips.

From another room, Jarvis would hear his mother holler, "Stop it, Norman!"

Norman also taught his sons to recite the Mamaroneck, New York, High School cheer.

During those days, the Rockwells enjoyed many harmonious times, according to Jarvis.[13] As he would come down the stairs, his father would be eating breakfast at the table and reading magazines like *The New Yorker*. He would greet Jarvis pleasantly as his son pulled out a chair and sat down. "In general, my father was a great guy," said Jarvis. The artist would come from the studio for lunch, and afterward, his mother often rubbed his father's head as he lay on the couch and napped. She often read to Norman as he painted. She had begun doing so after their marriage in New Rochelle in 1930. They made it all the way through the 1,200-page novel *War and Peace*, the story of the French invasion of Russia written by Leo Tolstoy. "She may have read it to him twice," Jarvis said.

Norman enjoyed reading various books and magazines, even though his formal liberal education ended when he dropped out of high school to study art. "He liked the kind of sophistication that wasn't overwhelming. He took *The New Yorker*, *Life* magazine, and the *Saturday Evening Post*. But he never read the *Post*. My father admired Dickens and Tolstoy, but I don't think he was interested in Dostoevsky." Fyodor Dostoevsky explored human psychology in the difficult era of nineteenth-century Russia. At dinnertime, his father would carve a roast or poultry and serve their mother, Jarvis, and his brothers Tommy and Peter. Norman would chat pleasantly. They also enjoyed dining on the back lawn. Sometimes, his father would tell stories from his childhood, such as about an Amsterdam Avenue, New York, kid the boys called "Dirty

Dewey." The kid would wear a dingy shirt styled after one worn by US Navy men and claimed that he looked like the famous Admiral George Dewey, who led the navy during the Spanish-American War. Dirty Dewey would shoot an arrow straight up into the air. The neighborhood kids stared skyward, fearing it might strike them before it hit the ground. Norman got a kick out of telling the story and would chuckle as he explained how after it landed Dirty Dewey would say, "Gimme de arrah mistah."

Along with his family, Jarvis enjoyed the church suppers in the Grange Hall and square dances at the pavilion on the Green. His rail-thin father once confided in him that he feared dancing with burly country women. "He was afraid one of them would swing him off his feet!" Jarvis breaks out in laughter. He admits to sometimes feeling slighted by the attention that people focused on his father, whether it was as they posed in the studio or at events around town. "I was the son of the man who seemed to be directing the town." The family couldn't help seeing Arlington through Norman's eyes. "My father owned West Arlington in that sense. . . . We were from behind the camera."

SPLENDID MODELS

With people around like farmer Floyd Bentley; Walt Squiers, the tall, rugged builder; and Buddy the Boy Scout, Jarvis believes his father would have been hard pressed to find a supply like the sturdy, genuine Arlington folks anywhere else. Along with these dairy farmers and carpenters were factory workers and executives, garage owners, and even a couple of old-fashioned general practitioners. There were puritans and villains, teetotalers and drunks, well-behaved and mischievous children, and the wealthy and beggars. Jarvis said, "It's amazing. That was the wonderful thing about Arlington. Every character was there in one small town, and they weren't self-conscious."[14] Jarvis remembered how Norman kept a pad of typewriter paper next to the family's wooden phone they cranked by hand and wrote down names and numbers. "Everyone was part of a small society. My father thought it was the ideal community. He was the first person to take people like that and paint detailed pictures of their faces and clothing in their real situations." Jarvis set up props and held gray, black, and white screens behind models as they posed and were photographed by Gene Pelham.

Both Jarvis and his brother Tom recall a story that their father would tell privately about a neighbor named Hoddy he intended to use in *Saying Grace*.

Norman, who had a dry sense of humor and quick wit, sometimes chuckled at the antics of colorful characters in town. Hoddy lived just beyond the covered bridge in one of three shacks set at the bottom of a mountain. When the bedraggled man with a long gray beard arrived at the studio, a wave of "natural perfume" followed him. Although a friendly man, Hoddy hadn't bathed or changed his clothes, possibly in months, because his shack had no running water. A brook ran down the mountain next to it, but he could scoop up only enough water for cooking and drinking. Neighbors knew Hoddy to be a hard worker who could not take a full-time job because he had been born with a clubfoot. Jim Edgerton, the neighbor who lived next to Norman, would occasionally open his door to find the fellow at his doorstep with an empty grain sack. Jim would fill it with potatoes from his basement. In the spring, Jim gave Hoddy work as a day laborer on the farm.

Although Norman rarely sent away a model he had his mind set on, this time he took Gene aside and told him he could not bear the odor and asked his assistant to please usher Hoddy out immediately. Norman's hygiene habits were at the other end of the spectrum. He kept his studio immaculate, even rubbing it down with alcohol.

Norman once brought a horse into the studio to model but had its handler quickly lead it out after it wasted no time doing its business. "After some distance, he had a good laugh when he told the story," Jarvis said with a chuckle.

Laughter ensued after a model named George Zimmer, an executive at a local manufacturer of plastic parts, posed for *Salesman in A Swimming Hole*. A traveling businessman stops his car next to a country bridge to take a dip in a river. "Zimmer was the ideal model—a great guy!" Jarvis said. The modeling session took place during the winter. To make George appear as if he had just surfaced, Norman dumped cold water over his head. The shock caused George to stand to his feet and exclaim, "Wow, that was cold!" Norman couldn't hold back his laughter. Zimmer broke into laughter too.

Family members were usually welcomed in the studio, but Norman often worked well into the night, leaving them to feel abandoned. When he did spend leisure time at home, he was sometimes drained and frustrated. He would agonize over his West Arlington masterpieces, by far the most complex in his body of work. In *The Long Shadow of Lincoln*, he included almost twenty models. In *Country Doctor*, Norman took on a huge project when he chose to paint the doctor's home office, a large living room with furniture, books, and

knickknacks, even a deer head mounted on the wall. To create these works, he had a multitude of decisions to make. His paintings had to entice a viewer and depict models and props that would allow that person to figure out the story quickly. Deciding on facial expressions, body language, skin and background colors, eye focuses, and props often required much thought and experimentation.

The most angst, however, was caused by the fact that he, like all sorts of freelancers, existed in a pressure cooker. He carried the burden of supporting his wife, sons, and mother and paying his assistant and housekeeper. "He was always afraid he wouldn't get more work," said Jarvis. Photographers had begun overtaking magazine illustrators, and he feared the *Post* might tire of his painted illustrations. "I don't think there was any danger of that. That was just part of his character," Jarvis tells me. "He worried a lot. . . . My mother was a worrier."[15]

A FATHER ABSENT IN MIND, A DISTANT BOY

Although they enjoyed laughs and small talk together, Jarvis, like his brothers Tommy and Peter, longed to have interpersonal discussions with his father rather than just small talk and about paint on canvas. A conversation Jarvis and Norman once had typified the artist's inability to have heart-to-heart talks with his son. Frightened and confused by thoughts he was having as a teen, Jarvis sought out his father and found him in the studio. He sat close to him. Norman was absorbed in a canvas on his easel. "I said, 'Pop, I don't understand you. I don't understand me. I don't know who I am. Talk to me.' He was painting this line across the bottom of green grass." As if he hadn't even heard Jarvis, he said, "Should I continue it?" In that moment, it struck Jarvis that his father couldn't handle discussing deeper interpersonal issues. "He was just focused on painting—that's what great people are." Jarvis believes his father might have felt incapable of real fathering due to the inferiority he felt during his childhood as a skinny, pigeon-toed boy with a star-athlete brother. He admitted to not transcending it all. Back in that era, few books existed on how to parent a child, and child therapists were rare. "At this point in my life," Jarvis said, "it doesn't bother me as much as it did. I've moved on."

Norman tended to project the emotions he was feeling into his paintings and put them "out there" for the world to view instead of sharing them with the family. He seemed to use them up doing so. To Jarvis, it seemed likely the

problems of everyday living seemed small compared to the excitement of his art. "It's an artist's way of dealing with life." Norman later conceived one of his most touching works during a period when he was really down, the three years before he moved to Stockbridge. All of the children were out of the house, leaving him and Mary with strong emotions of loneliness. Norman didn't discuss his feelings about the situation but projected them masterfully into the lamenting farmer whose boy is leaving home for college in *Breaking Home Ties*.

His father was almost always late for magazine and book deadlines, which could create tension in the household. Jarvis was sometimes around when people like *Post* art director Ken Stuart phoned and declared, "We need the painting now, Norman." Jarvis would sense his mother's anxiety when his father insisted she write notes he would dictate. She would read them to desperate publishing executives on the phone, such as Stuart. She would labor over the wording as she wrote such statements as "I have been extremely busy, and so, Ken, I will not be able to get the painting done on time. But I will get it to you soon." Once as Norman was completing the *Four Freedoms*, one of the *Post* editors drove to Vermont and pushed Norman to complete them.

Jarvis recalled that another client, Brown and Bigelow, would sometimes phone Norman and tell him they were sending a courier to stay at the Colonial Inn in Arlington. They needed to be certain that their calendar painting would be completed in time to meet their production schedule. As his father would hang the receiver back onto its wooden phone box, Jarvis would notice him grimace. "Oh God. Clair Fry is coming."[16] Brown and Bigelow told Fry, a calendar artist himself, not to return to its offices without bearing Norman's painting. "My father would invite Clair over for a visit once in a while because Arlington in the winter wasn't exactly a resort. But he couldn't have him sitting in the studio," Jarvis laughed. The moment Norman notified Fry that the painting was ready to go, the courier would swoop down on the studio like a hawk and whisk the picture off to his company in Minnesota.[17]

MEMORABLE NEIGHBORS

During his teens, Jarvis developed a fondness for another model, the local physician George Russell, who made a real-life rescue one day that Jarvis will never forget. Doc Russell, who modeled for *Country Doctor*, was known throughout Vermont for the extraordinary lengths he went to in his practice. During

World War II, he inoculated more than thirty thousand men for typhoid and smallpox. He personally drove children bitten by rabid dogs two hundred miles from Arlington to New York City for treatment. In one thirty-year period, he never missed a day making the rounds at the hospital in Bennington. Dr. Russell's collection of Vermont books and memorabilia is the largest in the state of Vermont and is housed in the Arlington Library.[18] In *Country Doctor*, the type of complex painting into which Norman poured his energy, Dr. Russell examines a small child in his quaint home office as concerned parents look on. The masterpiece could not be more genuine or poignant.

One day during a casual game of baseball on the Green, one of the local kids belted a shot that struck Jarvis in the forehead. Everyone heard a loud "pop." Dr. Russell raced to West Arlington and held Jarvis's head in his lap for the entire twenty-minute ride to the hospital. "I was out cold for a day or two," Jarvis recalled.

Jarvis remembered well the handsome model with black hair who speaks at a town meeting in *Freedom of Speech*. "Carl Hess was tall and handsome, a wonderful-looking guy. What a marvelous face!" Jarvis said. Carl's house was visible across the river once autumn leaves fell. He would fill the family car at his service station in West Arlington. When folks would stop for gas and ask Carl, "How are you?" he would reply in typical sparse Vermont vernacular, "'Bout so."

As a director, Norman often coaxed his Arlington models so that they would exhibit the same spirit Charles Dickens breathed into his characters, Jarvis notes. Norman first took a liking to the English author's dramatic scenes, containing a range of subjects from tragedy to triumph, when his father read to him at the dinner table in their late 1800s Victorian home in Mamaroneck. "Yes. Yes. Dickens is the key to the whole thing. . . . Dickens also included kids and dogs in his books," said Jarvis. Norman featured his family's playful black and white springer spaniel Butch in such paintings as *Going and Coming*. Butch hangs his head out the car window next to two riled boys. Jarvis remembers observing Butch running boldly to join bigger dogs to chase deer on Old Spruce Mountain, which rose behind his father's studio. "But he always lagged a safe distance behind," Jarvis laughed.

CHRISTMAS HOMECOMING

During his teens, Jarvis boarded at the Oakwood Friends School in Poughkeepsie, New York, one of three he would attend. Moving from school to school only added to the confusion and made him feel even more lost.[19] After attending Oakwood, he moved to California for a spell and attended Hollywood High School. "What a change!" he laughed. "My father went to California because my mother was drinking." Norman was distressed by her erratic behavior and moods and reduced the tasks with which he expected her assistance. He hired a banker to take over financial matters to help relieve her stress. He was baffled as to how he could help her stop drinking.

"He said she could come if she stopped." Mary did join the family in California, but before long, Jarvis found himself back at Arlington High School. After two months, he quit. It was during this period when he sketched a professional-quality self-portrait that reveals just how forlorn he felt. Although artistically drawn, his hair is mussed, and scruffy growth covers his chin. His eyes are large and dark.

It was while he was home for vacation from Oakwood that he posed for the painting *Christmas Homecoming*. It became Jarvis's favorite because his entire family posed with real-life Arlington friends, such as his schoolteacher Ann Marsh. Jarvis's "mother," modeled by Mary Rockwell herself, has thrown her arms around him (see figure 5.3). Like Ardis Edgerton, Jarvis believes this portrayal of his mother is the most lifelike his father painted. "I like this one because that's my mother hugging me." He lingers as he reviews the painting. His eyes turn sorrowful and his voice sentimental. "She had her troubles, but we all loved her."

Mary Atherton, Jarvis's real-life first girlfriend, waves to him from the back of the *Christmas Homecoming* group. Both age sixteen, they had been attending Oakwood. Jarvis and Mary had their first kiss while sitting on the concrete pier under the covered bridge during a Saturday evening square dance. He recalled how much he enjoyed promenading the pavilion floor with his girlfriend. The instructions from a caller at the pavilion leapt into his mind and brought a smile. "Swing with your Honolulu babe. When you're done, go back to where you begun, and swing with your Honolulu babe. Grand right and left around the hall."

"I didn't find school relevant to my life," Jarvis said. His father expressed concern. Always trying to help his sons succeed, he asked Jarvis, "Why don't you go to the Art Students League?" Just as Norman had, Jarvis left high school and went to New York to the school where his father had studied. When he returned, Norman converted a corncrib next to his studio into a place where Jarvis could create art.

On the right side of *Christmas Homecoming*, a blond teenage girl named Mary Immen looks on. "She was gorgeous," remarks Jarvis. Her father Bert was the real estate agent who brokered both of the Rockwells' West Arlington homes. Jarvis's brother Tommy appears in a brown plaid shirt as the all-American boy beaming with a smile. Jarvis notes that his father's depictions often didn't reflect real-life moods. Ironically, at the time, his brother was pained by his mother's illness. Norman included himself in the middle. Jarvis's brother Peter, wearing glasses, stands on the left. America's beloved Grandma Moses, the lady with white hair, sometimes visited Norman at the studio. "My father went to see Grandma Moses in Eagle Bridge, but she couldn't show him her studio. It was in her bedroom. She couldn't have a gentleman in there," he laughed. Did he know that a gallery in Paris once invited Grandma Moses, but she declined? She asked, "Who will feed the chickens?"

"Now that's realism," Jarvis exclaims. "Ha ha ha ha ha."

At about the time Norman painted *Christmas Homecoming*, Jarvis noticed his normally outgoing and garrulous mom showed signs of fatigue, but he didn't realize she had a serious issue with depression until he came home from the air force five years later.

During high school summers, Jarvis experienced low moods himself. He would lie for hours in his hammock, strung between two maples next to the back corner of his house. The view of the white Colonial on their green lawn, surrounded by the lush Green Mountain range and wide, blue skies, improved his outlook. Under the West Arlington sky on hot days, the sound of the Batten Kill soothed him as it whooshed under the covered bridge. Cows and horses grazed lazily in the summer heat on the mountainside. Jim Edgerton's barn next door was visible from a distance, as were the Vaughn barns and animals across the graveled road. "I think farms are wonderful. I liked the smell of barns and manure. I loved the voices of the animals." But Jarvis was not inclined to cross the yard to shovel manure, drive tractors, and pitchfork hay. "Tommy would go work for the farmer, and I would lie in

the hammock." All the while, the wheels of Jarvis's mind where churning. "I was sifting through life's experiences. I just didn't feel that I was right. I kept drawing heads that were split. I'd draw a line and try to remove it."

Jarvis's girlfriend Mary Atherton and her parents Jack and Maxime would attend dinner parties at the Rockwells' home from time to time. Norman admired Jack because he could create both highly marketable fine art and illustrations for magazines with equal skill. He also enjoyed tagging along as Jack fly-fished in the Batten Kill. Jack was an expert fisherman who wrote *The Fly and the Fish*, which has become an American classic. At times, Jack pestered Norman. How could he stand doing illustration work instead of branching out to fine art? Mary says this was all done in fun. However, in public, Jack, an opinionated man who could be boisterous, would defend Norman's human interest illustrations if someone criticized them.

Memories of one particular dinner party stood out in Mary Atherton's mind.[20] One summer day when she was a student at Bennington College, Norman and Mary set up a barbecue on their lawn between their home and the studio to celebrate the arrival of Norman's paycheck for a particularly complicated cover. Friends were having drinks and chatting when Norman appeared on his back porch holding a box. "I just got paid!" he hollered with a big smile. The guests turned to Norman, who grinned as he opened it. They watched as he took out handfuls of green bills and flung them high. He broke out in laughter. As the bills fluttered toward the ground, all were astonished that he would act so frivolously, Mary recalled.[21]

Being more of a formal sort, Jack Atherton didn't find the stunt amusing. "What the hell are you doing, Norman? Have you gone nuts?" Jack's scowl only made Norman laugh harder. Jarvis, Mary Atherton, and others scrambled across the yard plucking bills from the grass. They shook their heads as they returned them to Norman.

During the Korean War, Jarvis joined the air force. "I joined the Air Force so I wouldn't get shot at in the Army," he said in his typical unguarded fashion.[22] During his first assignment at Scott Air Force Base in Illinois, he created art for his base's newspaper. Like his father during World War I, he was soon sought after to draw cartoonish portraits of officers. His dislike of military life, pain over his mother's drinking, and confusion over what route to take in life caused the "distant" look on his face when he modeled. This is the period, in 1951, when Jarvis returned home and appeared in *Saying Grace*.

SAYING GRACE

Norman wanted to depict models whose expressions would reveal they were respectful and tolerant as the grandmother and grandson prayed. Jarvis was coping with the unpleasant feelings at the time. He had never completely acclimated to Vermont after leaving New Rochelle and had attended three different high schools. He was not happy serving in the Air Force. All these factors contributed to the lost expression and look of indifference. Jarvis, who claims his father did not find him effective as a model, sits at the center of the painting sold at auction for the highest price of any done by an American. Norman's intention, as he expressed it, was to create a group that is "neither enthusiastic nor annoyed, but curious," and Jarvis fit the bill perfectly.

Don Winslow, one of the students Jarvis brought to West Arlington from the Art Students' League, modeled as the young man seated next to him with the black cap, peering at the woman and the boy with the expression of intrigue. Winslow, a troubled but skilled artist, became Norman's apprentice for a spell. He also appeared in *The Plumbers* with Norman's assistant Gene Pelham and published two *Post* covers of his own.

"The students stayed in the schoolhouse. My father would go down and view their illustrations," Jarvis explained.

At the time, Jarvis had already begun drawing professional-quality portraits of his Vermont neighbors, which met his father's approval, including one of Bill Sharkey, who appears off to the side in *Saying Grace*, pulling on his coat.

MARY'S ILLNESS

When Jarvis, now age twenty-one, came home on leave from the air force, he noticed that his mother was not feeling well emotionally. "She would drink more sherry than she needed. My mother was sweet, but when she was depressed, she got very quiet. My poor mother." His father had begun driving her from Arlington to Stockbridge, and Mary would spend periods at the Austen Riggs Center. Her doctor concluded Mary had endured a difficult childhood that left unresolved psychological issues. She had not developed the coping skills to manage a challenging lifestyle as the wife of a driven, famous artist. "Her severe mother had demanded constant proof of her daughter's love and competence," wrote author Laura Claridge.[23] An abortion Mary had in England caused her anguish the rest of her life, according to Jarvis.[24]

He notes that low self-esteem ran in his mother's family. His maternal grand-father had felt beaten down. He was paid a salary by the family business but was not considered astute enough to participate in important matters, Jarvis said.

During that era, mental illness and alcoholism seemed dark and mysteri-ous. People like Norman and the children struggled in isolation to understand and cope with the turmoil. Those suffering didn't have access to the type of rehabilitation centers that exist today. Mary Whalen, model for *Girl at the Mirror*, notes that Alcoholics Anonymous had already been founded by Bill Wilson, who had grown up in nearby Dorset, Vermont. But being anony-mous, few knew of it. Doctors prescribed harsher, less effective treatments and medications that sometimes caused physical and psychological damage. Granddaughter Abigail Rockwell said that Mary suffered from severe trauma during her childhood that resurfaced during her Vermont years. Once treated for depression, she was given "lots of drugs," such as Seconal, a drug prescribed to distressed patients.[25] Norman liked "old-fashioneds," a sweet whiskey drink with bitters, but would stop before becoming intoxicated, ac-cording to Jarvis.

Jarvis eventually obtained his GED. "I think a writer would go to college, but an artist, not necessarily." Although he didn't go to college, Jarvis has read scores of books, including philosophy and nonfiction as well as fiction by Thomas Wolfe, John Updike, and F. Scott Fitzgerald. He found Hemingway "too macho."

One might expect to find Jarvis, with the collective value of his father's paintings being in the hundreds of millions of dollars today, living in a man-sion behind locked gates. Instead, he has remained down-to-earth as the Arlington Rockwell models he grew up with and lives contently in a modest but charming home in the Berkshires.

Tom managed his father's estate for many years, which eventually became known as the Norman Rockwell Family Agency. Although Norman gave many of his paintings to the museum, sold them for minimal prices, or gave them away, he maintained the licensing rights. They have been reproduced in various forms billions of times.

Before he died, Norman allowed his children to each select one of his paintings. Tom received *After the Prom*, and Peter received *The Choirboy*.

Norman wanted the public to enjoy the remainder and placed them in the Rockwell Museum.

"Of course, they weren't worth what they are now," Tom Rockwell said.

Does it bother him that he doesn't own more of them?

"I'd like to have made the $46 million the *Post* art director [Ken Stuart] got for *Saying Grace*. But you know. What are you going to do?"

Tom said his father felt obligated to give the painting to Ken Stuart, who assigned and paid him.

Are people sometimes better off without millions of dollars?

"Sometimes," said Tom. "You never know."

Perhaps today, Norman Rockwell would be glad he did not give his sons paintings that collectively would be worth billions of dollars. During his life, the illustrator mastered the art of remaining down-to-earth, as did many of his Arlington models. Perhaps he would be glad if he knew his sons have also remained genuine.

A FABULOUS PSYCHOANALYST

During the time when Jarvis left the Air Force and Mary was being treated at the Riggs Center, Norman too decided he needed treatment. He was suffering from low moods and fatigue. It was at Riggs that the famous American psychoanalyst Erik Erikson treated Norman. Jarvis laughed, "My mother was an inpatient. My father was an outpatient. My whole family knew Erikson. It was wonderful my father paid for therapy for all of us."[26] Jarvis now finds it a privilege that his family was exposed to one of America's masters of the human psyche. Erikson had been analyzed and mentored by Anna Freud, the daughter of the renowned Sigmund Freud. College professors today continue to teach Erikson's theory, the "Eight Stages of Psychosocial Development." Erikson, who never attended college but had worked extensively with children, developed methods to apply his theories to all ages.

The psychoanalyst, who coined the term "identity crisis," was a talented artist himself, which helped him to understand Norman. In Stockbridge, Erickson would sit on the couch and analyze Norman as he stood painting at his easel. "That was a very intelligent thing on the part of Erikson," Jarvis explained. "I'm really impressed with that. . . . Erikson would talk at a level my father could understand. He respected my father a lot. He *really* liked him. . . . He didn't try to change the way he worked," Jarvis laughed. "He saw that the

machine was working. 'Keep the screwdriver in your back pocket,' Erikson told himself."

After Jarvis left the air force, he took a class at the University of Texas and went to the Boston Museum School. During that period, he found himself going back to Stockbridge often. "I needed fathering, and I couldn't get anywhere without it." In retrospect, he realizes his mother's illness also weakened him when he was exposed to her distress for long periods of time. "She was taking energy from me and giving nothing back."

Jarvis's first exposure to psychotherapy came after his father volunteered him to drive the great psychoanalyst to a speaking engagement at Yale University in New Haven, Connecticut. Jarvis was having an "identity crisis," and what better psychologist could Jarvis have but the man who coined the term. He believes his father set him up to get to know Erikson with the intention of getting him the help Norman could not provide himself. "As a father myself, I appreciate that he finally got me help. It was really good of him to pay for the whole family to see Erikson. But it took a long time," Jarvis laughed. Erikson convinced Jarvis to move to San Francisco, where he could get away from his father to become independent and create his own identity. After arriving in the West with his suitcase, he took a pink piece of paper used to separate illustration boards. "I did a drawing of this human-looking creature that was coming up from the bottom and was working his way up through a whole bunch of stuff. It represented me. I was working my way through the confusion, which is positive, but I didn't realize it then."

In San Francisco, Erikson hooked Jarvis up with Allen Wheelis, who had also served as a psychoanalyst at the Riggs Center. Wheelis was also a renowned novelist who specialized in creating fictional neurotic characters. Jarvis recounted stories of his father's inability to have a deep interpersonal relationship. Wheelis shared stories of his own difficult childhood. His father had once made him cut the lawn with a pair of scissors. Jarvis continued in therapy for a number of years. "It was marvelous to go through but very difficult. That had been my life's biggest challenge—getting through it all."

Jarvis did not join the hippie or beatnik scenes but taught art and worked at Macy's and for a sandwich company. A family named the Lorenzini brothers employed him in their grocery store. The keen observer found the brothers fascinating as well as endearing. They were all named after opera characters. Maximillian, he explained, who ran the cash register and

overlooked the store, sang in an opera chorus. "Spartacus cut up the chickens. William Tell took care of all the ladies. Leonidas was a big guy who just stood there." Jarvis describes with a chuckle how he would have to scurry to the basement to hide when a union representative appeared. "I wasn't registered as a member. San Francisco was a big union town."

GNAWING REMORSE

Jarvis returned to Stockbridge eventually and settled permanently in the Berkshires. During the last years of his father's life, Jarvis believes remorse gnawed at him, although he genuinely tried to be loving and helpful during Mary's illness. Norman sometimes felt he had pushed his wife too hard and neglected her. "In some way, he felt guilty for my mother's drinking." Norman unquestionably loved Jarvis's mother, according to Buddy Edgerton, the Rockwells' neighbor during their West Arlington years. He referred to a letter, circa 1950, written by Norman: "Dear Mary. I love you and need you always. I know I am extremely difficult at times due to my absorption in my work. Sometimes it takes everything I have and all my time. No one else but you could have helped and sustained me as you have for twenty years. We have come a long way and I know we can, as a team go further and further. You are the finest person I have ever known. You are thoroughly and deeply good." Norman continued, "If you decide to be free, I consent. But I earnestly believe we can have our best times together."[27]

Norman remained dedicated to Mary, whom he first met in 1930 in California and who died in 1959 of a heart attack at the age of fifty-one. He drove her back and forth from Arlington to the Riggs Center before they moved to Stockbridge and later to the Institute for Living, some hours away in Hartford, Connecticut, according to Abigail Rockwell.[28] In *Spirit of America*, Norman's 1974 painting, Abigail, the blond girl, modeled next to her brother Barnaby among a diverse group of Americans in front of an American flag. She edited the 2019 edition of *Norman Rockwell, Illustrator*, which was coauthored by her father Thomas.

FINE ART OR ILLUSTRATION?

Being educated in the field and an artist himself, Jarvis has many thoughts about his father's body of work. Does he believe some of his paintings like *Saying Grace* are fine art? "I think most of them are illustration," he said, but

believes some of them contain fine art elements.[29] This may be true if one accepts the definition that fine art is to evoke serious emotions. Illustrations tell stories and usually accompany text. Discussing his father's style, Jarvis does not seem like your typical rural Vermonter. One is more likely to come across his stature, rich baritone voice, and charm at social events in places like New York City. He believes his father's 1936 painting called *Love Ouanga* is definitely fine art. A group of people praying in a country church glare at an elegantly dressed woman who has rudely interrupted a girl's prayers. She has come to find her son. "I think it was realistically done," said Jarvis. *Country Doctor*, with its deeply serious feeling, could be considered another example.

Jarvis said *Marbles Champion* is mostly "realistic" but does not consider it fine art. He grins. "My father's work is realism with some additional help." Jarvis has nothing but praise for *Girl in the Mirror*, in which Norman's favorite girl model, Mary Whalen, stares at her image, wondering if she is beautiful. "It's the sum of all he did right," Jarvis remarks. Art experts sometimes compare the work to Dutch painters like Vermeer, who painted rich green and brown backgrounds. "*Walking to Church* is a wonderful scene," he said. A nicely dressed couple and their two children are making their way through a city neighborhood strewn with trash.

Jarvis has come to appreciate his father's layouts more than ever but said, "I don't know to what extent he was thinking of design and balance." He refers to *Tired Salesgirl on Christmas Eve* as an example. The young female clerk Gene met at Duck Inn in Springfield, Vermont, slumps against a wall after the store has closed on Christmas Eve (see figure 2.1). "I think it's marvelous the way he designed this. The lines, colors, and the layout." He can't say enough about *The Babysitter*. A frazzled teenage girl holds a crying baby. "Look at the design. Look at the lines. It's taking the necessary elements and putting them into spatial relationships. Where chair meets diaper. The curve of the babysitter's arm. The straight line of her back." The layout of *Homecoming Marine* (see figure 8.1) fascinates him. "See the drop line in the center. It goes right through." The reddish line ends up at the bent elbow of the garage owner who stands at the rear. "It's taking all these natural elements and designing them together." Jarvis finds *First Sign of Spring*, where Gene Pelham modeled, to be "wonderfully designed." Gene poses as the man announcing that the first crocuses of spring have pierced the earth. Wearing a blue sweater, he stands over the yellow flowers and points downward. Jarvis pointed out, "Look at

the way the black sky comes down and meets the white." He also applauds the colors in Norman's portrait of President Kennedy, which reveals grave concern. "The yellow and blue. Wonderful colors!"

Jarvis also notices times his father lacked enthusiasm.[30] "I think he was bored when he did the Jack Benny portrait." Benny was a popular television comedian during the 1940s and 1950s. Jarvis can sometimes spot flaws in paintings others might not notice and points one out in *Shuffleton's Barbershop*, in which a group of men are playing music in the back room. "I like it, but I object to the black cat. He's too skinny."

In real life, Rob Shuffleton cut the Rockwell boys' hair. "You would walk in, and there was that rack of comic books." Jarvis points to them in the foreground of the painting. While the barber was clipping Tommy's hair with scissors, Jarvis noticed him glancing in his direction as he read comics. After the Rockwells paid for the haircuts and were walking out the door, Rob called out, "You read the comic book. You might as well pay for it."

THE ART OF JARVIS ROCKWELL

Jarvis's art career began with the creation of his masterful self-portrait in West Arlington during his late teens. He drew others that allow viewers to make a strong emotional connection, such as the depiction of neighbor Bill Sharkey, who lived in a shack down the road and appeared in *Saying Grace*. His drawings and some of his abstract art appear in the Stockbridge Museum, where he has been a popular speaker.

In the 1970s, Jarvis created web-like thread sculptures by draping colored string from the ceiling of his studio and in trees in Stockbridge forests. He formed balls of colorful plasticine clay to connect them. He found the many-colored threads striking as light shone on them. "One day when I was working, the light was coming through the pine forest. I looked over at the string, and there was a spider making his own web. We were partners," Jarvis once wrote in a Norman Rockwell Museum publication.

After his father died in 1978, Jarvis felt free to fully express himself and his own identity.[31] He began buying armfuls of toy action figures, such as film and TV characters, and fashion models. Jarvis sees them as creative commercial art because they are so detailed and show feeling in their poses and faces. Norman said in his autobiography that he "liked Jarvis's work" but didn't understand it. His father had found string art interesting but told Jarvis he

should create more marketable work. In his former Great Barrington, Massachusetts, studio, Jarvis created his first "toy installation." In an article called "Norm's Boy's Toys," two writers described the figures covering a multitude of shelves as "comic book superheroes, Disney Damsels, sci-fi monsters, fashion models, teen idols, movie villains, folk tale fairies." By that time, Jarvis had twelve thousand figures "cleverly juxtaposed for size, color, texture, theme and demeanor."[32]

Jarvis's wife Nova, in *Jarvis Rockwell: Maya, Illusion, and Us*, recalled her delight when she opened the door to her husband's Great Barrington studio. "Lights turned on. . . . Bright colors bounced off the toy-laden walls, each wall covered floor to ceiling with . . . shelves bearing an array of toys."

The Great Barrington toy installation gradually grew into a stepped twenty-foot-wide-by-eleven-foot-high pyramid called *Maya*, which Jarvis has exhibited at the Rockwell Museum. His inspiration began when he viewed temples in India adorned with images of gods and goddesses. These action figures, he believes, are our culture's deities that reflect on us in a meaningful way. Since *Maya*, he has been doing smaller installations, such as a 2018 exhibit at the Massachusetts Museum of Contemporary Art where he arranged figures on glass shelves hanging from a thirty-foot ceiling. The publicity for Jarvis's show explained that the figures are "alternatives to us whom we can interact with. . . . Rockwell uses the term *Maya*, adopted from Hindu Sanskrit, to understand the way we attach illusions to the visible world."

The "sculpts," as he calls them, confront each other with all sorts of expressions from smiles and frowns to excitement and terror. Jarvis's brother Tom said the important thing is for a viewer to imagine the sculpts' relationships. On the shelf at the top landing, Yoda, the *Star Wars* Jedi master, stands in a crowd. Yoda is a small figure compared to the others. His arms are thrown open wide as if he is addressing a group.

Jarvis points to the little green figure. "Yoda came to bring us wisdom."

Behind Yoda, Dobby, the house elf with large, pointed ears from *Harry Potter*, stands on the edge of the shelf dressed in a nightshirt, appearing vulnerable to a gang behind him. His eyes are wide with fear, his hands clutched together. Jarvis feels that assembling his exhibits of action figures with intriguing expressions is bringing him closer to his father psychologically. Norman created intriguing faces. One can't help but wonder if Jarvis also feels he is drawing closer to his mother, as he explained that he has included action

figures from her favorite book, *The Hobbit*, including its main character, Bilbo Baggins, the humble, home-loving hobbit who is called upon to recapture the dwarf treasure guarded by a fierce dragon.

Jarvis does not seem like a typical Vermonter. His style and bearing would more likely be found in a Manhattan club. At almost ninety years old, Jarvis is remarkably fit for a man his age. Wearing red suspenders, he steadies himself with a bright red cane and moves energetically about the gallery. In the baritone voice reminiscent of his father, the gray-haired man with bushy eyebrows greets his guests with handshakes and smiles warmly. They react with smiles of their own. He adds an exclamation point to some conversations by tilting back, steadying himself with his cane, and bursting into belly laughs, which are said to be a great stress reliever. As they peruse the gallery, his guests break out in smiles as they interpret the manner in which one sculpt relates to another. Jarvis, healthy and content, has come a long way since he posed for *Saying Grace* in 1951. He appears to be among the lost who have been found.

Does Jarvis regret not becoming a commercial illustrator?[33] "Oh no! Are you kidding? It's difficult being the son of a famous artist." He felt he couldn't create anything that would compare to his father's masterpieces. "You want to do it, but you say, 'What good will it do?'"

One evening during a chat on the phone, he wraps up a conversation by saying, "I believe it's a good thing my father moved to Vermont." Although Jarvis did not thrive in the Green Mountains of Vermont like his father, he recognizes the value of the time his family spent there. He has let go of the pain and loneliness he once felt living in the small village and now focuses on the bright side. He has helped many people by opening up about his life as the child of a celebrity.

Jarvis maintains a clear memory of the day many years after his Arlington days in 1984 when he was notified that his father died in Stockbridge at the age of eighty-four. "I came home and went into the house. Molly (Norman's third wife) and David Wood were standing at the top of the stairs." Wood was the first director of the Rockwell Museum. "They were somber. I went in the room and kissed my father good-bye. . . . There's always the art, and he will always be here in that sense. I look forward to seeing him again one day," Jarvis said, referring to the "hereafter."

Does Jarvis think his father loved him?

"Oh yeah. Yeah," Jarvis said tenderly.

Jarvis's final words that evening: "I have concluded that having been a human being has been an interesting experience."

The breadth and width of the fame his father achieved is beyond comprehension for him. At a Norman Rockwell model reunion at Arlington Memorial High School, a crowd overflowed the auditorium forty years after his father's death. Afterward, Jarvis sat on a bench on a grassy area outside of the building where he attended high school. People approached and greeted him. He leaned away from them for a moment. After contemplating, creases appeared on his forehead, and, in a baritone whisper, he remarked, "It's incredible, isn't it? How could this all have come from just one man?"

In *The Best of Norman Rockwell*, Tom wrote of his father, "He was, all in all, a lucky man. He liked to do what he was driven to do and was able to earn a good living doing it."[34]

The Vanishing Act

When Norman left Arlington to move to Stockbridge, Massachusetts, he said the "Irish good-bye." He did not tell a soul he was leaving except his lawyer John Whalen. Many felt a great loss and experienced hurt feelings. No one felt the hollowness of the empty white Colonial and red studio more than Gene Pelham. Gene loved being at the center of Norman's world, doing his variety of tasks, and driving but a mile to work. He had no reason to suspect Norman would leave. Norman had even purchased a plot in the cemetery across the street. Suddenly, at age forty-two, Gene found himself unemployed and minus a friend he had known since childhood. Gene's daughter Anne was nine years old at the time. "It was a horrible day at our house. Dad didn't see it coming. He ranted and raved and practically cried. I think the best work Norman did was in Arlington. There was a lot of my father in that work. He thought he deserved better than that. Norman had even been the best man at his wedding. Life got much tougher for us," said Anne Pelham.[1]

"I never thought we were rich, but he paid my dad enough," said his son Tom.

"My father had to reinvent himself," his daughter Melinda remembered.

Gene did see Norman again at art exhibits in Arlington. Another time, he visited with the artist when Norman was signing copies of *My Adventures as an Illustrator* in Bennington. Little did Gene know that Norman Rockwell would, in a sense, reappear in his life when he needed him most.

HURT FRIENDS

On an October day in 1953, Jim Edgerton tried to make sense of men loading boxes into a moving van parked in the driveway. *What's going on?* Next door, he found Norman sitting in his living room wearing a somber face. "We're moving, Jim."[2] Norman explained how he had grown weary driving from Arlington to Stockbridge, where Mary was now being treated at Riggs. He had been losing focus on his work. Mary's treatments at Riggs were costly. His son Tom was in college and Peter in prep school. "Those *Post* covers are going for millions now, but he was only getting $3,500 to $5,000 for them then," explained Ardis Edgerton.

Jim too had been under the impression that Norman had planned to spend the rest of his life in Arlington. Norman had gone as far as to say he wanted to be buried next to Jim so he could "reach down and tickle Jim's toes." After Norman drove off for the final time, Jim felt a deep loss.

Tom Rockwell was also caught unaware. He had been away at Bard College in Red Hook, New York. Norman hastily piled many of the family's belongings into storage but waited too long to retrieve them. "Somebody sold them all off," Tom recalled. He laughed at the improbability of it almost seventy years later. "I lost my electric trains and things like that. I lost my Rogers statues of New England characters. They were important." These popular plaster casts were sculpted by John Rogers during the nineteenth century and included Civil War politicians and veterans. Just as with the fire of 1943, Norman was probably not bothered much by the loss. "My father was devoted to his work and the present, and didn't like baggage," said Tom.[3]

As the Arlington people had time to discuss their neighbor and reflect, they felt less hurt. A number of factors had made the early 1950s trying for Norman. In *Norman Rockwell*, author Laura Claridge provides an illustrative image.[4] "Jarvis recalled watching his father standing by himself up on a hill near their house when the Vermont weather was gray, and the wind was blowing hard." He described his downcast father looking like "a stick figure" because "it was all falling apart."

It is important to note that Norman, like many artists, created his most important works under unbearable pressure. In November 1951, he painted *Saying Grace*. He also conceived, sketched, and posed the models for *Breaking Home Ties* and *Girl at the Mirror* in West Arlington in 1953, although he completed them shortly after the move.

Mary's depression pained Norman, but mental illness and alcoholism were things people didn't share openly back then. Most of the Edgerton and Rockwell children had left home, which contributed to the loneliness. Life became even darker when Mary's father Alfred Barstow died in 1952 and her mother Dora Gary Barstow in 1954. Norman's mother Anne "Nancy" Rockwell died in 1953.

Norman was strapped by paying not only living expenses but also tuition for his sons Tom and Peter and for Mary's care. According to Mary Whalen, Peter Rockwell once told an audience in Arizona that he recalled his father stopping at a bank during his final Vermont days to take out a loan of a couple of hundred dollars for living expenses.[5]

"He was just able to put one foot in front of the other. He couldn't have said good-bye," Mary Whalen, model for *Girl at the Mirror*, recalled. Ardis Edgerton agrees. "It was very, very difficult to make that move. He just had to divorce himself from thinking about it." Ardis also felt deeply saddened. It was at the end of her childhood when Norman drove across the covered bridge for the last time. Buddy had tears in his eyes watching the men fill the moving truck.

Tom Rockwell later got the chance to understand his father's departure from a work perspective. As he interviewed him for *My Adventures as an Illustrator*, Norman explained the effect the situation was having on his art. "In 1953, I left Arlington and moved to Stockbridge, Massachusetts. Restless again. And then I was having trouble with my work and thought that maybe a change of scenery would help me. . . . Among those I listened to were several psychiatrists from the Austen Riggs Center . . . and that, finally, was how I recovered from the crisis."[6]

SUBSEQUENT CONTACT

Norman returned to Arlington to visit and exhibit at street fairs and the Southern Vermont Arts Center. Ardis visited Mary Rockwell several times in Stockbridge during the 1950s but was saddened. The last time, she and Jim stopped by on the way to a county fair. "Mary was very quiet, not the Mary I knew." Mary loved Norman deeply and worked too hard in an attempt to please him. "It was more than one human being could do. She was just worn out, I'm sure. I couldn't say enough good about her." When Chuck Marsh visited Norman in the early 1960s, the artist signed *My Adventures as an*

Illustrator, "To my favorite male model, Chuck Marsh." Chuck said, "Today, I treasure it as a gift from a friend."

In 1959, Mary died of a heart attack at the age of fifty-one. That same year, Norman summoned Buddy to model for a Pfizer Pharmaceutical ad as a veterinarian fresh out of school. In 1964, he posed for a Scout calendar painting called *Growth of a Leader.* Norman created four portraits of Buddy to represent a Scout in all stages, Cub Scout, Boy Scout, Sea Scout, and Scoutmaster. Norman sketched and photographed Buddy's face from different angles and used pictures from his Arlington archives to paint him as the younger Scout. "He aged me ten years for the Scout Master and took off twenty years for the Boy Scout." Buddy's son Jimmy posed as the Cub Scout. *Growth of a Leader* made the Edgertons the only family in Vermont other than the Rockwells to have four generations pose.[7] Norman later received numerous BSA awards, including the Golden Eagle for outstanding service.

Mary Whalen visited Norman in the mid-1950s in Stockbridge.[8] "My dad was his lawyer, and Norman owned some property in Vermont. We got there at 8:00 a.m. Mary was delighted to see my father and me. She made us breakfast. Norman took me out into the studio and showed me a picture he was painting—*After the Prom.* A high school boy and girl, dressed in a suit and a gown, are sitting at the counter of a diner. 'I call this my chinless picture,' Norman told me." Both the boy and girl have faint chins. "Norman thought that was hilarious. He said, 'Mary, if you were here, I would have used you.'" Mary said, "It made me feel wonderful."

Mary saw Norman again in 1967. "I was living in Boston. I came up to Stockbridge with a new book on Norman, and he autographed it for me and my husband." Norman also sent her a wedding present, but she was never able to see him again because she and her husband Philip moved to Arizona. On November 8, 1978, Mary was listening to the radio as she was driving her car in Tempe. The newscaster took her by surprise when he announced, "The great American illustrator Norman Rockwell died today." Forty years later, sadness came over Mary's face, and she looked downward as she said, "He was a wonderful man. I stopped the car and just wept."[9]

A PENSION OF SORTS

After finding work selling advertisements for *The Pennysaver,* a publication with classifieds ads and articles about local events, Gene Pelham took

a gamble and started a publication called *The News Guide*. Now known as the *Vermont News Guide*, it provides information about events and posts classified ads. Gene drove the countryside selling advertisements. He and his wife Kay did the pasteup and delivered it to the printer each Friday. He also continued painting and selling his finished works.

During his later years, Gene entered an assisted living home, which drained his bank account. This spelled trouble for the Pelham children because their father had no pension or savings. This is when, you might say, Norman came to the rescue. Over the years, the artist had given Gene many of his paintings he considered rejects. But rather than paint over them as Norman suggested, Gene stowed them away. "The Pelham children took a pile of them out of storage," Tom Pelham explained. There were sketches, color studies, and unfinished and unwanted illustrations. By that time in 1990, these Rockwell works, previously considered of small value, had become worth appraising, even if unsigned.[10]

"We would call Linda Pero, the Rockwell Collections curator at the Stockbridge Museum. We'd ask her what she thought a particular one might go for these days. She liked us. We trusted her," Tom noted. After getting a grip on pricing, Tom, Anne, and Melinda let the art world know that they had original Rockwells for sale. Collectors responded.

One investor from Texas with a drawl contacted the Pelhams. Tom believes he might have been a man representing H. Ross Perot, who once ran for president of the United States in a three-way race against George H. W. Bush and Bill Clinton. The eccentric Texas billionaire owned many Rockwells and had phoned Arlington folks over the years to inquire about paintings like *Breaking Home Ties*. "I'd meet him at the Quality Restaurant in Manchester. He'd write a check and walk away with paintings. That's how we paid for dad's nursing home. They were like a pension from Norman, or they ended up working that way."

Tom sold a variety to the southerner, such as a full-size color study for *Home on Leave*. A navy man relaxes in a hammock on a lovely summer day after the close of World War II. Norman had done some of it in charcoal, the rest in paint. Another was the study for a 1947 *Post* cover, *Merry Go Round*, where Gene modeled as the artist painting a circus scene. He also sold the color study of *The Soda Jerk*. Norman's son Peter had modeled for a boy tending a fountain counter. A pretty girl gazes into his eyes.

We can be quite certain Norman would have been delighted. Tom Rockwell remarked, "I didn't know about all this. It's good." Tom knows many others whose financial burdens were eased by Norman's work. He once heard a story about the Benedict family, two of whom appear in the painting *Homecoming Marine*. The Benedicts, who owned the hunting camp where Tom spent time in his youth, fastened a painting created by his father onto a wall to seal out wind and rain. "Then they found out it was worth a lot of money. They took it down and sold it."

At one point, Tom Pelham realized he had another potentially valuable item hanging in his garage: the coat Carl Hess had worn posing for *Freedom of Speech*.[11] Gene had passed the old thing down to Tom for doing yard work. After Tom left for college, the jacket remained on a nail inside the Pelhams' garage. It looked about the same except that it was missing a sleeve. Gene had cut it off to use when buffing his car. One day, Tom thought, *The museum might find it interesting*. Tom's sisters thought, *What are we going to do with this old thing anyway?* They called Linda Pero. "We have this coat worn in *Freedom of Speech*. Do you want it?" Before long, the Pelhams received a brochure promoting an exhibit. At the museum, Tom found visitors gazing through glass in wonderment at his father's jacket in a display.

16

Saving *The Babysitter*

A painting titled *The Babysitter* holds a special place in the heart of an Arlington woman named Lucille Towne Holton. She modeled for it in 1947. Lucille and her family knew Norman from the West Arlington square dances.[1] "You'd always see him around town." Norman livened things up. "We all waited to see who would be on the *Post* cover next. It was exciting to find out." She remembered at age twelve in 1945 how Norman picked her up at home; her parents didn't have a car. Her father worked only sporadically due to health problems caused by exposure to nerve gas during World War I. As they drove to his studio, Norman's windows were open, and Lucille's hair blew every which way. In the studio, she exclaimed, "My hair is a mess." Norman replied, "Leave it that way. That's the way I want it." He explained the story he wanted to tell with *The Babysitter*. Lucille would pose as a teenage girl at her wits' end, reading a babysitting manual to learn how to pacify a crying baby. Norman worked with Lucille until she exhibited the expression of a frazzled teenage babysitter. Then he set a baby in her lap named Melinda, who happened to be the daughter of Gene Pelham. When they were ready to breathe life into the situation, Gene pricked Melinda's foot with a pin, and she burst into tears. This produced the desired effect, but the baby's mother, Gene's wife Kay, was horrified. Lucille tugged on her hair as she read the manual in desperation. To this day, both Lucille and Melinda find humor in the situation.

The painting began an interesting chapter in its life in 1947 shortly after the sixth grade class at the Elihu Taft School in Burlington, Vermont, visited Norman Rockwell at his studio during a field trip. The class was an especially tight-knit group.[2] The children all resided on a hill near the University of Vermont and began walking to school together about the time World War II began. It was a time when children were frightened but felt a sense of purpose collecting rubber and scrap metal around their neighborhoods and buying stamps to support the war effort. They sang rhyming songs mocking Hitler. Their families sacrificed because many necessities were rationed, including gasoline, rubber, and even shoes. Some felt the anxiety of their mothers, who were sick with worry because they wondered if their husbands would return alive from Europe or the Pacific. Sometimes, the children passed by homes where the blinds had been drawn and couldn't help but absorb some of the grief.

Classmates Lynne Swan and Lorna Brown knew each other well, and when they heard their friend Alison Pooley fainted during summer camp in 1947, they were concerned.[3] Alison's father J. E. Pooley was a professor at the University of Vermont and, during the war, a "block warden" who made sure the neighbors kept all windows dark so Germany's Luftwaffe bombers wouldn't target them if they appeared in the sky. People do faint occasionally, and it isn't always serious. Soon, however, the girls were distressed when they learned that Alison had leukemia, a disease that was fatal during that era. Lynne and Lorna would visit Alison at her home and felt sorrowful as they watched her grow increasingly pale and weak. The girls found it hard to bear because Alison, a tall girl with brown, wavy hair, had been especially confident and lively. She was interested in photography, played piano, and loved horses.

Later that summer, Lynne's mom and dad took her and Alison to the Champlain Valley Fair. Alison looked even more sickly. Lynne knew her friend was dying and could barely stand the heartache. The two didn't talk about the illness but focused on the colorful fireworks exploding in the sky. The angels took Alison away on September 11, 1947. "I don't want to go to the funeral," Lynn told her mother.

"You have to go."

Lynne did attend the gloomy event at St. Paul's Church in Burlington and was most upset when she saw the distress of Alison's mother. "That was really sad," she recalled. Lynne, Lorna, and the other heartbroken students felt compelled to "do something" in Alison's memory. Recollections of a school trip

they had made the previous autumn sparked their imaginations.[4] In October 1946, during Vermont's colorful fall foliage, Lynn, Lorna, Alison, and the rest of their class piled into the bus, making their first trip since gas rationing ended. They set out on an adventure dreamed up by their principal Catherine Cartier. With their popular teacher Miss O'Brien, they visited a Vermont poet, a rabbit farm, and an Underground Railroad location. Along the way, many of the girls went crazy over the boy on whom they all had a crush. Two boys were taunting them all.

Eventually that day, they found themselves at Norman Rockwell's West Arlington studio, three hours south of Burlington.[5] The students connected with the tall, charming artist who carried a tobacco pipe. His wife Mary, with curly brown hair, greeted them warmly. The young people listened as Norman explained step by step how he created his masterpieces, from charcoal sketches to layouts to color studies and finally oil on canvas. He showed them his brushes and paints as well as original paintings. Lynne, Lorna, Alison, and their classmates admired the painting on Norman's easel, *Men Working on the Statue of Liberty*. It had been published in the *Post* that summer. Norman gave the students autographs, the signed pencil sketch for *Statue of Liberty*, and red apples from the grove at the base of Big Spruce Mountain behind his studio. Visiting the artist was the highlight of the trip, and the kids purchased a book about him for their school library.

A MEMORIAL PAINTING

After Alison's death, her classmates collected $48, the equivalent of about $600 in 2023. Catherine Cartier, the principal, wrote to Norman and told him that Alison Pooley, a member of the Taft class who visited him, had died and asked whether he could send them "something" that would serve as a memorial for $48. She explained that Alison found his presentation fascinating. "She could draw, and that's why she was interested in Rockwell," said Lynne.

Before long, the principal was opening a package and found the 1947 painting called *The Babysitter* wrapped in butcher's paper. Norman had obviously been moved. It was an appropriate memorial because the model in the painting was about Alison's age.[6]

After a ceremony in the Taft auditorium on April 27, 1948, the principal hung the original oil painting on a hallway wall, where it graced the hall for a couple of decades. It was removed at some point and found its way into

storage. Eventually, a janitor discovered it leaning against a wall next to the boiler and noticed Norman Rockwell's signature. The principal thought it to be a mere print, and it found a home on the wall of the superintendent of schools. Lynn learned of the whereabouts of the painting around 1967, and she and her classmates sprang into action. They called the superintendent's office, but he was on sabbatical. The assistant superintendent declared, "That painting is not real."

She responded, "Oh yes it is! Norman Rockwell gave it to our class." She told him the story.

The assistant superintendent explained that the painting was in good shape, except for minor vandalism. "Someone stuck a pin in it."

Lynne responded, "Norman Rockwell stuck that pin in it. It was there when we received it."

"I'll tell you what I'm going to do," said the superintendent. "I'm going to have it appraised at Sotheby's in New York."[7] The auction house appraised *The Babysitter* for $30,000, and the school stored it in the Chittenden Bank vault. "There it sat and sat and sat," Lynne explained. By the 1990s, the painting made a trip back to New York, and the terrific news was that Sotheby's appraised it at $300,000. Starved for cash, the school board discussed selling it. Lynne, Lorna, and the former Taft sixth graders of 1947 were outraged. Lorna believed she and her classmates were the rightful owners. After all, they raised money for it, even though Norman refused it.

Lynne enlisted the help of Norman's former West Arlington next-door neighbor and Scout model James A. "Buddy" Edgerton, who happened to live in Burlington. They sat in the superintendent's office with the school's legal representative, who supported the former sixth grade class. "They told us what the dilemma was, and we said, 'You just can't sell this thing,'" Buddy recalled.[8] It was an irreplaceable piece of their past and reminded the students of their love for Alison and how the situation touched Norman. "If they sold it, the painting probably would have gone to some wealthy investor in Texas or Japan, and we'd never see it again. A lot of people were ready to fight for it," Buddy said.

FUND-RAISING

Lynne's enthusiasm for Alison Pooley and her family motivated her to find a solution. Lynne and her classmates realized they could hire a lawyer to prove

in court they owned the painting. But both sides came to an agreement after Burlington lawyer Samuel Bloomberg proposed an idea. In 1996, Lynne, Lorna, and Buddy launched a campaign called "Save *The Babysitter*," whereby Alison's former class would raise $300,000 to buy the painting and hang it in the Fleming Museum at the University of Vermont. Lynne, Buddy, and others had many meetings. When they appeared on Burlington TV, armed guards stood beside the painting. Lynne held receptions at the Chittenden Bank, which brought the painting out of its vault. Lucille and Melinda attended some of these fund-raising efforts. "We had quite a campaign," said Buddy.

Raising the money became more of a challenge than the Taft class expected.[9] Many potential donors believed the school board had been financially irresponsible and might abscond with their donations to pay off debt. "No way, Jose," Lynn would say. Her classmates were adamant that the money fund after-school art programs. She and Alison had participated in painting, dance, and music programs at the Fleming Museum on Saturday mornings as kids. The Taft class persevered, but after they reached only half their goal, the possibility of reaching it looked grim. Fortunately, the school board accepted what they had raised. They agreed to hang the painting in the Fleming.

In October 1997, with a background of orange and crimson foliage, the class held a parade, a "Penny March," along several roads leading to College Street in Burlington and then up to the Fleming Museum.[10] Spectators lined the streets, and a marching band played. Members of the media attended, such as *People* magazine and television crews. *The Babysitter* models Lucille and Melinda sat in chairs on a pickup truck beside a print of the painting made by Sotheby's. The class concluded the ceremony by carrying it up the walkway and into the Fleming to the rooms near where Alison had sketched, danced, and played piano. At the reception, Lynne presented the painting, standing with her former teacher Miss O'Brien, Alison's sister Suzanne, the sixth grade class, and dignitaries. She told the story of Alison's excitement over visiting Norman and Mary Rockwell and how the students were grief stricken when their classmate died. "We said we must put the painting in the Fleming, and we did," said Lynne. "That was important to me, and it was a fun day! Alison would be happy." We can be sure Norman would be glad he made such an appreciated contribution.

The Frantic Search
for a Masterpiece

In 1962, Don Trachte Sr. ventured out from his home in the village of Sand-gate, which borders on West Arlington, to spend a couple of hours viewing paintings at the Southern Vermont Arts Center in nearby Manchester. Don was pleasantly surprised to come across his friend Norman chatting with enthusiasts about his work on exhibit. A cartoonist for the nationally syndicated comic strip called *Henry*, Don had moved to Sandgate in 1950 to join Norman and other artists. He would chat with Norman in his studio and wound up posing for *The Shiner* as the puzzled school principal sitting at his desk. He is mulling over how to discipline the girl with the black eye, modeled by Mary Whalen, who sits on the bench outside his office smiling.

At the Arts Center, Don took a lingering look at *Breaking Home Ties* and the melancholy father and college-bound son perched on the rusted bumper of a pickup truck (figure 17.1). The canvas held priceless sentimental value. The elder model happened to be Don's soft-spoken friend and next-door neighbor Floyd Bentley (figure 17.2). Norman's image of the horse trainer captured a tranquillity dear to Don's heart. Seated next to the weather-worn trainer, his college-bound son appears anxious to leave. He cranes his neck and peers toward the tracks. Small details enhance the masterpiece. The young man has already marked his books. He holds a bagged lunch with a pink ribbon in his hands that suggests that his mother wanted to be remembered on his trip. Originally, Norman included the boy's mother but

used the ribbon to give her a presence. The farmer's expression reveals his lament.

"What's the price for *Breaking Home Ties*?" Don asked.[1]

"I'm selling it for $900," Norman replied.

Don wrote out the check that changed the course of his family's life forever. The value steadily increased over the years, and by the early 2000s, appraisers figured that collectors would pay millions. The Trachtes could have enjoyed a luxurious lifestyle, but Don Sr. considered selling distasteful. He called it "a painting of a friend by a friend."

FIGURE 17.1

Breaking Home Ties: The melancholy horse trainer was Floyd Bentley, the cousin of the Rockwells' cook and housekeeper Marie Briggs. The Trachte family found this painting to be missing just when they decided to sell it for millions of dollars. *Source*: Courtesy of the Norman Rockwell Family Agency.

FIGURE 17.2
Floyd Bentley mowing a meadow with his team. *Source:* Courtesy of Bob Road.

The several million subscribers to the *Saturday Evening Post* voted *Breaking Home Ties* their second most favorite Rockwell painting in 1955. Christopher Finch, artist, connoisseur, and author of *Norman Rockwell: 332 Magazine Covers*, later said, "It may just be the finest painting he ever did." Abigail Rockwell, the artist's granddaughter, believes there is no question it is her grandfather's "best."

THE CARTOONIST DON TRACHTE SR.

From 1946 to 1995, Don Sr. earned his living drawing the Sunday version of the *Henry* comic, one of the longest running in American history. It was syndicated in four hundred newspapers in forty countries. Henry is a young, bald, and mute boy who communicates through pantomime. Humorous situations in *Henry* bring smiles to readers' faces. For example, in one strip, he hits baseballs. In the last frame, he has batted one through a storefront window, and one can't help smiling as the distressed owner assesses the damage. After spending a day or two each week creating *Henry*, Don Sr. produced fine art paintings depicting cowboys and Native Americans of the Old West. He also created pastoral Vermont scenes. Just after World War II, he entertained troops for the United Service Organization in Europe, Japan, and the Philippines.

For thirty years, *Breaking Home Ties* hung in the Trachtes' living room above a stereo cabinet.[2] The family marvels over the fact that none of the kids knocked it off the wall or damaged it with a baseball. By 2003, however, the four Trachte children agreed that selling the picture, which now hung in their father's studio next to his woodstove, made sense. Nonetheless, the thought of handing it over to a new owner saddened them. They cherished their memories of helping Floyd on his horse and dairy farm. They reasoned that auctioning their masterpiece at Sotheby's in New York might bring the greatest yield. Experts estimated *Breaking Home Ties* would bring $7 million. However, the Trachtes couldn't rule out a private sale, which would eliminate the gamble.

After deciding to sell in 2003, Trachte's daughter Marjorie insisted the painting be stored in safekeeping. The Rockwell Museum in Stockbridge threw its arms open and put *Breaking Home Ties* on exhibit. The public raved. Only a handful of people had seen it in fifty years.[3]

Don Trachte Jr. became the family's point man. He cherishes his memory of posing for a *Child Life* magazine Rockwell illustration called *Santa's Helpers*. At about five years old, he and Melinda Pelham, Gene's daughter, modeled standing in front of Santa. Gene posed as Santa. As an infant in 1947, Melinda had posed for *The Babysitter*.

MANAGING A "ROCK STAR"

Managing the American public's treasure had become about as stressful as managing a rock star for Don Sr. Neighbors wanted to stand next to it for photographs and sometimes showed up with friends. Curators gnawed at him to borrow it for exhibits, and those requests were frequent. Don Sr. almost always refused them but occasionally allowed a local bank to display it. "My dad was extremely nervous about having it out of his hands," said Don Jr. "It created a constant worry in his mind. . . . He did not want to insure it because that would disclose its location and value. He was at a point in his life when he wanted to close himself off from the world." Don Sr. also feared *Breaking Home Ties* might sustain damage in transit. It would require a conservator to touch it up, not a foolproof process. Still worse, he worried it might not make it back home.[4]

Don Sr. weakened in 1964 when Norman called to request permission to ship the painting to Moscow for a year. During the 1960s, the Russians engaged in a number of cultural exchanges with the United States. "How

could he say 'no' to the man who created it?" While it hung in Russia, Prime Minister Nikita Khrushchev declared that he liked the folksy work of art best of all. The painting arrived home safely.[5]

On its return, Norman Rockwell phoned Don Sr. from Stockbridge and informed him that someone was offering $35,000. "I don't want to sell it," said Don Sr.

"I think you're crazy not to accept the money," said Norman. "But I appreciate your loyalty to me."

Calls came to Don Sr. in the late 1960s from people like H. Ross Perot, who wanted to purchase *Breaking Home Ties*. The billionaire even wrote letters. "How much do you want these days?" Perot would ask.[6]

"I don't want to sell. I have told you, it's a painting of a friend by a friend." Don Sr. would not cave in.

"Can I at least have a photograph?" Perot pleaded. He asked if he could send his photographer to Don Sr.'s studio in Sandgate. Don Sr. refused the offer and told the billionaire that he would have high-quality photos taken and sent. Don Sr. had two pictures taken but never sent one to Perot.

To understand why the painting meant so much to Don Sr., one must know the story of the weatherworn farmer Floyd Bentley.[7] Norman had used Floyd as a model for his first version of *Freedom of Speech*. He is seated at the front left in the Arlington Town Hall as model Carl Hess speaks to those assembled for a town meeting. *Breaking Home Ties* represented all Don Sr. and Norman Rockwell loved about casual living in the secluded Vermont village. The scene brought to mind how Floyd's collection of cows and horses kept the steep, grassy hillside next to his home clipped short except for the prickly weeds they passed over. Below the hill, his land flattened out to accommodate what neighbors and out-of-town visitors called the "Yellow Farmhouse." Not far from the house stood his quaint, sagging grayed barns. From there, the meadow extended downhill to a tranquil section of the fifteen-foot-wide Green River, tinted that color by natural minerals. Under limbs shading the bank, opaque green ribbons of water flowed over white, brown, gray, and green rocks and smooth, flat stones. Lingering in that quiet setting, one feels enveloped in the peaceful memory of times past, far from the cares and hectic pace of modern life. From their windows, the Trachtes took in that pastoral setting and enjoyed visiting the humble farmer at the Yellow Farmhouse. His collies Laddie and Dixie closely resembled the dog portrayed in the master-

piece. The Trachte children assisted Floyd and his cousin Charley loading hay bales on wagons in the fields and helped him tend to his livestock.

Floyd, a man of few words, spoke slowly and gently with an old-time Vermont accent. He began "farming it" in the early 1900s. His first love was traveling southern Vermont and nearby New York State, buying and selling horses, such as sturdy Belgians and Percheron workhorses. He managed to eke out a living selling the milk of a few cows, gardening vegetables, and training horses. Floyd also mowed fields and roadsides for his customers using a mechanical mowing machine pulled by workhorses.

One time, Don Sr. asked Floyd, "How many horses to you have?" With that, Floyd went silent. Don Sr. wondered if Floyd had heard his question. Then he realized Floyd was picturing in his mind the farms in Sandgate where his horses were being kept and counting them. "Forty-two," Floyd finally replied. An original horse rescuer, Floyd brought unwanted horses home and persuaded folks to allow one or two to graze in their meadows. People would say of Floyd, "It would have taken him less time to walk where he was going than it took to fetch a horse from a field."

A tragedy that occurred in 1929 etched the melancholy expression on the already sensitive man's face. Both Floyd's mother and his brother died suddenly at the same hour one week apart.[8] To make his grief worse, Floyd had to sell the home he and his brother had purchased, which is located just across the river from Norman's former studio. In 1953, when he modeled, Floyd sat on the Sandgate Board of Selectmen and once served as the town's "pound keeper."

Until his final days, Floyd eschewed gasoline-powered equipment. The Trachtes would hear only the clicking of a sickle bar and an occasional snort from one of the horses. Neighbors considered Floyd's fields the most well-groomed of their area.

Floyd's housemate and cousin Marie Briggs prepared meals and kept house for the Rockwells. During the early 1950s, Marie became a source of comfort to the family. When Norman's wife Mary grew ill with depression and felt unlovable, Norman once wrote in a note, "I love you, and so does Marie." The artist included Miss Briggs, as the Rockwells called her, in his charcoal sketch for the United Nations called *We the Peoples*. On the right side, she wears a head scarf as she did during her days at the Rockwell home (see figure 11.1). She dressed in long skirts and modest, pale blouses buttoned to her neck.

People remember most her warm smile, generosity to her neighbors, and the goods she baked and sold at the Wayside Country Store in West Arlington.

Don Jr. began his friendship with Floyd as a small boy. He liked to visit Floyd at the farm to help him tend to his horses and cows. He has a vivid memory from when he was six years old and stood with Floyd as he roped a bull to a tree.

"You have to go home now, Donnie," Floyd said in his soft-spoken manner. "There's something I have to do."

Donnie was aware that many animals were raised for food, but the thought of their being butchered upset him. He dashed back home across the gravel road but from his yard heard a gunshot. He ran around a tree in circles to cope with what he knew Floyd had to do.

Some of Don Sr.'s most cherished times were when he dropped in at Floyd and Marie's. Their casual country home served as a gathering place where locals discussed their small businesses and the state of the town. During that era in rural Vermont, locals depended on each other for survival. They supplied each other with firewood, lumber, meats, and produce and helped one another build barns and repair homes. Norman had moved to West Arlington to experience life with these folks, whom he called "honest and dignified," as much as to paint them.

A RELENTLESS PURSUER

The future of *Breaking Home Ties* became a stressful issue again in 1970 when Don Sr. and his wife began divorce proceedings.[9] The biggest question regarding their estate became who should have possession of *Breaking Home Ties*. It had already increased in value to perhaps $200,000. It seemed as if Don Sr. might have taken the opportunity to sell to Perot but still found the idea of selling distasteful. Perot would call frequently—lots of calls. One time, Don Jr. decided to talk to Perot. After he heard the former presidential candidate's voice, he declared, "This is Henry."

"Henry?" Perot asked in his southern drawl.

"I'm in the comic strip," Don Jr. laughed. Don Jr. admits that chatting with a man of Perot's stature impressed him.

Don Sr. became annoyed to the point where he arranged to have his number unlisted, but it wasn't long before Don Jr.'s brother Dave reported that Perot had called him.

"Oh darn!" Don Sr. shouted. "You can't get away from this man!" Trachte Sr. finally informed Perot he had turned over responsibility for the painting to his son Don Jr.[10]

By 1973, the Trachtes were in the final stage of their divorce. They came up with a solution to please all: gift *Breaking Home Ties* to the children. The agreement gave Don Sr. the right to hang the painting for the rest of his life in his studio, which stood on the other side of Floyd's farm. The Trachtes actually owned seven more paintings, two by Norman's photographer Gene Pelham, including one by his closest friend and the most prolific American illustrator of that era, Mead Schaeffer, and another by *Post* cover illustrator George Hughes. The court also permitted Don Sr. to hang the one by George Hughes.

AUTHENTICITY IN DOUBT

It was during late 2004 that comments by an esteemed art connoisseur invaded Don Jr.'s scenic Vermont countryside like a noxious gas. An esteemed American portrait painter named John Howard Sanden proclaimed the family's prized possession "a fake."[11] He insisted that the face of the young man leaving for college in the Trachtes' "original" Rockwell differed from the 1954 *Post* cover. "It is a third-rate replica," Sanden declared. He has painted portraits of distinguished Americans like President George W. Bush and First Lady Laura Bush and Billy Graham.

It would be an understatement to say the family members became upset. Don Jr. recalled, "I was totally furious. Who does this guy think he is? We've had this painting for over forty years!" Don Jr. paid a visit to the Stockbridge Museum. He noticed, for the first time, that *Breaking Home Ties* looked dull compared to Norman's others. "The other Rockwell paintings glisten. Norman put a lot of paint on his work. But I could not discern a difference in the young man's face," Don said. *Perhaps Norman hadn't put the same energy into our painting.* In his final days at the time, Don Sr. had no comment. Sanden had injected enough doubt that Don Jr. began wracking his brain. *If our painting is not the original, who could have duplicated it? Someone would have to have done it during one of the times Dad loaned it for exhibit.* A gut-wrenching year ensued.

What could have happened to the original if ours actually is a fake? The Russians would have had an opportunity to create a replica or modify *Break-*

ing Home Ties at the exhibit when Khrushchev viewed it. The painting had also made a stop for an exhibit in Egypt. *Maybe it was copied and the original kept there.* But as far as Don Jr. knew, the painting had arrived home safely. His father, an art expert, would have noticed if the one returned to him had been a fake.

Another possible explanation occurred to Don Jr. He reflected on the time he had sent the painting to a conservator in Williamstown, Massachusetts, to clean the woodstove smoke residue. Had the conservator dulled its surface by cleaning it aggressively?[12]

During the period Don Jr. was considering selling at Sotheby's, he allowed another auction company named Illustration House to borrow a painting by Norman's friend, the illustrator Mead Schaeffer. Schaeffer had been the previous owner of the Trachtes' home. On examining the painting, Roger Reed, owner of Illustration House, had sent it back to the Trachtes. "Something's distorted in this picture," he told Don Jr. He theorized that Schaeffer might have modified it at a later date.

"I can see now it was another clue, but I told myself, 'The world's crazy, not me,'" said Don Jr. "Who is this man to tell me Schaeffer's painting has issues?" He can still remember the smell of the oil paint the day the artist showed up at his home and gave Don Sr. the opportunity to select one of his paintings. Don Jr. had been sitting on the stone wall next to his home on the Green River when Schaeffer arrived. His father had selected the one he sent to Reed, an illustration for *Harper's Magazine* in 1935.

In the ensuing months, more experts agreed that something was not right with the *Breaking Home Ties* on display at the museum.

The family took a break from the controversy in May 2005 when Don Trachte Sr. died at age eighty-nine. At his July memorial service, Don Jr. brought some of the paintings done by Arlington artists to share with family and friends. When his younger brother Dave brought them home, he found a duplicate of one done by Don Sr.'s friend George Hughes, who also painted covers for the *Post*. The two befuddled brothers laughed to dissolve the stress. "Why would Hughes, who painted over 225 *Post* covers, make a duplicate?"[13]

Don Jr. might have seen this as another clue, but denial fogged the situation. Around early 2006, he took a train to New York City to consult Peter Rathbone, collector of American art at Sotheby's, and put an end to the scuttlebutt. He would also consider selling the painting at auction. Rathbone was

away on vacation. In hindsight, that turned out to be a good thing. He met instead with Roger Reed, the proprietor of Illustration House, who declared, "My dad and I have been to Stockbridge. Something has been changed to a degree that significantly diminishes the value of *Breaking Home Ties*."[14]

Reed's comments knocked the wind out of Don Jr. *Of all the Rockwells, why our painting?* On the train ride home to Vermont, he fought to wall out the insanity from his mind. Don Jr. reported to his brothers and sister, "I thought we had a valuable painting, but maybe we don't." To learn that their painting, once valued at $7 million, was now seriously compromised distressed all the Trachtes. Don finally reached the point where he told himself, "I'm just going to live my life. To heck with this painting. If Stockbridge wants to continue hanging onto it, fine. If not, fine."

The Stockbridge Museum pushed away the dark clouds once again when they declared that the Trachtes owned an authentic Rockwell.[15] Don Jr. continued working at his full-time job and tried to ignore the situation, but it proved impossible. On returning from vacation, Sotheby's Peter Rathbone phoned. "I want to put *Breaking Home Ties* in our Spring Auction in May. It's a major work you have. Business is excellent in the auction market."

Don Jr. did not mention the doubt John Howard Sanden and Roger Reed had expressed. He was putting the onus on others to prove the painting was not authentic. Although he would have loved to sell, he told Rathbone that his family would consider the offer. Rathbone rang his phone weekly.

Meanwhile, Don Jr.'s brother Dave, owner of a car repair shop on the Green River perhaps a mile down the road from his folks and Floyd, searched for clues in his father's studio. One day, he discovered an album containing negatives of their painting. When the two brothers looked through a magnifying glass, they noticed subtle differences.

Don Jr. asked his brother, "Do you think it's a different focus or shutter setting?"

"No," Dave replied. "Something is different."[16]

As Sanden had noticed, the eyes and mouth of the young man going off to college seemed slightly different. The twenty-first negative appeared to be modified from the original *Post* cover version. Number twenty-two looked identical to it. If Don Sr. had modified the painting, the original should have come first. Don Jr. speculated that perhaps his father had spilled something

and repaired it. They decided to have the negatives printed to examine the painting more closely.

The two brothers decided to ask the curator at the Rockwell Museum in Stockbridge to examine the original painting to see if she saw anything about it that seemed peculiar. At first, they did not show her the photographs so that she would not be biased in her decision. She did not mention anything about the discrepancies they saw in the photographs. When they did show her the photographs, she saw the Trachtes' point but could not say conclusively that they were different. She did, however, point out that in one, the lips of the young man craning his neck to look for the train appeared lighter in color.

Don revisited the time period when his father allowed *Breaking Home Ties* to visit Russia. Khrushchev and the Russians had adored the painting. It seemed plausible that a Russian artist (or even one in Cairo) had created a replica and kept the original. *Maybe we'll never know*, he thought. The idea of an unsolved mystery and possible theft tortured him more than not being able to sell the painting. Nothing could be worse than not "finding the body." Don Jr. feared Rockwell fans would criticize his family. "I thought we'd lost an important American painting."

SEARCHING FOR THE TRUTH

The Trachte brothers agreed they must get more aggressive. Don Jr. asked the Williamstown Art Conservation Center, a nonprofit organization in Williamstown, Massachusetts, to analyze the painting. The organization, which cleans, preserves, and repairs, is a leader in restoring Rockwells. "We're swamped," an administrator replied.[17] Since the Trachtes had millions of dollars at stake, Don Jr. begged, "Please take the painting. I have to know the truth." Williamstown cleaned *Breaking Home Ties* and evaluated it. Don Jr. received an e-mail from the Art Conservation Center. "These are clearly Norman Rockwell brush strokes, his underlayment, and the coloration he uses. We found no modifications. . . . There's nothing to worry about."[18]

The Art Conservation Center's conclusion did not convince Don Jr. He had the photo negatives printed and saw definite differences about the face. "I have to believe our painting is a replica," he told Dave. But why hadn't his father mentioned anything? Comparing the photos to the *Post* cover of 1954 did not help. Don Jr. restrained himself from showing the two photos to Reed and Rathbone; he wanted to leave the burden of proof on them.

How will we prove our painting is real, a replica, or one that's been modified? The Trachte brothers decided they would turn their father's studio upside down. They hoped to find a significant clue. Since Don Jr. lived three hours north in Burlington, Vermont, and Dave lived locally, he would search. In the basement, he found the crate Norman had used to ship *Breaking Home Ties* to Russia. The next day, he discovered an extra-tall roll of canvas, a size his father did not use. Don Sr. painted the Old West, Vermont countryside, and portraits using short canvases. The two of them mulled over possibilities night after night. One day in the quiet, still setting of Sandgate, Dave's intuition spoke loudly. He had always found something peculiar about the bookshelf in his father's study. He recalled how, in 1990, his father built the bookcases with unusually deep shelves. Dave noticed a peculiar, slight crack between the wall of the bookshelf and the adjoining one. He had never given it much thought, but now he surmised that the crack just might be significant. On the fourth day of his search, Dave called Don Jr. "I think there may be paintings behind a wall."[19] Don Jr. replied, "I'll come down tomorrow, and we'll take the shelves down."

The next day, Dave greeted Don Jr. at the studio with a smirk and led his brother to the bookshelf. They began removing books and lifted the shelves off. A ninety-degree jog about the size of a two-by-four in the adjacent wall became obvious. *Wow, this is pretty unusual,* Don thought. When he touched the wall, it moved slightly. He pulled on it, and it opened eight or nine inches. On a second wall behind the first, the two landscape paintings by Norman's assistant Gene Pelham came into view. The smell of oil paint wafted from the opening. "It brought me back to my childhood. I remembered when my parents first hung *Breaking Home Ties* in our house," Don Jr. recalled. In that moment, Don began feeling much better when a thought leapt into his mind. *Holy Cow, I know what's going on.*[20]

In a peculiar way, he began to appreciate his father's ingenuity. *You can't fold up paintings to stow them away. You have to hang them flat and make a place where no one can find them. My father did the perfect job hiding them from our mother after the divorce. Then, if someone had taken the one hanging near the woodstove, they would have stolen a mere replica.*

Don Jr. and Dave pulled the wall open wider. Five more paintings their father had purchased thirty years before revealed themselves. The paintings

appeared to be the originals of the replicas hanging in their mother's house. The Trachte brothers were delightfully shocked. "We felt enormously good."

As they stood before the opening, Don Jr. believed the anguish and the twists and turns were about to come to an end. Butterflies fluttered in their stomachs. *It did make sense Dad would have hidden* Breaking Home Ties *the furthest back*. But still, they hadn't seen it yet, and it might not be there. Their next move might be a colossal moment. They stood still for perhaps five, ten, or even twenty minutes. Finally, the two pulled the next wall open. There, they beheld on a large, framed canvas their beloved neighbor Floyd with the melancholy expression dressed in the old work clothes and sitting on the rusted bumper at the train station. It *had to be* the original. They lifted it from the shelf in a state of euphoria—for how long, they can't say. They decided it best to put the paintings back where they had been hidden and replaced the shelves. The giddy brothers realized it was March 17, St. Patrick's Day 2006. They vowed to call themselves O'Trachte thereafter (figure 17.3).

FIGURE 17.3
Don Trachte Jr. stands before the wall in his father's Sandgate, Vermont, studio where he and his brother Dave found the original *Breaking Home Ties* hidden after a year-long, nerve-wracking search. *Source*: Photo by S. T. Haggerty.

INFORMING THE PUBLIC

Don Jr. and Dave agreed they would not tell a soul before informing the Norman Rockwell Museum.[21] It would not be fair for the museum to learn the bizarre story from the media. Since it was Friday night, they'd have to wait until the museum opened on Monday. Worry crept into Don Jr. *What if the studio burned down? A roof leak could also destroy the painting.* He had to chuckle at himself. *It's been behind that wall for thirty years, and I'm worried sick?*

The next day, they couldn't restrain themselves from removing the shelves again, reexamining the paintings, and ogling them. The mouth of the young man next to Floyd appeared exactly as it did on the 1954 *Post* cover. Their find would affect a number of other people as well. John Sanden's adamant claim that the painting was a fake had resulted in a search for truth. Illustration House's Roger Reed and Sotheby's Peter Rathbone would be greatly relieved.

Don Jr. worried about the feelings of the Art Conservation Center, which might be embarrassed, having been fooled by a fake. He decided, however, that telling the whole story as soon as possible would be best. Williamstown could find solace in the fact that Don Sr. had created a darn good replica.[22]

The next day, a Sunday, Don left messages for the curator, Stephanie Plunkett. "Stephanie, I want to come see you tomorrow." Three days after the discovery, Don Jr. and Dave floated through the museum doors precisely at the moment the clock struck eight. Don recalled, "It was a long walk down the hall to the conference room wondering what Stephanie's thoughts might be." The brothers explained how they found the photo negatives. They explained why Don Sr.'s replica looked authentic. An artist himself, Don. Sr. had observed Norman at the easel and knew every step his friend took when creating illustrations. Don Sr. would have remembered his friend's brand of brushes and paints, his often-used colors, as well as the way he stroked on paint. "I'm sure my father had a ball creating the replica," said Don Jr.

Stephanie told the Rockwell museum director, Laurie Moffat, she must come at once. They all knew the Trachtes' discovery would be a national media event that would require skillful handling. When Moffat arrived at the table, she expressed concern. How could they be 100 percent certain the painting behind Don Sr.'s wall was the original? Perhaps the mystery would take another turn. *Oh please!* thought Don Jr. His father could have eased

everyone's tension simply by posting a note behind the bookshelf, "CONGRATULATIONS! YOU FOUND THE ORIGINAL!"

Moffat felt the museum must control the story but also needed to satisfy her board of directors and be fair to the Art Conservation Center. A grin appeared on her face, easing the tension Don felt over the fact that his father had been shady. She found the stunt fascinating.[23] The next day, Don Jr. greeted white-gloved museum workers at his father's Sandgate studio. With hands as gentle as nurses lifting a baby, they wrapped the eight originals and their replicas and transported them to Stockbridge.

Moffat broke the news to only a handful of museum coworkers and allowed them to view the originals. She told them they must not leak to the news media. The museum needed time to authenticate and to develop a strategy.

A MEDIA EXTRAVAGANZA

The museum prereleased the story to the *New York Times* and eventually set the date of April 6 for the press conference. The Trachtes attended as a family. As Don Jr. prepared to speak in the museum auditorium, media trucks began pulling up. He noticed ABC, NBC, CNN, and a slew of others.[24] *Uh oh, this is a bigger news story than I thought.* Although not accustomed to speaking at this type of event, exhilaration lubricated Don's vocal cords as he stood at the podium. He fed the enthused audience highlights of the life of *Breaking Home Ties* beginning in 1962 when his father bought it from Norman for $900. He described his father's misery as a masterpiece owner and the painting's trip to Russia and Egypt. He told how Sanden had exclaimed, "Your painting is a third-rate replica!" He fed the press chunks of anecdotes illustrating the anguish his family endured during the past year as well as the exhilarating discovery.

Media members, art brokers, and fans moved their eyes from the replica of *Breaking Home Ties* to the original. The museum also exhibited the work of Don Sr.'s *Henry* cartoon strips prominently. Henry's mischievous spirit entertained the crowd as it had newspaper readers across the world. The *New York Times* ran the story on its front page, broadcasters featured it on radio and TV, and it was all over the internet.

Don Jr. couldn't help himself from phoning his old pal Ross Perot.[25] In his high-pitched southern drawl, the Texas billionaire exclaimed, "That's quite a story y'all have up there."

"Sure is," Don Jr. said. Remembering that his father refused to send a photo of *Breaking Home Ties*, Don Jr. had two taken of the reproduction. He kept one and sent the other to Perot. Don Jr. asked, "Do you realize you and I are the owners of two photographs of a fake?"

Perot laughed. "We oughta sell them at Sotheby's and split the money."

As the family consulted experts and contemplated how to market *Breaking Home Ties*, tension stiffened Don Jr.'s neck once again. A poorly executed sale could mean the loss of some millions of dollars. *Haven't I already suffered enough?* An auction might be the best route, but they sometimes go awry. Sotheby's did have a track record of success, but what if some bizarre hex wreaked havoc? What if the auctioneer botched the sale? What if the big potential bidders failed to show?

Alice Walton, a billionaire and one of the owners of Walmart, requested a private viewing, which pleased Don. Often, anonymous buyers purchase Rockwell paintings and stow them away from the public. Don Jr. thought she might be the type to loan it to a museum for a long-term exhibit. Walton declined to purchase.[26]

Don Jr. once again contacted the painting's most persistent suitor. After bugging them for four decades, the Texas billionaire, believe it or not, said he had no interest because he had begun to divest of his paintings. He hadn't tired of the painting, though. A *Forbes* magazine photo, published on September 23, 2013, shows that Perot maintained a fondness for *Breaking Home Ties*.[27] He stands in front of a framed lithograph.

Although keenly aware of the risks, Don believed selling at auction would serve his family best. He arrived at Sotheby's auction house in Manhattan on the morning of the sale. His brothers Dave and Jon and their sister Marjorie, as well as some of their spouses and children, joined him. Don told himself he would be content if the bidding reached $10 million. The highest price previously paid for a Rockwell had been for *On Leave*, the *Post* cover of September 15, 1945. It sold for $9 million. Owned by none other than Perot, it depicts a navy man in uniform resting in a shaded hammock on a lovely summer day.[28] As they strode to Sotheby's, Don felt a heavy burden. The auction would last a few minutes but would affect the family for generations. But he had consulted with family members; they allowed him to make the major decisions. *But have I made the right decision?*

The Trachtes strolled into the elegant Sotheby's lobby. A representative escorted them to their reserved box on the second floor. It overlooked the auctioneer's stand and provided a bird's-eye view of the auditorium as bidders filed in. *Breaking Home Ties* hung prominently in a glow of light on the front wall. The Trachtes took long last looks at Floyd in their "painting of a friend done by a friend," which had hung on their living room wall nonchalantly during their childhood. Normally, all the paintings slated for sale on a given date are featured in a single brochure. However, the world found the mystery of the lost painting so intriguing that Sotheby's believed the masterpiece deserved its own. The fourteen-page glossy detailed the bizarre story.

The Trachtes took their plush seats and tried to relax. Don felt good that Sotheby's had placed their painting in the fourteenth slot of a couple hundred paintings. He had been told a warmed-up group of art investors tend to call out higher bids when they raise their paddles.

THE GAVEL BANGS

The auditorium fell into a silence pregnant with excitement as the auctioneer stepped up to the stand. He banged his gavel and announced a starting price of $3 million. Numbered white placards shot into the air. A Sotheby's representative manned the phones and relayed the bid numbers to the auctioneer. The younger Trachte grandchildren wiggled in their seats; Don feared one might fall off the balcony. The sale took off. The auctioneer called out, "$1 million here. $2 million there." The bidding rose: $3 million, $4 million, and $5 million.[29]

The excellent start transformed Don's anxiety into excitement. After $5 million, however, he saw no more white paddles shooting into the air. His heart sunk. Could this be the end, $2 million under experts' expectations? *Maybe I should have worked harder to sell it privately?* He breathed a sigh when the pace quickened. The auctioneer called out, "$6 million here . . . 7 . . . 8 . . . 9 . . . $10 million there." A wave of relief washed over Don Jr. Even if the bidding ended now, no one could argue that he had not served his family well. But that thought was replaced by a greed he could have never imagined. *Come on! Bid higher! More. More. More!* Placards continued rising, and the phone agent relayed more numbers to the auctioneer. Nestled in the private box with his family, Don enjoyed these moments immensely: $11 million, $12 million, $13 million. Don found himself floating on a cloud. Finally, at

$15.4 million, the room hushed. Still ravenous, he hoped bids would resume popping, at least like reluctant kernels of popcorn. But they did not. It was over. "Sold for $15.4 million!" the auctioneer shouted. The amount shattered the record set at previous Rockwell auctions. To the best of Don's memory, the auction took perhaps five minutes, but the excitement took him so far away that it may have been twenty. Was Don ecstatic? "I guess I was," he chuckles. The Trachtes pulled the curtain to seal off their private box from the auditorium crowd.

No one can quantify the extent to which media accounts of Don Sr.'s shenanigans pushed up the sale price of *Breaking Home Ties* and other Rockwell paintings that have been sold since, but no one doubts that the effect has been significant.[30]

Reflections

Who was Norman Rockwell, and what inspired him to eventually become America's most beloved illustrator? Perhaps it began when he realized that he was sacrificing his true self to indulge in the excesses of glamorous parties with society's elite. He yearned for a simpler life where he could live according to his deepest values and break out of his mold of creating illustrations with a cartoonish tone to move into realism.

On the first day of a visit in Arlington, Vermont, he and his wife Mary bought a vacation home and stumbled on a village of people who represented the lifestyles and values he cherished. He was ecstatic at the thought of sharing their faces with the world. He moved there permanently two years later to live among these salt-of-the-earth people in the scenic Green Mountains. Many were owners of small businesses and dairy farmers who were dependent on each other for survival and recreation. This made them accountable to one another, which fostered an honesty he found refreshing. His new neighbors just happened to make terrific models. Their faces revealed their true feelings. They were not self-conscious and were eager to model. Their expressions and clothing told the stories of their lives.

Once he began painting masterpieces such as *Marbles Champion*, *The Forging Contest*, and *The Four Freedoms* in Vermont, the American people fell in love with the artist and his work and he with them. Norman Rockwell

never looked back. Most experts believe he did his best work during that era, the 1940s and 1950s.

Norman Rockwell's Models: In and out of the Studio emphasizes that the essential ingredient in these paintings was the models, the local townspeople who actually lived the roles they portrayed. They were not actors motivated by fame and fortune but friends and neighbors willing to lend a hand. They even had fun! None could have foreseen the future impact of Rockwell's work.

Rockwell's presence in the community was a novelty to the townsfolk. His family offered a glimpse at what else there could be beyond the Green Mountains, including the concept of art as a worthy vocation. The townsfolks' presence in his life and the lives of his young family was a grounding force.

To accomplish this, Norman knew he must join in the political, social, and recreational activities of the community. He needed to bond with his neighbors to study, albeit informally, their personalities, mannerisms, and emotions. This gave him the ability to find the people who would bring a painting alive. Immediately, he enjoyed activities such as social club events, dances, church suppers, and political meetings. His respect for rural Vermonters continued to grow as he discovered that his Vermont neighbors possessed a strong intellect, common sense, and scientific knowledge, of which sophisticated city dwellers are often not aware.

Norman was a person who saw goodness in people and wanted to inspire people with images of who they were. Because he treated them as welcomed guests in his studio and was charming and polite, models felt at ease and allowed him into their lives. They revealed tender feelings of love and affection, pride, fear, and levity.

Norman became a man for his time when his country came face to face with World War II. His work became not just a livelihood but a mission when he realized he could play a significant role in convincing Americans to join the Allies in the fight against Hitler or accept the consequence that the Führer would take over Europe. This advocacy for the value of freedom and independence added new depth to his paintings, and they resonated with the American people.

Norman's rural Vermont models have become avatars that represent the traditional American values which were displayed in the *Saturday Evening Post* cover illustrations and which continue to be enjoyed by a large segment of the American population and people around the world. It was Norman's

next-door neighbor, a respected member of the community, who inspired his *Freedom of Speech* painting after Jimmy Edgerton stood at an Arlington Town Meeting and voiced the unpopular opinion against building a new school. Norman felt a deep appreciation for the intelligence of the American people, whom he believed had the sense to consider conflicting opinions to arrive at sensible solutions. Carl Hess, the handsome gas station owner a mile from Norman's home, became the face representing that principle in America when Hitler was threatening to become the dictator of Europe.

For his Boy Scout paintings, Norman used the boy living next door to represent American youth at its best. Buddy Edgerton had excellent leadership skills in the community, a kind way with people, and devotion to his country. Norman's indispensable assistant Gene Pelham became an avatar for an appreciation of simple fun. Small-town doctor George Russell stood for American medical providers at their best, showing personal devotion to their patients. Walt Squiers became a symbol of the spiritual strength needed to persevere in tough times.

Mary Whalen Leonard represents girls as they approach womanhood and are pondering their physical appearance. Sophie Rachiski Aumand is the quintessential young woman worked to exhaustion and deserving of compassion. Duane Parks is the worn soldier who, after seeing active duty, has come home a changed man with a need to express what he has experienced. May Walker, the elderly woman in *Saying Grace*, represents people who are fragile and find their strength in their creator.

Although a segment of the American public today has been desensitized by high-excitement media images, there will always be people who appreciate genuine Rockwellian images of people finding significance in simple but meaningful moments in life and patriotism for a country where people are born free in a world too often ruled by tyrants. After all, the emotions of human beings are the same as they were at the dawn of humankind: fear, anger, worry, sadness, happiness, and elation.

Norman had the well-rounded beliefs many Americans share. He stood behind America's obligation to defend freedom but also advocated that humankind should avoid war whenever possible because of its devastating consequences. The fact that Norman remained a traditional artist during a time when most artists flocked to fine and modern art, and he chronicled twentieth-century American history and its values, makes his body of work

all the more special and desirable. It is worth our time to view, cherish, and ponder.

Although the interdependence of people and the quaint nature of small towns in America has largely vanished, people still connect with the feelings of his characters, as revealed by the expressions on their faces. The nostalgic tone of his paintings takes people away from their complicated lives to the simpler place and time for which they long, just as Norman yearned to leave city life and move to rural America.

Bios of the Models

RUTH MCLENITHAN SKELLIE

The real-life marbles thrower continued telling her story of modeling for *Marbles Champion* at the Sugar Shack in Arlington and at other events until she passed on in October 2018 at age ninety-one. Ruth McLenithan Skellie had the energy of someone half her age. She said, "It was thrilling to model for Norman Rockwell. I feel blessed to have been a part of his life." Ruth was a member of a small group who posed for one of the approximately twenty *Post* covers Norman created in his first Arlington studio on River Road between 1939 and 1943, before it burned to the ground. Ruth worked as a homemaker and produced bridal and graduation outfits as a dressmaker for sixty years.

SOPHIE RACHISKI AUMAND

Being a Rockwell model has added a dimension of fun to Sophie's life. "To this day, people come with prints, calendars, and cards for me to sign." Recently, her dentist requested her signature. Sophie married Turk Aumand in 1951, two years after posing for *Tired Salesgirl on Christmas Eve*, and has spent her married life being a homemaker.

GENE PELHAM

Gene died in 2004 at the age of ninety-five. Throughout his life, he turned away almost all writers who requested interviews because he believed they

would misrepresent his words.[1] His paintings hang in a number of esteemed galleries, including museums in Tucson, Boston, and Bethesda and at the Southern Vermont Arts Center, where he became a trustee. Dean G. Witter, founder of the retail stock brokerage firm Witter and Company, once flew Gene to New Orleans to paint his portrait. At one time, Witter was the largest investment house on the East Coast.

TOM PELHAM

Tom graduated from Tufts University, where he majored in urban studies, and attended graduate school at Harvard University. He is surprised at the level of success he has achieved. "I left a Division III high school in 1967, and by 1972, I was the transportation coordinator for the City of Somerville, Massachusetts." Under Vermont Governor Richard Snelling, Gene and Kay Pelham's son served as the state's commissioner of housing. Under Governor Howard Dean, he was the commissioner of finance. After a stint in the Vermont State Legislature, he served as the state's tax commissioner for Governor Jim Douglas. The former Rockwell model finished his career as Vermont's deputy secretary of administration. "It's a long way from being a kid throwing hay bales on a wagon and jumping off the covered bridge in West Arlington."

MELINDA PELHAM MURPHY

Melinda was raised in West Arlington and graduated from Arlington High School. She attended Katharine Gibbs School in Boston, worked for a large law firm, and raised her two children in a country village outside that city. She restored three historic homes before retiring to Vero Beach, Florida. She recently purchased a second dwelling in Shelburne, Vermont, in order to be closer to family and friends in her beloved state. Melinda enjoys antique homes, reading, gardening, and learning something new every day.

ANNE PELHAM

Anne Pelham was born in the house in West Arlington she grew up in. She graduated from Arlington Memorial High School and obtained her BS in accounting from the Massachusetts College of Liberal Arts. "Growing up in West Arlington was a fortuitous life chapter that, sadly, is a rarity these days. Upon reflection, it was a childhood for which I am most grateful," said Anne.

MARJORIE SQUIERS COULTER

Today, Marjorie is the last model still living who posed for *The Four Freedoms*. Her brother David, who also appeared in *Freedom from Fear* as the boy, served in the US Navy and was awarded seven patents during his years working for Texas Instruments. Marjorie drove a bus in the Arlington school system and once worked with other models at a Rockwell Museum that was located in Arlington. She has spoken to audiences at the Stockbridge Rockwell Museum. She still has one of the dolls that appears in *Freedom from Fear*. Where else would Marjorie have met her husband Jerry Coulter but at the dance pavilion on the Green, the same place Norman Rockwell danced.

WALT SQUIERS

After finishing Norman's buildings, Walt occasionally received a phone call from the artist requesting him to fix a window in the studio broken by foul balls hit by one of the artist's sons or a friend. After Norman left town, Walt continued building and renovating houses in the Arlington area. He died in 1976.

CLARICE SQUIERS

Despite her disability from her broken neck at age twenty, Clarice eventually worked in human resources at Arlington's Mack Molding plant. She lived until the age of ninety-two and died in 2000. "Her foot would always drag, but eventually we'd walk four miles together," explained Marjorie.

BUDDY EDGERTON

Buddy has shared his experiences growing up next to the Rockwell family in public forums like the Rockwell Museum in Stockbridge. He wrote the book *The Unknown Rockwell*. He retired as a professor emeritus from the University of Vermont's College of Agriculture after thirty years. In 2009, Governor Jim Douglas declared a Friday in December as Buddy Edgerton Day in Vermont. Buddy has been married to his wife Dot for more than sixty years, and they remain in Vermont.

While emptying their home to prepare for its sale in 1983, the Rockwells' former next-door neighbor Joy Edgerton Freisatz found the color study for *Saying Grace*. In 1951, Norman had given it to her. She and her husband Robert donated it to the Rockwell Museum in Stockbridge.[2] The Edgertons also found the charcoal sketch of *Guiding Hand* in a dresser, tucked inside an

issue of the *Post*. They donated that to the museum as well. Buddy's sisters also gave the museum a sketch of a Christmas painting Norman created for *Child Life Magazine.*

ARDIS EDGERTON
Ardis and her husband Ray Clark eventually owned four IGA supermarkets. She performed every job from managing stores to stocking shelves. Ardis's two children still own Clark's IGA in Londonderry, Vermont. Norman said about her parents in his biography, *My Adventures as an Illustrator,* "Jim and Clara are about the nicest, finest, people I have ever known." Ardis now lives in Ocala, Florida, but returns each year to visit the white Colonial her family resided in for five generations. The family has a cabin on the mountain behind it.

DUANE PARKS
The *Homecoming Marine* would get a good laugh out of crowds at the Vermont Rockwell model reunions about the night he told Norman, "I ain't modeling for no darned artist" at the square dance. Duane ultimately found Vermont a peaceful place to recover from his World War II posttraumatic stress. He worked in the dairy industry, retiring in 1986. He took up downhill skiing at age sixty-nine and completed a hike of the Long Trail with his son at eighty-two. In his later years, the man who once considered himself too rugged to pose for an artist hooked rugs and needlepointed.[3] An American patriot to the end, Duane would push himself to his feet after he could not walk to salute the flag at events. Duane died in 2015 at the age of ninety-four.

TOM PAQUIN
Born in 1941, Tom has lived his entire life in the Bennington area, except for during World War II. Tom admits he never played a trumpet but did play a guitar in his teens. He is the owner of T&M Enterprises in Bennington, which molds plastic parts for household plumbing, valve bodies for deep-well pumps, waste line cleanouts, and check valves. Tom enjoys attending reunions of the Rockwell Arlington models.

DON HUBERT JR.
Don Hubert, a US Army veteran, is retired from his career as a corporate accountant. Don attends Vermont model reunions and gives presentations

on his modeling experience with *Saying Grace* to Rotary Clubs and church groups. Don's brother Charlie modeled for *Walking to Church*, which was sold during the same Sotheby's auction.

PAUL ADAMS

Paul graduated from St. Joseph's College in Bennington, Vermont, with an associate degree in business management. He worked in a dairy creamery, a paper mill, and a seed company before embarking on a career with the New York State Highway Department. He retired with thirty-one years of service, beginning as a laborer and progressing to equipment operator. Paul believes that Norman was ahead of his time in helping the black race by including its people in important paintings. "I think he went about it the right way."

PAULINE ADAMS

As a child, Pauline could not foresee the public attention she would receive as a Rockwell model. Pauline tried her hand as a practical nurse, but she found more fulfillment raising five children, gardening, and cooking. She helped her husband Peter Grimes start his own church in Bennington, Vermont. Pauline continues to sing gospel songs. "We're trying to carry on what Norman depicted in his United Nations sketch and *Golden Rule*," she said.

Both Paul and Pauline realized the importance of Norman's work when they worked at the former Norman Rockwell Gallery in Arlington for more than ten years. Excited groups of tourists from all over the world would climb out of as many as three or four buses at a time and ask the models to autograph prints. The television show *Good Morning America* broadcasted live from the Arlington museum. "We all stood together and called out, 'Good Morning America.'"

CHUCK MARSH

After graduating from Dartmouth College, Chuck followed in his father's footsteps and served in the US Navy for six years, achieving the rank of lieutenant. He remained in the reserves and retired as a captain after fifteen additional years. After active duty, Chuck attended Stanford Business School. He took a job for a commercial real estate company and eventually purchased it. His company developed shopping centers in Arizona and California.

MARY WHALEN LEONARD

Mary taught English prior to her marriage to Philip Leonard. Afterward, they moved west when he took a job teaching math at Arizona State University. Mary lived in Arizona for forty-nine years, where she raised three children. She was employed as a hospital chaplain and in pastoral care for the elderly, sick, and dying. Recently, Mary and Philip moved back to Vermont, where her heart has always been.

LUCILLE TOWNE HOLTON

Lucille, a lifelong resident of Arlington, Vermont, currently assists her son in operating Chauncey's Restaurant in that village. "Hundreds of people ask me if I really am the girl in *The Babysitter*. I say 'yes,' but many don't believe me at first."

DON TRACHTE JR.

Don grew up in the West Arlington community and has spent most of his life there with many Rockwell models. He attended Arlington High School and Western State College of Colorado, graduating with a degree in economics. He worked for aerospace companies in sales and marketing. He organizes Vermont's Norman Rockwell model reunions. He is a popular speaker at such places at the Norman Rockwell Museum in Stockbridge. He never fails to engage audiences when he tells the story of *Breaking Home Ties*, the missing masterpiece.

Notes

Norman Rockwell's Models: In and out of the Studio is based primarily on the author's extensive interviews with the Vermont Rockwell models, their families, and neighbors. He also drew from his lifetime of West Arlington recollections. The facts he used from other sources are listed in these endnotes.

INTRODUCTION

1. Norman Rockwell, *My Adventures as an Illustrator* (New York: Harry N. Abrams, 1995), p. 130.

CHAPTER 1

1. Jarvis Rockwell, unpublished interview with the author, August 28, 2016.

2. *My Adventures*, p. 237.

3. Ibid., p. 349.

4. Robert Berridge, "More Than Meets the Eye," *Saturday Evening Post*, August 23, 2012.

5. Ruth McLenithan Skellie, unpublished interview with the author, August 15, 2015.

6. Ibid.

7. Ibid.

8. Ibid.

9. Ibid.

CHAPTER 2

1. Sophie Rachiski Aumand, unpublished interview with the author, December 28, 2015.

2. Ibid.

3. Ibid.

4. Ibid.

5. Ibid.

6. Ibid.

7. Ibid.

CHAPTER 3

1. Mary Adams, *Bennington Banner*, September 24, 1956.

2. Tom Pelham, unpublished interview with the author, November 16, 2016.

3. Melinda Pelham, unpublished interview with the author, March 14, 2017.

4. Staff of the Institute for Creative Learners, *Dyslexia and Creativity* (Lubbock, TX: Institute for Creative Learners, 2019).

5. Ibid.

6. Interview with Tom Pelham, January 30, 2017.

7. Ibid.

8. *My Adventures*, p. 349.

9. Ibid., p. 460.

10. Ibid., p. 379.

11. Norman Rockwell Museum website, https://www.nrm.org.

12. *My Adventures*, p. 383.

13. Ibid.

14. Stuart Murray and James McCabe, *Norman Rockwell's Four Freedoms* (New York: Gramercy, 1998), p. 62.

15. *Norman Rockwell's Four Freedoms*, p. 60.

16. *My Adventures*, p. 385.

17. *Norman Rockwell's Four Freedoms*, p. 86.

18. *My Adventures*, p. 386.

19. Interview with Melinda Pelham, March 14, 2017.

20. Ibid.

21. Interview with Tom Pelham, November 16, 2016.

22. Anne Pelham, unpublished interview with the author, February 17, 2017.

23. Interview with Tom Pelham, February 17, 2016.

24. Ibid.

25. Mary Adams, *Bennington Banner*, September 24, 1956.

CHAPTER 4

1. James A. Edgerton and Nan O'Brien, *The Unknown Rockwell: A Portrait of Two American Families* (Essex River Junction, VT: Battenkill River Press, 2009), p. 30.

2. Marjorie Squires Coulter, unpublished interview with the author, November 8, 2015.

3. Ibid.

4. Ibid.

5. Ibid.

6. Shirley Lawrence Letiecq, unpublished interview with the author, November 11, 2016.

7. *My Adventures*, p. 388.

8. Marjorie Squires Coulter, unpublished interview with the author, November 8, 2015.

9. Hallmark editors, *The Kansas City Spirit, Rockwell's Gift to the City*, https://www.hallmarkartcollection.com/artwork/the-kansas-city-spirit, 2019.

10. The editors, *Flood of 1951*, Kansapedia, Kansas Historical Society, https://www.kshs.org/kansapedia/flood-of-1951/17163, 2019.

11. Hallmark editors, *The Kansas City Spirit, Rockwell's Gift to the City*, https://www.hallmarkartcollection.com/artwork/the-kansas-city-spirit, 2019.

CHAPTER 5

1. *My Adventures*, p. 27.

2. Photograph provided by Ardis Edgerton, February 15, 2016.

3. Jarvis Rockwell, unpublished interview with the author, November 28, 2019.

4. Thomas R. Rockwell, unpublished interview with the author, June 26, 2017.

5. Interview with Jarvis Rockwell, November 28, 2019.

6. Arthur Guptill, *Norman Rockwell, Illustrator* (New York: Watson-Guptill Publications, 1946), p. 37.

7. Buddy Edgerton, unpublished interview with the author, July 20, 2016.

8. *My Adventures*, pp. 252, 361.

9. Interview with Thomas R. Rockwell, June 26, 2017.

10. Circa 1959 photograph, courtesy of Jarvis Rockwell, February 17, 2021.

11. *The Greatest Hitter Who Ever Lived* (film produced and directed by Nick Davis, Big Papi Productions, 2018).

12. *My Adventures*, p. 96.

13. *My Adventures*, p. 288.

14. Thomas Rockwell, *The Best of Norman Rockwell* (Philadelphia: Courage Books, 2018), p. 7.

15. Interview with Buddy Edgerton, July 20, 2016.

16. Ibid.

17. Stephen Ambrose and C. L. Sulzberger, *American Heritage History of World War II* (Rockville, MD: New Word City, 1997), introduction.

18. Interview with Thomas R. Rockwell, June 26, 2017.

19. Ibid.

20. Jacob M. Appel, "Thomas Rockwell, Writer: Where Fried Worms Come From," http://www.educationupdate.com/archives/2003/march03/issue/car_rockwell.html, March 2003.

21. *The Unknown Rockwell*, p. 228.

22. Interview with Thomas R. Rockwell, June 26, 2017.

23. Martin Oakland, unpublished interview with the author, August 30, 2015.

24. Interview with Thomas R. Rockwell, June 26, 2017.

25. "1958," https://www.nationalcoldwarexhibition.org/timeline.

26. "Labor Force and Unemployment in 1959," https://www.jstor.org/stable /41834345.

27. Description of Thomas Rockwell Collection, Social Archives, University of Virginia, 1970.

28. Interview with Thomas R. Rockwell, June 26, 2017.

29. Ibid.

30. Ibid.

CHAPTER 6

1. Interview with Buddy Edgerton, November 14, 2019.

2. Ibid.

3. *The Unknown Rockwell*, p. 70.

4. Karen Abbott, "What (or Who) Caused the Great Chicago Fire?," https://www .smithsonianmag.com/history/what-or-who-caused-the-great-chicago-fire-6148 1977, October 4, 2012.

5. Norman Rockwell, *Rockwell on Rockwell: How I Make a Picture* (New York: Watson-Guptill Publications), p. 101.

6. *My Adventures*, p. 426.

7. Steve Mills, "Uncowed Aldermen Clear Mrs. O'Leary," *Chicago Tribune*, October 7, 1997.

8. Interview with Thomas R. Rockwell, June 26, 2017.

9. *Rockwell on Rockwell*, p. 71.

10. Interview with Buddy Edgerton, November 14, 2019.

11. *Rockwell on Rockwell*, p. 91.

12. *The Unknown Rockwell*, p. 157.

13. *The Unknown Rockwell*, p. 211.

14. Interview with Buddy Edgerton, November 14, 2019.

15. *The Unknown Rockwell*, p. 140.

16. Interview with Buddy Edgerton, July 20, 2016.

17. Ibid.

18. Ibid.

19. Don Crofut, interview with the author, September 24, 2018.

20. *The Unknown Rockwell*, p. 181.

21. Interview with Buddy Edgerton, July 20, 2016.

22. Donald Robert Stoltz, Marshall Stoltz, and William F. Earle, *The Advertising World of Norman Rockwell* (New York: Madison Square Press, 1985), p. 30.

CHAPTER 7

1. Ardis Edgerton, unpublished interview with the author, February 11, 2016.

2. *The Unknown Rockwell*, p. 65.

3. Interview with Ardis Edgerton, January 11, 2016.

4. Interview with Ardis Edgerton, April 14, 2016.

5. Interview with Ardis Edgerton, January 11, 2016.

6. "Greatest Magazine Cover," *My Adventures*, p. 402.

7. Interview with Ardis Edgerton, January 11, 2016.

8. Susan E. Meyer, *Norman Rockwell's People* (New York: Harry N. Abrams, 1981), p. 74.

9. S. T. Haggerty, interview with Ardis Edgerton, April 4, 2016.

10. Interview with Ardis Edgerton, April 4, 2016.

11. Shari Randall, "Norman Rockwell's Murder Mystery," https://writerswhokill .blogspot.com/2018/03/norman-rockwells-murder-mystery.html, March 12, 2018.

CHAPTER 8

1. "Ed Durlacher—Central Park Newsreel," *Square Dance History Project*, http:// squaredancehistory.org/items/show/145.

2. Unpublished interview with Luella and Candace Parks, April 29, 2016.

3. Donald Fisher, unpublished interview with the author, April 7, 2019.

4. Ibid.

5. Interview with Luella and Candace Parks, April 29, 2016.

6. Hugh Henry, *Arlington along the Batten Kill: Its Pictured Past* (Arlington, VT: Arlington Townscape Association, 1993), p. 133.

7. S. T. Haggerty interview with Donald Fisher, April 7, 2019.

8. Interview with Luella and Candace Parks, April 29, 2016.

9. Ibid.

10. Chuck Marsh, unpublished interview with the author, July 31, 2016.

11. S. T. Haggerty, interview with Candace and Luella Parks, August 29, 2016.

12. History.com Editors, "Iwo Jima," https://www.history.com/topics/world-war-ii /battle-of-iwo-jima, June 7, 2019.

13. Ibid.

14. Marilyn Karcher, "Rockwell's Marine: PFC Duane Parks Epitomized Returning War Hero," *Leatherneck*, August 2008, p. 33.

15. Ibid.

CHAPTER 9

1. Tom Paquin, unpublished interview with the author, August 9, 2015.

2. *Rockwell on Rockwell*, p. 160.

3. Tom Paquin, unpublished interview with the author, August 9, 2015.

4. *Rockwell on Rockwell*, p. 160.

5. Interview with Tom Paquin, August 9, 2015.

CHAPTER 10

1. Interview with Don Hubert Jr., October 13, 2015.

2. Carol Vogel, "Norman Rockwell's America," *New York Times*, September 18, 2013.

3. Interview with Don Hubert Jr., October 13, 2015.

4. Ibid.

5. Ibid.

6. History.com Editors, "Battle of the Bulge," https://www.history.com/topics /world-war-ii/battle-of-the-bulge, 2019.

7. *My Adventures*, 128.

8. *Norman Rockwell, Illustrator*, 129.

9. Mrs. Hubert, copy of a letter to Donald Hubert, October 12, 1997.

10. *Rockwell on Rockwell*, p. 166.

11. Interview with Don Hubert Jr., October 13, 2015.

12. *Rockwell on Rockwell*, p. 166.

13. *Rockwell on Rockwell*, p. 167.

14. *Rockwell on Rockwell*, p. 166.

15. *Rockwell on Rockwell*, p. 167.

16. Article Don Hubert Jr. saw at Arlington Memorial High School, Norman Rockwell.

17. Abigail Rockwell, "Norman Rockwell and Faith," *Saturday Evening Post*, October 8, 2015.

18. S. T. Haggerty interview with Ardis Edgerton, 2017, Ocala, Florida.

19. Interview with Don Hubert Jr.

20. Interview with Don Hubert Jr., October 13, 2015.

21. Interview with Jarvis Rockwell, August 28, 2016.

22. Interview with Buddy Edgerton, June 29, 2016.

23. *My Adventures*, p. 50.

24. Interview with Don Hubert Jr., October 13, 2015.

25. Luisa Navarro, "Norman Rockwell Painting 'Saying Grace' Brings Record $46 Million at Auction," https://www.cnn.com/2013/12/04/us/rockwell-saying -grace-auction/index.html, December 5, 2013.

26. Interview with Jarvis Rockwell, August 8, 2016.

27. Interview with Thomas R. Rockwell, June 26, 2017.

28. Charles Desmarais, "Lucas Bought Rockwell Painting 'Saying Grace' at Record Price," *San Francisco Chronicle*, August 31, 2016.

29. Sarah Cascone, "What Is a Narrative Art Museum? 6 Things to Expect from George Lucas's New LA Museum," https://news.artnet.com/art-world/what-is-a -narrative-art-museum-george-lucas-1258994, April 17, 2018.

CHAPTER 11

1. Paul Adams, unpublished interview with the author, July 6, 2015.

2. *New York Times*, April 17, 1949.

3. "The Comedy Team of Tim and Irene Ryan (aka Granny of the Beverly Hillbillies)," https://thelifeandtimesofhollywood.com/the-comedy-team-of-tim -irene-ryan-aka-granny-of-the-beverly-hillbillies, March 28, 2021.

4. Pauline Grimes, unpublished interview with the author, July 6, 2015.

5. History.com Editors, "Korean War," https://www.history.com/topics/korea /korean-war, August 4, 2009.

6. Interview with Pauline Adams Grimes, July 6, 2015.

7. Interview with Paul Adams, July 6, 2015.

8. *My Adventures*, p. 425.

9. Interview with Paul Adams, July 6, 2015.

CHAPTER 12

1. Interview with Chuck Marsh, July 31, 2016.

2. Ibid.

3. Ibid.

CHAPTER 13

1. Unpublished interview with Mary Whalen Leonard, August 30, 2015.

2. Ibid.

3. Ibid.

4. Ibid.

5. Interview with Mary Whalen.

6. Ibid.

7. Ibid.

8. Ibid.

9. *Norman Rockwell's People*, p. 154.

10. Ron Schick, *Norman Rockwell: Behind the Camera* (Boston: Little, Brown, 2009), p. 136.

11. Interview with Mary Whalen Leonard, August 30, 2015.

12. Ibid.

13. Ibid.

14. Ibid.

CHAPTER 14

1. "Family Relationship of Norman Rockwell," https://famouskin.com/famous
-kin-chart.php?name=33296+norman+rockwell&kin=24679+stephen+hopkins.

2. Interview with Jarvis Rockwell, August 28, 2016.

3. *My Adventures*, p. 334.

4. Interview with Jarvis Rockwell, August 28, 2016.

5. Ibid.

6. Norman Rockwell, *The Saturday Evening Post Norman Rockwell Review*
(Indianapolis: Curtis Publishing Company, 1979), p. 109.

7. Interview with Jarvis Rockwell, August 28, 2016.

8. Editors, photo of gravestone of Thaddeus Wheaton, https://www.findagrave
.com, 2019.

9. Stephanie Plunkett, *Jarvis Rockwell: Maya, Illusion, and Us* (Stockbridge, MA:
Norman Rockwell Museum Publications, 2013).

10. Interview with Jarvis Rockwell, August 28, 2016.

11. *My Adventures*, p. 388.

12. Ibid.

13. Interview with Jarvis Rockwell, January 10, 2019.

14. Interview with Jarvis Rockwell, August 28, 2016.

15. Ibid.

16. Ibid.

17. Interview with Jarvis Rockwell, January 10, 2019.

18. Dr. Russell's collection, Arlington Library, Arlington, Vermont.

19. Interview with Jarvis Rockwell, January 10, 2019.

20. Mary Atherton Varchaver, unpublished interview with the author, October 8,
2016.

21. Interview with Mary Atherton Varchaver, October 8, 2016.

22. Interview with Jarvis Rockwell, November 18, 2018.

23. Laura Claridge, *Norman Rockwell: A Life* (New York: Modern Library, 2003), p. 357.

24. Interview with Jarvis Rockwell, November 18, 2019.

25. Abigail Rockwell, unpublished remarks, *My Adventures as an Illustrator* book signing, June 23, 2019, Norman Rockwell Museum.

26. Interview with Jarvis Rockwell, November 18, 2018.

27. *Norman Rockwell*, p. 376.

28. Remarks by Abigail Rockwell at the Norman Rockwell Museum, June 23, 2019.

29. Interview with Jarvis Rockwell, August 28, 2016.

30. Ibid.

31. Interview with Jarvis Rockwell, November 18, 2018.

32. David and Mary Verzi, "Norm's Boy's Toys," *Berkshires Week*, 1996.

33. Interview with Jarvis Rockwell, August 28, 2016.

34. *The Best of Norman Rockwell*, p. 8.

CHAPTER 15

1. Interview with Anne Pelham.

2. Interview with Ardis Edgerton.

3. Unpublished Interview with Thomas R. Rockwell, June 26, 2017.

4. *Norman Rockwell*, p. 387.

5. Interview with Mary Whalen Leonard, August 30, 2015.

6. *My Adventures*, p. 435.

7. *The Unknown Rockwell*, p. 262.

8. Interview with Mary Whalen Leonard, August 16, 2016.

9. Ibid.

10. Interview with Tom Pelham, January 30, 2017.

11. Ibid.

CHAPTER 16

1. Lucille Towne Holton, unpublished interview with the author, November 8, 2015.

2. Lynn Swann, unpublished interview with the author, September 3, 2018.

3. Ibid.

4. Ibid.

5. Ibid.

6. Ibid.

7. Interview with Lynn Swann, September 3, 2018.

8. Interview with Buddy Edgerton, July 27, 2018.

9. Interview with Lynn Swann, September 3, 2018.

10. Ibid.

CHAPTER 17

1. Unpublished interview with Don Trachte Jr., December 12, 2015.

2. Ibid.

3. Ibid.

4. Ibid.

5. Ibid.

6. Ibid.

7. Recollections of S. T. Haggerty.

8. Unpublished interview with Charles Bentley Jr., October 10, 2014.

9. Interview with Don Trachte Jr., December 12, 2015.

10. Ibid.

11. Ibid.

12. Ibid.

13. Ibid.

14. Ibid.

15. Ibid.

16. Ibid.

17. Ibid.

18. Ibid.

19. Ibid.

20. Ibid.

21. Ibid.

22. Ibid.

23. Ibid.

24. Ibid.

25. Ibid.

26. Ibid.

27. Christopher Helman, "The Museum of Ross Perot," *Forbes*, https://www
.forbes.com/sites/christopherhelman/2013/09/04/the-museum-of-ross
-perot/?sh=206e9a18307c, September 23, 2013.

28. "Norman Rockwell Painting 'Saying Grace' Brings Record $46 Million at
Auction."

29. Interview with Don Trachte Jr., December 12, 2015.

30. Ibid.

BIOS OF THE MODELS

1. Interview with Tom Pelham, January 30, 2017.

2. Interview with Buddy Edgerton, July 20, 2016.

3. Obituary of Duane Parks, *Bennington Banner*, February 7, 2015.

Index

Adams, Carl, 170–74, *176*

Adams, Martha: family of, 171–75, *176*; friendships of, 169–70

Adams, Mary Beth, 170–74, *176*

Adams, Paul, 170–75, *175–76*, 265

Adams, Pauline, 170, 265

Adams, Virgil, 170, 174

advertising: in *Bennington Banner*, 191; illustrations for, 46, 185

Africa, 10, 172–75

After the Prom (Rockwell, Norman), 230

Alcoholics Anonymous, 217

Allied Flags (Rockwell, Norman), 120

American Magazine, 32, 44

anxiety, 17, 209–10

April Fools (Rockwell, Norman), 39, 41, *41*, 45, 78, 120

architecture, 70–71

art: artists, 210–11; authenticity of, 12; children in, 11–12, 37; colors in, *14*, 15, 33; in culture, 1–2; Grand Central School of Art, 29; humor in, 39, 41, *41–42*, 43; illustrations as, 95, 161, 220–22; inspiration from, 64; Lucas Museum of Narrative Art, 1, 168; for Pelham, G., 29–31; props for, 24; psychology and, 10, 43–44; religion and, 21–22; by Rockwell, J., 222–25; sports and, 29; in Stockbridge Museum, 49; United States in, 18; value of, 1, 44–46; Williamstown Art Conservation Center, 249, 252–53; World War II in, 57–59, *59–60*

Arthur Godfrey's Talent Scouts (TV show), 43

Art Students League, 166

Atherton, John "Jack," 65, 215

Atherton, Mary, *85*, 213, 215

Aumand, Sophie (née Rachiski). *See* Rachiski, Sophie

Aumund, Turk, 261

authenticity: of art, 12; of *Breaking Home Ties*, 246–55, *251*; models for, 17

Automat restaurants, 161–62

The Babysitter (Rockwell, Norman):
 process for, 126–27, 242; reputation
 of, 42, 48–49, 233–37, 266; Rockwell,
 J., on, 221
Back to Civvies (Rockwell, Norman),
 104, 116, 124
Ball, Lucille, 153
Ban Ki-moon, 177
Bard College, 90–91
Barrymore, Ethel, 134
Barstow, Alfred, 229
Barstow, Dora Gary, 229
baseball, 24, 75–76, 80, 126, 212
basketball, 85–87, 109–11, 183–84
Becktoft, Art, 104–5, 116, 125, *125*
Bellemare, Louis, 149
Benedict, Bob, Jr., 72–73, *144*, 232
Benedict, Bob, Sr., 37, 68, *69*, 124,
 142–43, 232
Benedict, John, *144*, 232
Bennington Banner, 37–38, 80, 104, 149,
 191
Benny, Jack, 222
Bentley, Charles, Jr., *176*, 244
Bentley, Floyd: modeling by, 3–4, 49, 87,
 90, 239, *240*; reputation of, 49, 239,
 241, 242, 243–45
The Best of Norman Rockwell (Rockwell,
 T.), 225
The Beverly Hillbillies (TV show), 171
bicycles, 55
Blank Canvas (Rockwell, Norman), 6
Bloomberg, Samuel, 237
Boston Red Sox, 24
Boy on a Diving Board (Rockwell,
 Norman), 91
Boy on a Train Car (Rockwell,
 Norman), 91

Boy Reading Sister's Diary (Rockwell,
 Norman), 77
Boy Scouts of America, 81, 90,
 100–102, 107–8, 112, 147–48,
 230
Boy's Life (magazine), 100
Boy with a Baby Carriage (Rockwell,
 Norman), 29
Breakfast (Rockwell, Norman), 114
Breaking Home Ties (Rockwell,
 Norman): authenticity of, 246–55,
 251; Bentley, F., in, 3–4, 49, 87, 90,
 239, *240*; legacy of, 266; psychology
 in, 134–35; value of, 4, 231, 239–41,
 240–41, 255–56
Briggs, Marie, 3, 90, 175, *176*, *240*,
 244–45
Britain: Germany and, 37–38, *59*; United
 States and, 57–58
Brooklyn Dodgers, 80
Brown, Billy, *118*, *125*, 125–26
Brown, Lorna, 234–37
Brown and Bigelow (insurance
 company), 101–2, 147, 181, 211
Buck, Bob, 139
Buddy. *See* Edgerton, James
Bush, George H. W., 231
Bush, George W., 246
Bush, Laura, 246
Butler, "Shaky" Bill, 170–71, 173

cabin, 62
California: culture of, 219–20; family in,
 87–88, 213
Call Me Norman (book), 2
cameras, 32
Campbell, Duncan, 147–48
Canfield, Martha, 188

career: anxiety in, 209–10; with Brown and Bigelow, 211; of Buddy, 108, 263; criticism of, 6; deadlines in, 121; finances in, 228; flops in, 101–3; friendships in, 49; with Hallmark, 64–65; integrity in, 4; Marsh, C., in, 179–81; of Moses, 170–71; of Pelham, G., 246; personality and, 257–60; preoccupation with, 75–77; Rockwell, J., on, 220–22; Rockwell, T., and, 91–93, 103; of Rockwell, P., 134; *Saturday Evening Post* for, 1–3, 5, 92–93; success in, 167–68; of Trachte, Don, Sr., 46, 190, 241–42

cartoons, 46, 190, 239, 241–42

Caught Napping (Rockwell, Norman), 48

Chicago Cubs, 126–27

childhood: in New York City, 3; of Pelham, G., 29–30; of Rockwell, J., 10–12, *14*, 15, 69, 199–200, 204–8; of Rockwell, M., 200; of Rockwell, T., 10–12, 69–72, 78; sports in, 192–94

Child Life (magazine), 48, 264

children: in art, 11–12, 37; baseball for, 75–76, 212; bikes for, 55; children's books, 93–96; culture to, 16; dolls for, 59, *59*; in nature, *60*; of Pelham, G., 46–49, *47*; psychology of, 191–92; sports for, 46–47, 80; Squier family, 71; during World War II, 234

China, 135, 171–72

Christmas Homecoming (Rockwell, Norman): family in, 83–84, *85*, 180; models for, 91, 143, 161; Moses in, 169; Rockwell, J., on, 213–14; value of, 181

Christy's auction house, 168

Claridge, Laura, 216, 228

Clark, Ardis Edgerton, *63*

Clark, Ray, 135, 264

Clinton, Bill, 231

Cold War, 18, 93

colors: in art, *14*, 15, 33; color studies, 263; in illustrations, 147–53, *152–53*; McLenithan, R., and, 140; models and, 7, 9, 140; perfectionism with, 77–78

comics, 46, 190, 222, 239, 241–42

communism, 162, 171–72

Coulter, Jerry, 263

Coulter, Marjorie (née Squiers), 53–55, 57–61, *59–60*, 201, 263

Country Doctor (Rockwell, Norman), 20, 179–80, 209–12, 221

criticism: Buddy on, 105–6; of career, 6; of *Day in the Life of a Boy*, 186

Crofut, Charlie, 126

Crofut, Don, 109–11

Crofut, Doris, 105, 140

Crofut, Rena, *85*, 105, 140

Crofut, Sidney, 140

Cross, John, Jr., *118*, 119

Cross, John, Sr., 119

Cross, Yvonne, *118*, 123

Cullinan, Cheryl, 185

culture: art in, 1–2; of California, 219–20; to children, 16; *Country Doctor* in, 20; fame in, 38–39, 257–60; *Marbles Champion* in, 6; marbles in, 11–12; models in, 13, *14*, 15–16; nature in, 72–73; of New York, 200; of New York City, 30; psychology and, 259–60; radio in, 24; reputation in, 20; *Saturday Evening Post* in, 173–74, 196–97, 207; shock, 204–6; of

United States, 11–12, 46, 65, 161–62;
of Vermont, 4, 31, 47, 52–53, 74–75;
of World War II, 3, 18, 258
Curtis Publishing, 156, 164. *See also*
Saturday Evening Post

Darnell, Linda, 133
Dartmouth Alumni Magazine, 179
Day in the Life of a Boy (Rockwell,
Norman), 143, 180–81, 186
Day in the Life of a Girl (Rockwell,
Norman), 180–81, 186, *187*
deadlines, 121
Dean, Howard, 262
death, 96, 217–18, 222, 224–25, 230
Decker, Clarence, Sr., 74
Decker, Phyllis, 74
depression, 89, 90–91, 105, 134, 162,
196, 213–18
Dewey, George, 208
Dickens, Charles, 181, 207, 212
Diggriss, Belle, 170
Disabled Veteran (Rockwell, Norman),
62–63
Diving Board (Rockwell, Norman), 91
dolls, 59, *59*
Dorr, Yvonne (née Cross), *118*, 123
Dostoevsky, Fyodor, 207
Douglas, Jim, 262–63
Douglas, Kirk, 133
The Dugout (Rockwell, Norman), 126
Dunlop, Clyde, 58
Durlacher, Ed, 137
dyslexia, 29–30

East Wind over Weehawken (Hopper),
167–68
economy: of Cold War, 18; value in,
47–48; of World War II, 98

Edgerton, Ardis: biography of, 264;
Buddy and, 114; family of, 162;
modeling by, 106, 115–16, *118*, 124–
27, *125*, 126–27, 133, 213; on move,
229; relationship with, 114–17, 191;
Rockwell, M., and, 114–15, 119–21,
133–35, 206, 229; Rockwell, T., and,
124–25; sports to, 123–24; Vermont
for, 113–14, 121–23
Edgerton, Clara: Edgerton, Jim, and,
97–98; friendship with, 206, 211, 264;
modeling by, 68, *69*, 121; as mother,
101, 107, 113, 125, *125*; personality
of, 79–80; Rockwell, M., and, 105
Edgerton, Edith, 113
Edgerton, Elva, *63*, 106–7, 123–24
Edgerton, James (Buddy): biography
of, 263–64; on criticism, 105–6;
Edgerton, A., and, 114; education of,
111; friendships with, 79–81, 83, 89–
90; illustrations to, 101–3; modeling
by, *63*, *82*, 100–101, 106–8, 112, *112*,
114, 148, 175, *175*, 193, 230, 259; on
perfectionism, 104–5; relationship
with, 99–101, 108–10; Rockwell, T.,
and, 84, 94, 99; on Rockwell, M., 220;
support from, 236; Vermont for,
97–99
Edgerton, Jim: Edgerton, C., and, 97–98;
as father, 98–99, 107, 113; friendship
with, 104–5, 123, 206, 209, 264; in
local politics, 259; modeling by, *63*,
69, 99, 106–7, 114; on move, 228;
as neighbor, 79, 81, 83–84, 89–90;
Rockwell, T., and, 68
Edgerton, Joy, *63*, 106, 113, *125*
education: of Buddy, 111; in
illustrations, 157–61, 179; by
Marsh, A., 204, 213; in New York,

3; philanthropy for, 188; with photography, 87–88; of Rockwell, J., 166, 213–14; of Rockwell, M., 78; of Rockwell, P., 162; of Rockwell, T., 88–90, 134; tuition fees, 229; Whalen, Mary, in, 266
"Eight Stages of Psychosocial Development" (Erikson), 218
Eisenhower, Dwight, 81, 195
Eliasson, Jian, 177
Emily Stew (Rockwell, T.), 96
Erikson, Erik, 218–19
E.T. (Spielberg), 201
Europe: family in, 200; Germany and, 57–58, 80; Soviet Union and, 106; United States and, 81; World War II and, 37–38, 139

Fall Bounty (Rockwell, Norman), 120
fame: in culture, 38–39, 257–60; after *Four Freedoms*, 38; of *Girl at the Mirror*, 221; of *The Golden Rule*, 177; of *Henry*, 239, 241–42; of Moses, 148–51, 169–71, 214; psychology of, 26; from *Saturday Evening Post*, 8–9, 56, 56–57, 78, 99, 141, 184, 258–59; of *Saying Grace*, 167–68; in United States, 3, 20
family: of Adams, M., 171–75, *176*; in California, 87–88, 213; in *Christmas Homecoming*, 83–84, *85*, 180; of Edgerton, A., 162; in Europe, 200; finances, 227–32; help from, 3; of Hubert, D., Jr., 159–61; in illustrations, 160–61; in New York, 67–68; Pelham, G., and, 22–23, 230–32; personality and, 2; relationships in, 12; Rockwell, P., and, 201,

208–10; Rockwell, T., and, 84–90, *85*, 201, 208–10; Squier, 51–52, 61–64, *64*; *Tired Salesgirl on Christmas Eve* and, 21–22; of Trachte, Don, Jr., 242, 245–49; on vacation, 10–11; Vermont for, 69–72; after World War II, 81, *82*, 83–84. *See also specific family*
Family Tree (Rockwell, Norman), 92
finances, 227–32
Finch, Christopher, 241
First Sign of Spring (Rockwell, Norman), 44, 102, 221–22
Fisher, Don, 85–88
Fisher, Doris, 86–88
Fisher, Dorothy Canfield, 188–89, 193
Fishing Still Life (Rockwell, Norman), 120
Fitzgerald, F. Scott, 139, 217
Fixing a Flat (Rockwell, Norman), 120
The Flirt (Rockwell, Norman), 162
Flower Grower (magazine), 91
Fonda, Henry, 133
Food Package from Home (Rockwell, Norman), 32, 114
Four Freedoms (Rockwell, Norman): assistance with, 34, 36; inspiration for, 33–34; legacy of, 263; models for, 74, 161; process for, 37–39, 57–59, *59–60*; reputation of, 1, 3, 20, 106
France, 158
Francis (pope), 177
Freedom from Fear (Rockwell, Norman), 37–38, 57–59, *59–60*, 61, 74, 263
Freedom from Want (Rockwell, Norman), 38–39, *40*, 72–73, 203
Freedom of Speech (Rockwell, Norman), 35, 36–37, 53, 68, 114, 204, 232

Freedom of Worship (Rockwell, Norman), 37–38, 54, 61, 86, 106, 167, 204

Freisatz, Joy Edgerton, 263–64

Freud, Sigmund, 218

Friend in Need (Rockwell, Norman), 109

friendships: of Adams, M., 169–70; with Buddy, 79–81, 83, 89–90; in career, 49; with Edgerton, C., 206, 211, 264; with Edgerton, Jim, 68, 104–5, 123, 206, 209, 264; with Moses, *176*; after move, 228–29; with Pelham, G., 227; of Rockwell, T., 79–80; with Squier family, 51–52, 61–64, *64*; with Squiers, C., 106; with Trachte, Don, Sr., 242–45; in Vermont, 31–32, 258

Gehrig, Lou, 29

Germany: Britain and, 37–38, *59*; Europe and, 57–58, 80; Japan and, 106, 139; Nazis, 80, 139, 158–59, 259; United States and, 116, 158–59; after World War II, 81

G.I. Homecoming (Rockwell, Norman), 91, 117, *118*, 126, 148, 158

Gillis, Willie, 139

Girl at the Mirror (Rockwell, Norman): fame of, 221; legacy of, 1, 134; process for, 127, 191–93; reception of, 195–97, *197*

Godfrey, Arthur, 153

Going and Coming (Rockwell, Norman), 20, 95, 119, 123–24, *130*, 212

The Golden Rule (Rockwell, Norman), 167, 177, 265

Good Morning America (TV show), 265

The Gossips (Rockwell, Norman), 62, 103, 105, 121, 140

The Graduate (Rockwell, Norman), 93

Graham, Billy, 246

Grand Central School of Art, 29

Grand Central Station, 156–57

The Grapes of Wrath (Steinbeck), 78

Great Depression, 30

Green Mountain Diner, 180

greeting cards, 48

Grimes, Peter, 265

Grout, Freeman, 109, 111, 163

Growth of a Leader (Rockwell, Norman), 230

Guam, 138, 143, 146

A Guiding Hand (Rockwell, Norman), 81, *82*, 107–8, 263–64

Guptill, Arthur, 73

Hall, Frankie, 103, 180

Hall, Joyce, C., 64–65

Hallmark, 48, 64–65

Happy Skiers on a Train (Rockwell, Norman), 44, 68, 121

Harrington, Amelia, 62

Harrington, Jesse, 62

Hartness, James, 18

Hedges, Susan, 8–10

Helping Hand (Rockwell, Norman), 163

Hemingway, Ernest, 217

Henry (comic), 46, 190, 239, 241–42, 253

Hess, Carl: career of, 53; modeling by, *35*, 36–37, 49, 232; reputation of, 212, 259

Hess, Henry, 39, 41

Hibbs, Ben, 119

His First Day of School (Rockwell, Norman), 155, 157, 159–61

Hitler, Adolf, 18, 80, 259

Hoisington, Billy, *40*

Hoisington, Shirley, *40*

Holton, Lucille Towne, 126–27, 233, 237, 266

Homecoming Marine (Rockwell, Norman): *G.I. Homecoming* and, 158; legacy of, 72–73, 264; process for, 143–44, *144*, 146, 148; Rockwell, J., and, 203, 221; staging for, 124

Home on Leave (Rockwell, Norman), 231

Hopkins, Stephen, 199

Hopper, Edward, 167–68

The Horseshoe Forging Contest (Rockwell, Norman), *56*, 56–57, 63

Howard, George, 70–71

"How Goes the War on Poverty" (*Look*), 173

How to Be a Millionaire (Rockwell, T.), 96

How to Eat Fried Worms (Rockwell, T.), 95–96

How to Get Fabulously Rich (Rockwell, T.), 96

Hoyt, Irene, *118*

Hubert, Charlie, 265

Hubert, Don, Jr.: on auction, 166–67; biography of, 264–65; discovery of, 158–59; family of, 159–61; modeling by, 155–57, 161–66, *165–66*

Hubert, Don, Sr., 158–60

Hughes, George, 246–47

humility, 52

humor: in art, 39, 41, *41–42*, 43; in illustrations, 78; in personality, 24–26

identity, 218–19

illustrations: for advertising, 46, 185; Africa in, 172–73; as art, 95, 161, 220–22; in autobiography, 4, 33, 92–93, 168, 227, 229, 264; to Buddy, 101–3; cameras and, 32; colors in, 147–53, *152–53*; education in, 157–61, 179; family in, 160–61; in greeting cards, 48; humor in, 78; in *Kansas City Spirit*, 65; perfectionism with, 102–3; philosophy of, 167; photography and, 210; professionalism with, 26; religion in, *165*, 174; Rockwell, T., on, 220; by Rockwell, J., 224; in Russia, 243, 247, 249; Society of Illustrators, 119; for *Tom Sawyer*, 5; to Trachte, Don, Sr., 239–40, *240*; in United States, 1–2; value of, 155–57, 167–68, 242. *See also specific illustrations*

I Love Lucy (TV show), 153

Immen, Bert, 214

Immen, Dot, 161

Immen, Mary, *85*, 161, 214

income: of Pelham, G., 42; reputation and, 17; from *Saturday Evening Post*, 44–45

inheritance, 217–18

inspiration: from art, 64; for *Four Freedoms*, 33–34; from landscapes, 6; from pets, 212; for *Saying Grace*, 158–59; from Vermont, 5, 258–60

integrity, in career, 4

Iwo Jima, 80, 143, 145–46

The Jackie Robinson Story (film), 80

Japan, 106, 139, 145–46, 171

Jarvis Rockwell (Rockwell, Nova), 223

Jaws (Spielberg), 201

Johnson, Marilyn, *125*

Kansas, 64–65
Kansas City Spirit, 65
Kellogg's Corn Flakes, 46, *47*
Kennedy, John F., 30
Khrushchev, Nikita, 93, 243, 247, 249
Killington, Edward, *69*
Korean War, 135, 162, 171, 215

landscapes, 6, 18, 48–49, 122, 200, 204, 250
Lawrence, Dorothy, 58, *59*
Leonard, Mary (née Whalen). *See* Whalen, Mary
Leonard, Philip, 266
Life (magazine), 74, 207
Lincoln, Abraham, 170
Lindbergh, Ann Morrow, 109
Lindbergh, Charles, 109
Lindsey, Charlie, *40*
literature, 207, 217
"Local Pilot Missing in Action" (*Bennington Banner*), 104
The Lone Ranger (comic), 112, *112*
The Long Shadow of Lincoln (Rockwell, Norman), 62–63, *63*, 106, 124–26, 140, 209
Look (magazine), 173
Lorimer, Horace, 93
Love Ouanga (Rockwell, Norman), 221
Lucas, George, 1, 168
Lucas Museum of Narrative Art, 1, 168
Luxembourg, 158

Mack Molding, Inc., 144, *144*
Marbles Champion (Rockwell, Norman): assignment for, 6, 147; contemporary themes in, 7; model search for, 8–10; models in, 11–13, 261; realism in,

221; Rockwell, J., in, 200–201; in *Saturday Evening Post*, 13, *14–15*, 15–16; studio work for, 10–11; success of, 17
marriage, 91–92
Marsh, Ann, *85*, 179–81, 204, 213
Marsh, Chuck: biography of, 265; relationship with, 179–81, 186, *187*, *187–88*; on Rockwell, Norman, 143, 229–30
Marsh, Donnie, *85*, 180, 186
Marsh, Lee, 179, 181
Martin, Jim, Jr., 74, 161
Martin, Jim, Sr., 37, 58, 74, 161
Mason, Phyllis, 74
Massachusetts, 227–32
Maya (Rockwell, J.), 223
McKee, Harvey, 52–53, 56, *56*, 73–74, 117
McKee, Jenny, 117
McLenithan, Franklin, 8, 13
McLenithan, Ruthie: biography of, 261; colors and, 140; experience of, 13, *14–15*, 15–16; first meeting with, 8–10; modeling by, 11–13, 201–2; in studio, 10–11
medicine, 211–12
Melville, Herman, 120
memorabilia, 10
Men of Tomorrow (Rockwell, Norman), 108
Men Working on the Statue of Liberty (Rockwell, Norman), 235
Merry Go Round (Rockwell, Norman), 44, 231
military: in Korean War, 215; Marsh, C., in, 265; Motor Transport Corps, 203; Rockwell, J., in, 134, 162, 199, 215;

United States, 137–46, *145*; Wheaton, T., in, 203–4

Miller, Harlan, 109–11

Mirrieles, Edith, 78

Missouri, 64–65

Moby Dick (Melville), 120

models. *See specific topics*

Moffat, Laurie, 252–53

Moses, Grandma: career of, 170–71; fame of, 148–51, 169–71, 214; friendship with, *176*; relationship with, 169–70

move, to Massachusetts, 227–32

movies, 70

Mrs. O'Leary's Cow (Rockwell, Norman), 101–3

murals, 30

Murder Mystery (Rockwell, Norman), 133–34

Murphy, Melinda (née Pelham). *See* Pelham, Melinda

Music Hath Charms (Rockwell, Norman), 52–53, 56, 73–74, 117

My Adventures as an Illustrator (Rockwell, Norman), 4, 33, 92–93, 168, 227, 229, 264

"My Gal's a Corker, a Real New Yorker" (song), 207

My Studio Burns (Rockwell, Norman), 78, 205–6

National Academy of Design, 29

nature: children in, *60*; in culture, 72–73; in Kansas, 64–65; of Vermont, 53–54, *56*, 56–57, 61–62, 68, *69*, 116–17, 121–22, 205

Nazis, 80, 139, 158–59, 259. *See also* Germany

New Chair (Pelham, G.), 33

New Rochelle. *See* New York

New York: Art Students League in, 166; culture of, 200; education in, 3; family in, 67–68; Vermont and, 6, 30–31, 70–71, 204

New York City: Automat restaurants in, 162; childhood in, 3; culture of, 30; entertainment in, 83; Grand Central Station in, 156–57

The New Yorker (magazine), 207

New York Times, 149, 253

Norman Rockwell (Claridge), 228

Norman Rockwell, Gallery, 265

Norman Rockwell, Illustrator (Rockwell, T.), 220

Norman Rockwell: 332 (Finch), 241

Norman Rockwell Museum, 1, 168, 174–75, 222, 231, 252, 263

"Norm's Boy's Toys" (article), 223

North Korea, 162, 171–72

No Swimming (Rockwell, Norman), 95, 181

Noyes, Nip, 144, *144*

Oakland, Martin, 91

Obama, Barack, 177

Obama, Michelle, 177

O'Connor, Irene, 92

Of Mice and Men (Steinbeck), 78

Old Man and Boy Skating (Rockwell, Norman), 126

Oliver Twist (Dickens), 181

O'Neil, Jim, 127, 191

O'Neil, Sharon, *85*, 127, 191

On Leave (Rockwell, Norman), 254

On My Honor (Rockwell, Norman), 90, 100–101

Our Heritage (Rockwell, Norman), 109

Paquin, Tommy, 147–53, *152–53*, 264

Parks, Blanche, 141–43

Parks, Duane, 137–46, *144–45*, 148, 264

Parks, Jane, 141

Parks, Jean, 141

Parks, Lorraine, 141–42

Parks, Ray, 138

Patton, George, 30, 159

Pease, Hershey, 140

Pelham, Anne, 44, *47*, 227, 231, 262

Pelham, Gene: art for, 29–31; assistance
 from, 22, *28*, 33–34, *35*, 36, 89, 143,
 157, 185; biography of, 261–62;
 career of, 246; children of, 46–49,
 47; collaboration with, 39, *40–42*,
 41–43; contract with, 17; creativity
 of, 162–63; devotion of, 18, 21,
 259; family and, 22–23, 230–32;
 as father, 233; first meeting with,
 31–33; friendship with, 227; income
 of, 42; landscapes by, 250; modeling
 by, *165*, 221–22; with models, 33;
 after move, 230–32; personality of,
 43–44, 121, 190; photography by, 23,
 25, 75, 115–16, 150, 164, 172, 186,
 193; professionalism of, 19, 36–39;
 reliance on, 44–46, 209; Rockwell,
 J., and, 208; Rockwell, M., and, 46;
 Rockwell, T., and, 88; in studio, 57–
 58; *Vermont News Guide* by, 230–31

Pelham, Katharine, 43, 46, 233

Pelham, Melinda, 39, 41, *47*, 48–49, 231,
 233, 237, 242, 262

Pelham, Tom, 42, 44–49, *47*, 231–32,
 262

Pelham, Vicky, 30–31, 41

The Pennysaver, 230–31

perfectionism, 45–46, 77–78, 102–5

Pero, Linda, 231–32

Perot, Ross, 168, 231, 243, 245–46,
 253–54

personality: career and, 257–60; of
 Edgerton, C., 79–80; family and,
 2; humility, 52; humor in, 24–26;
 of Pelham, G., 43–44, 121, 190;
 perfectionism, 45–46; of Rockwell,
 M., 22–24, 87, 107; storytelling, 68–
 69; of Trachte, Don, Sr., 245–46, 256

pets, *128*, *131*, 212

philanthropy, 188

philosophy, of illustrations, 167

photography: education with, 87–88;
 illustrations and, 210; by Pelham, G.,
 23, 25, 75, 115–16, 150, 164, 172, 186;
 by Pelham, Gene, 193; of Squier, C.,
 64; of Squier, W., *64*; in studio, 32

The Plumbers (Rockwell, Norman), 86

Plunkett, Stephanie, 252

poetry, 88, 126

Pooley, Alison, 234–37

Pooley, J. E., 234

Pooley, Suzanne, 237

Portmanteau (Rockwell, T.), 96

portraits, 48–49

posttraumatic stress, 264

Princeton University, 89

professionalism: with illustrations, 26;
 with models, 24; of Pelham, G., 19,
 36–39; reputation and, 21–22; in
 studio, 23, *132*

props, for art, 24

psychology: anxiety, 17; art and, 10,
 43–44; of artists, 210–11; in *Breaking
 Home Ties*, 134; of children, 191–92;
 culture and, 259–60; of fame, 26;
 identity in, 218–19; in literature, 207;

posttraumatic stress, 264; of Rachiski, Sophie, 21–22; of religion, 18–19; of Rockwell, J., 213–15; of value, 44–46

psychotherapy, 218–20

publishing, 121

Puppy in the Pocket (Rockwell, Norman), 67

race, in United States, 169–77, *175–76*, 265

Rachiski, Ruzia "Rosa," 18–22, 26, 28

Rachiski, Sophie: biography of, 261; modeling by, *27, 28, 28,* 259; mother of, 18–20, 28; psychology of, 21–22; in studio, 24–26

Rachiski, Stan, 22

Rackety Bang and Other Verses (Rockwell, T.), 93–94

radio, 24

Rathbone, Peter, 247–49, 252

Reagan, Ronald, 156

Reed, Roger, 247, 252

relationships: with Buddy, 99–101, 108–10; with Edgerton, A., 114–17, 191; in family, 12; with Marsh, C., 179–81, 186, *187, 187–88*; with Moses, 169–70; with Rockwell, J., 71, 208–11, 223–24; with Rockwell, M., 51, 75–76, 101, *128,* 207, 220, 229; with Rockwell, T., 67–69, *69,* 75–77, 93–96; at *Saturday Evening Post,* 6, 43–44, 156; with Squiers, W., 51–53, 203, 263; with Stuart, Ken, Sr., 211; with Whalen, Mary, 183–85, 193–96, 230

religion: art and, 21–22; in illustrations, *165,* 174; psychology of, 18–19; for

Rockwell, M., 54; in United States, 170–71

Riggs Center, 218–20, 228

River Pilot (Rockwell, Norman), 55

Robinson, Jackie, 80

Rockefeller, Nelson, 169–70

Rockwell, Abigail (granddaughter), 77, 217, 220, 241

Rockwell, Anne (mother), 229

Rockwell, Barnaby (grandson), 220

Rockwell, Gil, 67

Rockwell, Jarvis (son): art by, 222–25; on career, 220–22; childhood of, 10–12, *14,* 15, 69, 199–200, 206–8; Coulter, M., and, 55; culture shock and, 204–6; depression and, 214–15, 216–18; education of, 166, 213–14; in military, 134, 162, 199, 215; modeling by, *63, 85,* 106, 143–44, *144,* 155, 199, 201–3; with models, 24; psychology of, 213–15; in psychotherapy, 218–20; relationship with, 71, 208–11, 223–24; Rockwell, P., and, 70; Rockwell, T., and, 84, 94, 100–101, *129;* with Roosevelt, 38; Russell and, 211–12; on success, 168; in Vermont, 201–4, *202*

Rockwell, Mary (wife): assistance from, 17, 23, 25, 57; childhood of, 200; death of, 230; depression of, 89, 90–91, 105, 134–35, 162, 196, 213–14, 216–18; Edgerton, A., and, 114–15, 119–21, 134–35, 206, 229; Edgerton, C., and, 105; education of, 78; modeling by, 37, *40,* 84, *85,* 114, 213; as mother, 144; Pelham, G., and, 46; personality of, 22–24, 87,

107; photograph of, *127*; relationship
with, 51, 75–76, 101, *128*, 207, 220,
229; religion for, 54; Rockwell, P.,
and, *131*; Rockwell, T., and, 142;
Squiers, C., and, 61; stories by, 204–
5; support from, 71, 84, 110; Whalen,
Mary, and, 189–91, 217
Rockwell, Nancy (mother), 37, *40*
Rockwell, Norman. *See specific topics*
Rockwell, Nova (daughter-in-law), 223
Rockwell, Peter (son): career of, 134;
education of, 162; family and, 201,
208–10; inheritance of, 217–18;
modeling by, *85*, 143–44, *144*, 214,
231; with models, 24; Rockwell, J.,
and, 70; Rockwell, M., and, *131*;
Whalen, Mary, on, 229
Rockwell, Tommy (son): basketball and,
184; Buddy and, 84, 94, 99; on career,
103; career of, 91–93; childhood
of, 10–12, 69–72, 78; Edgerton, A.,
and, 124–25; Edgerton, Jim, and,
68; education of, 88–90, 134; family
and, 84–90, *85*, 201, 208–10; on
finances, 227, 231–32; friendship
with, 79–80; in high school, 87–88;
on illustrations, 220; inheritance
of, 217–18; modeling by, *63*, 67–68,
77, 81, *82*, 83–84, *85*, 90–91, 93,
106, 205–6; with models, 24; on
move, 228–29; *My Adventures as an
Illustrator* and, 168; Pelham, G., and,
88; poetry of, 126; relationship with,
67–69, *69*, 75–77, 93–96; Rockwell, J.,
and, 84, 94, 100–101, *129*; Rockwell,
M., and, 142; in Vermont, 72–75
Rockwell on Rockwell (Rockwell,
Norman), 104–6, 126, 146, 151

Rogers, John, 228
The Rookie (Rockwell, Norman), 24
Roosevelt, Franklin, 3, 38–39, 99–100
Rosie the Riveter, 168
Rotary Club, 158
The Runaway (Rockwell, Norman), 1
Russell, George, 180, 211–12, 259
Russia: as Soviet Union, 38, 106, 171–72,
174; United States and, 93, 243, 247,
249

Salesman in A Swimming Hole
(Rockwell, Norman), 209
Salter, Winston, 11, *14*, 15, 201–2
Sanden, John Howard, 246, 248–49, 253
San Francisco, California, 219–20
Santa's Helpers (Rockwell, Norman),
48, 242
Saturday Evening Post: for career, 1–3,
5, 92–93; in culture, 173–74, 196–97,
207; fame from, 8–9, *56*, 56–57, 78,
99, 141, 184, 258–59; income from,
44–45; readers of, 241; relationship
at, 6, 43–44, 156; reputation of, 38,
151–52; staff, 119; Sudler in, 92. *See
also specific illustrations*
Saying Grace (Rockwell, Norman): color
study for, 263; debut of, 164–67,
165–66; inspiration for, 158–59;
legacy of, 1, 44, 79, 134–35, 265;
models for, 161–64, 259; process for,
89, 159–61, 208–9, 215–16; Rockwell,
J., in, 199; at Sotheby's, 155–57,
167–68; value of, 44, 218
Schaeffer, Elizabeth, *85*
Schaeffer, Lee, *85*
Schaeffer, Mead, 44, *85*, 120, 246–47
Schaeffer, Patty, *85*

sculptures, 223

Secoy, Frank, 86

self-portraits, *42*

Sharkey, Bill, 79, *165*, 166–67, 222

The Shiner (Rockwell, Norman), 105, 190–91

Shuffleton, Rob, 222

Shuffleton's Barbershop (Rockwell, Norman), 1, 135, 222

Signs (Rockwell, Norman), 44

Sitting on the Wrong Side (Pelham, G.), 33

Skellie, Ruth (née McLenithan). *See* McLenithan, Ruthie

sketching, 172, 263–64, 265

Smith, Bob, 83

Smith, L. Robert, *69*

Smith, Ray, 87–88

Smith, Walt, 31, 47, 73, 87

Snelling, Richard, 262

Society of Illustrators, 119

The Soda Jerk (Rockwell, Norman), 91, 231

softball, 113–14, 123–24

Sotheby's auction house: *The Babysitter* and, 236; *Breaking Home Ties* and, 242, 247–48, 254–56; *Saying Grace* and, 155–57, 167–68

South Korea, 162, 171–72

Soviet Union, 38, 106, 171–72, 174

Spaulding, Don, 112, *112*

Spielberg, Stephen, 30, 168, 201

Spirit of America (Rockwell, Norman), 220

sports: art and, 29; baseball, 75–76, 127, 212; basketball, 85–87, 109–11, 183–84; in childhood, 192–94; for children, 46–47, 80; softball, 113–

14, 123–24; in United States, 24

Spring Landscape of Equinox Pond, VT (Rockwell, Norman), 48–49

Squiers, Clarice: biography of, 263; friendship with, 106; injuries of, 54–55; modeling by, 37, 57–58, 61, 63, *63–64*; personality of, 62; recovery of, 60

Squiers, David, 57–58, *59*, 74, 201, 263

Squiers, Herb, 144, *144*

Squiers, Marjorie, 53–55, 57–61, *59–60*, 201, 263

Squiers, Walt: modeling by, 37, 52–53, 55–57, *56*, 61–65, *63–64*, 106–7; relationship with, 51–53, 203, 263; support from, 144, 259; Wheaton, T., and, 206; with wife, 54

Star Dust (film), 133

Star Wars (film), 223

Steinbeck, John, 78

Stockbridge. *See* Massachusetts

Stockbridge Museum, 49

storytelling, 68–69, 73–74

Strictly a Sharpshooter (*American Magazine*), 32, 44

Stuart, Ken, Jr., 156

Stuart, Ken, Sr., 156, 211, 218

Sudler, Gail, 91–92

Swan, Lynne, 234–37

The Tattoo Artist (Rockwell, Norman), 74, 120

Time (magazine), 149

Tired Salesgirl on Christmas Eve (Rockwell, Norman): assignment for, 17–19; family and, 21–22; model selection for, 6, 19–21, 102, 133;

models for, 24–26, 261; preparations
for, 22–24; reputation of, 26, *27–28*,
28; Rockwell, J., on, 221
Tolstoy, Leo, 207
Tom Sawyer (Twain), 5, 181
Trachte, Dave, 245–46, 248–53
Trachte, Don, Jr.: biography of, 266;
family of, 242, 245–49; legal matters
of, 249–56, *251*; modeling by, 4, 48
Trachte, Don, Sr.: career of, 46, 190,
241–42; friendship with, 242–45;
illustrations to, 239–40, *240*;
personality of, 245–46, 256
Trachte, Marjorie, 242, 254
Trimming the Tree (Rockwell, Norman),
43
Truman, Harry, 135, 149, 172
Trumpet Practice (Rockwell, Norman),
150–53, *152–53*
tuition fees, 229
Tuttle, Linda, 180
Twain, Mark, 181

Understood Betsy (Fisher, D. C.), 188,
193
United Kingdom, 93
United Nations, 171, 174, 177, 265
United States: in art, 18; Britain and,
57–58; in Cold War, 93; comics in,
46, 190; culture of, 11–12, 46, 65,
161–62; Europe and, 81; fame in,
3, 20; farming in, 47–48; Germany
and, 116, 158–59; government,
38–39; Great Depression, 30;
history, 259–60; illustrations in,
1–2; Japan and, 145–46; in Korean
War, 162; military, 137–46, *145*, 215;

philanthropy in, 188; race in, 169–77,
175–76, 265; religion in, 170–71;
reputation in, 16; Russia and, 93, 243,
247, 249; Soviet Union and, 171–72,
174; sports in, 24; Thanksgiving in,
38, *40*; women in, 201–2
The Unknown Rockwell (Buddy), 108,
263
Updike, John, 217

value: of art, 1, 44–46; of *The Babysitter*,
236; of *Breaking Home Ties*, 4,
231, 239–41, *240–41*, 255–56; of
Christmas Homecoming, 181; in
economy, 47–48; of illustrations,
155–57, 167–68, 242; of *On Leave*,
254; psychology of, 44–46; of *Saying
Grace*, 44, 218. *See also* Sotheby's
auction house
Van Brunt, James K., 73
Vaughn, Curnel, *63*, 107, 140
Vermont: architecture of, 70–71;
basketball in, 183–84; for Buddy, 97–
99; culture of, 4, 31, 47, 52–53, 74–
75; for Edgerton, A., 113–14, 121–23;
for family, 69–72; friendships in,
31–32, 258; home in, *130*; inspiration
from, 5, 258–60; landscapes of, 18,
48–49; leaving, 227–29; nature of,
53–54, *56*, 56–57, 61–62, 68, *69*,
116–17, 121–22, 205; New York and,
6, 30–31, 70–71, 204; reputation in,
257; Rockwell, J., in, 201–4, *202*;
Rockwell, T., in, 72–75; studio in,
129–30; Vermont Rockwell Models
Association, 4; visiting, 229–30;
weather in, 228

Vermont News Guide, 49, 230–31
Vishinsky, Andrei, 174
The Voyeur (Rockwell, Norman), 123

Walker, Harry, 24
Walker, May, 156–57, 163–66, *165*,
 259
Walker, Ralph, 163
Walking to Church (Rockwell, Norman),
 221, 265
Walmart, 168, 254
Walton, Alice, 168, 254
Washington, George, 30
West Arlington. *See* Vermont
We the Peoples (Rockwell, Norman), 3,
 90, 114, 169–77, *175*, 244–45
Whalen, John, 183–85, 190, 194, *198*,
 227
Whalen, Margaret, 183–86, 194–96
Whalen, Mary: biography of, 266;
 modeling by, 127, 175, *175*, 180–81,
 185–86, *187*, 188–89, 191–93, 196–
 97, *197–98*, 221; relationship with,
 183–85, 193–96, 230; Rockwell, M.,
 and, 189–91, 217; on Rockwell, P.,
 229
Whalen, Peter, 185, 188–89
Wheaton, Bess, 71–72, 203

Wheaton, Thaddeus, 61, 71–72, 203–4,
 206
Wheelis, Allen, 219
When Your Doctor Treats Your Child
 (Rockwell, Norman), 74
Wilcox, Orin, 162
Wilcox, Stubby, 47
Williams, Claudia, 76
Williams, Ted, 24, 75–76
Williamstown Art Conservation Center,
 249, 252–53
Wilson, Bill, 217
Winslow, Don, 123, 166
Witter, Dean G., 262
Wolfe, Thomas, 217
women, 201–2
Women's National Press Club, 169–70
World War II: in art, 57–59, *59–60*;
 casualties of, 106–7; children during,
 234; culture of, 3, 18, 258; economy
 of, 98; end of, 115–16; Europe and,
 37–38, 139; family after, 81, *82*,
 83–84; Germany after, 81; medicine
 in, 211–12; Nazis in, 158–59, 259;
 posttraumatic stress from, 264;
 Roosevelt during, 99–100

Zimmer, George, 209

About the Author

Author photo by Jeff Edrich

S. T. Haggerty is a longtime writer of fiction, nonfiction, and poetry. He is known for his skill at telling intriguing, heartfelt stories with honesty as well as lively and concise language. A former editor for McGraw-Hill Publications in New York City, he is a freelancer who has traveled the country to create features on top businesspeople and business strategy as well as general interest stories. He graduated from Southern Vermont College with a BS in business management/communications and received his MA in journalism at the University of South Carolina, attending on a full scholarship. His first book, *Cows in the Fog and Other Poems and Stories*, is loved by many and has been praised by publishing executives, such as Amy Newmark, editor in chief of *Chicken Soup for the Soul* books, who wrote him a personal note saying, "*Cows in the Fog* is a wonderful book. I like it. I really like it." He is a lover of stories, and his readers are the reason he writes. He especially enjoys reading at bookstores, libraries, and art centers.